# Paris Living

GUILLAUME DE LAUBIER

# *Preface*

In the world of architecture and design, few cities inspire as profoundly as Paris. *Paris Living* invites you to explore the elegance, eclecticism, and charm of Parisian homes through the lens of the talented photographer Guillaume de Laubier. Renowned for his sensitivity to light and atmosphere, de Laubier captures not only interiors but also the essence of life within them, offering an intimate portrayal of how Parisians live, create, and dream.

Parisian homes mirror the city itself—a seamless blend of history and modernity, where every residence tells a unique story. From the grand Haussmannian apartments with their soaring ceilings and intricate moldings to contemporary lofts adorned with avant-garde art, the homes featured in this book celebrate the diversity of Parisian style. Each interior reveals the personalities of its inhabitants through distinctive collections, thoughtful design choices, and compelling personal histories.

Within the pages of *Paris Living*, readers will discover interiors that honor both tradition and innovation. Designers, architects, and homeowners have shared their visions, crafting spaces that merge vintage charm with modern aesthetics. Here, antique treasures coexist harmoniously with sleek furnishings and curated artworks, each carefully selected to reflect Paris's rich cultural heritage.

This journey through Parisian interiors is more than a visual delight—it is an exploration of the art of living. Every photograph reveals the soul of a city that treasures beauty, creativity, and individuality. Whether it is an artist's atelier, a fashion designer's retreat, or a family home passed down through generations, each space embodies the vibrant spirit of Paris. Through Guillaume de Laubier's lens, *Paris Living* captures not only the physical beauty of these interiors but also the intangible atmosphere that makes them so unmistakably Parisian.

As you turn these pages, may you be inspired to see Paris not merely as a city of landmarks and boulevards but as a mosaic of lives laced with elegance, whimsy, and passion. *Paris Living* is an invitation to step into these sanctuaries, admire their beauty, and perhaps infuse your own life with a touch of Parisian inspiration.

Welcome to the heart of Paris, where every home is a masterpiece and every room tells a story waiting to be discovered.

Maria Aziz

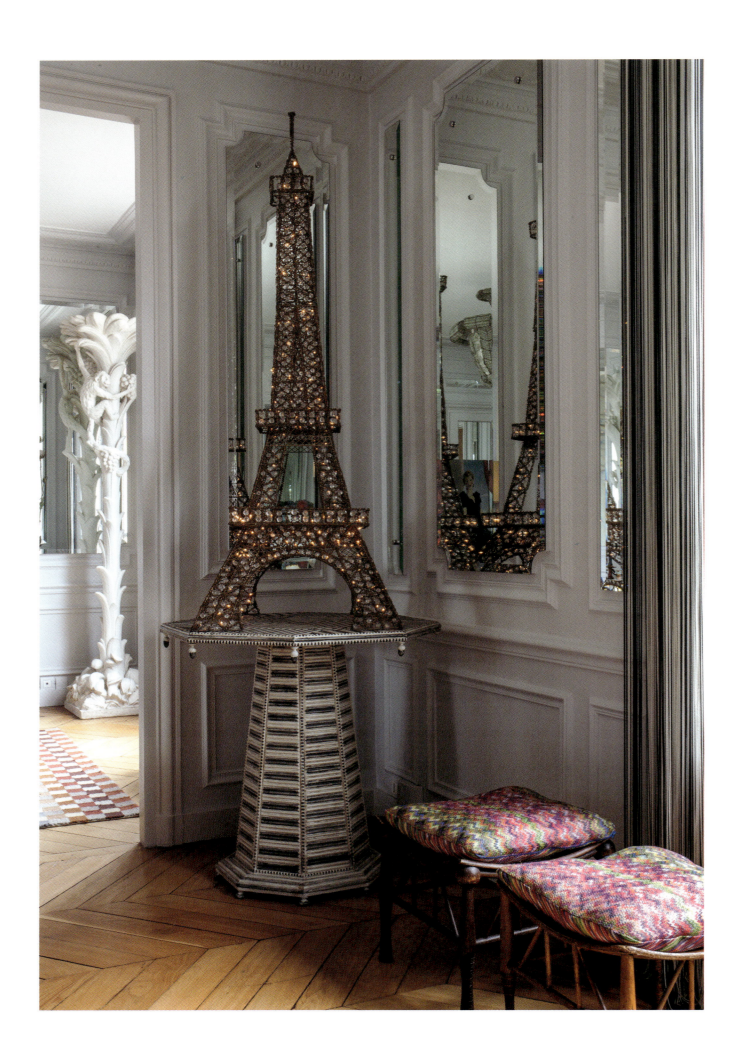

*Table of Contents*

| | |
|---|---|
| 08 | Whimsical Abode |
| 24 | Personal Museum |
| 36 | Empire Elegance |
| 52 | Parisian Poise |
| 68 | Artful Living |
| 82 | Historical Echoes |
| 92 | Artful Heights |
| 100 | Chic Sanctum |
| 110 | Fabric Fantasia |
| 122 | Urban Haven |
| 138 | Architectural Mastery |
| 150 | Intimate & Feminine |
| 162 | Creative Sanctuary |
| 174 | Sculpting Time |
| 188 | Prince of Plastic |
| 200 | Textile Tale |
| 214 | Spatial Symphony |
| 230 | Cosmopolitan |
| 246 | Cultural Heritage |

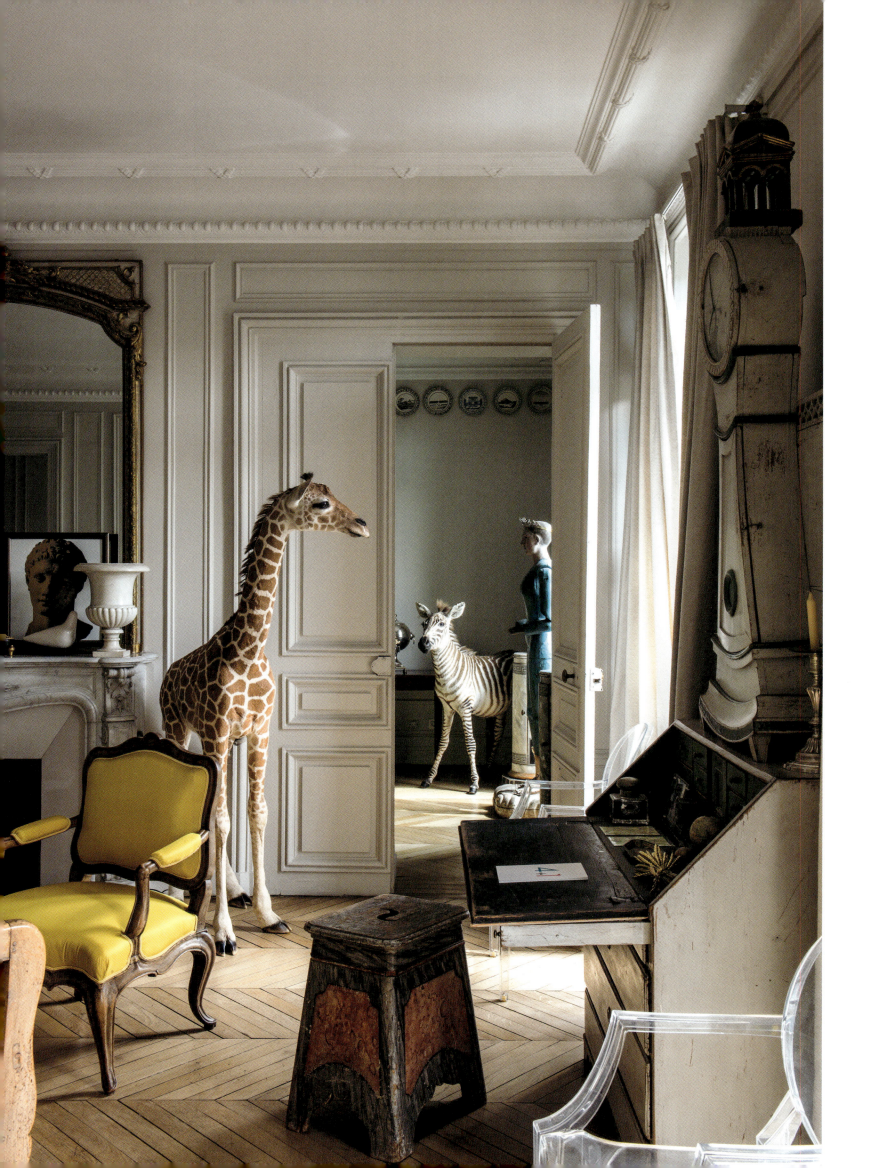

# Whimsical Abode

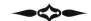

In this elegantly styled room, a Gustavian desk pairs seamlessly with a Louis XV yellow armchair, creating a sophisticated blend of classical design. A Philippe Starck chair adds a modern twist, while an Italian faux-marble stool, part of a vintage pair, introduces a touch of artistry. In the adjoining room, a striking zebra from the Design et Nature gallery in Paris and an 18th-century Mexican Virgin procession statue—one of the first pieces to grace this home—infuse the space with distinctive, worldly charm.

**Jean Mortier's Paris apartment serves as a testament to artistic expression and sophisticated living. Acquired in 2002, this six-room residence captures breathtaking views of the iconic Eiffel Tower and Arc de Triomphe, making it not just a home but a gateway to the historical beauty of Paris.**

Located in a classic Haussmannian district known for its grand boulevards and elegant architecture, the apartment uniquely blends traditional grandeur with eclectic decor. An intriguing collection of stuffed animals adds a whimsical contrast to the refined backdrop. These are not mere ornaments but integral to the apartment's charm, injecting playful yet sophisticated elements that reflect Mortier's distinctive aesthetic.

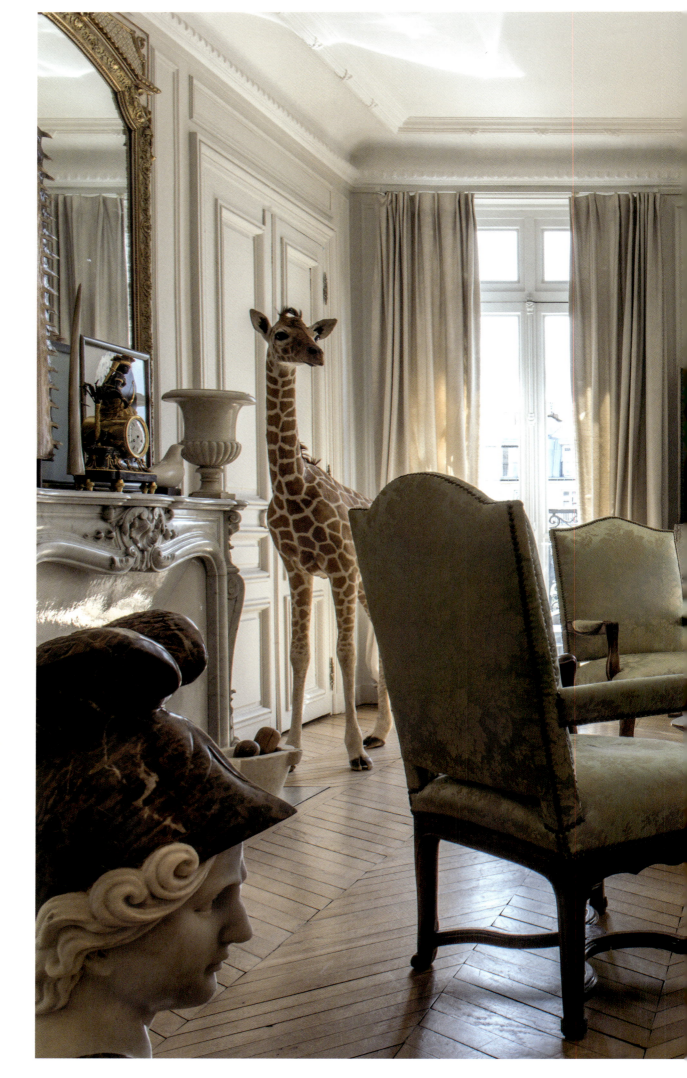

In the grand salon, 19th-century Italian busts purchased in Rome lend a touch of historical grandeur to the space. Yellow Louis XV armchairs, upholstered in fabric from Marché St. Pierre, offer an elegant contrast to green Louis XIV chairs covered in Othello fabric by Verel de Belval. At the heart of the room, a low Nénuphar coffee table by Janette Laverrière and produced by Editions Perimeters, serves as a centerpiece, adorned with pottery by ceramist Claire Bogino and a 1950s vase discovered at the Vanves flea market. To the right, a green Regency-era sofa from the Quintaou flea market in Anglet has been newly reupholstered, adding a fresh touch. In the background, a Gustavian cabinet from Antwerp completes the elegant ensemble.

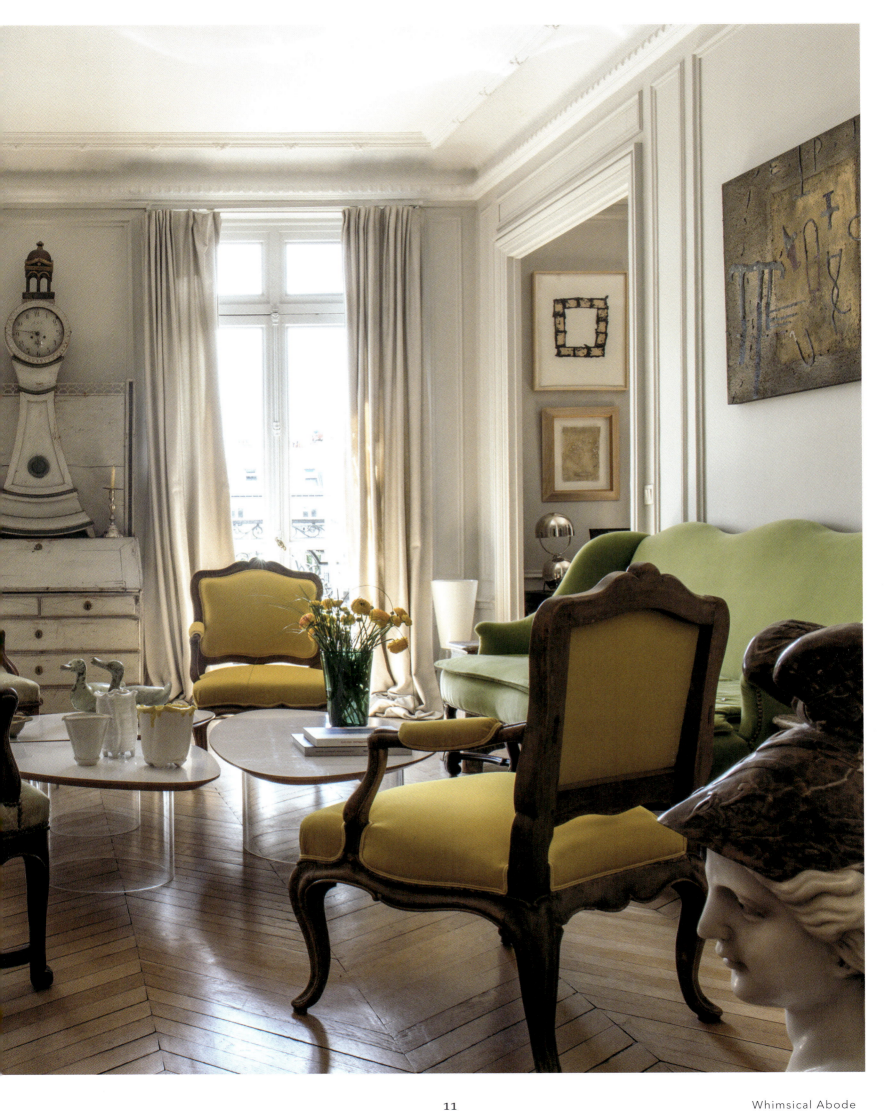

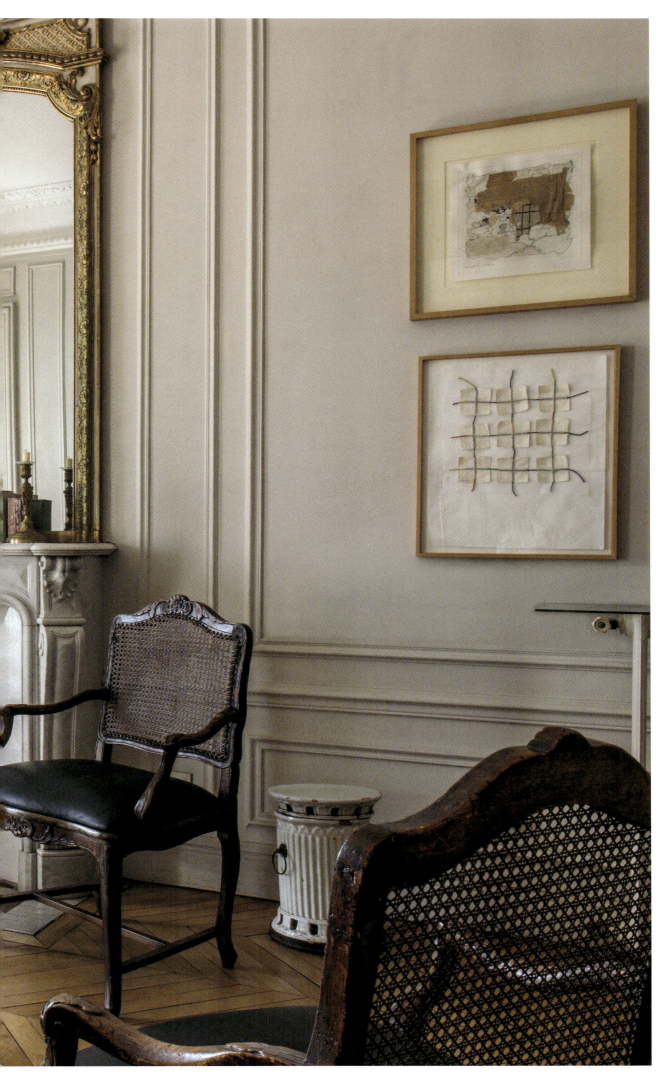

In this elegant corner, a Louis XVI bench attributed to George Jacob (acquired from the Daguerre auction) pairs with Regency-era cane chairs. A coffee table, adorned with ceramics by Claire Bogino, sits beneath a stately original fireplace with a classic Pendule au Nègre Le Marin clock on top. Artworks by Anne-Marie Milliot enhance the refined ambiance.

Whimsical Abode

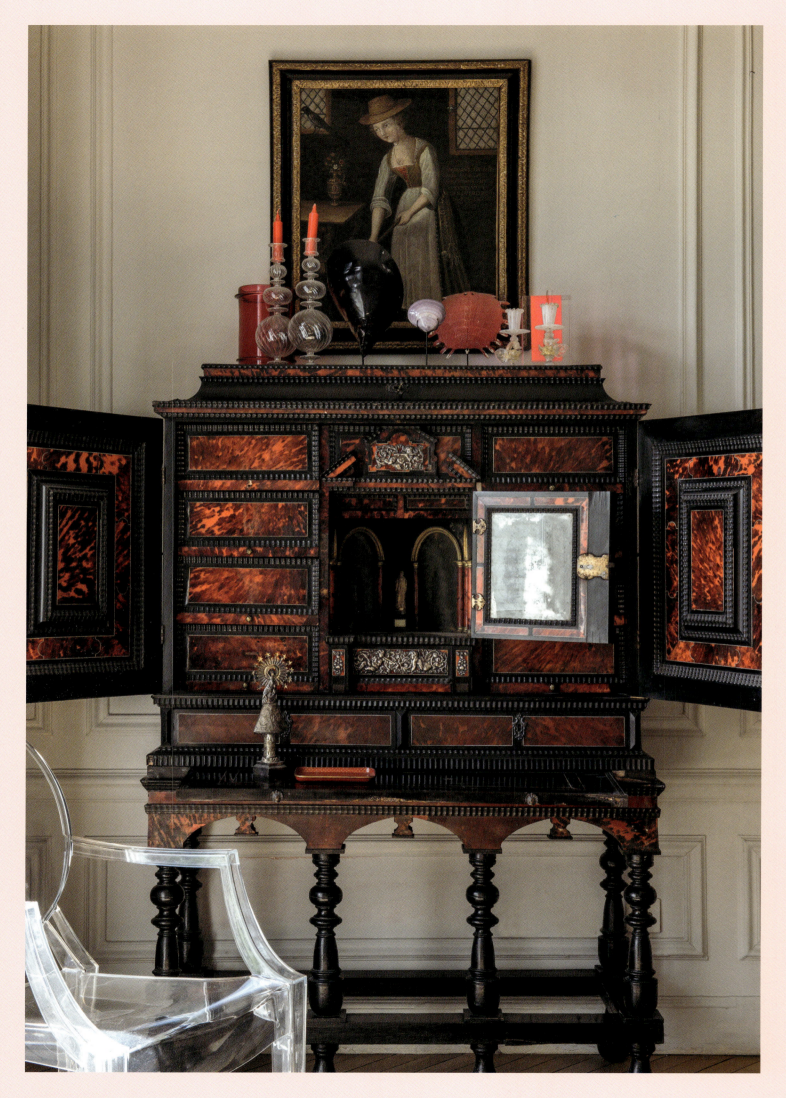

Each room in the home boasts a unique personality, with a color palette of gray, yellow, and green, adding vibrancy and elegance. The dining room, Mortier's favorite, is designed for entertaining, reflecting his love for hosting guests in a space that combines antique charm with contemporary flair. Among the standout pieces is a dramatic stuffed tiger, a signature item that adds boldness to the decor, embodying Mortier's adventurous spirit and passion for unique, memorable objects.

While aesthetics are paramount, functionality is equally prioritized. The kitchen and bathrooms have been modernized into sleek, highly functional spaces, creating a striking contrast to the artistic themes that dominate the living areas. This balance highlights Mortier's skill in merging practical living with artistic expression, ensuring his home is as comfortable as it is visually captivating.

(Left) In the petit salon, a striking 17th-century Antwerp cabinet crafted from blackened pearwood and red tortoiseshell (sold by Rémi Le Fur) commands attention. The cabinet is complemented by a 17th-century Dutch painting, lending historic charm. A Louis Ghost chair by Philippe Starck for Kartell introduces a transparent, contemporary element, while a modern Capsule Stool by Hervé Van der Straeten (see previous page) contributes a sculptural, artistic flair.

(Above left) The dining table features an asparagus-patterned majolica dinnerware collection from the Vanves flea market, complemented by antique green glassware. Japanese porcelain and a vintage glass cooler form the centerpiece, adorned with lush plants. Playful Eiffel Tower-shaped candle holders from a decorative arts shop complete the scene, all bathed in the soft glow of a chandelier.

(Above right) *Les Cosmogonies* by Victoria Magniant (daughter of V. Lopez), sourced from Galerie V, brings a vibrant, luminous flair to the space.

(Below) In the dining room, a late 18th-century English mahogany table is paired with Philippe Starck chairs, surrounded by an eclectic mix of unique pieces: to the right, a Restoration-era serving cart and two faux-marble columns from 1820, recently sourced in Brussels, add a touch of antique charm. Overhead, a Spanish chandelier, once used for royal celebrations in the streets of Madrid and now a staple in Jean's homes, casts a warm, inviting glow. The wall features an artwork by Nîmes artist André Debono, while a frieze of late 18th-century black and white Creil plates adds a decorative accent above. Framing the windows, elegant curtains from a national furnishings sale exude sophistication, while a whimsical zebra from the Design et Nature boutique on Rue d'Aboukir adds a playful touch.

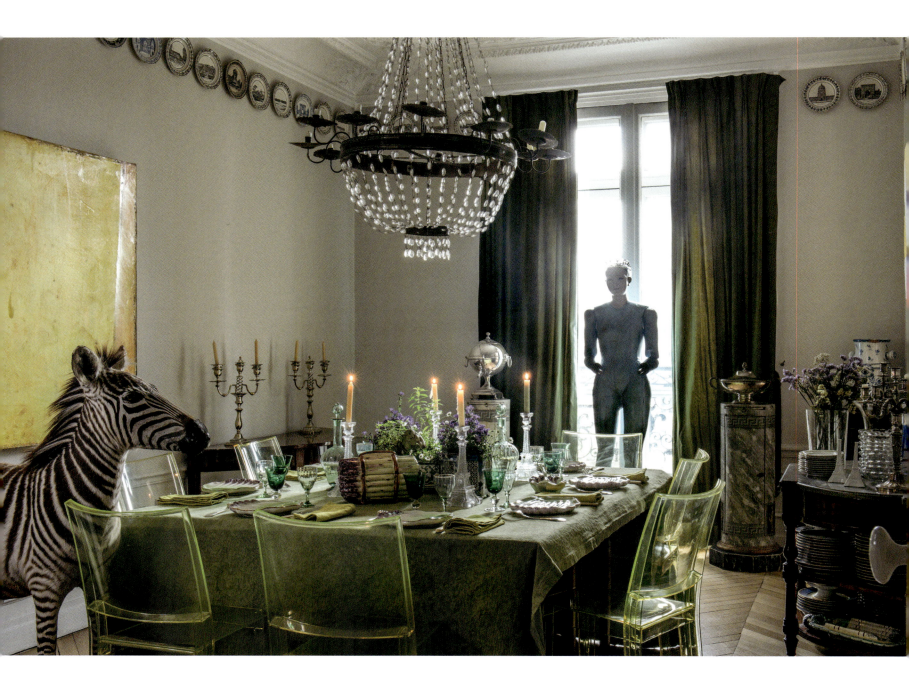

Paris Living

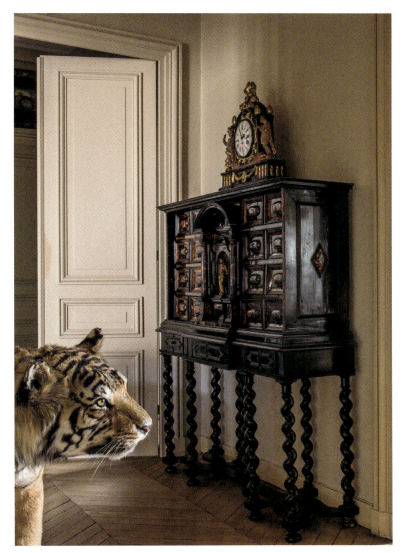
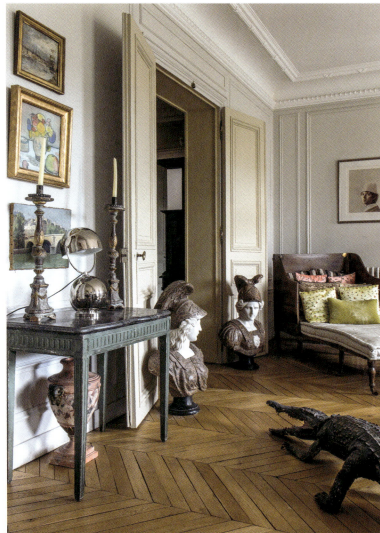

(Above left) In the entrance, an Indochinese tiger from the collection of designer and friend Josephus Thimister stands proudly alongside an 18th-century Italian cabinet and a 17th-century wooden clock, creating an intriguing fusion of historical elegance and exotic intrigue.

(Above right) A Louis XVI console, sourced from Vanves, accompanies a curated selection of items, including a crocodile from an 18th-century cabinet of curiosities and an ornate decorative vase. Nearby, a Napoleonic army bed, adorned with distinctive cushions, adds a unique, storied presence. A portrait by Gregorio Ciartas (1982), hangs above, infusing the space with a refined touch.

Mortier's decorating inspiration draws from his personal history and his frequent visits to flea markets, reflecting his journey of growth and evolving taste. Influenced by designers like Hervé Van der Straeten and Janette Laverrière, he has curated a space that feels both carefully crafted and intimately personal. Each piece, from furniture to decorative accents, tells a story of past adventures, friendships, and a deep appreciation for the past.

Mortier's Parisian apartment is more than just a home —it's a dynamic expression of his life's passions, blending art, history, and modernity. It serves as a testament to the power of personal space to mirror and enhance the lives and tastes of its inhabitants, making it a true artistic sanctuary in the heart of Paris. —

In the study, a striking black and white console table, custom-designed by Janette Laverrière for Jean Mortier, serves as a focal point, crafted from laminate, beech plywood, sycamore, and steel. A blue lamp by Eric Gizard sits atop, adding a touch of modern flair. A striped Louis XVI-style armchair offers classic elegance, while vintage black seats, sourced from the Vanves flea market, introduce an element of charm. A unique painting from Rio contrasts beautifully with the warm Farrow & Ball wall color, likely in the shade Orangery. The space is grounded by a Casa Lopez Cordoba rug.

Paris Living

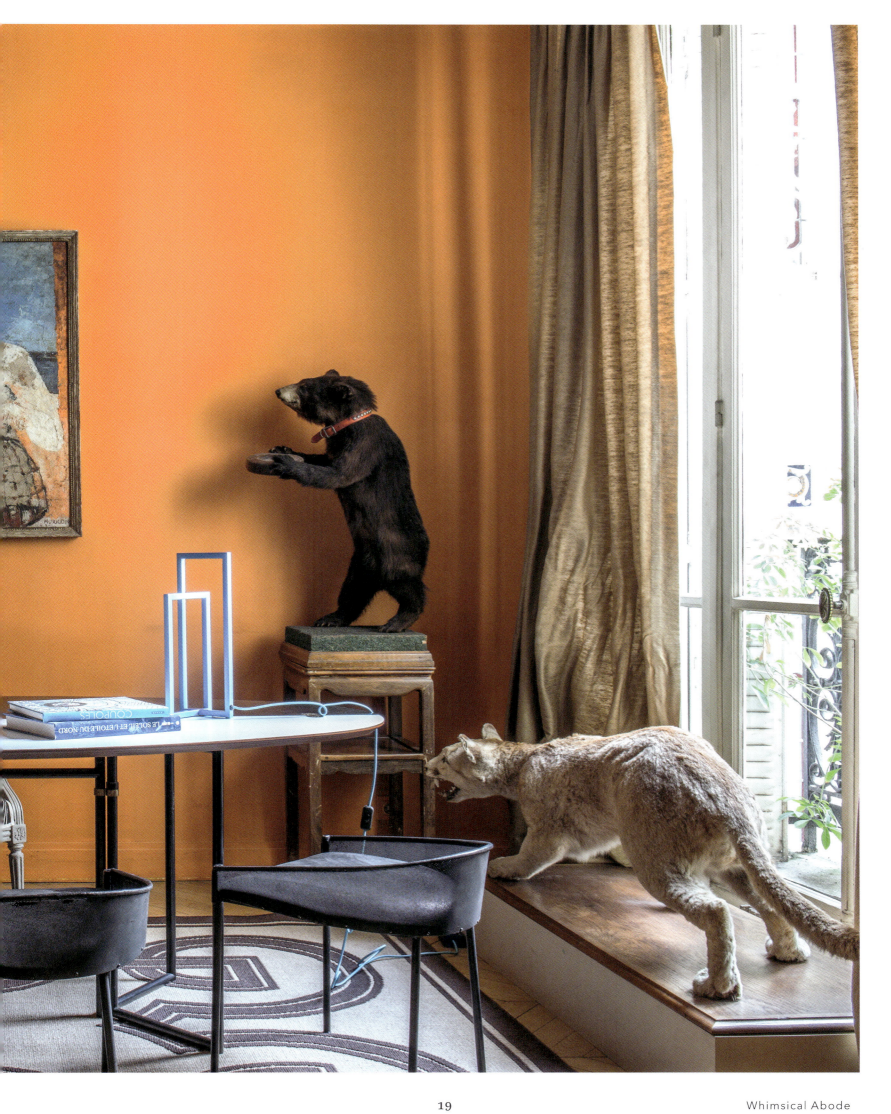

(Below) The kitchen, designed by the owner, stands out with its sleek, contemporary aesthetic, providing a stark contrast to the rest of the apartment. Located at the end of a 12-meter corridor, this space occupies a former bedroom and features glossy black car lacquer cabinetry and stainless steel surfaces, complemented by a sky-blue ceiling for an airy feel. On the countertop, a Vincent Darré x Monoprix vase and a Rowenta toaster add personality, while a central rolling table designed by Jean Mortier enhances functionality for gatherings. The table is adorned with a Vincent Darré x Monoprix pitcher and mugs, featuring Copacabana's iconic sidewalk patterns. Wooden stools from Habitat complete the setup.

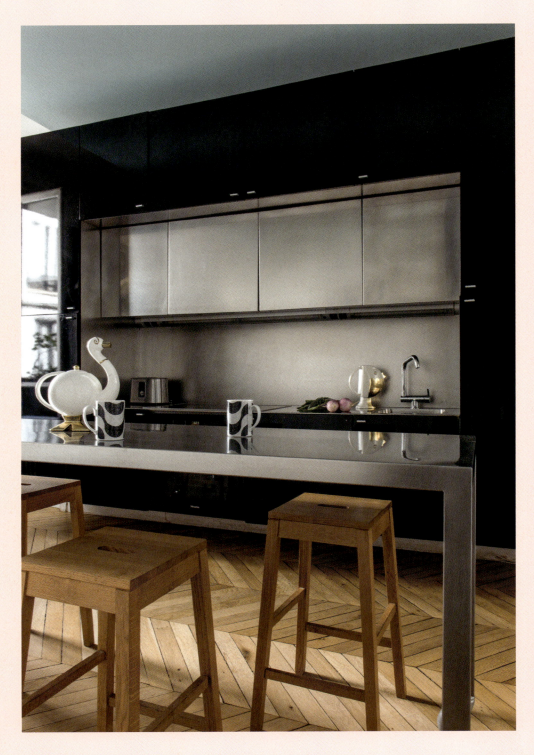

(Right) An industrial cabinet, originally sourced from the Vanves flea market, has accompanied Jean to his New York loft and back, embodying a sense of adventure. Atop it rests a taxidermied blue-footed booby next to a Vincent Darré x Monoprix bowl. Above, a 1935 painting by Clément-Serveau adds a historical touch.

Paris Living

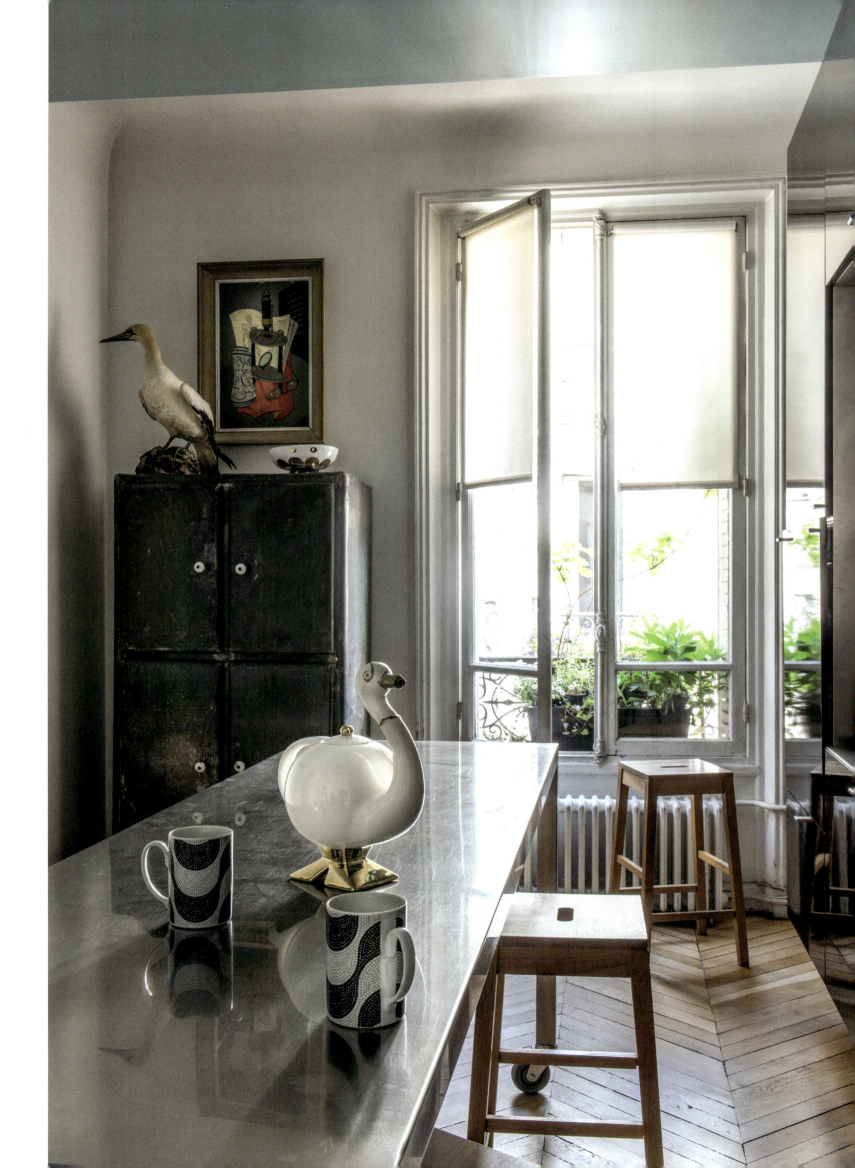

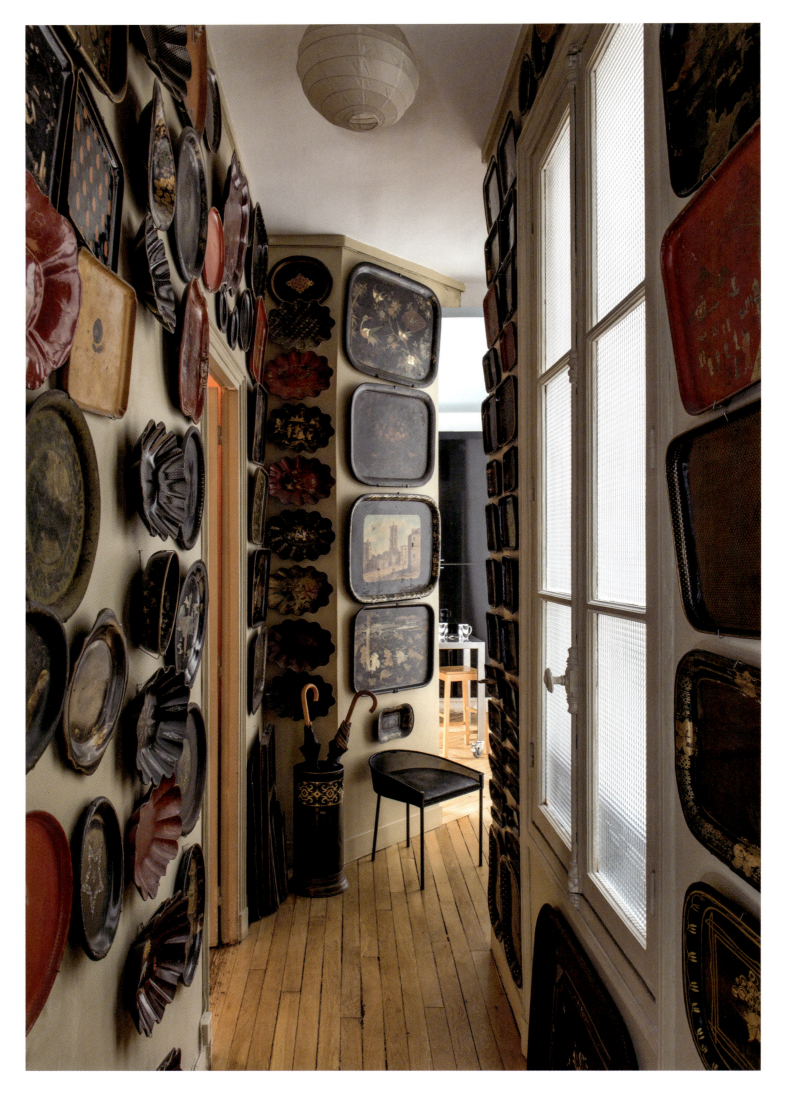

Paris Living

Jean Mortier's Parisian apartment is more than just a home—it's a *dynamic expression* of his passions, seamlessly blending *art, history,* and *modernity*.

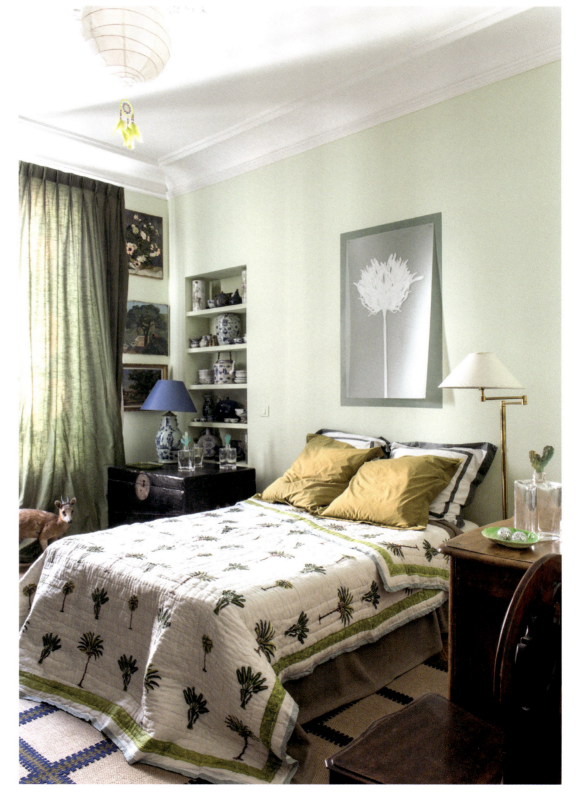

(Left) The corridor features an eclectic collection of Napoléon III-era trays and decorative table objects made from papier-mâché and metal. A black chair from the Vanves flea market introduces a modern touch, while a Napoléon III painted metal umbrella stand complements the historical charm. The original parquet flooring completes the vintage ambiance.

(Right) In the bedroom, a palm-patterned bedspread by Bloom Paris pairs with linens from La Redoute and Delorme, adding texture and warmth. A Casa Lopez rug inspired by Napoléon III design complements the space. Atop a chest sits a Hilton McConnico cactus carafe (1987 for Daum), paired with an antique English plate. An 18th-century Chinese trunk from Beijing holds a collection of McConnico carafes and a faience lamp. Shelves hold Japanese porcelain pieces from the 18th and 19th centuries, accompanied by a contemporary artwork by Frédérique Lucien (2007). Curtains sourced from National Furniture sales frame the windows, while an English floor lamp and a 19th-century chair add classic, elegant touches.

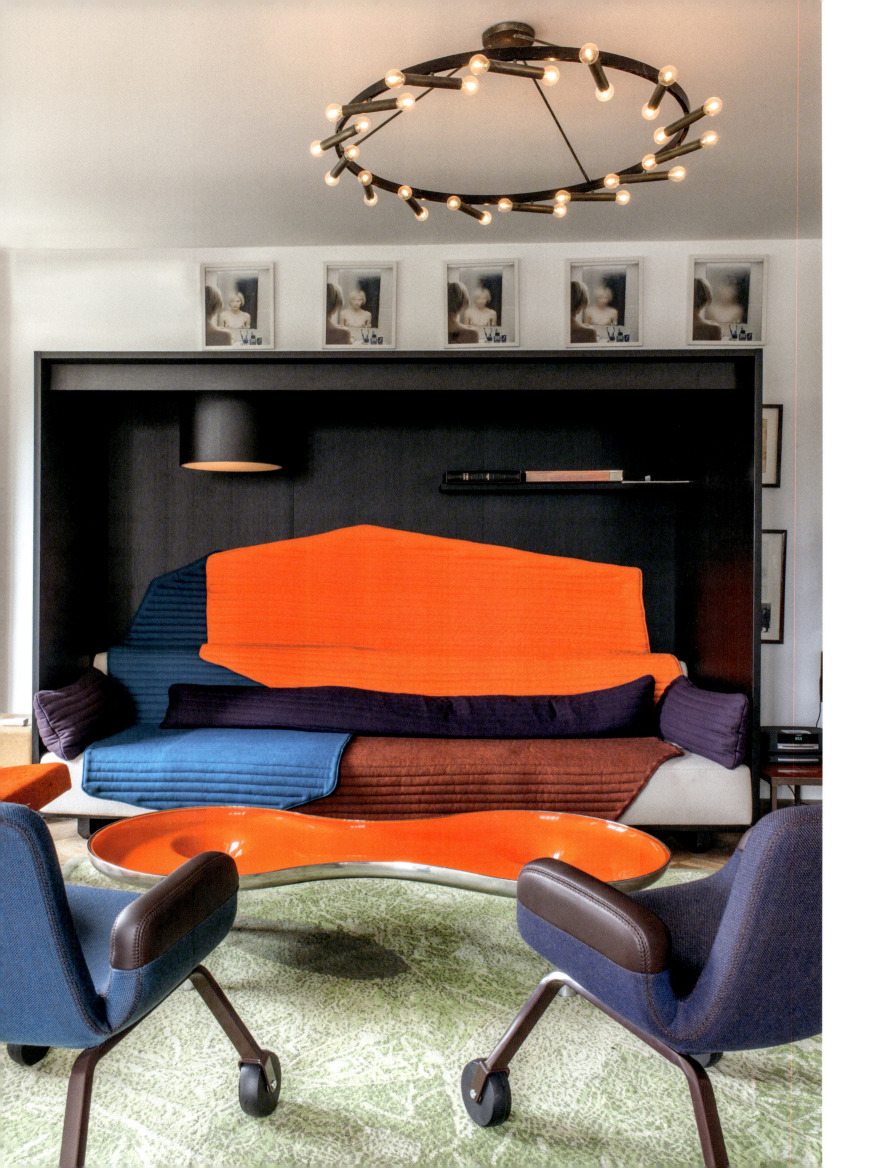

# Personal Museum

**Across the tranquil waters of the Seine, under the shadow of the Eiffel Tower, lies the Parisian home of Didier and Clémence Krzentowski, the distinguished founders of Galerie kreo. Renowned for their impeccable taste and influence in the design world, their apartment is a living reflection of their lifelong journey through contemporary art and design.**

Didier, the son of Polish immigrants turned resistance fighters, began his collecting passion with humble key chains. As his interests evolved within the vibrant cultural landscape of 1980s Paris, he gravitated toward contemporary art and photography, with particular admiration for artists like Cindy Sherman and Nan Goldin. This passion soon expanded to an impressive collection of vintage lamps from the 1950s to the 1990s, with nearly 700 models featuring the work of his idol, Gino Sarfatti.

A contemporary ambiance is crafted with a sofa by Ronan & Erwan Bouroullec, complemented by Marc Newson's *Orgone Chop Top* coffee table. Hella Jongerius's UN lounge chairs add modern comfort, while a ceiling light by Gino Sarfatti adds a sophisticated illuminating touch.

(Below) The space features Jasper Morrison's *Variation* marble low console, lending a sleek, minimalist aesthetic. On the console are works like Meschac Gaba's *Dreadlocks Bulb* and Richard Fauguet's *Nike Clogs*. Adding a conceptual layer, Danh Vo's *We the People* artwork enriches the decor with thought-provoking symbolism.

(Right) A blue sofa by Pierre Paulin provides a bold seating option alongside Robin Day's armchairs. The *Ignotus Nomen* coffee table by Pierre Charpin anchors the room, while a pendant light by Gino Sarfatti casts a refined glow.

(Next page) The room showcases Marc Newson's 1993 *Orgone Stretch Lounge*, surrounded by an eclectic collection of objects by renowned designers, including the Bouroullec brothers, Shiro Kuramata, Hella Jongerius, Andrea Branzi, and Ettore Sottsass. Lighting includes a pair of black Elysée wall lights by Pierre Paulin and a vibrant multicolored wall light by Gino Sarfatti, adding warmth and dynamic accents to the modern aesthetic.

Paris Living

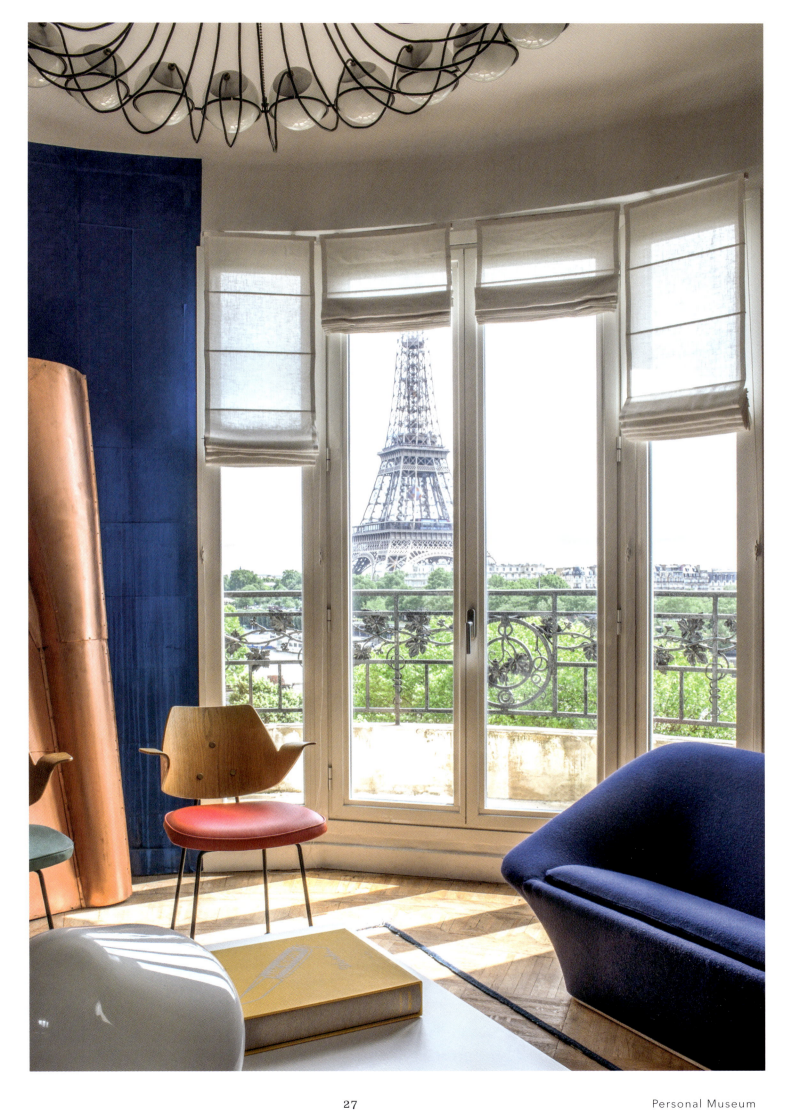

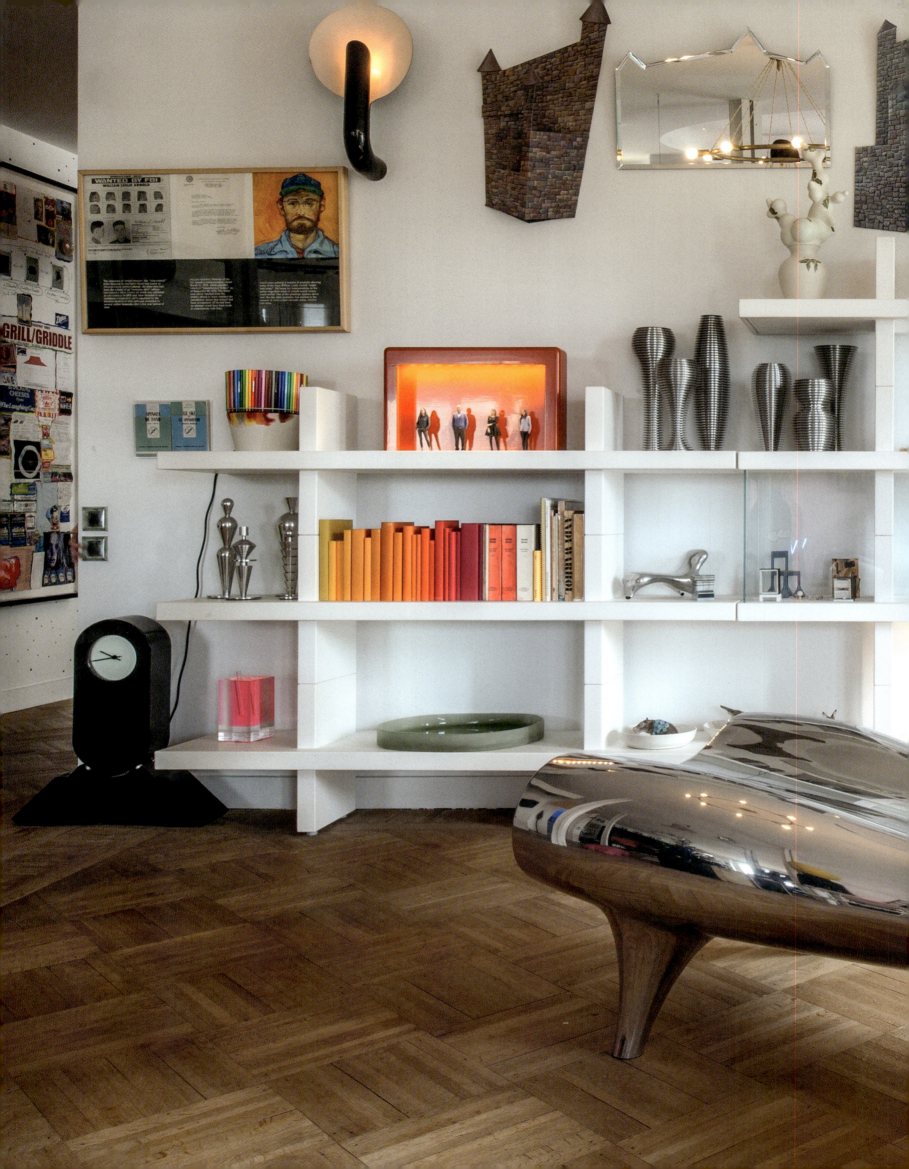

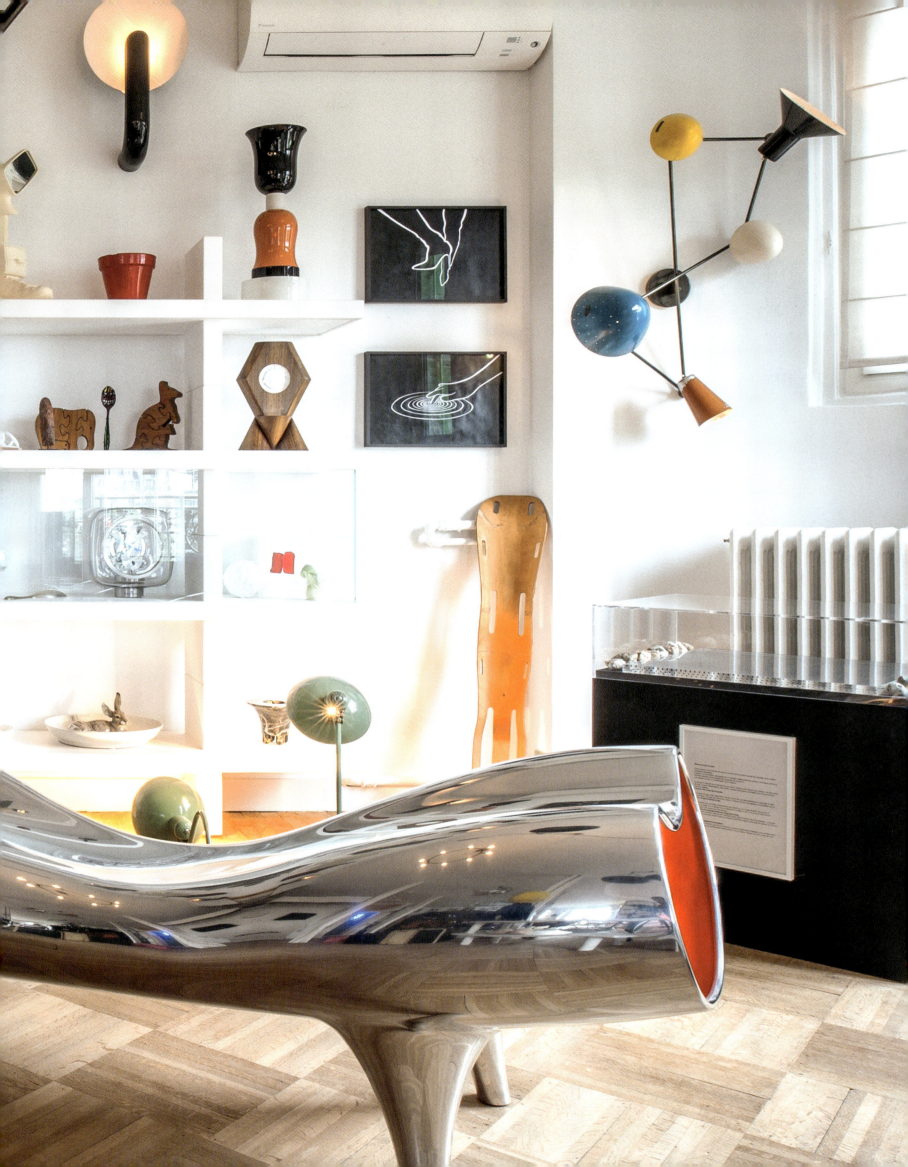

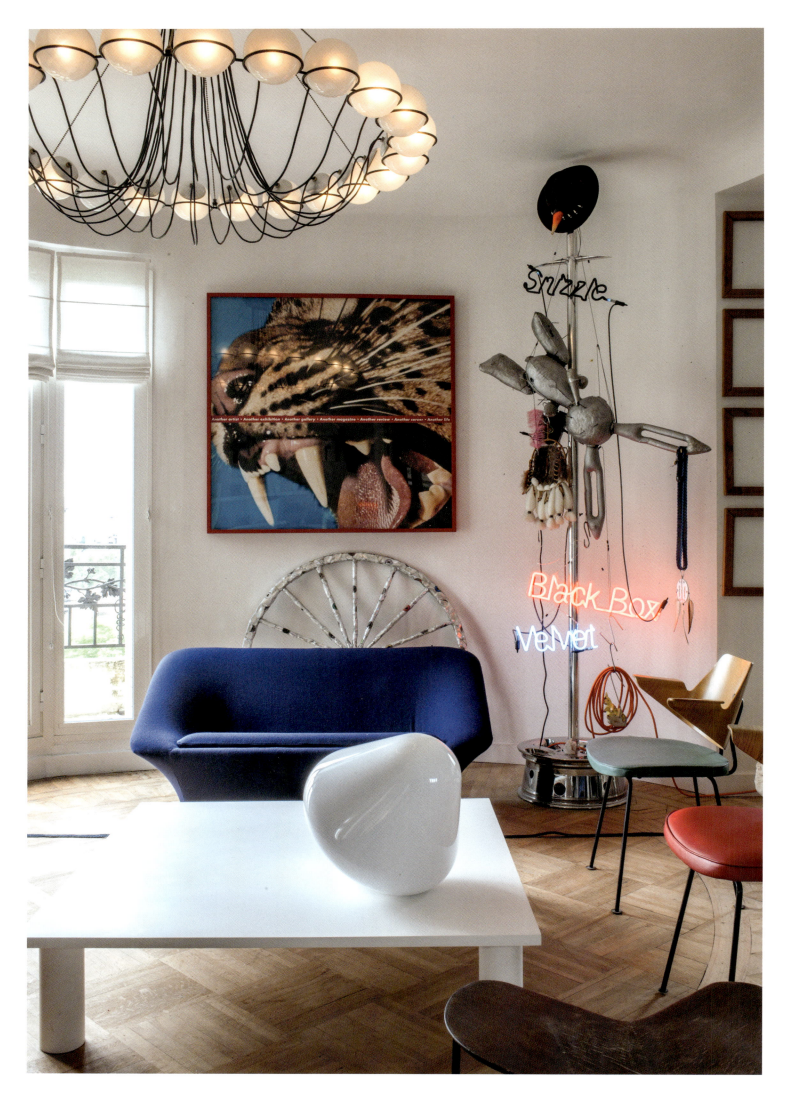

Paris Living

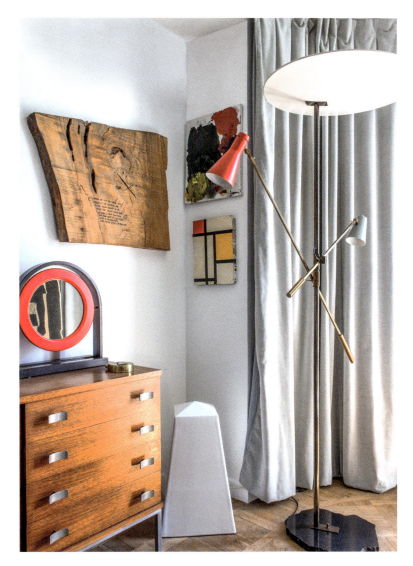 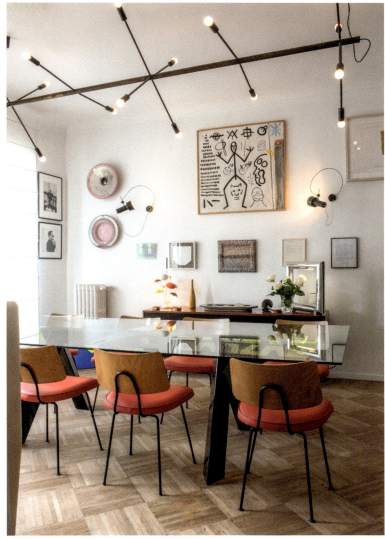

Perched atop a classic Belle Époque building with its iconic dome and wrought iron balconies, the Krzentowskis' apartment offers breathtaking views of the city. Clémence—a young, talented Sorbonne graduate—reimagined the space, originally composed of smaller, traditional rooms, transforming it into a spacious living room. When their youngest child was born, the couple expanded further, incorporating an adjacent apartment into their home. This required difficult sacrifices, including parting with a cherished piece by Maurizio Cattelan.

For the Krzentowski's, the home is an extension of their gallery—a space where form often triumphs over function. Iconic pieces, such as a bronze Christmas tree by Philippe Parreno and a magical ceiling by Ugo Rondinone that emits paper snowflakes, fill the living space, creating a whimsical and ever-changing interior landscape. Even the oversized, sculptural sofa by the Bouroullec brothers has found its rightful place within this artistic haven.

(Left) The seating area is anchored by Pierre Charpin's *Ignotus Nomen* coffee table, complemented by a bold blue sofa by Pierre Paulin and armchairs by Robin Day. Art pieces include a striking sculpture by Jason Rhoades, a compelling photographic work by Barbara Kruger, and Christian Marclay's *Wheel*. A pendant light by Gino Sarfatti adds an elegant finishing touch.

(Above left) An Ettore Sottsass mirror graces an Alain Richard cabinet, creating a refined focal point. A sculpture by Boris Achour enhances the artistic presence, while a floor lamp by Gino Sarfatti provides elegant illumination. A thought-provoking work by Jimmie Durham completes the setting, adding depth and cultural resonance.

(Above right) A painting by A.R. Penck hangs above timeless Robin Day chairs, offering a classic seating solution. Konstantin Grcic's Banzai table introduces a modern sculptural element, while a pendant light by Giampiero Aloi provides subtle, understated lighting.

(Left) An earthy terracotta and bronze cabinet by Elizabeth Garouste adds a textured, artisanal quality to the space. A desk by Jean Prouvé combines functional elegance with industrial charm, while a minimalist wall shelf by Pierre Charpin offers streamlined storage, creating a harmonious blend of craftsmanship and modern design.

(Right) A photograph by Erwin Wurm injects a touch of humor and a contemporary perspective on sculpture, while a painted mirror by Bertrand Lavier blurs the boundaries between painting and object, adding an intriguing layer of artistic depth.

For the Krzentowski's, the home is an *extension of their gallery*—a space where *form* often *triumphs* over function.

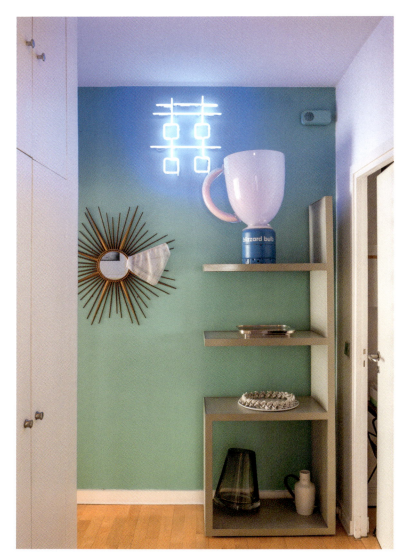
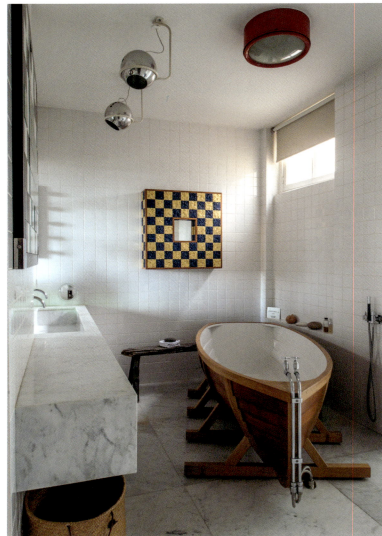

(Above left) A mirror piece by Latifa Echakhch adds a reflective, thought-provoking element, while a neon artwork by Dominique Gonzalez-Foerster introduces a vibrant, conceptual flair. The *Blizzard Bulb* lamp by Hella Jongerius completes the ensemble, with its playful yet refined design.

(Above right) The *Bath Boat* tub by Studio Wieki Somers offers a whimsical yet functional centerpiece in the bathroom, complemented by an avant-garde mirror crafted by Alessandro Mendini. Overhead, elegant ceiling lights by Gino Sarfatti provide a warm, sophisticated glow.

(Right) A dynamic ceiling installation by Ange Leccia sets the tone for the room, accompanied by Allan McCollum's *Plaster Surrogates* wall piece, adding a unique textural dimension. A sculpture by David Noonan offers a contemplative, artistic presence. The *Grey Grappe* carpet by Ronan & Erwan Bouroullec grounds the design with its subtle texture, while a low chair and ottoman by Pierre Paulin offer modern comfort and style.

Despite the grandeur of their surroundings, the Krzentowski's maintain a simplistic approach to their personal lives, particularly in the culinary realm. With a compact kitchen and limited interest in cooking—Clémence playfully admits she can't cook an egg—the couple often dines out or hires professional chefs when entertaining friends, including fashion icon Azzedine Alaïa.

The Krzentowski residence is more than a home; it's a personal museum that captures the essence of their aesthetic and philosophical journey through the world of design. Every piece and every artist represented tells a story of a life dedicated to the pursuit of beauty and artistic expression. For the Krzentowski's, this is not just a residence; it's where they embody the art of living. —

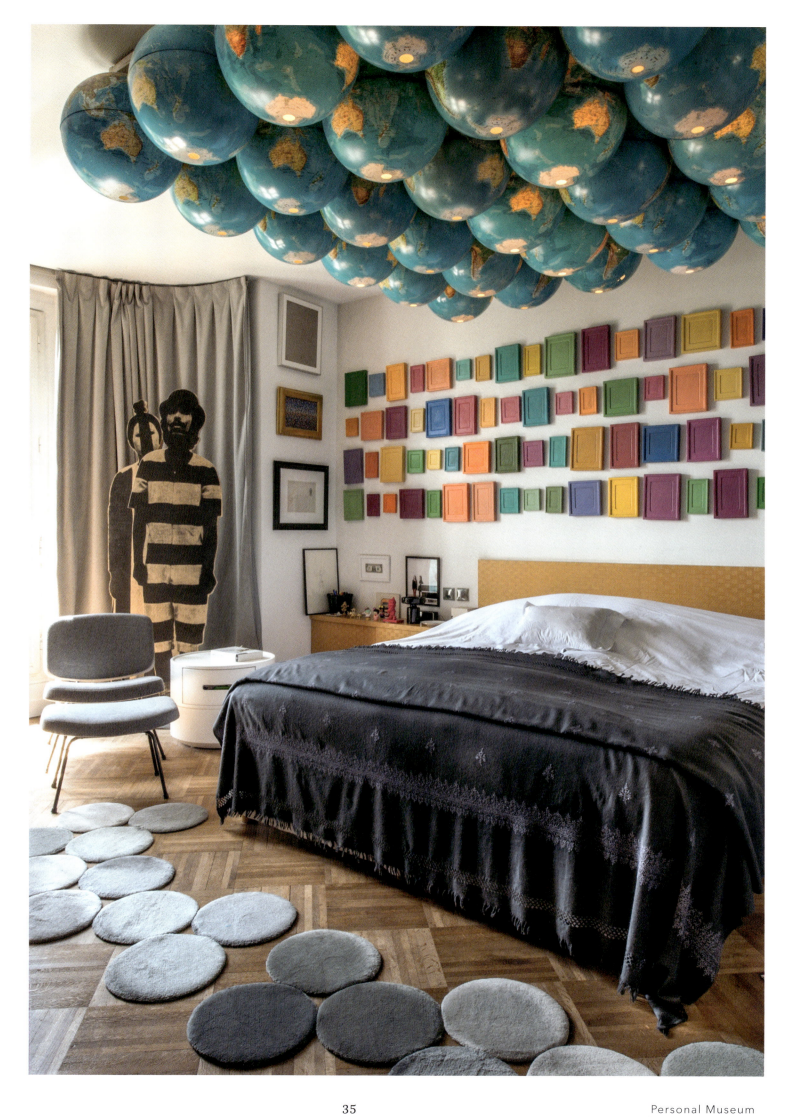

Personal Museum

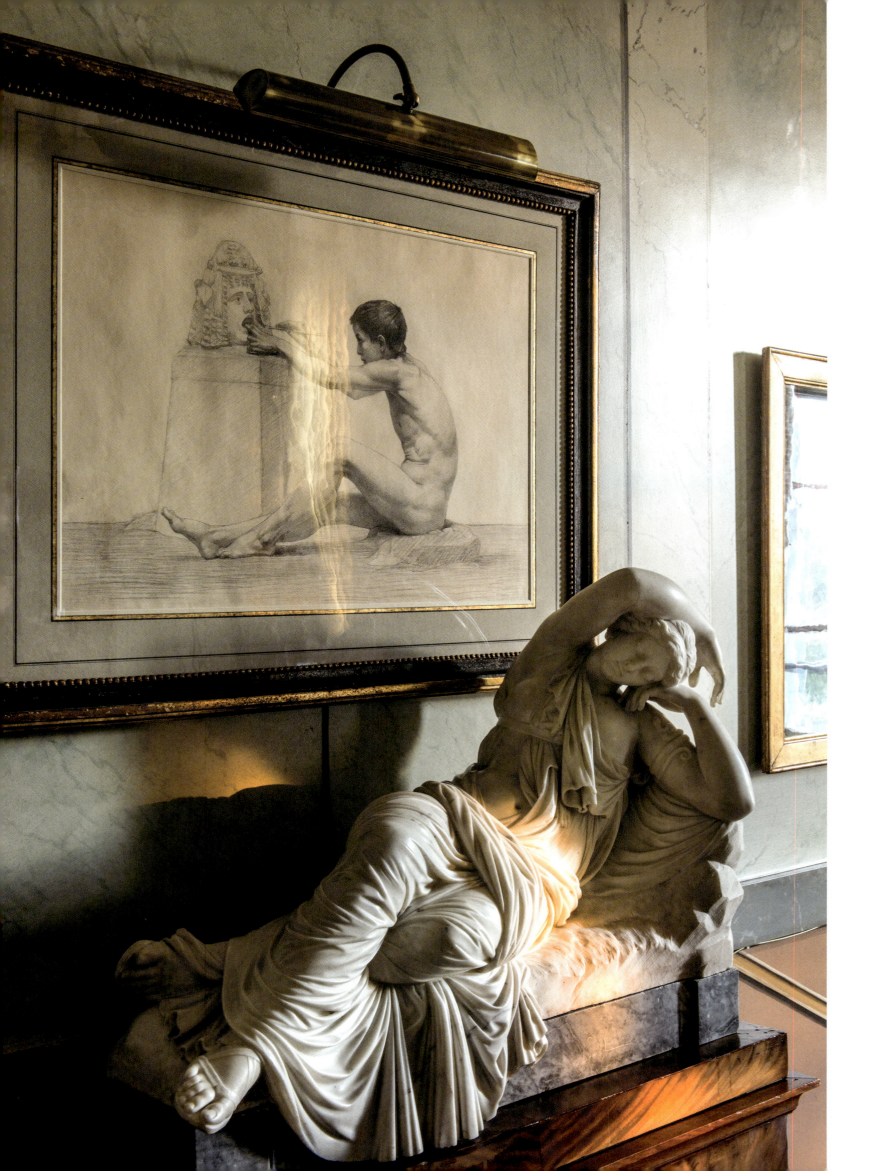

# Empire Elegance

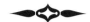

(Left) The *Sleeping Ariadne*, housed in the Vatican Museum, is a Roman Hadrianic copy of a Hellenistic sculpture from the Pergamene school, dating to the 2nd century B.C. This celebrated white marble piece (c. 1795–1805), attributed to François-Frédéric Lemot (1772–1827), remains one of antiquity's most renowned sculptures. Beside it, a neo-classical drawing captures a young boy immersed in sculpting, epitomizing the era's admiration for classical art.

(Next page) A pair of gilt bronze Empire chandeliers casts a lavish glow across the room. Marble busts of philosophers Homer and Socrates (c. 1800) embody the enduring legacy of classical wisdom. Nearby, a marble bust of Emperor Hadrian from 2nd-century Italy, perched atop a Roman column (c. 100 A.D.), exudes timeless grandeur.

**Nestled on Rue de Rivoli, overlooking the Tuileries Gardens, a striking residence exudes the grandeur of the First Empire. The owners, avid art collectors, have curated a home that feels as if it has been transported directly from the age of Napoléon. Situated in the prestigious 1st arrondissement, this historic residence captures the essence of neoclassical elegance through its architecture and meticulously curated interiors, while offering serene views of the Tuileries Gardens.**

The allure of the past is immediately felt upon entering the home. The original architectural elements, dating back to the Empire period, include high ceilings adorned with classical moldings featuring palmettes and decorative motifs. These elements set the tone for the residence's "chambre en enfilade" layout—a graceful sequence of interconnected rooms offering both privacy and openness.

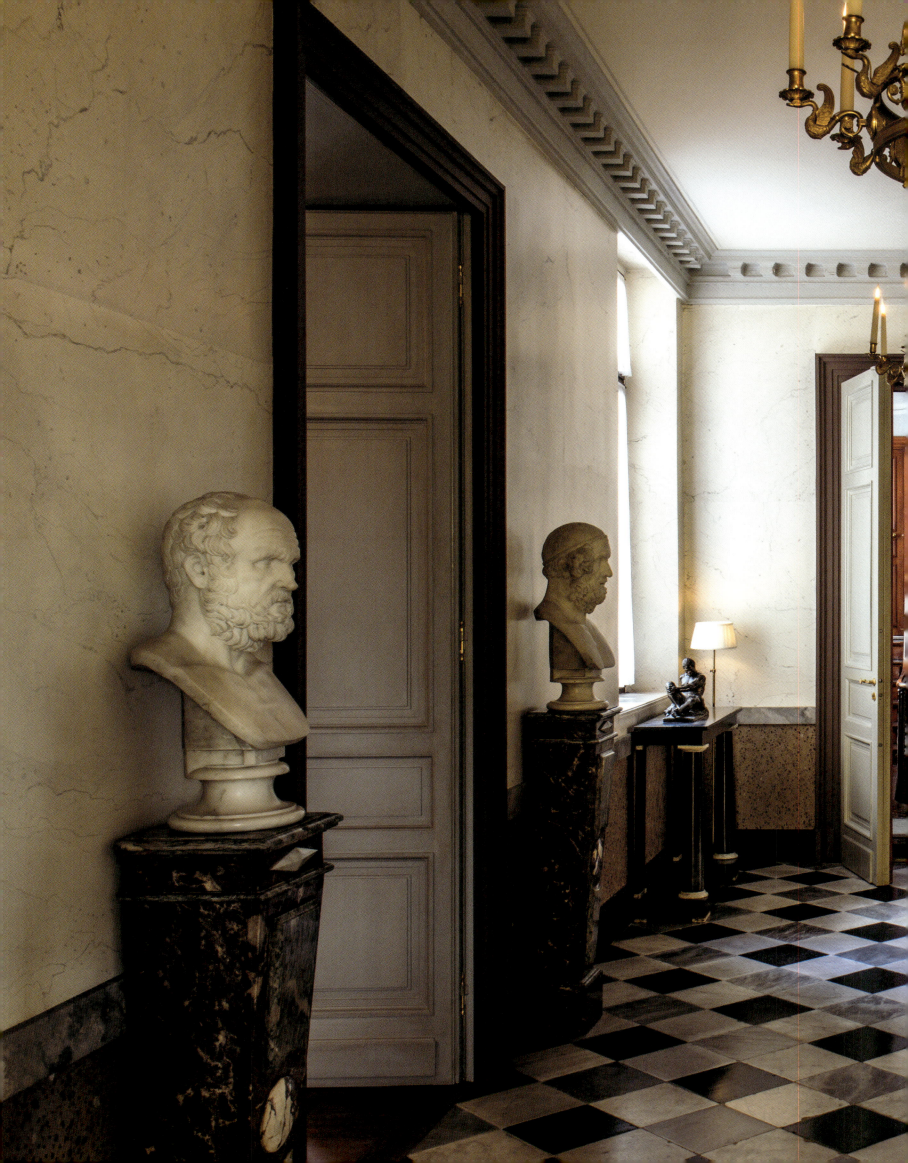

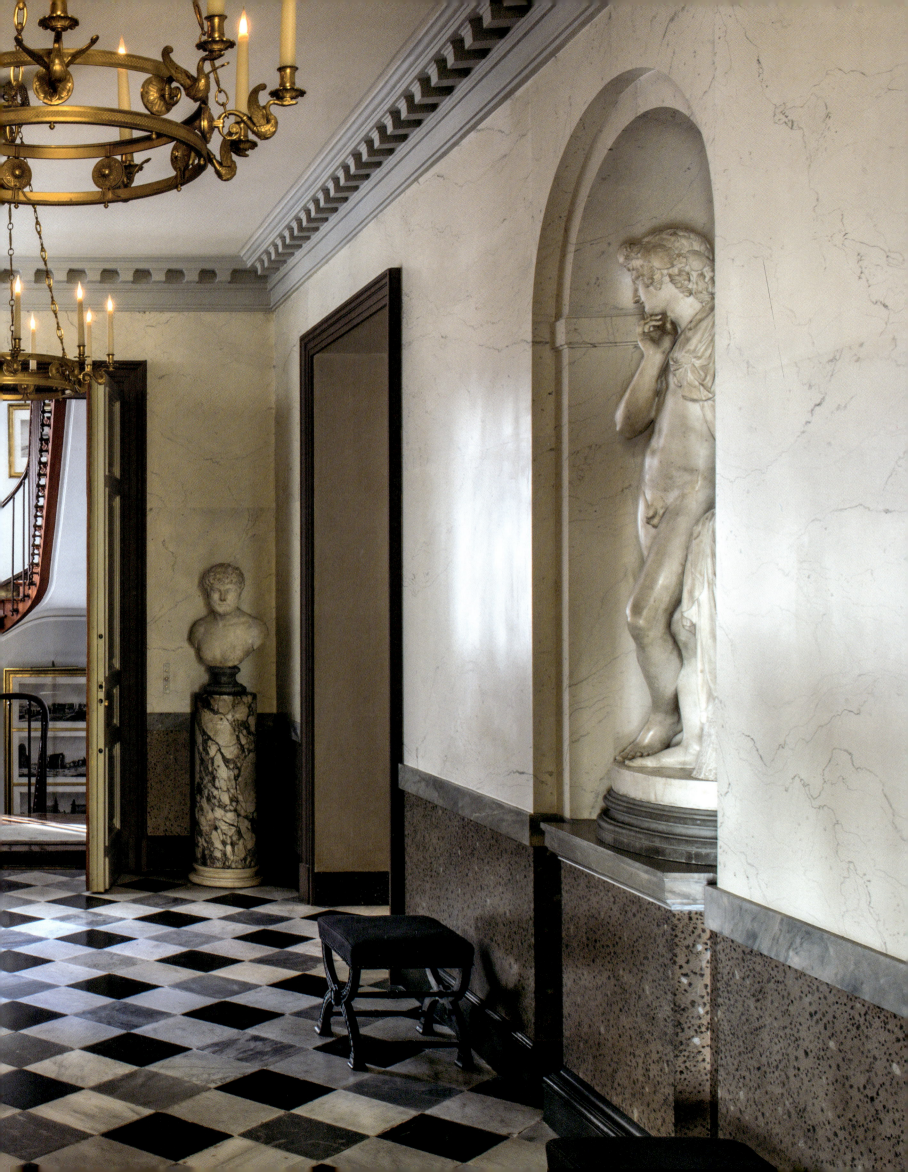

A key attraction of the home is its prime location. Positioned directly across from the Tuileries, the residence offers rare tranquility amidst the bustling heart of Paris. These peaceful views and the home's historical significance created an irresistible charm.

Spanning several rooms, the residence is primarily a space for relaxation. The grand salon stands out as the heart of the home with its vast, light-filled space and preservation of original details, serving as both a hub for leisure and a living piece of history.

Over the years, the home has evolved to blend aesthetic pleasure with comfort. The design philosophy was clear from the outset: to restore and highlight the classical architecture while integrating the comforts of modern living. This intent is reflected throughout, from period furniture and artwork to antiquities from ancient Greece, Rome, and Egypt.

(Left) A 19th-century alabaster coupe adorned with bronze arms in the form of bearded figures sits alongside the 18th-century Rondanini Medusa masterfully carved from Carrara marble. Completing the display is a *Retour d'Egypte* console table crafted from rare marble, featuring legs intricately sculpted into sphinx heads and feet.

(Above left) Marble sculpture of Antinous by Rinaldo Rinaldi, Padua, Italy, circa 1820.

(Above right) A unique marble piece, *Cenotaph of the Gracchi*, by Eugene Guillaume, circa 1848.

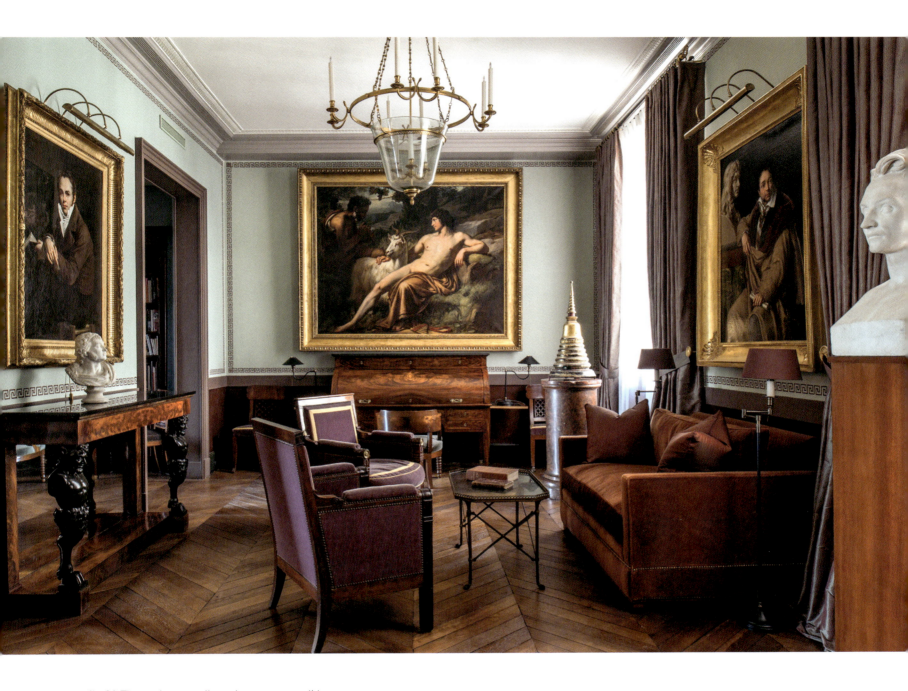

(Left) The sculpture gallery showcases a striking blend of historical pieces. On the left, a statue of Antinous depicted as a pharaoh highlights his deified status in ancient Roman culture. To the right, an early 19th-century Italian marble sphinx, inspired by the iconic sphinx from the House of the Faun in Pompeii, reflects the neoclassical fascination with ancient motifs.

(Above) The fumoir is a meticulously curated space, featuring large canvases from 1800–1824, a rare marble portrait bust of Casimir Delavigne by David d'Angers, signed and dated 1826, and Consulate-period furnishings. Together, these elements evoke the elegance and refined taste of the era.

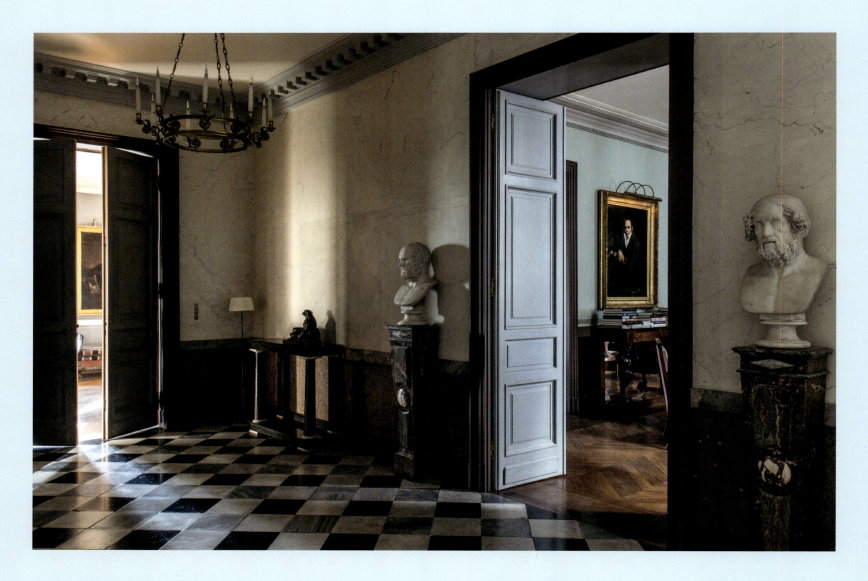

(Right) This collection boasts a mahogany console table with a black marble top, supported by satyr-shaped monopods, circa 1798. Accompanying the table are rare 18th-century patinated bronze sconces adorned with faun heads and gilt bronze details. A Directoire-period Klismos-style chair in green patina adds a classical touch, while a 5th-century B.C. bronze hydria is elegantly displayed on a Russian granite pedestal, circa 1800. The ensemble also features an 1808 self-portrait by Auguste Rivière, an 18th-century Swedish gilt bronze and crystal chandelier, a Directoire-period guéridon with ebonized satyr monopodia, and a 4th-century B.C. Apulian calyx-krater.

Striking a balance between functionality and beauty has been a careful process. While the aesthetic vision often took priority, practical considerations were never sidelined. The muted colors and rich textures throughout the home complement the classical architecture, ensuring a harmonious balance without overwhelming the senses.

The homeowners find continuous inspiration for their decor from museums and historic buildings around the world. These influences are woven into the personal touches that make the residence unique, with items acquired from auctions and antique shops, adding layers of history and individuality. Each piece tells its own story, contributing to a larger narrative of historical appreciation and personal taste.

Perhaps the most rewarding aspect for the homeowners has been the revival of the home's original design. Seeing the classical elements restored and the rooms filled with carefully selected objects has been a deeply satisfying transformation. This restoration ensures that the residence not only honors its historical roots but also serves as a timeless sanctuary in the heart of Paris. —

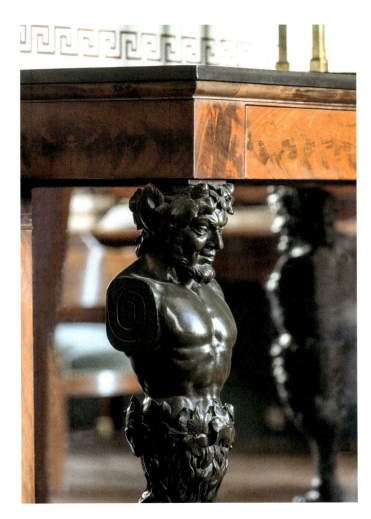
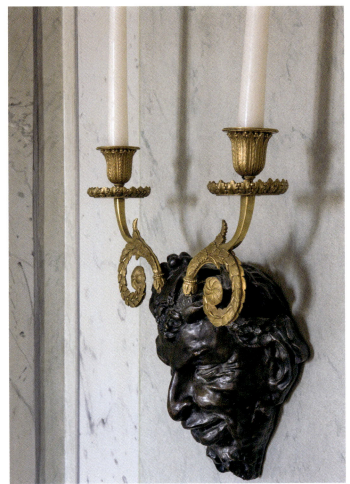

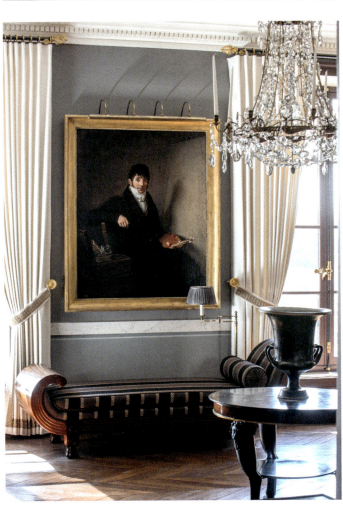

Empire Elegance

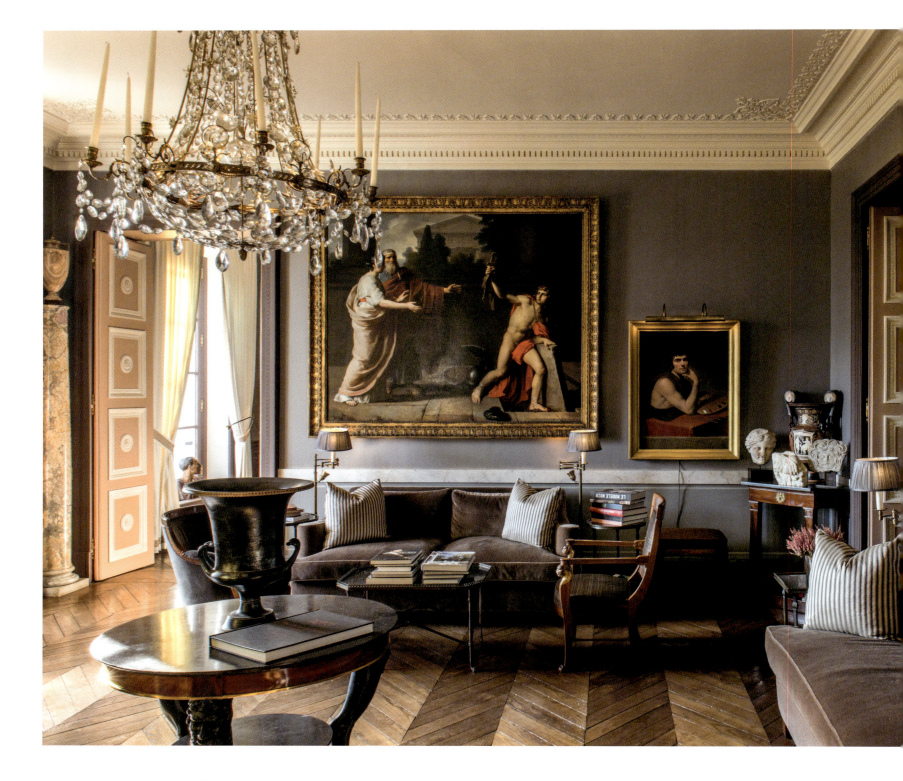

(Above) In the grand salon, an 18th-century Swedish gilt bronze and crystal chandelier casts a luminous glow, while a Campanian black-glazed calyx-krater (4th–3rd century B.C.) introduces a touch of antiquity. Dominating the space is *Theseus Finding the Sword of his Father* (c. 1793), a commanding neoclassical painting by Augustin-Louis Belle, complemented by Robert Lefèvre's 1806 *Portrait of Countess Mollien* and a self-portrait by Giuseppe Errante, circa 1790. The collection of classical antiquities includes a Roman marble head of the goddess Juno (1st–2nd century A.D.), a marble oscillum fragment (1st century A.D.), a marble relief of Medusa (2nd century A.D.), and an Apulian red-figured Volute Krater, circa 340–320 B.C.

The *design philosophy* was clear from the outset: to restore and highlight the *classical architecture* while integrating the *comforts* of *modern living*.

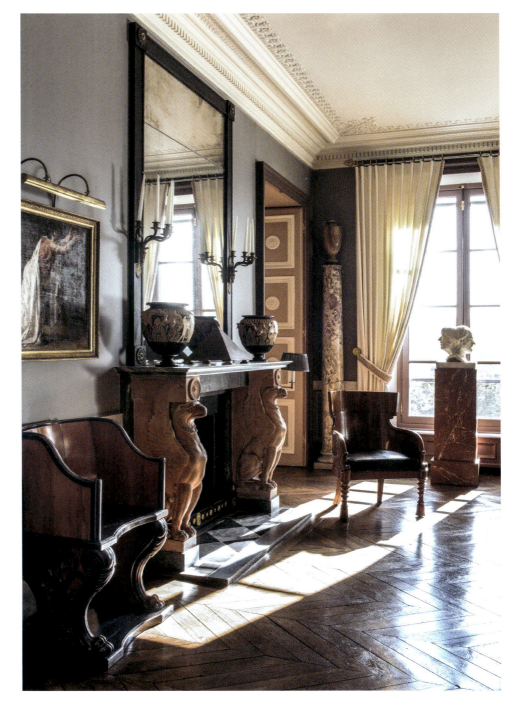

(Right) The grand salon's original fireplace is embellished with motifs drawn from antiquity, including a pair of Etruscan red-figured *stamnoi* (4th century B.C.) and terracotta griffins—mythical creatures combining the body of a lion with the head and wings of an eagle, symbolizing strength and wisdom. Nearby, a late 18th-century wooden chair by Thomas Hope, modeled after a Roman marble throne, further enhances the neoclassical ambiance.

Empire Elegance

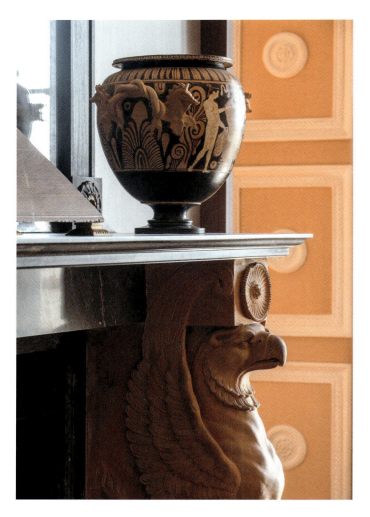
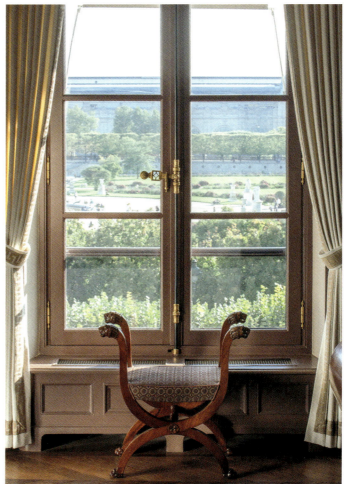
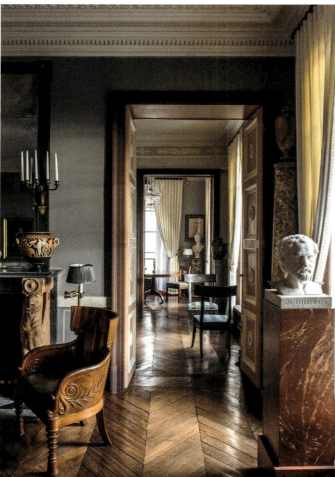
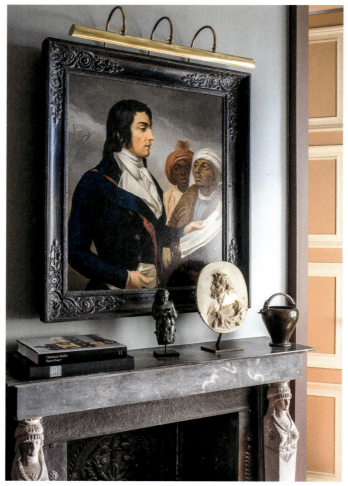

Paris Living

> The *muted colors* and *rich textures* throughout the home enhance its classical architecture, achieving a *harmonious balance* without overwhelming the senses.

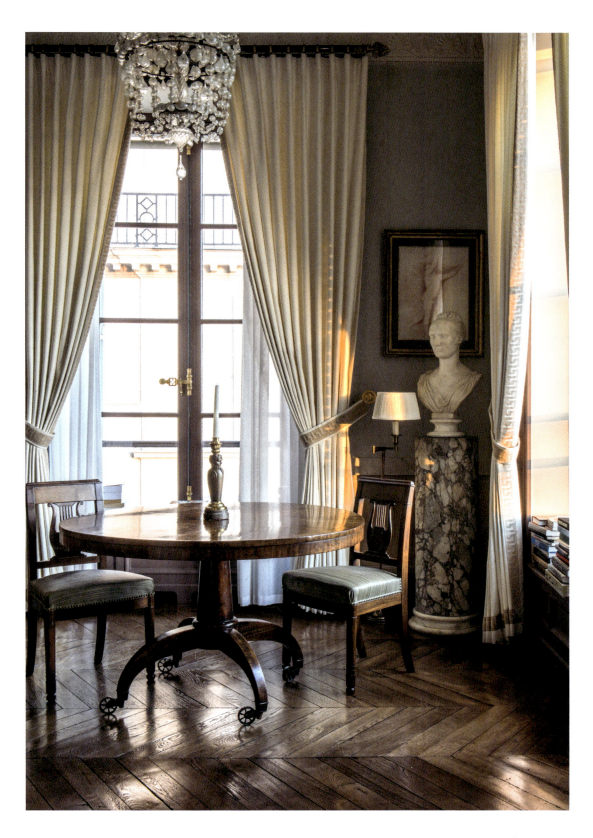

(Left) A 4th-century B.C. Etruscan red-figured stamnos introduces a touch of antiquity to the grand salon. By the window a Consulat tabouret (c. 1800) offers a perfect vantage point overlooking the Tuileries Gardens. Nearby, a Percier & Fontaine chair, stamped Jacob Frères and originally from the Château de Saint-Cloud, exemplifies refined craftsmanship. The room is further enriched by an 18th-century Janus marble bust of Brutus (man of action) and Seneca (man of thought). A marble bas-relief of a faun, attributed to Pierre II Legros, accompanies the 1805 portrait by Andrea Appiani of General Desaix delivering orders from the First Consul to the Egyptians, adding layers of historical depth and artistic sophistication.

(Right) In the boudoir, an early 19th-century Regency mahogany circular dining table is paired with lyre-back mahogany chairs from the same period. A marble *Bust of Elisa Bonaparte Baciocchi* by Lorenzo Bartolini (c. 1808) graces the space, resting atop a Roman column dating to approximately 100 A.D., later adapted as a pedestal during the 17th–18th century. Overhead, a Venetian blown glass chandelier from around 1830 bathes the room in a soft, elegant glow.

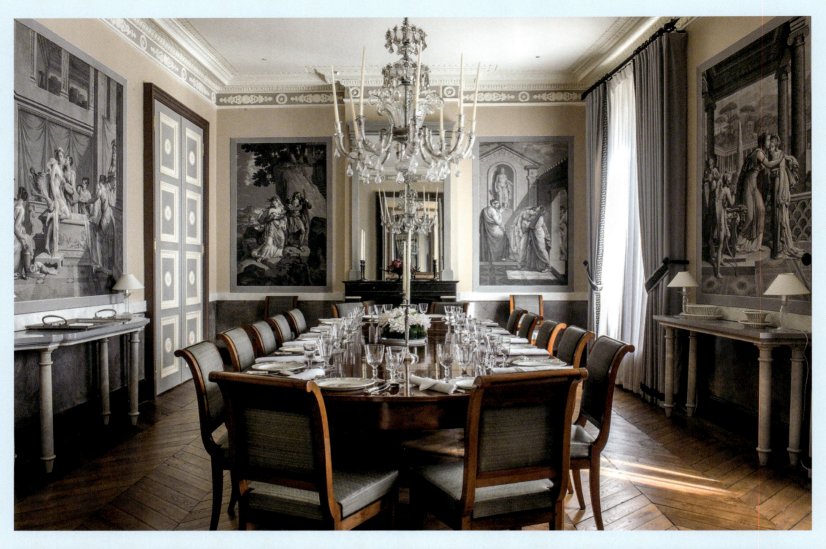

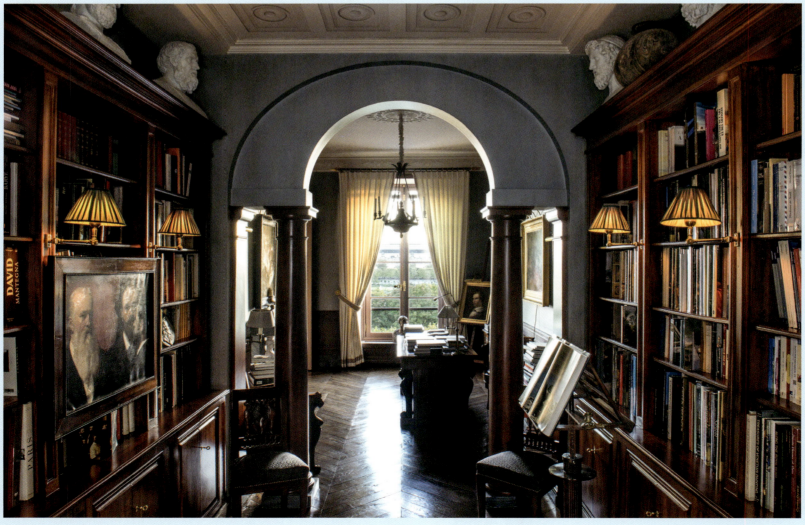

Paris Living 50

(Left, top) In the dining room, the warm glow of candlelight from a Venetian chandelier (c. 1795–1805) highlights walls adorned with *papier peint en grisaille*, *L'histoire de Psyché et Amour*. This first edition, created in 1816 by Duffour and composed by Louis Laffitte, offers a panoramic narrative inspired by Jean de La Fontaine's *The Loves of Psyche and Cupid* (1669) and Apuleius's *The Golden Ass*. The decor serves as a neoclassical homage to the trials of love, with Laffitte's artistry drawing inspiration from the works of François Gérard and Pierre-Paul Prud'hon, evoking the romantic allure of Psyche's myth.

(Left, bottom) In the library, *A Trio of Friends* by Carolus-Duran (1892) adds a touch of late 19th-century elegance. This triple portrait of Hector Lemaire, Zacharie Astruc, and Antoine Favard enriches the space with its depiction of camaraderie and artistic sophistication.

Empire Elegance

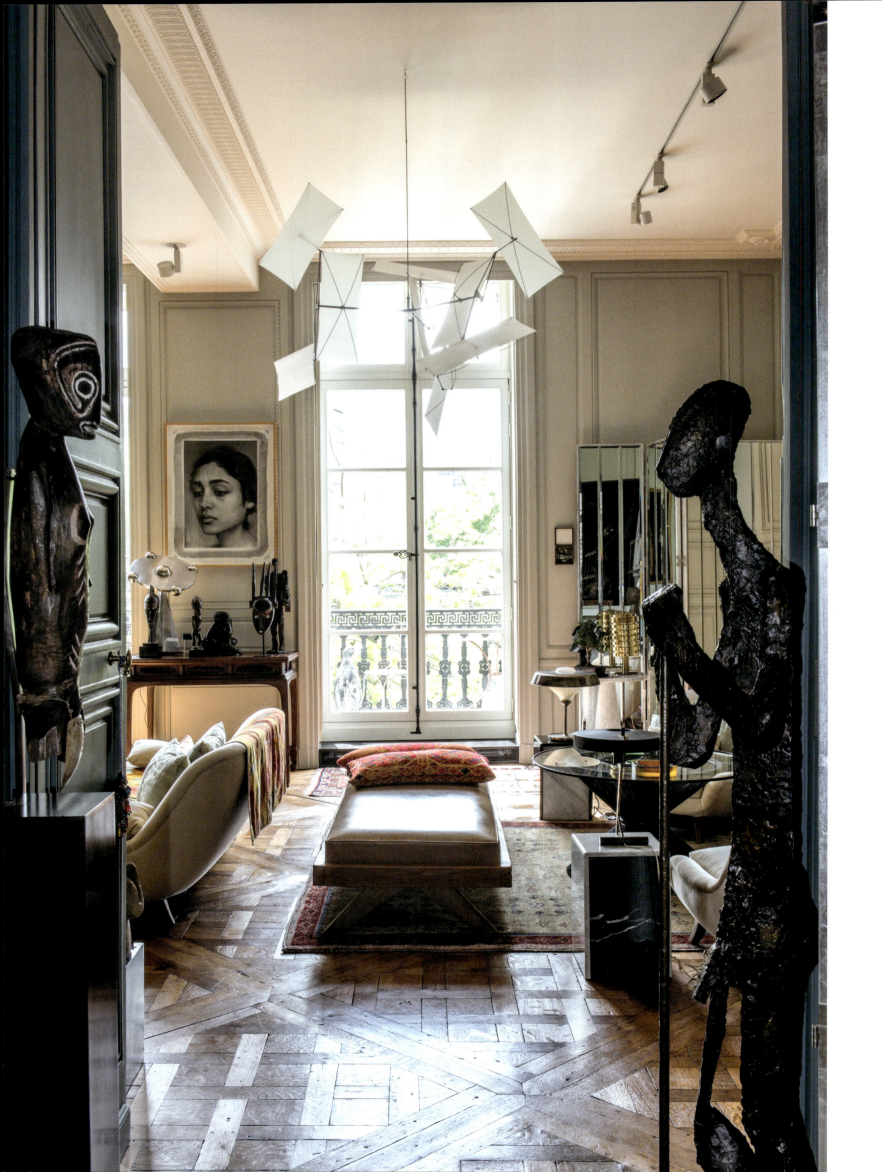

# Parisian Poise

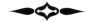

This elegant room is defined by a meticulously restored Versailles parquet floor, which imbues the space with timeless historic charm. To the right, *Le Berger*, a sculpture by Robert Couturier, introduces a contemplative presence. Suspended above, a mobile by Japanese artist Susumu Shingu from Osaka adds dynamic movement and a sense of lightness. Anchoring the room is a Pierre Jeanneret daybed, sourced from Chandigarh, India, which sits gracefully beneath a striking black and white portrait of Golshifteh Farahani, exuding sophistication and cultural depth.

**Positioned gracefully on the historic Île Saint-Louis, Madame Boinet's apartment—an exquisite creation by Laurent Maurice Minot—strikes a harmonious balance between historical reverence and custom modernity. Located on Quai de Béthune, this distinguished residence within the 17th-century Hotel Particulier boasts impressive high ceilings and timeless allure.**

The apartment captivated Madame Boinet with its commanding views of the Seine and its balcony serving as a personal watchtower over the heart of Paris. Spanning six principal rooms, not counting bathrooms, dressing areas, and a laundry room, the apartment echoes the grandeur of its era, serving as a peaceful retreat from her frequent travels and engagements with architectural marvels across France.

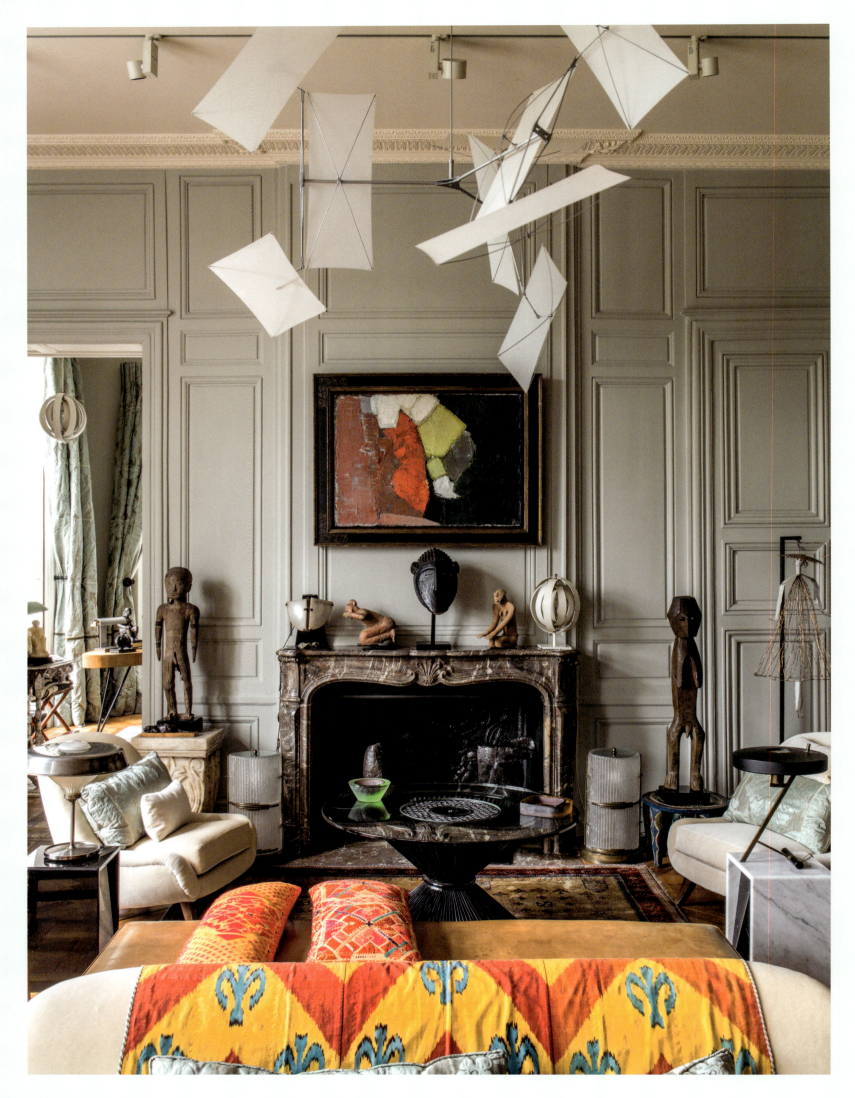

(Left) A painting by Nicolas de Staël graces the wall above an ornate marble fireplace, surrounded by an intriguing collection of sculptures and artifacts. The Matégot coffee table anchors the space, while colorful textiles and intricate patterns on the couch infuse it with warmth and texture.

(Right) In the center, a 17th-century Flemish school painting—attributed to an anonymous artist—is framed in dark elegance. Flanking it are Senufo statues, introducing a sense of cultural depth and artistry. A Dan mask, formerly part of the esteemed Pierre Vérité collection, commands attention with its striking design and elaborate details.

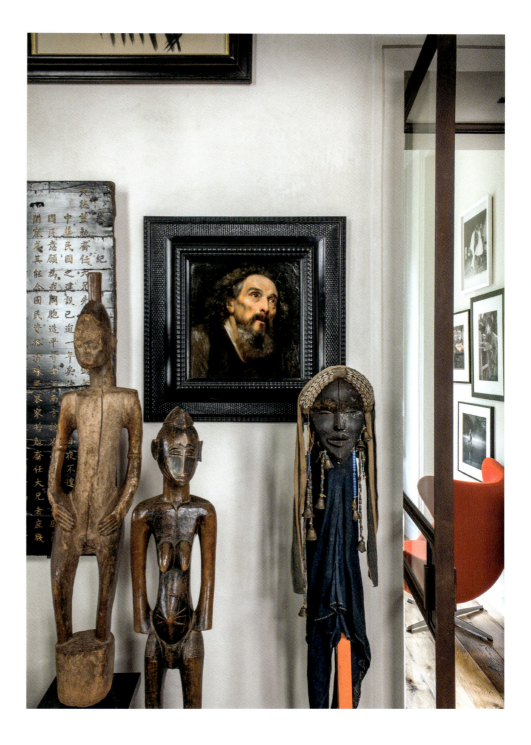

Throughout the home, Laurent Maurice Minot *embraces* the *original architectural elements* rather than overshadowing them.

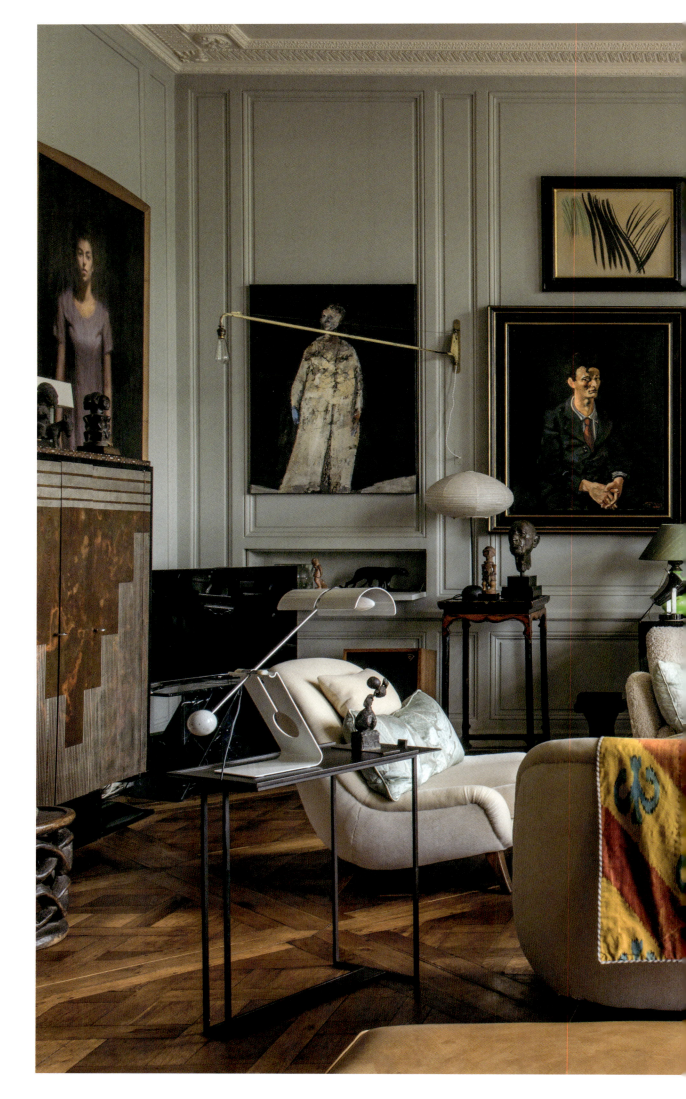

The focal wall of the living room showcases a stunning gallery of portraits and abstract works. Highlights include a Hans Hartung piece at the top left, a portrait of Jean-Louis Barrault by André Derain, and a painting by Canadian artist Jean-Paul Riopelle in the bottom right. The furniture is equally remarkable, featuring a meticulously crafted side table by Laurent Maurice Minot, designed with the golden ratio to bring a touch of mathematical elegance to the room.

Paris Living

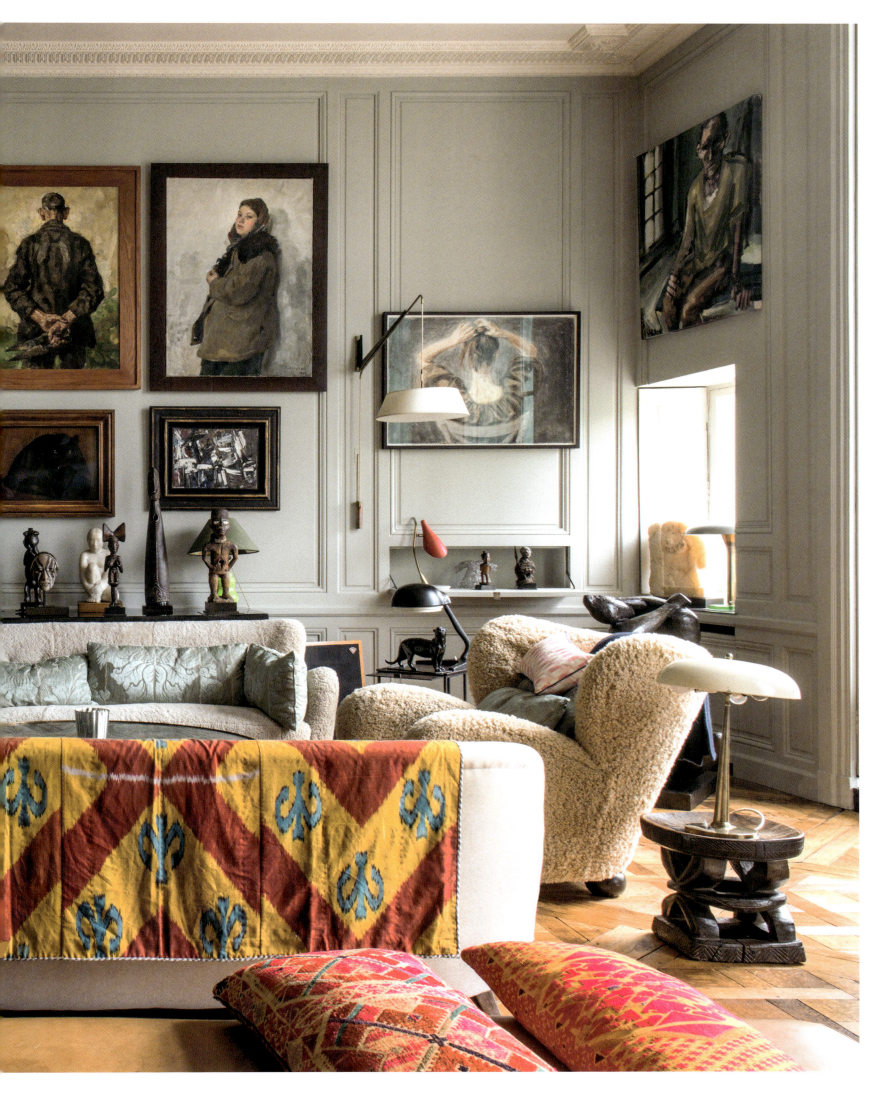

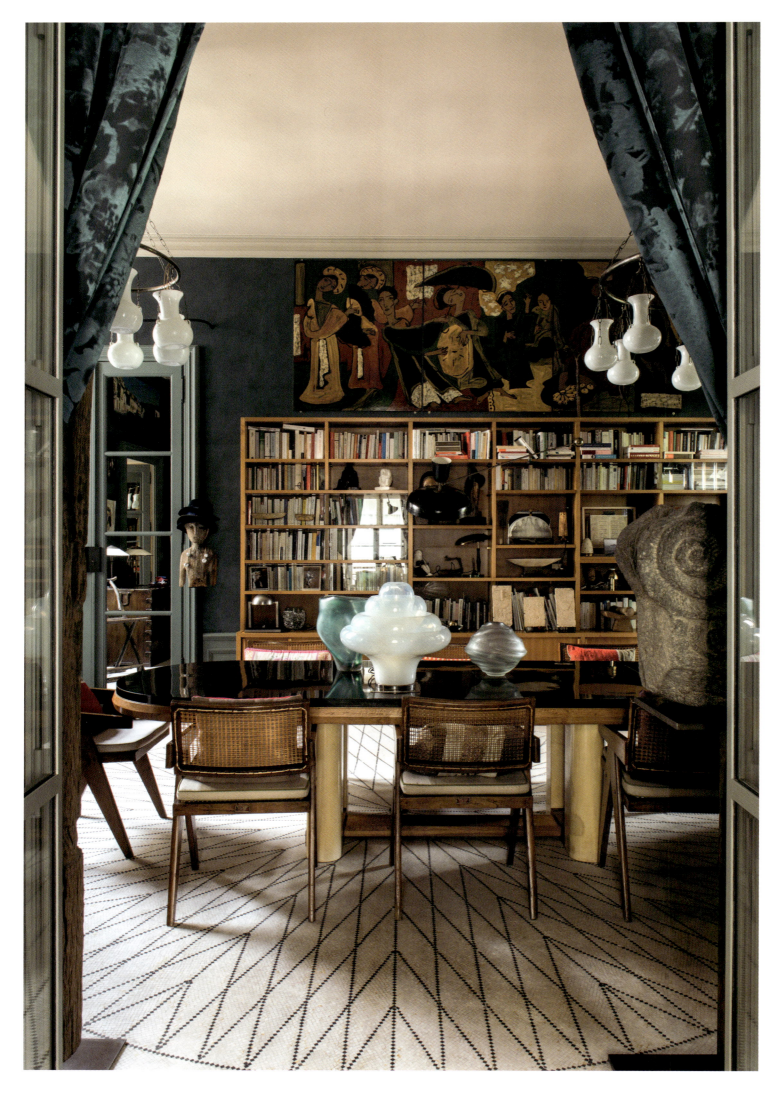

(Left) Between two painted metal doors inspired by the greenhouses of Caserta, two traditional hammam pendants hang with effortless elegance. The architect-designed floor pattern reimagines the intricate geometry of an ancient Herculaneum design. The room's focal points are the impressive library shelves by Pierre Jeanneret, sourced from Chandigarh, showcasing a curated collection of artifacts and books, blending form and function seamlessly.

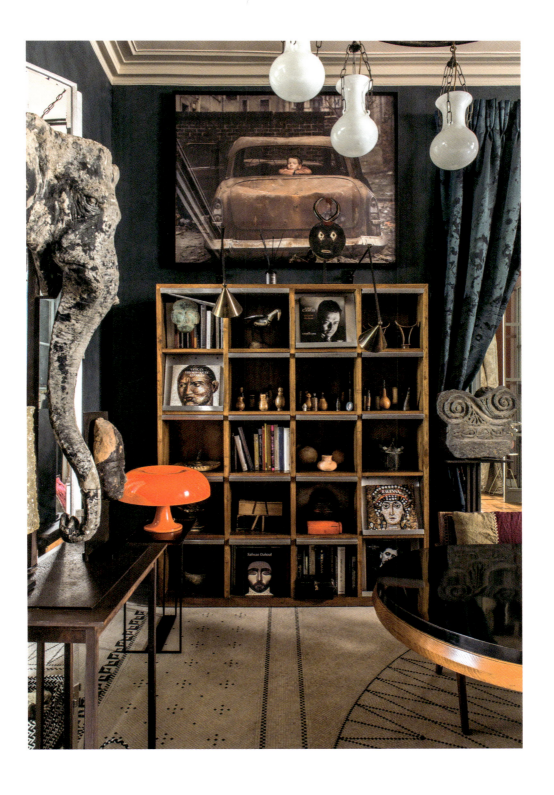

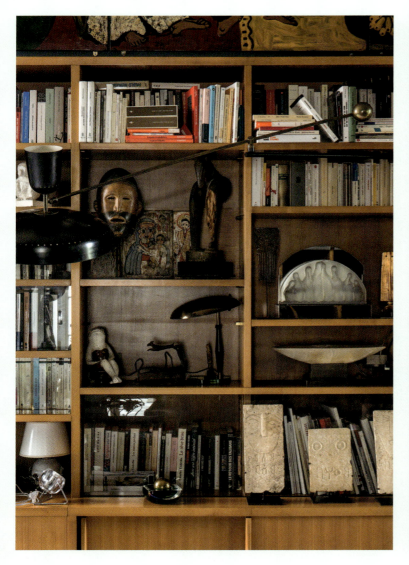
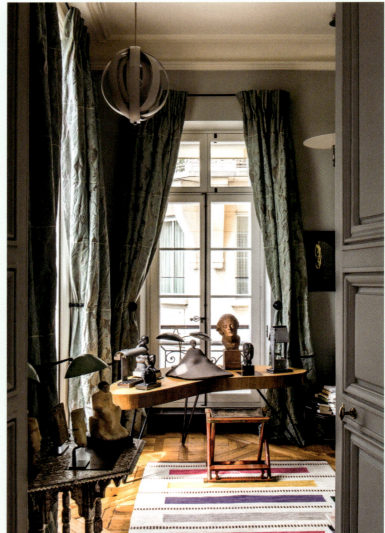

(Above left) In the entrance library, an unsigned artwork is paired with a Pierre Guariche lamp, highlighting a carefully curated collection of books and objects from diverse cultures. The shelving also features evocative *Yemeni* sculptures, adding historical resonance to the space.

(Above right) In a sunlit corner room overlooking the river and the Left Bank, a Danish pendant light casts a soft glow over a Syrian octagonal mother-of-pearl table, adorned with a Yemeni sculpture. Nearby, an anonymous 1950s boomerang-shaped desk—seemingly weightless—serves as a pedestal for a terracotta sculpture by Georges Jeanclos.

(Right) This serene bedroom is defined by the striking *Adam and Eve* statue by Robert Couturier, its sculptural presence lending an artistic intimacy to the bedside.

The entrance hall, which doubles as a salon, is one of the most dynamic spaces in the home. Here, black and white marble *tesserae* form an intricate circular pattern, reminiscent of ancient villa designs from Herculaneum. This grand entrance connects the main living spaces, setting the tone for the apartment's layered and intricate design narrative.

Throughout the home, Laurent Maurice Minot embraces the original architectural elements rather than overshadowing them. Monolithic doors and expansive glass partitions evoke the grandeur of the royal greenhouse at Caserta near Naples, allowing light and sightlines to flow seamlessly from room to room. The floors, painstakingly crafted with 10 mm marble tesserae from Damascus, pay homage to Roman mosaics, their geometric precision contrasting beautifully with the organic flow of the living spaces.

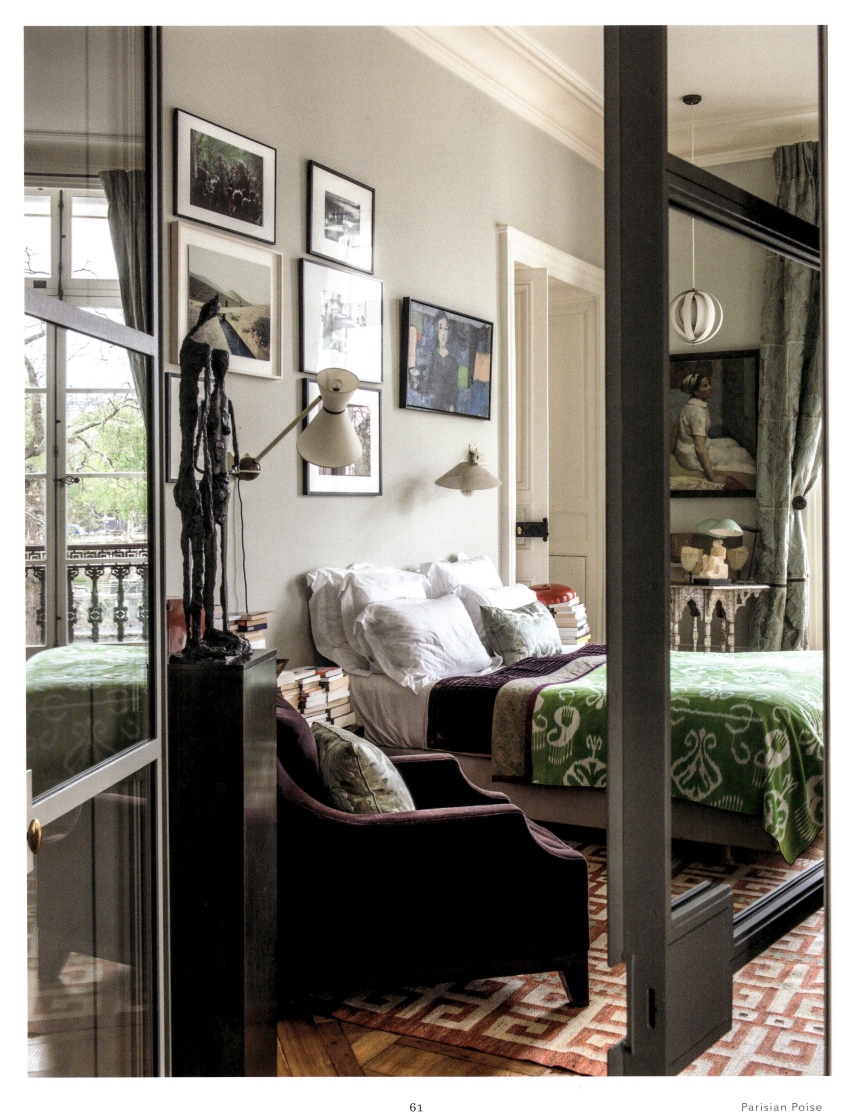

Functionality and aesthetics are seamlessly integrated. Storage solutions are discreetly hidden behind mirrored panels and woodwork, reminiscent of the opulent, concealed details found in Parisian boutiques. Each mirror, meticulously chosen by Vincent Guerre—the restorer of the Hall of Mirrors at Versailles—reflects not only the physical beauty of the apartment but also the thoughtful curation behind every placement.

The decor embodies a philosophy of sightlines, designed not to recreate the past but to elevate the present. The layout encourages fluid circulation, creating a visual journey that offers constantly shifting perspectives, much like the ever-changing views of the Seine outside the windows.

Madame Boinet's extensive travels served as a rich source of inspiration for the apartment's design, with Mediterranean influences prominently woven into the space. Ancient textiles and intricate tiling evoke far-off places, all brought together under the expert eye of Laurent Maurice Minot, whose architectural vision underpins every detail in this elegant Parisian sanctuary.

———

(Right, top left) Two Swedish lamps and a pair of 18th-century French glass vases frame anonymous plaster figures, creating a serene tableau that balances historical elegance with subtle artistry.

(Right, top right) A sleek marble console by Mangiarotti showcases a collection of Ethiopian crosses, offering a striking contrast to the minimalist white backdrop. The intricately designed floor, inspired by a villa in Stabia, ties the space to its classical roots.

(Right, bottom left) A gallery wall featuring photography by Édouard Boubat and Sabine Weiss introduces an artistic narrative to the kitchen. Complementing this are a Swedish cabinet and finely crafted custom metalwork cabinetry, highlighting the room's dedication to craftsmanship.

(Right, bottom right) A marble sculpture by Parvine Curie (see next page) and a portrait of Giacometti by Iranian artist Morteza Khosravi add layers of depth, seamlessly integrating modern art with functional design.

> The decor embodies a philosophy of *sightlines*, designed not to recreate the past but to *elevate the present*.

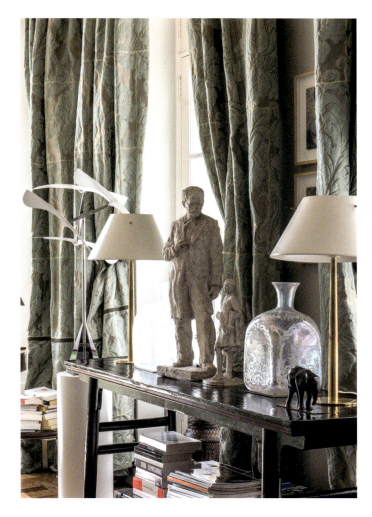
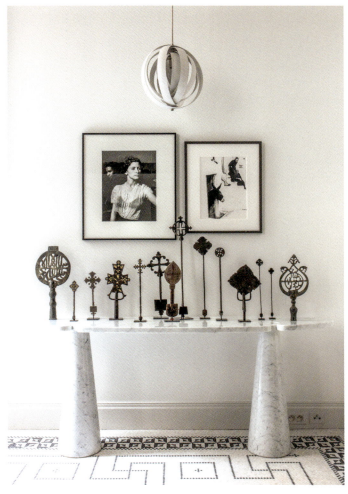
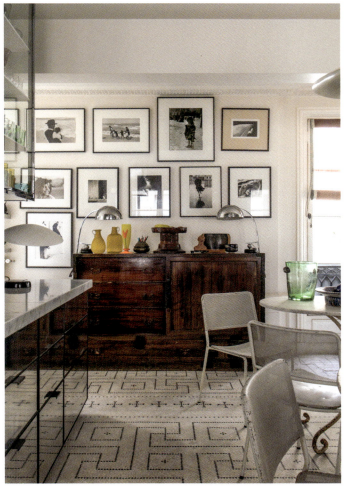
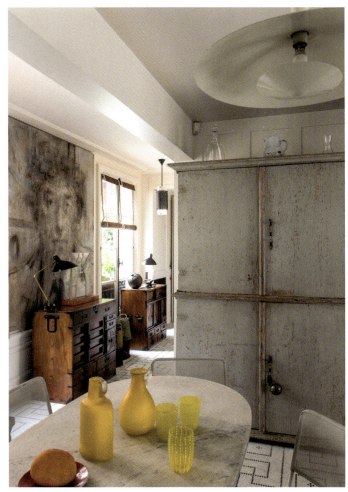

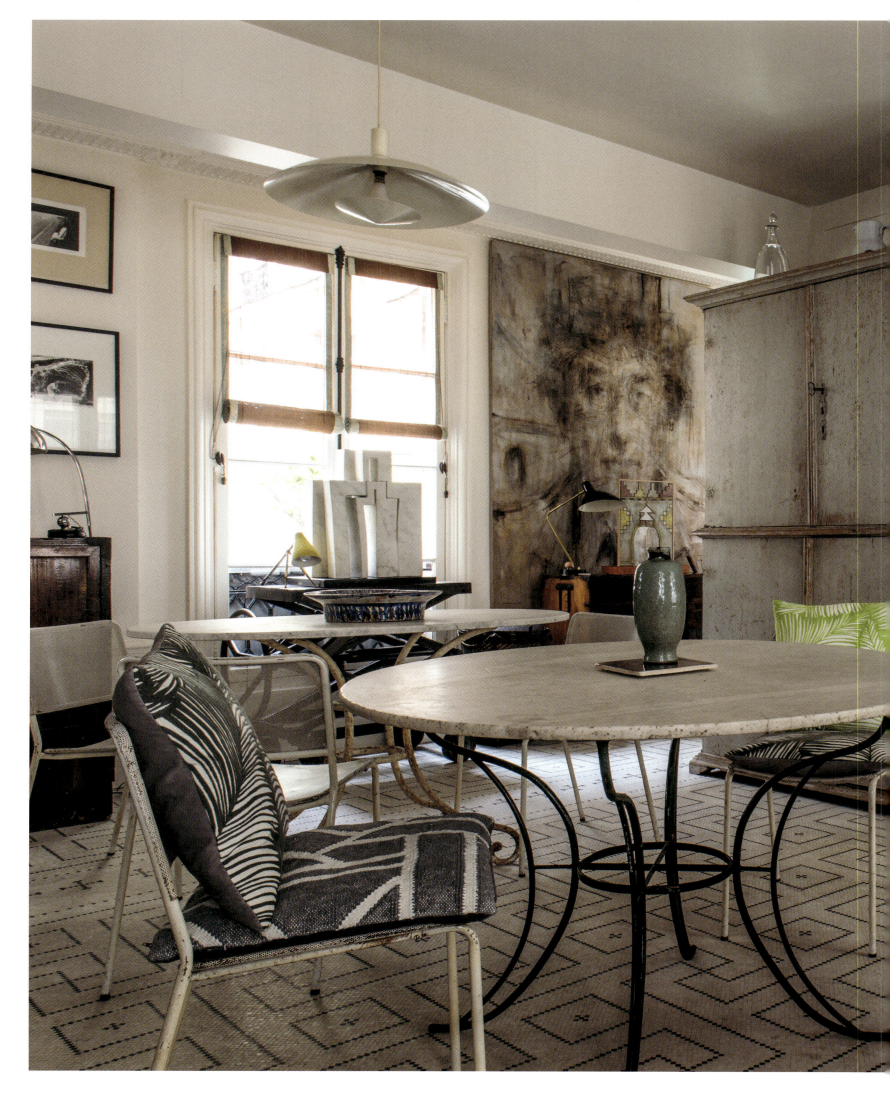

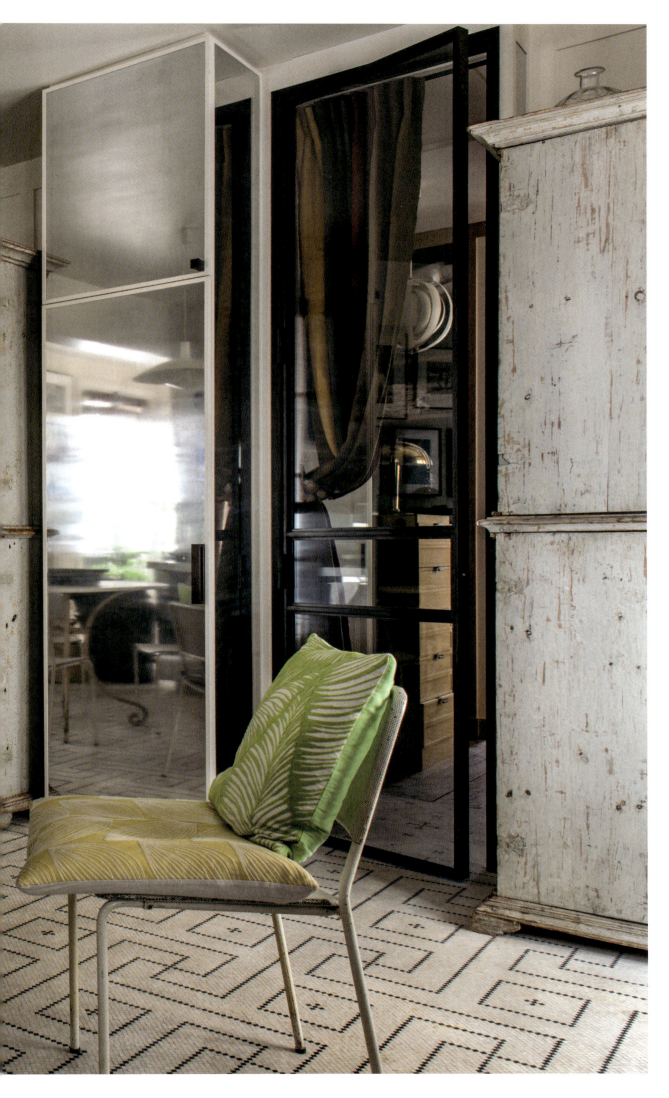

This room achieves a harmonious balance between history and contemporary design, anchored by a Stabia-inspired floor crafted from 10 mm white marble tesserae. Flanking the space are two twin 18th-century Swedish painted wood cabinets, exuding rustic charm and elegance. These cabinets frame two functional doors, each featuring metalwork that plays with light, transparency, and reflection to enhance the room's atmosphere.

Parisian Poise

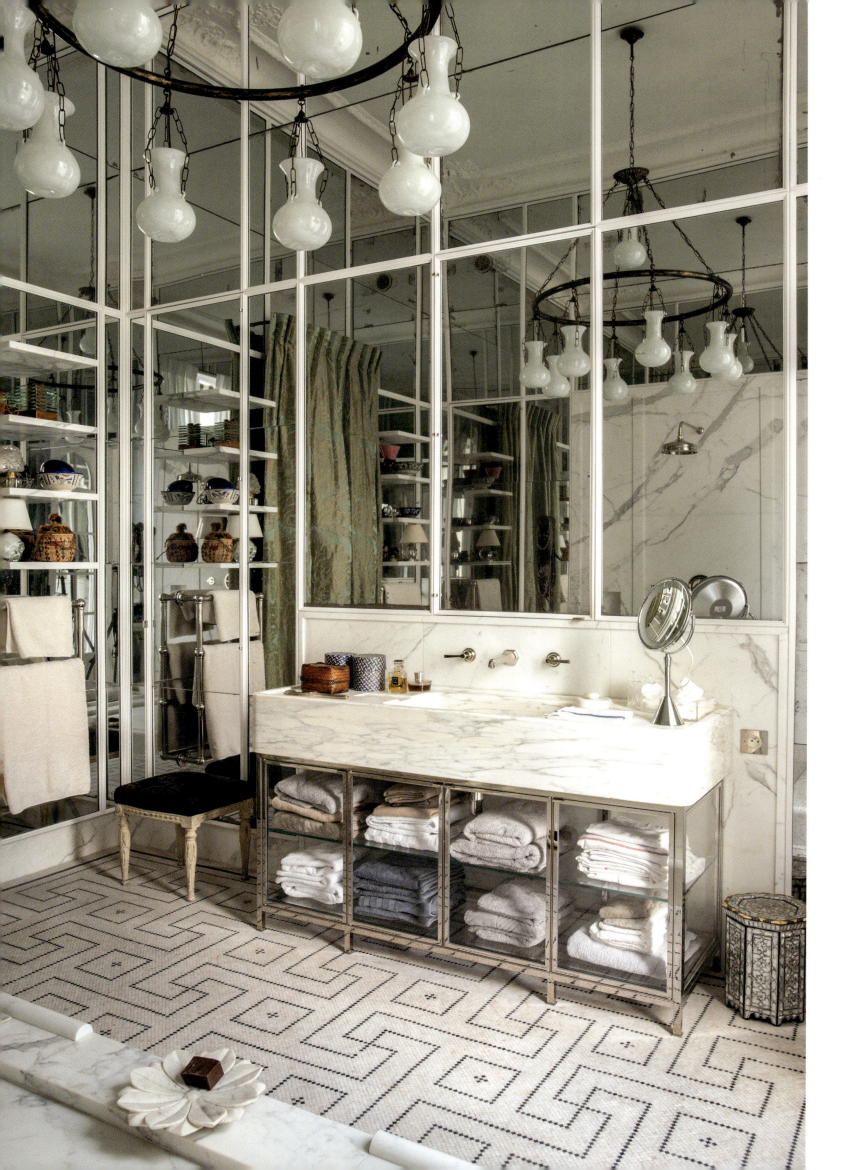

(Left) Suspension lighting, sourced from an old mosque in Aleppo, casts a soft glow over a space defined by thoughtful curation. The room is rich with intricate details, including a monumental open shower, bordered by painted wooden frames holding antique mirrors, expertly crafted by Avignon-based artisan Vincent Guerre. A gleaming nickel pharmacy cabinet supports a monolithic sink basin from Damascus, infusing the room with understated luxury. A Jacques Adnet lamp sitting on a cantilever shelf adds a modern touch, blending old and new with finesse.

(Below) The second bathroom presents a masterful interplay of historical and artistic elements. Its washbasin, reminiscent of a holy water font, is an ancient piece from Damascus, elegantly cantilevered over a marble-clad wall. Complementing the space are charcoal artworks by Raphaël Thierry, adding a contemporary artistic dimension.

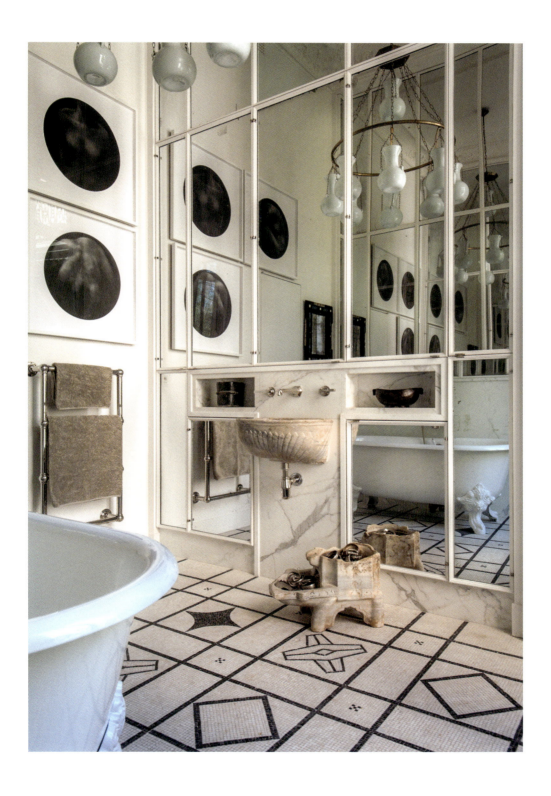

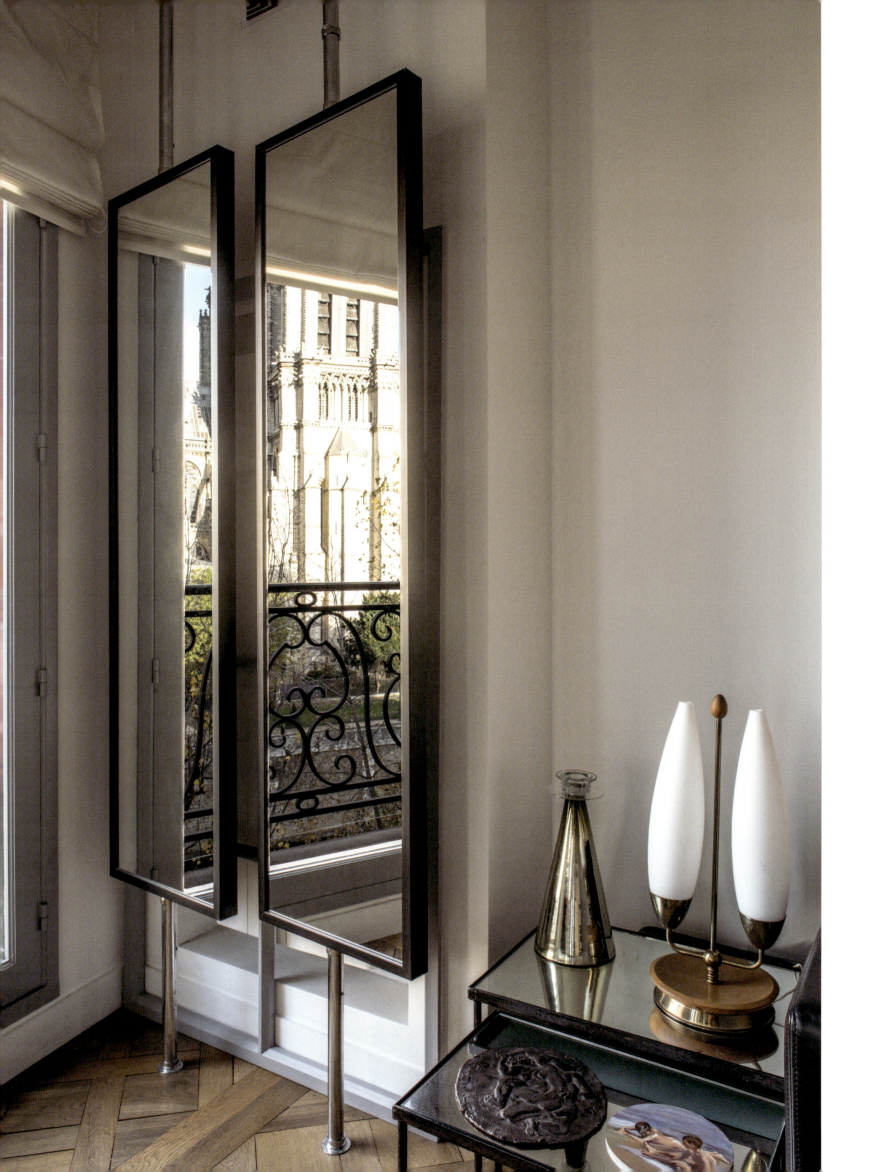

# Artful Living

**In an enviable location with a breathtaking view of Notre-Dame de Paris, this apartment designed by Patrice Nourissat, a former student of the prestigious École Camondo, is a masterclass in blending functionality and artistry.**

Patrice Nourissat purchased the apartment a decade ago, drawn to its unique setting and the extraordinary view of the iconic cathedral. This stunning backdrop set the tone for the harmonious fusion of design and art within the space.

At the heart of the residence is its expansive open-plan living area, combining the kitchen, dining room, and living room into one seamless loft-like volume. The entire space is built around a striking, curved glass ceiling, featuring frosted glass and lead-framed windows—a subtle nod to the architectural grandeur of Notre-Dame. Patrice Nourissat designed the space without future adaptation in mind, tailoring the renovations at the time of purchase specifically to suit his lifestyle.

What distinguishes this apartment is its focus on functionality rather than adherence to a particular interior design style.

A clever arrangement of pivoting mirrors amplifies the breathtaking view of Notre-Dame, blending the exterior landscape with the room's interior, creating a sense of depth. This elegant design choice, inspired by Patrice Nourissat, invites the viewer to experience a dynamic perspective that shifts with movement. On the nesting tables, a selection of curated vintage objects sits alongside a painting inspired by Sorolla, crafted by artist Véro Van der Esch, adding a touch of artistic refinement to the space.

(Below) In the living room, overlooking the scenic view, a large Polish pastel artwork takes center stage, complemented by two vintage 1950s armchairs upholstered in Picart le Doux tapestry.

(Right) A 1940s sideboard blends modern and antique styles, serving as a perfect display piece. Bathed in natural light, the passage features a pastel drawing by Marcel Gillis, whose dual identity as a painter and poet adds a lyrical touch.

Artful Living

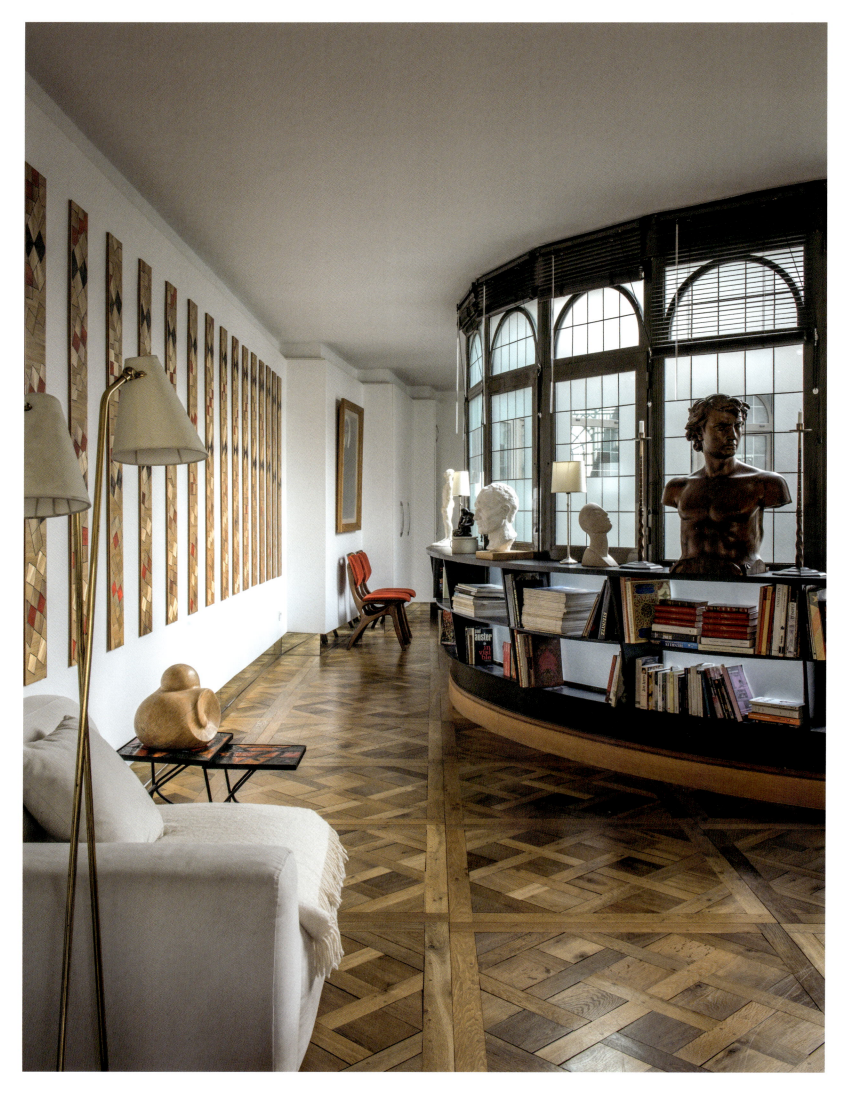

At the heart of the apartment, a frosted glass rotunda framed in lead overlooks the inner courtyard, softly diffusing light into the living room. Thoughtfully designed as a low library, this space doubles as an art gallery, with sculptures and curated books adding layers of meaning and depth. A wooden antique bust stands alongside sculptures by the designer's daughter, Magali Nourissat, imbuing the area with a deeply personal touch. The Versailles parquet flooring lends timeless charm to the contemporary architecture, while Laurent Lévèque's straw marquetry panels on the left wall provide a textured warmth that harmonizes artistry with sophistication.

The decor is intentionally understated, allowing the flow and practicality of the space to take center stage. Patrice Nourissat draws inspiration from decorative arts and his encounters with unique objects. Influences from legendary designers such as Madeleine Castaing and David Hicks can be felt, yet the apartment maintains an eclectic style that resists strong stylistic declarations.

An all-white palette amplifies natural light, creating a bright and airy ambiance. Custom details, like countertops clad in leather that match the tops of bookshelves surrounding the central glass structure, add tactile richness. These shelves, filled with objects collected over the years, offer a personal touch to the otherwise minimalist design.

A key feature of the apartment is the artwork of Patrice Nourissat's daughter, Magali Nourissat, whose sculptures and drawings are proudly displayed. These pieces complement the simplicity of the decor, adding depth and narrative to the space. The apartment becomes a living gallery, where Patrice Nourissat's connection to art and family is on display.

A lacquered and marquetry screen cleverly conceals the kitchen's functional elements, embodying the designer's philosophy of merging utility with beauty. Throughout the space, practicality and aesthetics are intertwined, reflecting a cohesive yet eclectic design ethos.

Ultimately, this Parisian apartment is a reflection of Patrice Nourissat's life—a space where art, design, and functionality coexist in perfect harmony, all while paying homage to the grandeur of its historic surroundings. —

> The apartment is a *living gallery*, where Patrice Nourissat's *connection* to *art and family* is on display.

(Below) In this refined workspace, a Danish 1970s desk exudes an inviting and relaxed charm, perfectly balancing elegance with the whimsical touch that Patrice Nourissat cherishes. Vintage leather-accented chairs upholstered in raw canvas add warmth and a sense of history. Against a backdrop of arched windows, a 1940s bronze sculpture and a plaster bust by Magali Nourissat create refined focal points. Carefully selected books, personal artifacts, and curated desk essentials infuse the space with life, transforming it into an imaginative and art-filled study.

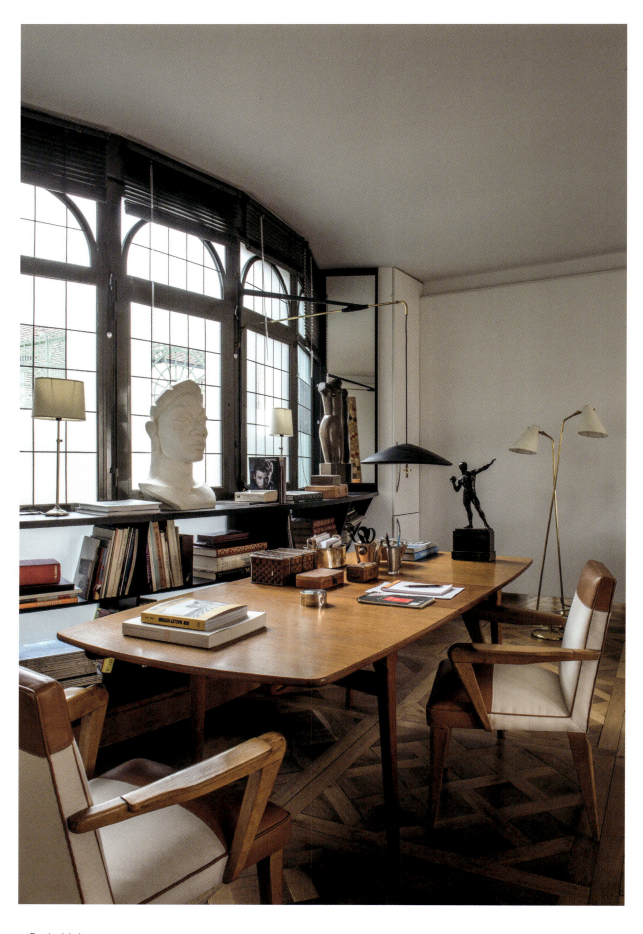

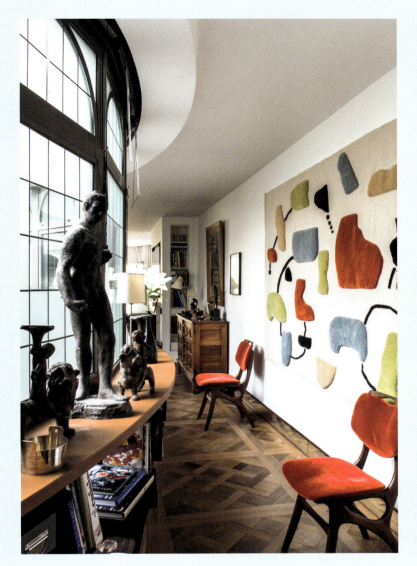
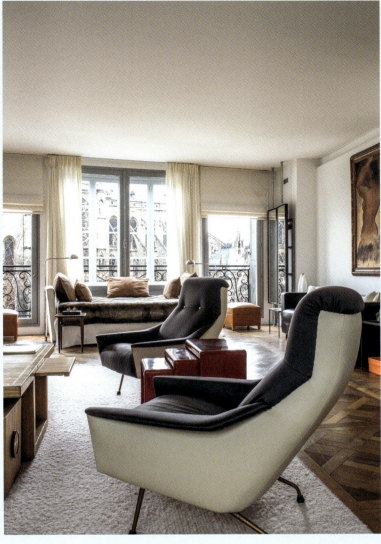

(Above left) In the hallway, a playful surprise awaits: a rug boldly displayed on the wall. Patrice Nourissat skillfully challenges conventions with this whimsical design choice, while antique sculptures lend timeless character and elegance to the daring composition.

(Above right) A bright and inviting living area showcases a pair of 1950s armchairs, adding mid-century charm and elegance to the space. Positioned in front of windows that frame a stunning view of Notre-Dame, this inviting area offers cozy spots to sit, chat, sip a drink, dream, and marvel at the breathtaking surroundings.

This Parisian apartment is a *reflection* of Patrice Nourissat's life—a space where *art, design, and functionality* coexist in *perfect harmony.*

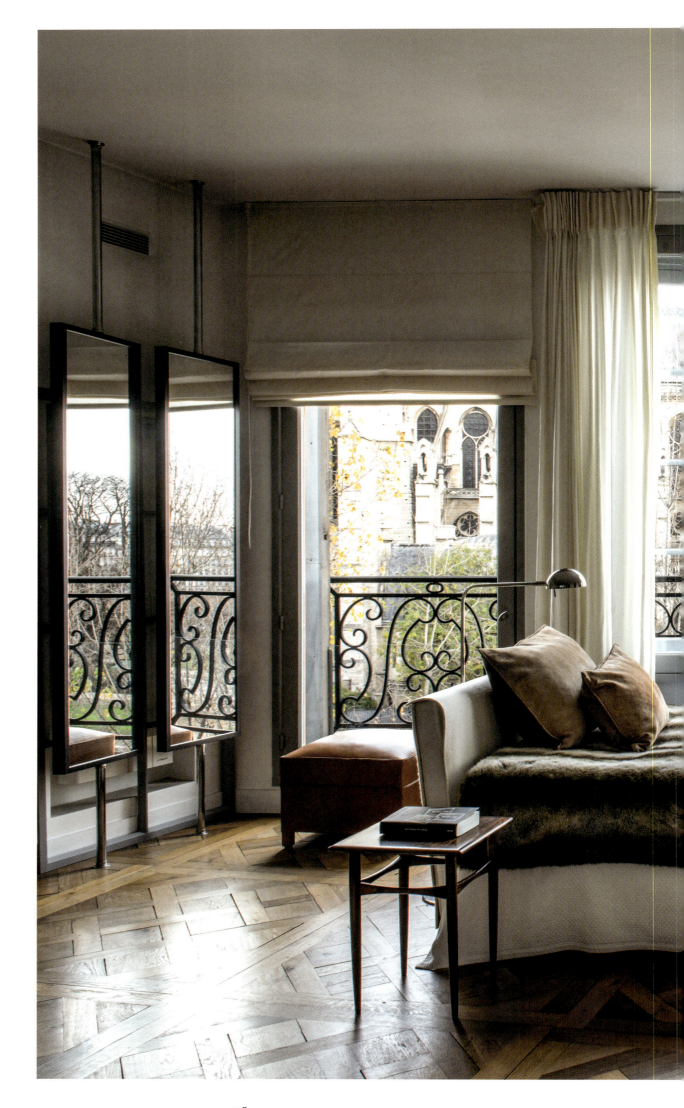

Facing the cathedral, a versatile sofa that doubles as a daybed offers a rare opportunity to sleep under the Parisian sky. The clever placement of mirrors amplifies this breathtaking view, reflecting the cityscape and drawing it deep into the heart of the room.

Paris Living

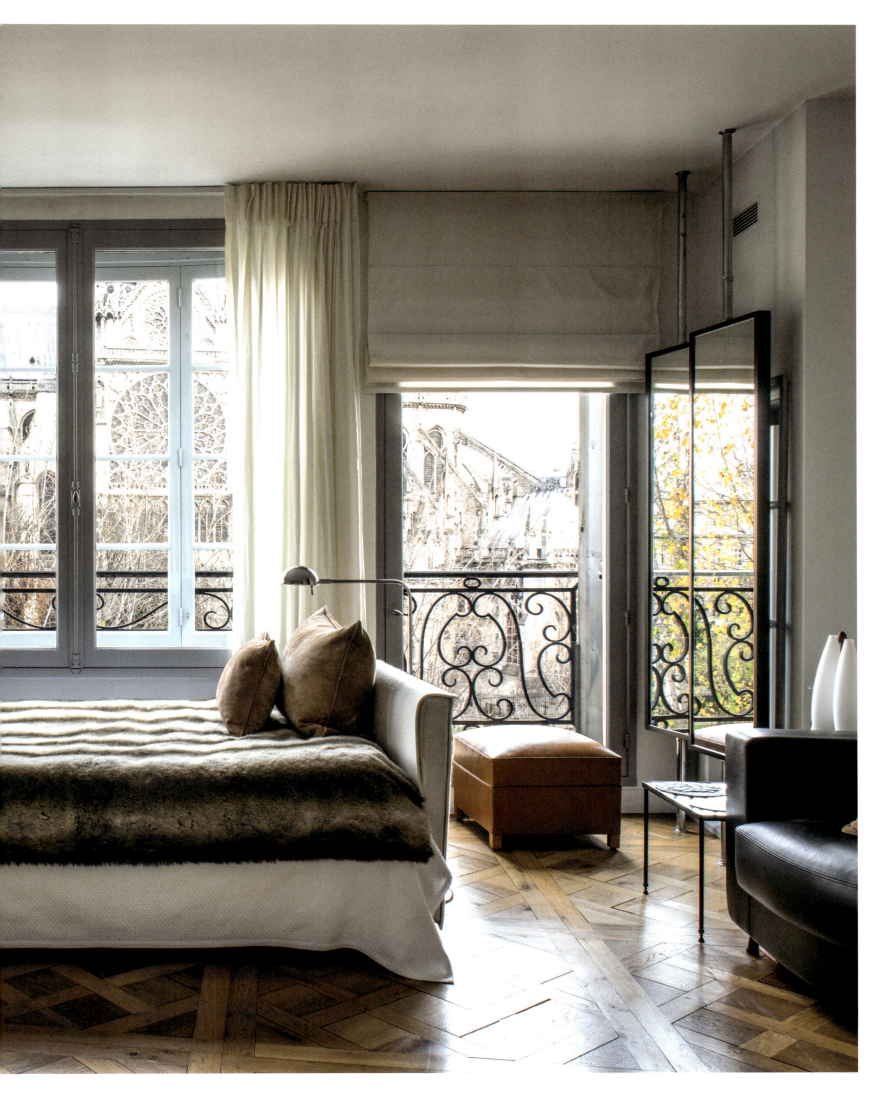

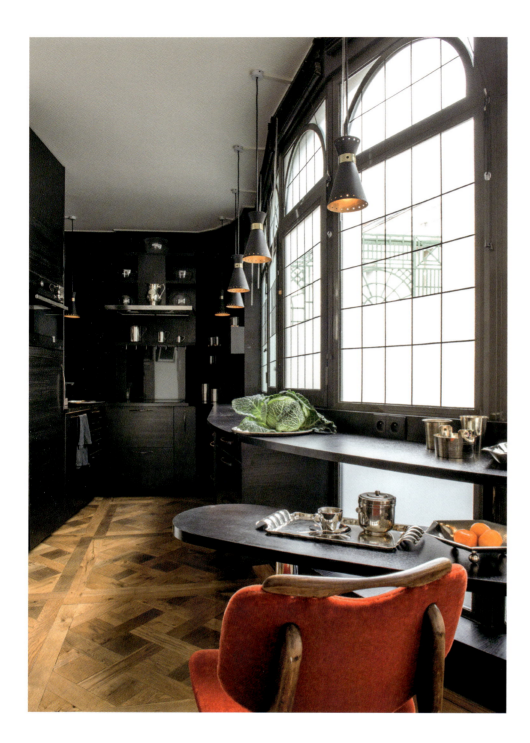

(Above) The kitchen, seamlessly integrated into a compact yet open space, balances comfort with functionality. Its thoughtful design ensures every detail contributes to an aesthetic reminiscent of a cabinet of curiosities. Black wood provides a bold contrast, enhancing the vibrancy of colors throughout the room.

(Right) Along one living room wall, a large 1937 pastel of a female nude by Gantzel commands attention above a uniquely shaped sofa. This inviting piece is complemented by another sofa with a leather cushion and faux fur throw, adding layers of warmth and texture for a cozy, inviting ambiance.

Paris Living

Throughout the space, *practicality* and *aesthetics* are intertwined, embodying a *cohesive* yet *eclectic design ethos*.

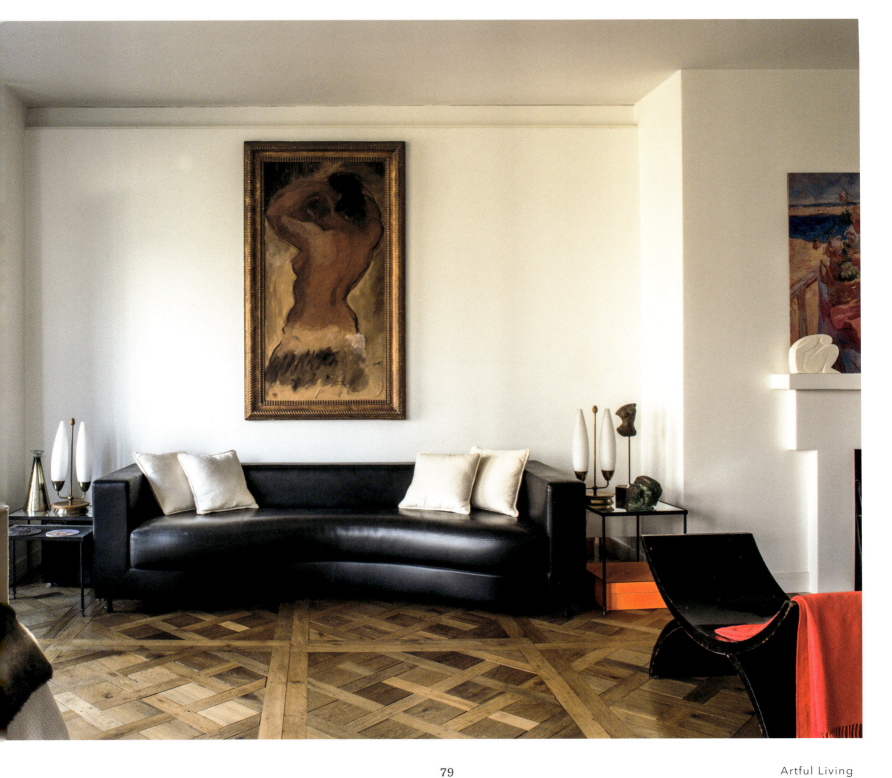

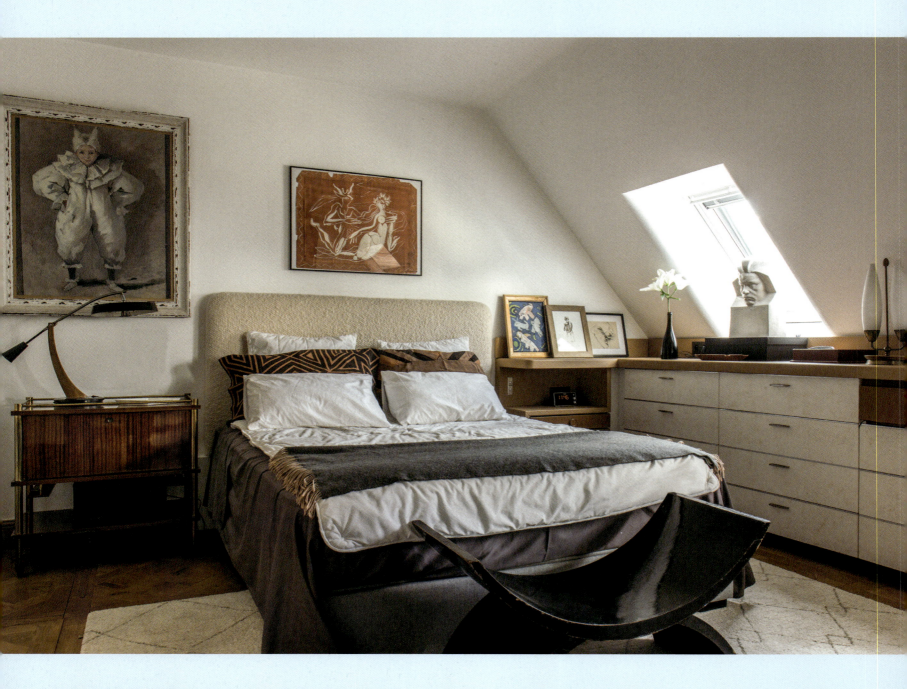

The bedroom masterfully blends classic elegance with modern elements. Thoughtfully curated vintage furniture, alongside intimate sketches, infuse the space with character and charm. A crackled ceramic bust of Berlioz adds a touch of historical artistry, while dresser drawers wrapped in parchment and accented with metal offer a refined textural context. The leather-topped dresser and sleek black lacquer stool elevate the room's sophistication, repurposing materials in imaginative ways that elevate the room's sophistication.

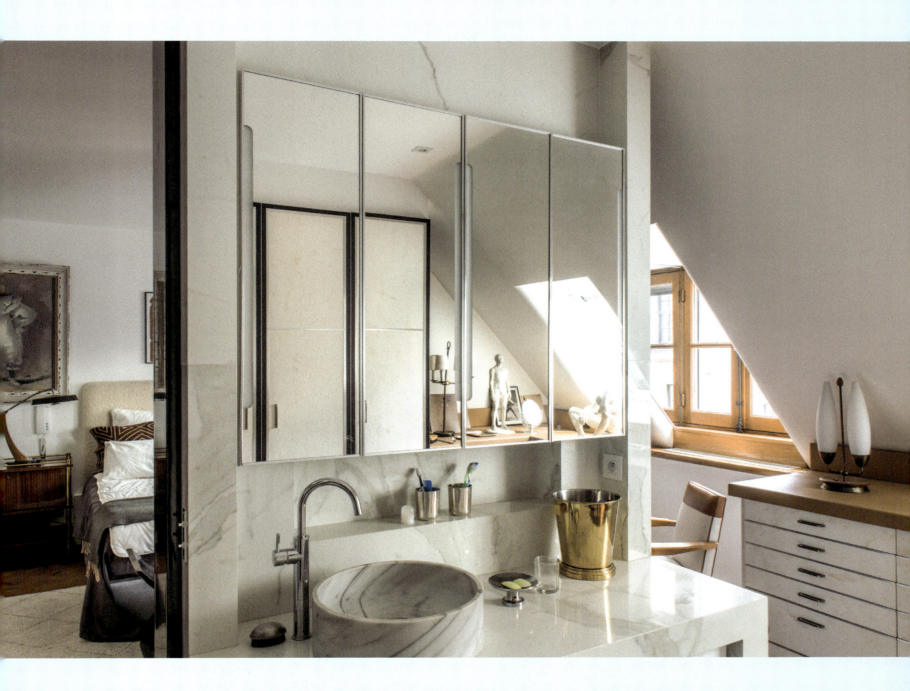

This elegant bathroom showcases a bespoke vanity and sink crafted from opulent Calacatta marble, infusing the space with timeless sophistication. A concealed sliding door seamlessly integrates the marble-clad bathroom with a dressing area, creating a cohesive, open space. Leather and paper accents harmonize with the natural brightness, adding warmth and texture.

# Historical Echoes

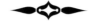

The 1956 Modular Sofa and 1948 Tray Table by George Nelson, both from Galerie Christine Diegoni, establish a foundation of enduring elegance. Lighting by Serge Mouille includes the iconic 1953 *Trépied* lamp from Galerie Transparence and a 1954 dual-arm wall sconce from Galerie David Corcos, providing sculptural illumination. A 1982 photograph by Alain Fleischer (Galerie Le Réverbère) and a 1949 George Nelson cabinet (Galerie Christine Diegoni) complement the decor, along with ceramics by Vassil Ivanoff and André Aleth Masson, and a zoomorphic vase (c. 1950) from Galerie Anne-Sophie Duval.

**Nestled in the heart of Montmartre, beneath the gaze of Le Moulin de la Galette, lies a remarkable loft apartment that stands as a testament to modern design and artistic collectivism. Owned by Caroline Wiart and Patrice Galiana, the space is more than just a home—it's a dynamic showcase of rare and inventive art.**

Originally a gloomy, underlit space, the apartment was transformed by the couple into a radiant, open-plan living area. They removed most of the interior doors, except for their daughter's private bedroom, allowing the loft to function as a cohesive flowing space. At the center, an elliptical coffee table by Charles Eames anchors the room, defining its layout while preserving a sense of openness. Large windows on three sides bathe the interior in natural light, enhancing both the artwork and architectural details.

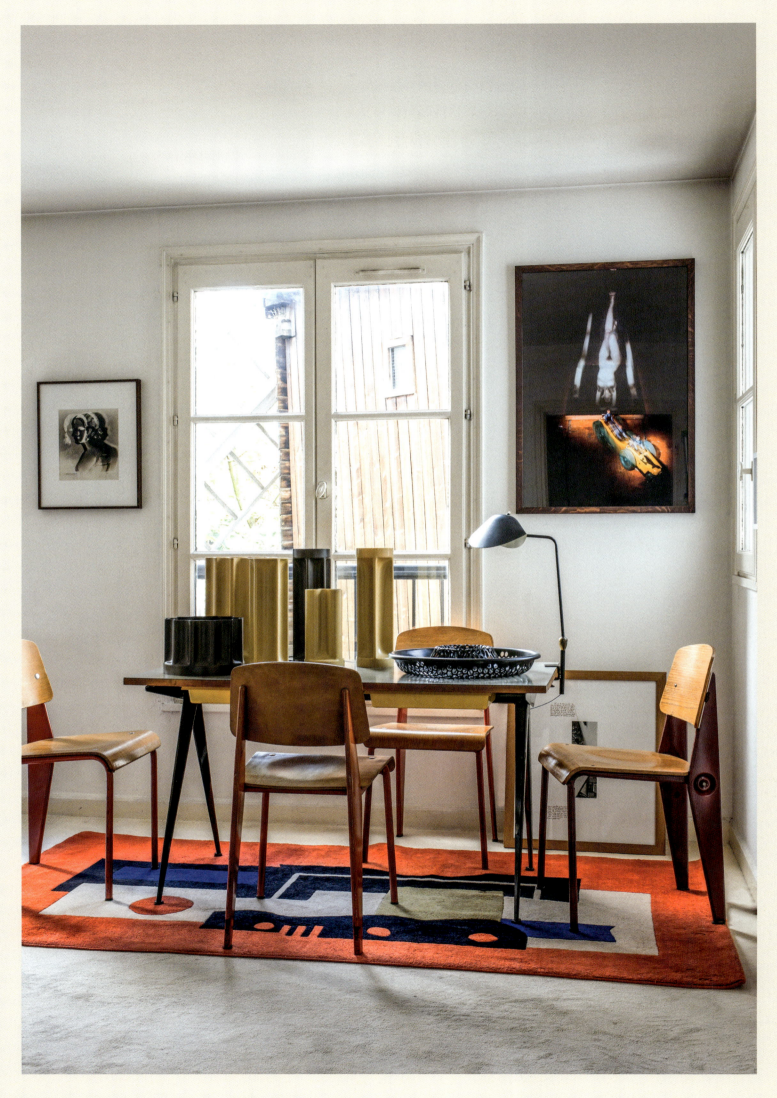

Each piece in Wiart and Galiana's collection is chosen with care, *blending functionality* and *artistic vision*.

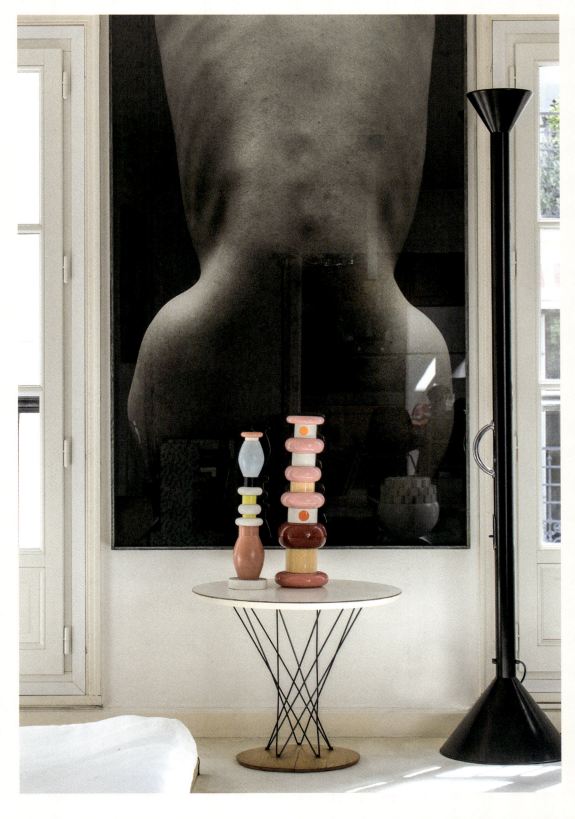

(Left) A 1953 *Compas* table by Jean Prouvé pairs seamlessly with three 1950 *Standard* chairs and a 1950 *Démontable* chair, all from Galerie Christine Diegoni, embodying Prouvé's functional elegance. Complementing the furniture, Serge Mouille's 1958 double-jointed *Agrafée* lamp (Galerie Christine Diegoni) offers versatile and sculptural lighting. Italian modernism shines through with Enzo Mari's *Bambu* vase set from 1969 and the 1965 *Atollo* bowl by Danese. These are paired with evocative photography: an Alain Fleischer piece from 1986 (Galerie Le Réverbère) and a 1938 photograph by Osamu Shiihara (MEM Gallery Tokyo). Anchoring the design is a *Rouge* rug (c. 1927) by Fernand Léger for Maison Myrbor, adding bold artistry to this timeless composition.

(Right) A 1956 guéridon by Isamu Noguchi (Galerie Christine Diegoni) exudes sculptural grace, while two *Totem* vases by Ettore Sottsass from the Flavia series (#5 and #1, 1964/96) introduce bold, modern lines. The limited-edition black *Callimaco* floor lamp by Sottsass for Artemide (1989) serves as a striking focal point. A 1997 photograph by Jacques Damez from the *Tombée des nues* series (Galerie Le Réverbère) completes this carefully curated ensemble.

George Nelson's 1956 modular sofa pairs elegantly with his 1948 tray table and two 1949 cabinets (Galerie Christine Diegoni), creating a foundation of understated sophistication. Lighting by Serge Mouille, including a 1954 dual-arm wall sconce (Galerie David Corcos), adds sculptural refinement, while Ettore Sottsass's *Bruco* floor light for Poltronova brings a touch of playful functionality to the space. Artwork, such as a 1982 photograph by Alain Fleischer, enriches the space. Iconic furniture completes the setting with Charles & Ray Eames's 1950 *DAR* chair and 1951 black *ETR* coffee table (Galerie Christine Diegoni), Sori Yanagi's 1954 *Butterfly* stool, and Alvar Aalto's 1933 bentwood chair (O.y. Huonekalu-ja Rakennustyötehdas A.b, Turku). Adding texture and visual interest, the decor includes Enzo Mari's 1989 *Ferro* glass vase from the 1991 *Che fare a Murano* series (Danese, first edition), Martine Bedin's 2005 *Caracalla* white vase, and ceramics by Vassil Ivanoff and André Aleth Masson. A circa 1950 zoomorphic vase (Galerie Anne-Sophie Duval) brings whimsy, while Charlotte Perriand's 1962 *iroko* tripodal stools (Laboratoires Sandoz model) offer natural warmth.

Paris Living

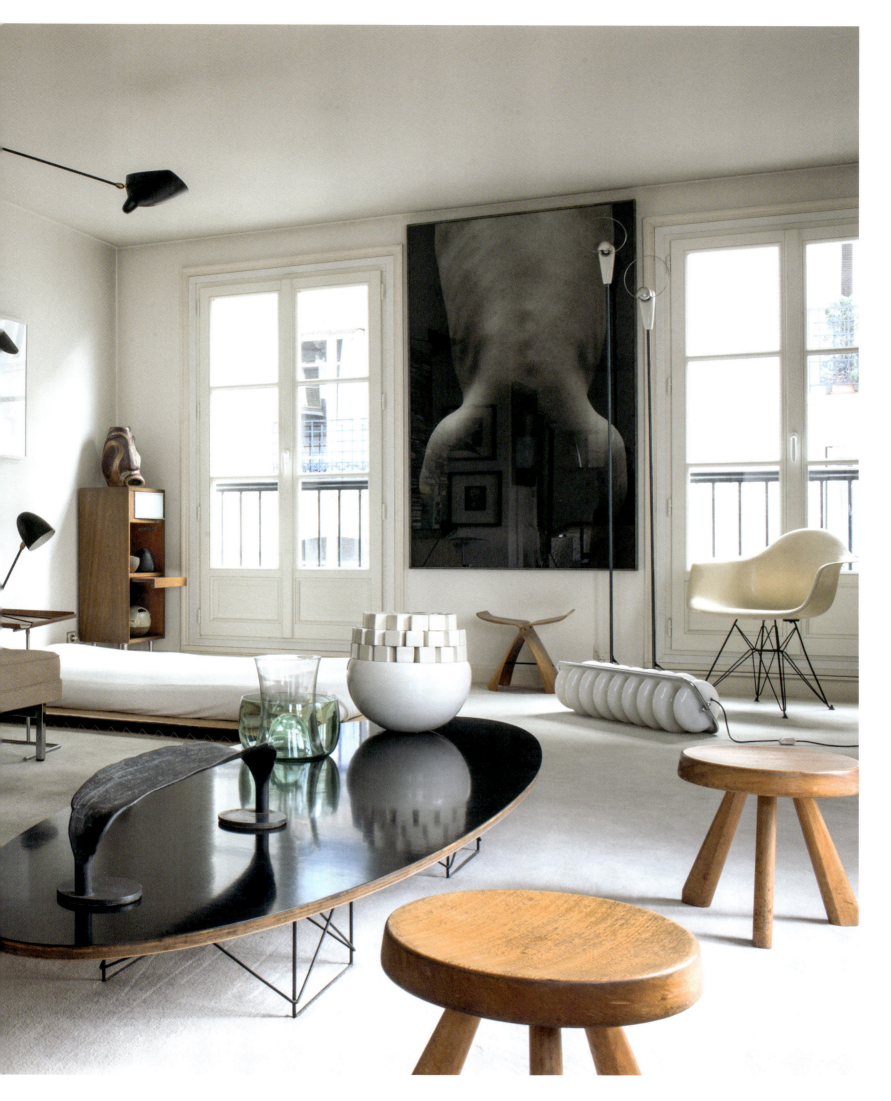

Historical Echoes

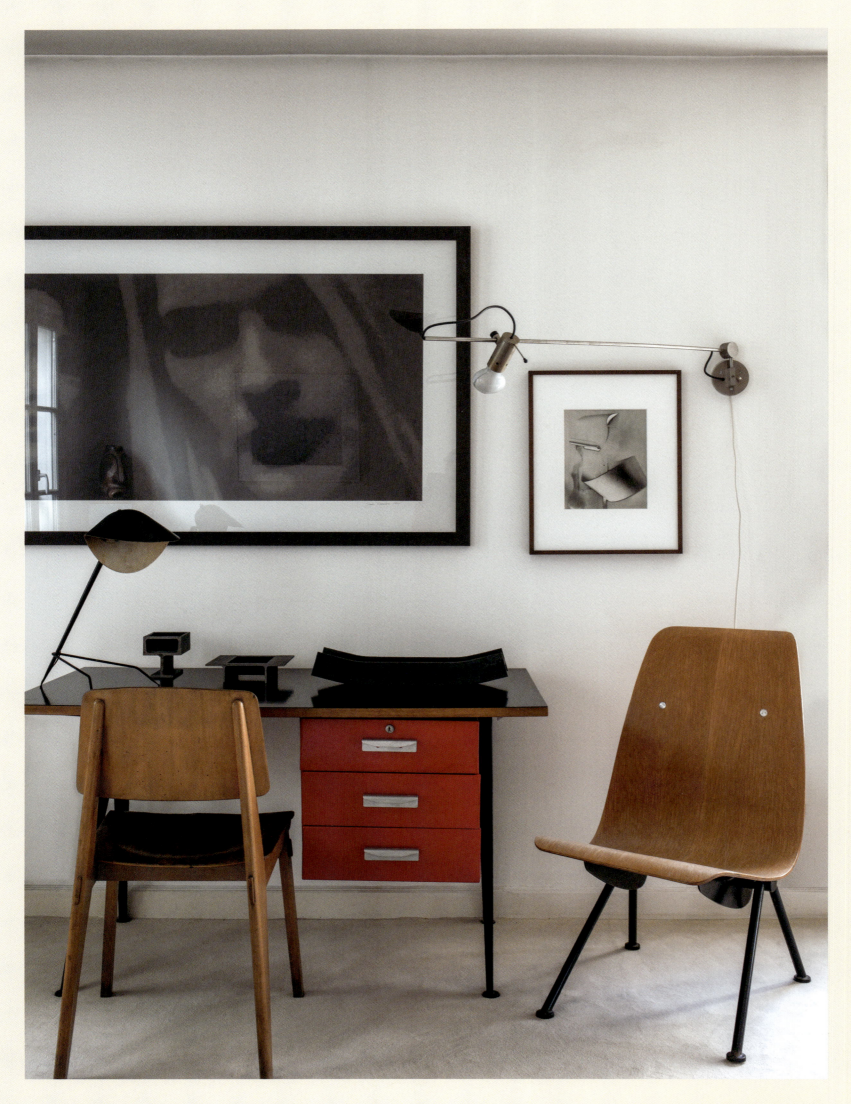

Each piece in Wiart and Galiana's collection is chosen with care, blending functionality and artistic vision. Standout pieces include Enzo Mari's innovative *Putrella* structures, used here as functional components of a work desk, and Ettore Sottsass's striking *Teodora* chair with its gray and white patterns and transparent backrest. These items are complemented by an array of French photography that pushes the boundaries of the medium, featuring works by Alain Fleischer, Lionel Fourneaux, and Jacques Damez.

The apartment's aesthetic is marked by minimalist white walls and resin-coated floors, chosen to amplify the abundance of natural light. Thoughtfully placed bursts of color create bold, vibrant contrasts, particularly in the

(Left) This workspace combines timeless design with artistic flair. Jean Prouvé's 1953 *Compas* desk and 1942 *Tout Bois* chair (Galerie Christine Diegoni) exude functional elegance, further enhanced by Prouvé's 1954 *Cité Universitaire* chair, Serge Mouille's 1953 *Trépied* lamp (Galerie Transparence), and Tito Agnoli's 1954 *Applique 255*. The decor gains an artistic dimension through Enzo Mari's 1958 *Putrella* series (Danese), a 1930s Osamu Shiihara photo (MEM Gallery Tokyo), and a 1997 Sam Samore photograph (Galerie Anne de Villepoix).

(Above left) Jean Prouvé's 1953 *Compas* table (Galerie Christine Diegoni) is paired with Serge Mouille's 1958 *Agrafée* lamp for versatile and sculptural lighting. An Alain Fleischer photograph from 1986 (Galerie Le Réverbère) enhances the setting with artistic depth, while Enzo Mari's 1973 white *Samos* bowl (Galerie Olivier Verlet) introduces a sleek and modern accent.

(Above right) This arrangement highlights a 1949 cabinet by George Nelson (Galerie Christine Diegoni) complemented by a sculptural ceramic vase by Vassil Ivanoff, depicting an Africanist face in stoneware. Two ceramic bowls by Elisabeth Joulia complete the scene, adding artisanal texture and a refined sense of craftsmanship.

carefully curated furniture, which spans mid-century modern to contemporary designs. Notable pieces include a Formica dining table paired with red lacquered metal chairs by Jean Prouvé, and a distinctive metal light fixture by Serge Mouille that elegantly extends over the living area.

Through their intuitive and knowledgeable approach to collecting, Wiart and Galiana have created a living space that transcends the traditional boundaries of home and gallery. Their Montmartre loft is not just a residence, but a dynamic celebration of design history and modernity. Every corner tells a story, and every piece is a landmark in design, making the loft a remarkable testament to personal expression and artistic vision. —

> Through their *intuitive* and *knowledgeable approach* to collecting, Wiart and Galiana have created a living space that *transcends* the traditional *boundaries* of home and gallery.

Unique design and art pieces define this space, including Martine Bedin's 1981 *Terminus* floor lamp (Memphis, first edition, no. 34) and Ettore Sottsass's 1983 signed mirror, alongside the 1984 *Teodora* armchair (Vitra, first edition). George Nelson's 1955 *Half-Nelson* table lamp (Galerie Christine Diegoni) introduces a touch of mid-century sophistication. Photographs enrich the narrative, featuring a 1995 image by Lionel Fournaux (Galerie Le Réverbère) and two works (c. 1940s) by Weegee, capturing poignant moments of a man with a harmonica and a man with a horse in the snow.

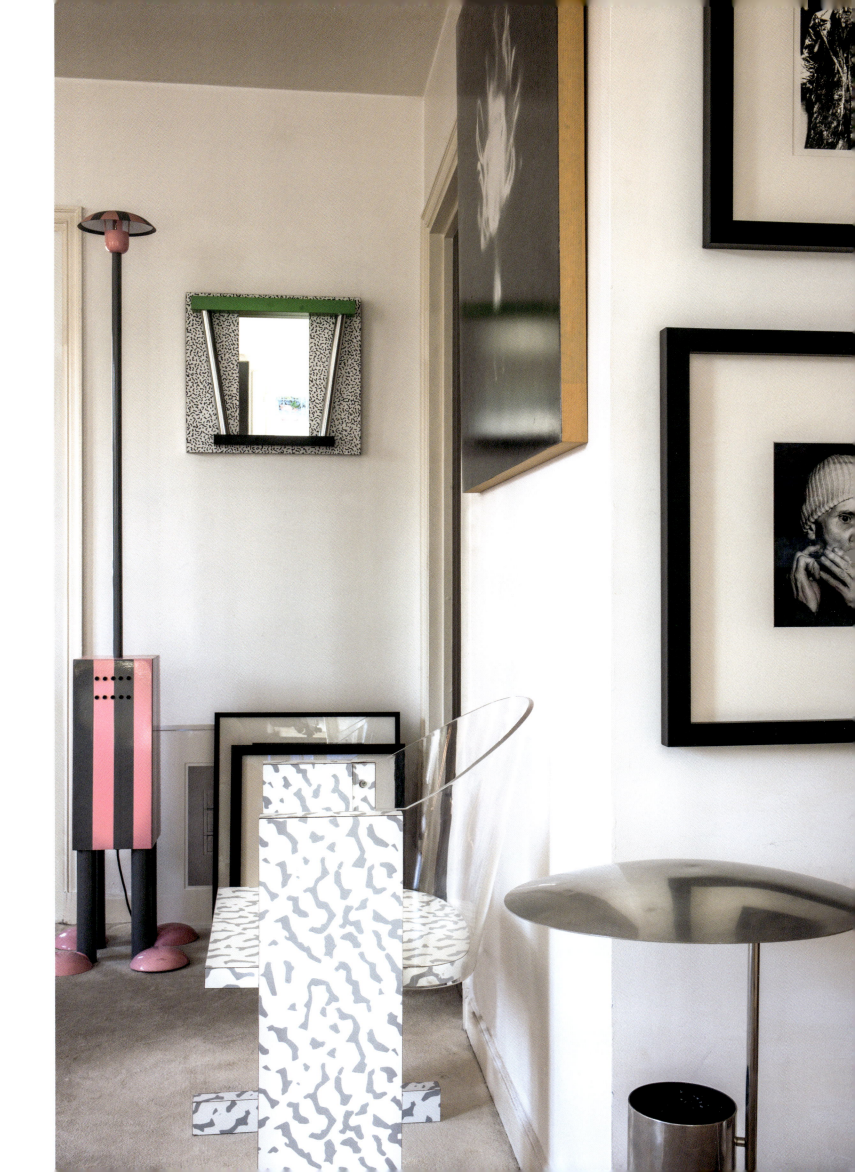

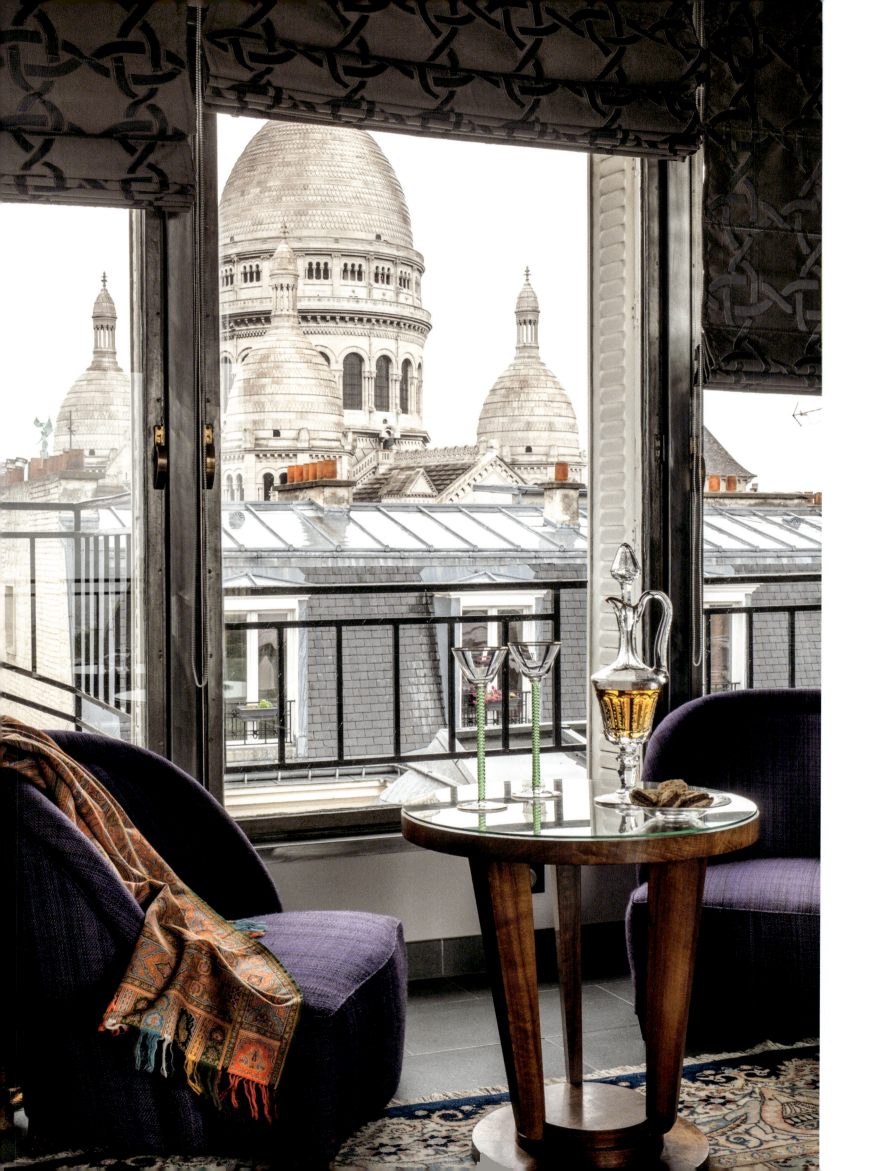

# Artful Heights

**Perched in Montmartre, veiled by the soft embrace of a morning mist, stands the sophisticated apartment of Olivier Baroin—a renowned jewelry expert deeply influenced by the artistry of Suzanne Belperron. High atop a stone building, his home offers expansive panoramic views of the city.**

Baroin acquired this top-floor sanctuary in January 2013, drawn by its exceptional location and dual views: one window frames the Sacré-Cœur, while another stretches across Paris to the Eiffel Tower, embodying the quintessence of city living. Originally compartmentalized, Baroin transformed the apartment into an open-plan space, blending loft and studio elements with antique treasures that trace the journey of his two-decade career. The year-long renovation saw him tear down walls to craft a home that reflects both his personal style and functional needs.

His living room, a spacious area framed by expansive bay windows, is his favorite part of the home. More than just a room, it serves as a serene vantage point, offering moments of serenity and inspiration amidst the bustling city below.

An Emile Gallé side table, paired with a Saint-Louis crystal decanter and Murano glass goblets from the renowned collection of Suzanne Belperron, transforms a corner into a perfect relaxation spot, framed by a breathtaking view of the iconic Sacré-Cœur in the distance.

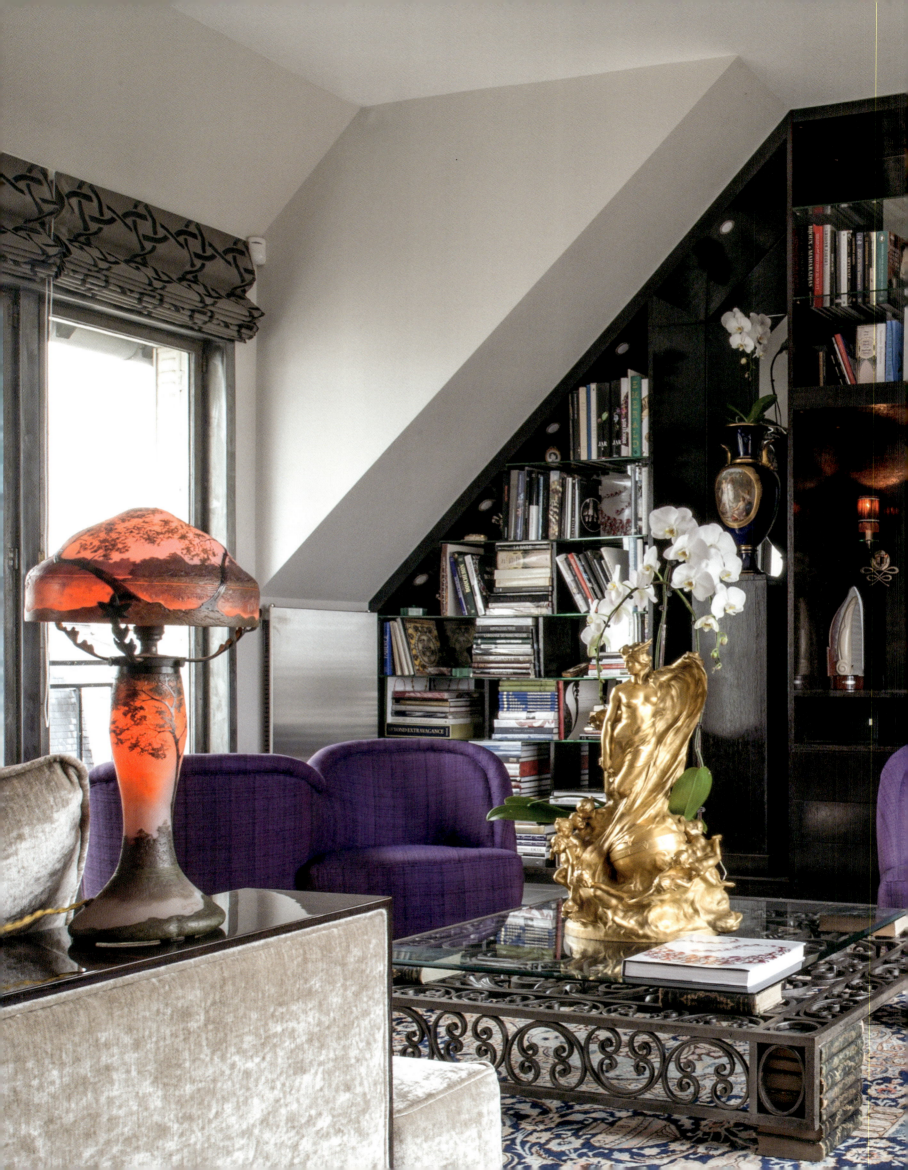

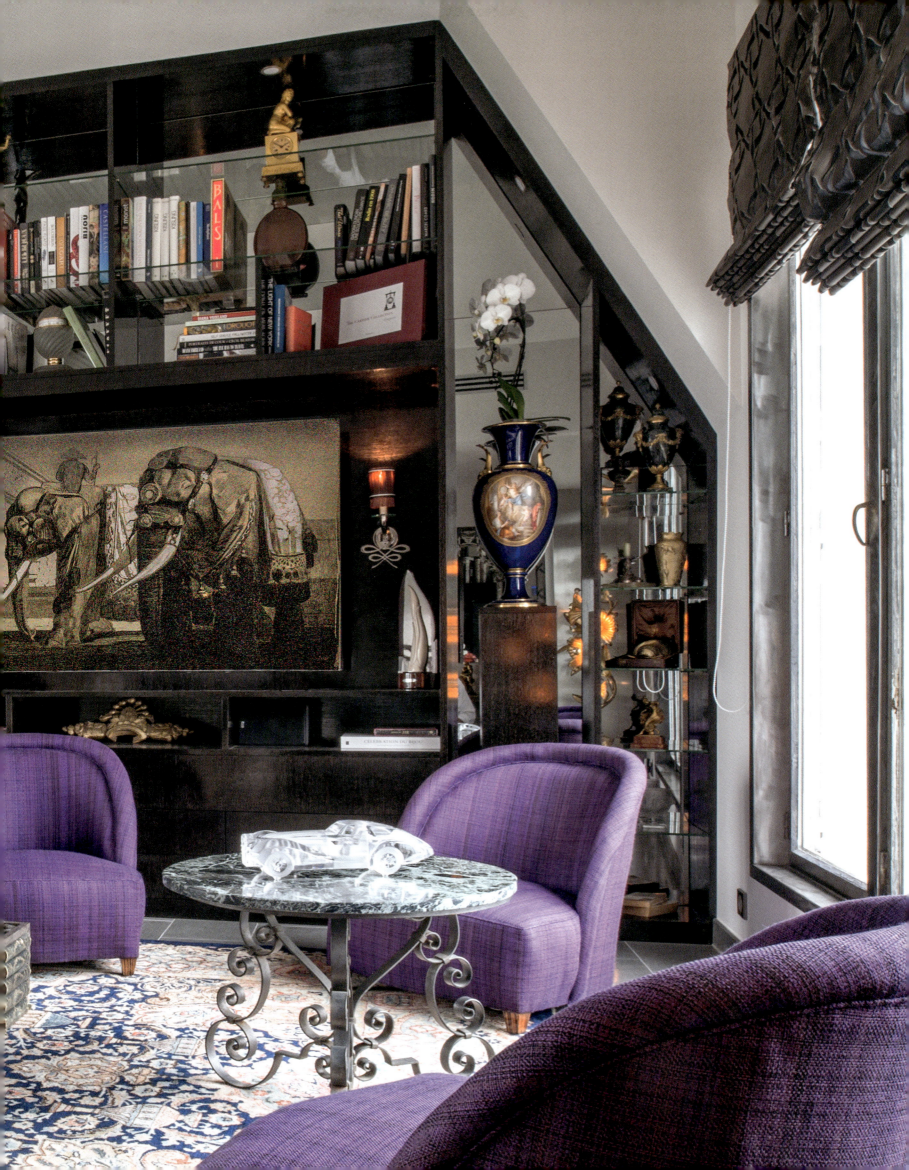

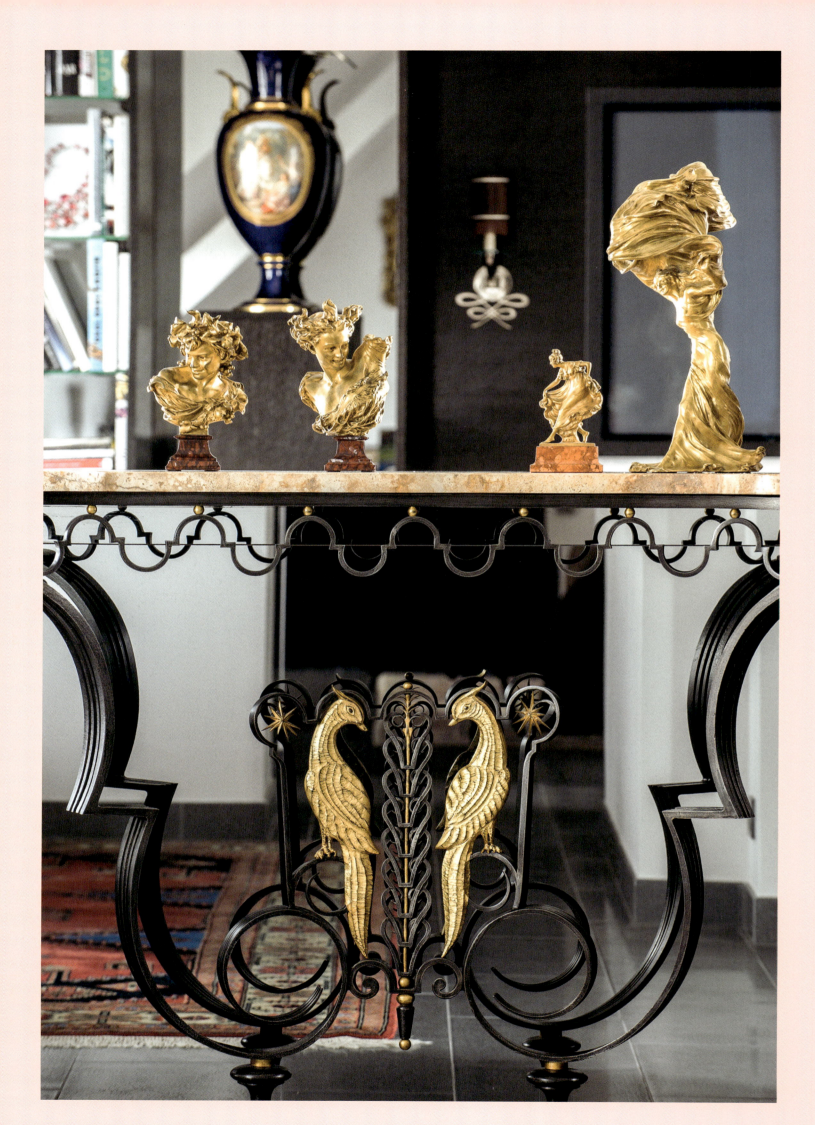

(Previous page) The room captivates with its eclectic charm, featuring a Legras table lamp and an intricate bronze clock sculpture titled *Allégorie au Temps* by Raoul Larche. The seating, originally designed in the 1930s by Marcel Coard for Suzanne Belperron, includes four armchairs and a unique "confidante" sofa. Above, Paul Jouve's 1923 artwork *Royal Elephants in Hue*—rendered in pencil and watercolor—adds a touch of exotic artistry. Completing the grandeur, a pair of deep blue Sèvres vases from 1863 stand prominently, infusing the rook with historical gravitas.

(Left) A Messanier console table in wrought iron with a travertine top anchors the composition, featuring a striking medallion with two parakeets. Atop the console are captivating golden bronze sculptures, including Raoul Larche's masterpiece *Loie Fuller*, circa 1900. This lamp sculpture exquisitely captures the dancer's flowing motion in bronze.

> "Revealing one's interior is akin to *baring one's spirit*," Baroin asserts, emphasizing the personal significance of *every item's placement.*

Functionality and aesthetics are harmoniously combined in Olivier's home. Steel-gray floors and extensive use of Macassar wood provide a subtle backdrop, allowing colorful elements to stand out. Among them is a 1930s living room suite designed by Marcel Coard for Belperron, upholstered in a rich cardinal violet. This piece, along with François-Raoul Larche bronzes and significant 19th-century Sèvres vases, exemplifies Olivier's love for the Art Deco period and his skill in merging historical richness with contemporary living.

Each item in Olivier's collection tells a story, from the violet living room set acquired from Belperron's estate to the eclectic pieces found at flea markets and antique shows. His deep connection with each piece is evident, as he insists on decorating his home himself, reflecting his soul through his surroundings. "Revealing one's interior is akin to baring one's spirit," Baroin asserts, emphasizing the personal significance of every item's placement in his home.

The village-like atmosphere of Montmartre, with its close-knit community and familial friendly neighbors, profoundly influences Olivier's approach to life and living. This environment offers a stark contrast to the fast pace of Paris, providing a nurturing space where everyone knows each other and lives in harmony. Baroin cherishes this aspect of Montmartre, allowing it to guide his decor choices and ensuring that his home not only reflects his aesthetic but also fosters a sense of community and well-being. —

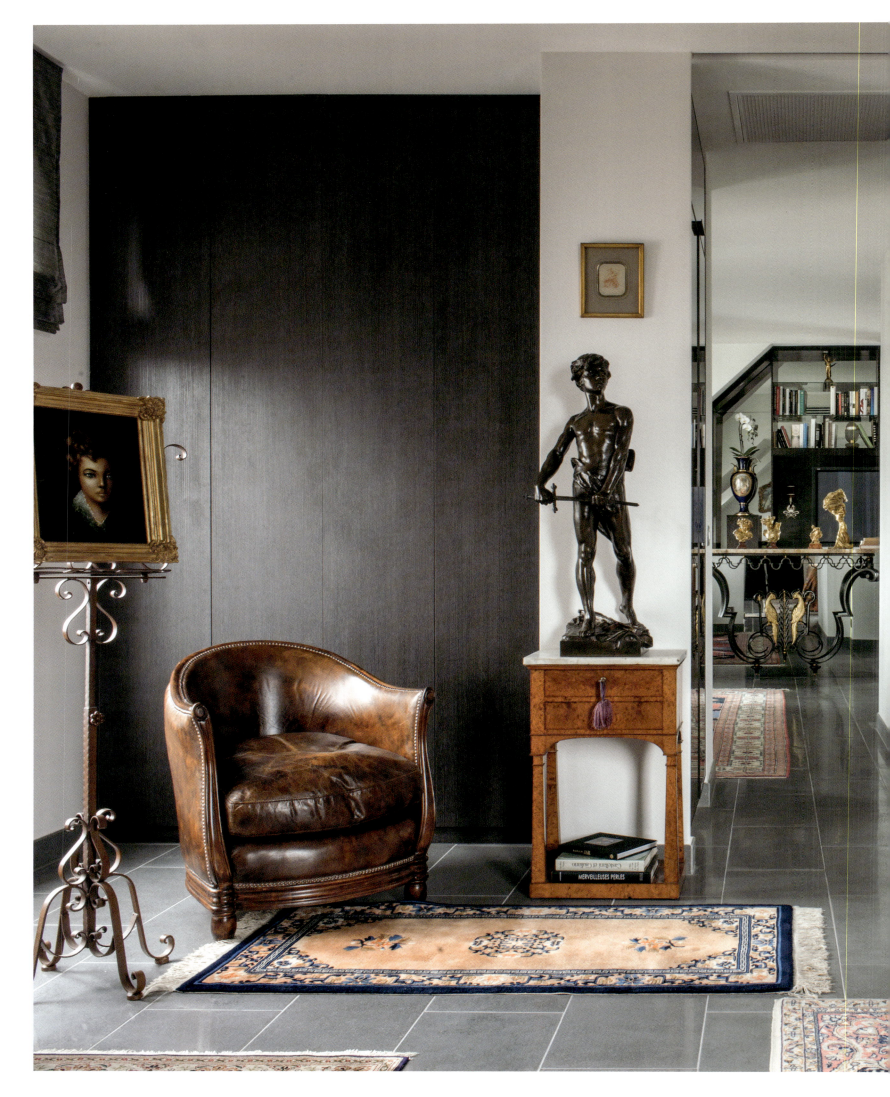

François-Raoul Larche's bronze sculpture, *20 Ans*, cast in dark patina by Siot-Decauville, exudes elegance on a small wooden side table. Nearby, a stamped Jansen table supports Alliot's gilded bronze masterpiece *Le Baiser*, adding romantic charm.

Artful Heights

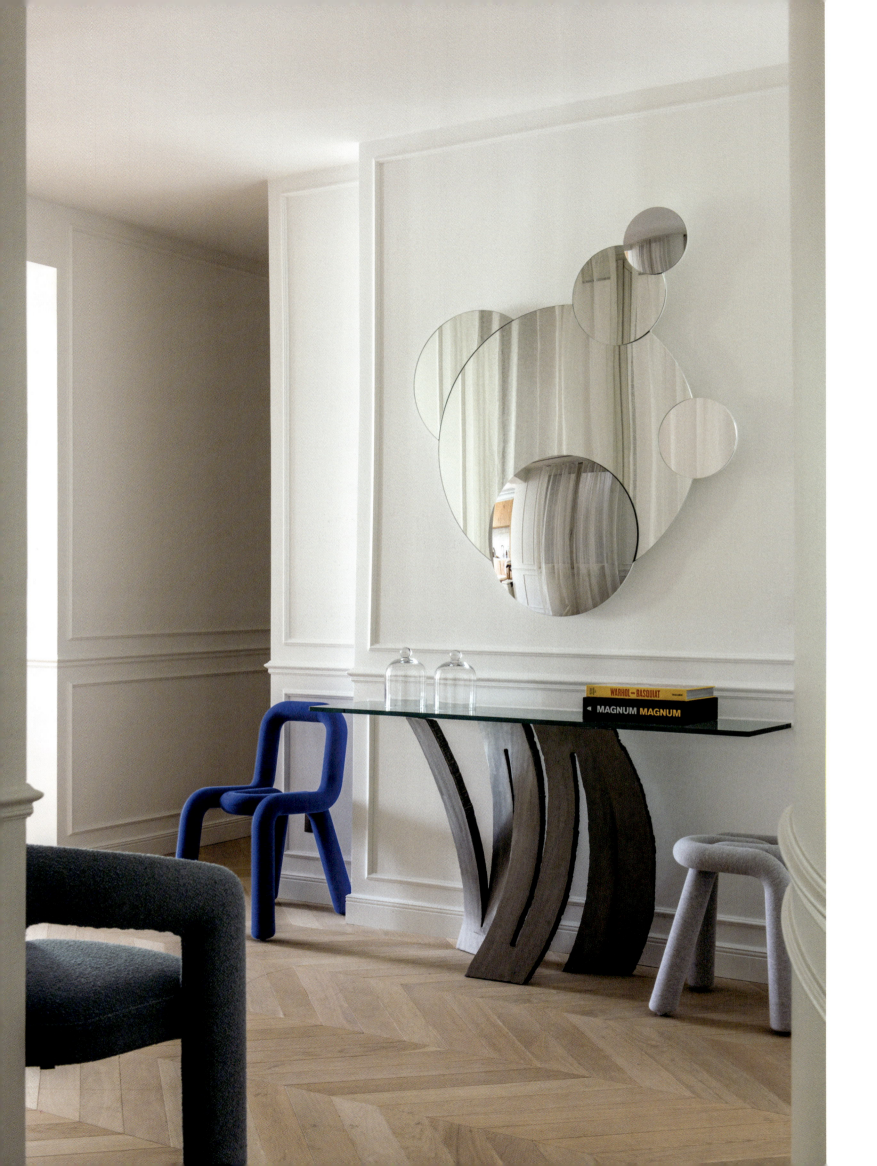

# Chic Sanctum

**Diana Ghandour, a luminary in interior architecture and furniture consultation, skillfully blends creativity with an acute spatial awareness to transform ordinary spaces into personalized sanctuaries. Her Paris apartment on Avenue Marceau is a prime example of her design prowess, showcasing both the elegance and innovation that defines her work.**

Acquired in 2016 and thoughtfully renovated in 2023, Ghandour's Parisian retreat immediately captivated her with its sunlit interiors and vibrant energy. "The moment I stepped in, it felt alive with potential for happiness," she recalls, underscoring the intangible qualities that turn a mere structure into a home.

Used as a pied-à-terre for family vacations, the apartment features five master bedrooms, a smart family room, and a spacious open kitchen that flows into a grand dining area. Ghandour has meticulously crafted each room to strike a perfect balance between functionality and visual appeal, ensuring that every space is as practical as it is beautiful.

This stylish entryway masterfully balances modernity with playful elements. A vibrant electric blue chair and soft gray pouf by Moustache infuse bold color and texture, creating an engaging contrast against the neutral backdrop. The sculptural console and artistic bubble mirror from Roche Bobois form a dynamic focal point, with their reflective and curved designs adding depth and sophistication. Natural wood flooring and minimal decor emphasize a clean aesthetic, ensuring that each carefully selected piece commands attention.

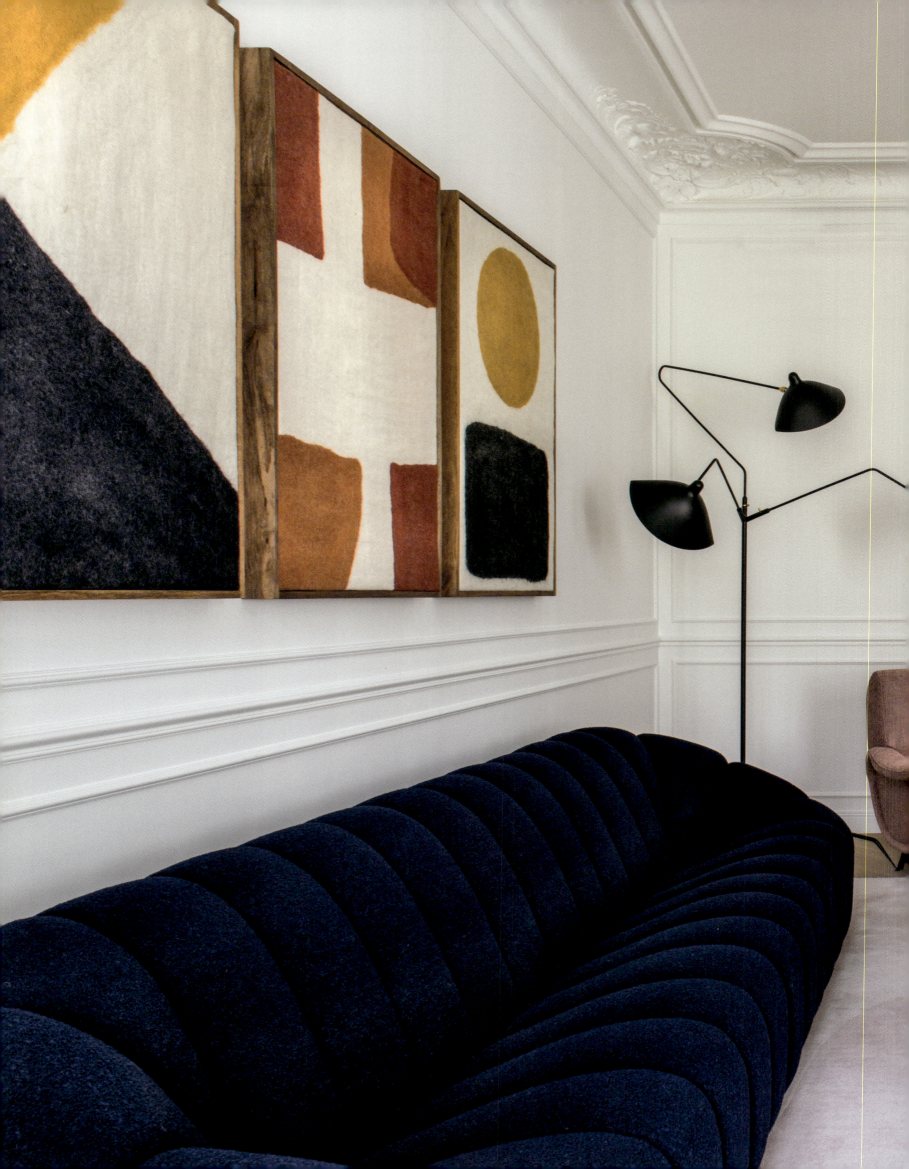

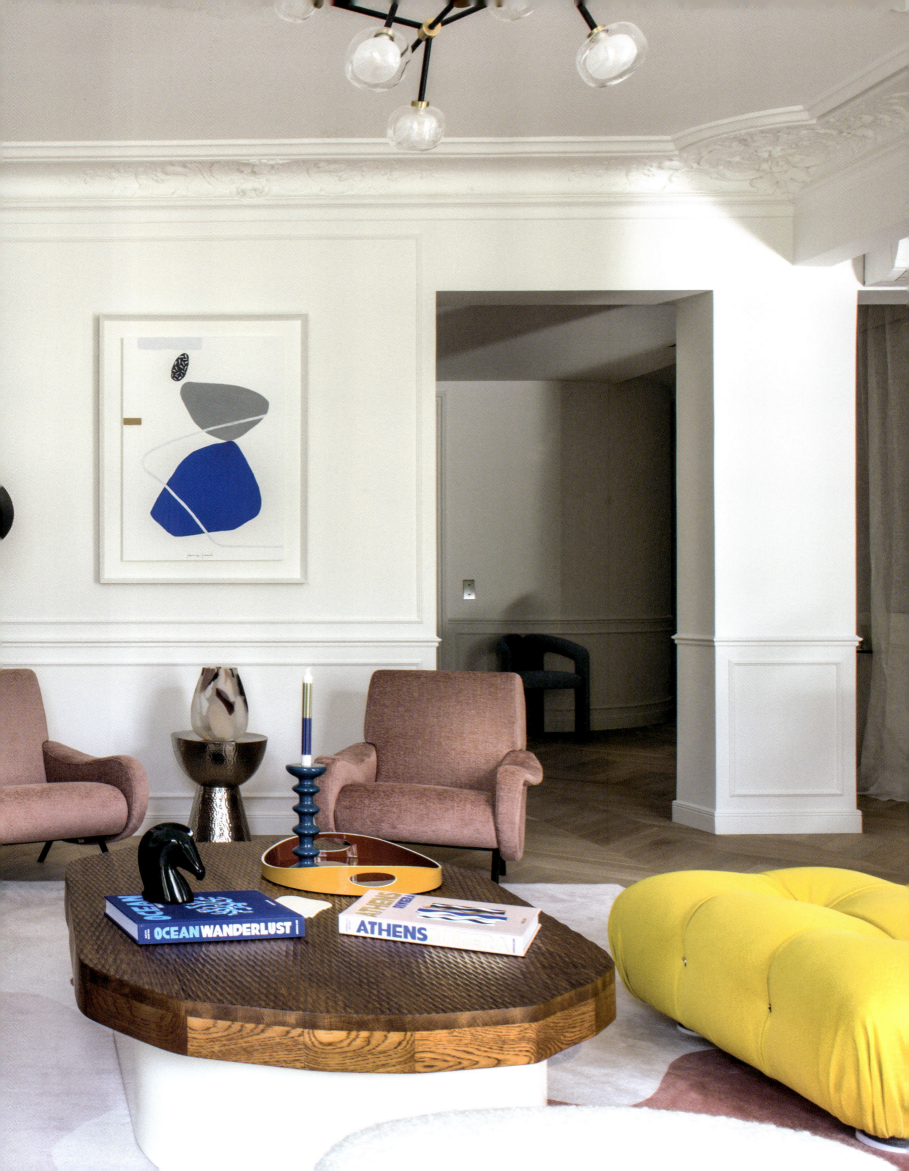

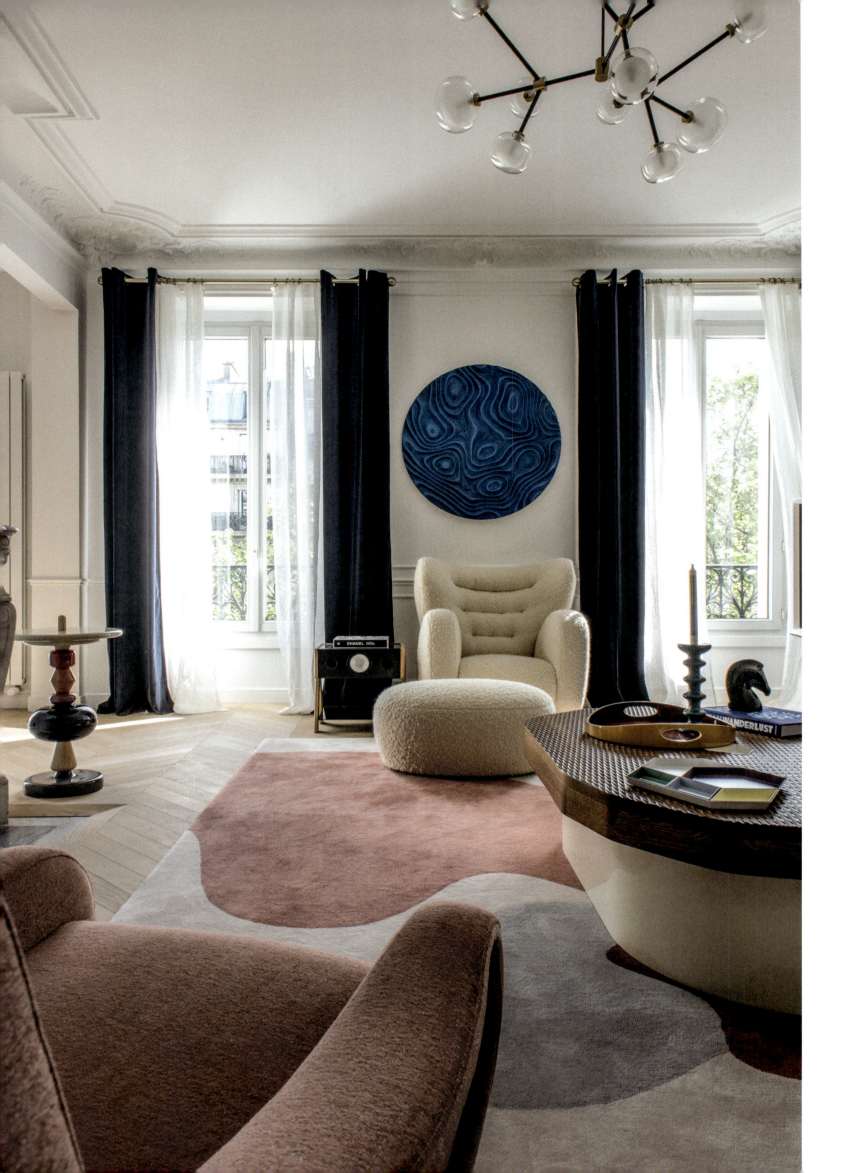

(Previous page) This living room exudes a harmonious blend of bold hues and tactile elements, thoughtfully curated with design pieces. At its heart is Pierre Paulin's *360* sofa in vibrant blue, paired with powder pink *Lady* chairs from Cassina, creating a striking interplay of colors. A colorful woolen wall art installation provides warmth and texture, while a sculptural coffee table by Pierre Augustin Rose and a playful yellow pouf from B&B Italia introduce dynamic shapes. The Ferrara rug ties the room together with understated charm, while lighting by Serge Mouille and the *Nabila* chandelier from Tooy add an elegant finish. Completing the ensemble is an abstract mixed-media artwork by a Spanish artist, which punctuates the space with creativity and energy.

(Left) The *Minautore* by Pierre Augustin is complemented by a vibrant art piece from Cyryls Design. The guéridon table showcases the exquisite Ferrara rug from his collection, while curated accessories from Assouline and Hermès lend a refined touch to the decor.

> In Ghandour's decor, *color* and *texture* serve a purpose beyond aesthetics—they evoke *specific* emotions.

The open kitchen, made from warm oak, is the heart of the apartment. "It's where we come together as a family, making it my favorite spot," Ghandour explains, reflecting her design philosophy of creating spaces that foster joy and harmony. The apartment also showcases Osmanian architectural influences, adding a sense of historical elegance to its modern interiors. Ghandour's approach emphasizes optimizing space to accommodate her large family while maintaining inviting communal areas.

As an expert in creating environments that foster well-being, Ghandour focuses on the psychological effects of spatial design. "Functionality equates to well-being," she notes, a belief mirrored in her use of vibrant colors and minimalist, comfortable furniture to balance practicality with aesthetics. Drawing inspiration from French homes and Ottoman architecture, she creates spaces that are fluid, harmonious, and infused with modern minimalism.

On her Instagram platform, @what_hipp, Ghandour explores the interplay between art, architecture, and interior design. Her influences, from *Elle Decoration* to architects like Zaha Hadid and French designers such as Pierre Paulin and Pierre Augustin Rose, are evident throughout her work.

In Ghandour's decor, color and texture serve a purpose beyond aesthetics—they evoke specific emotions. Yellow symbolizes prosperity, blue reflects authenticity, and pink conveys love. Each choice is carefully curated to enhance the ambiance of the room.

Signature pieces in the apartment include a mix of vintage and contemporary furniture from renowned French designers like Christophe Delcourt and Pierre Paulin. These pieces do more than occupy space—they tell stories, encapsulating personal journeys and artistic pursuits. —

This stylish kitchen blends modern design with functional elegance. A sleek Flos lamp provides ambiance lighting, while a table by Christophe Delcourt is paired with chairs from the *Invisible* collection by Simon Emanuel. The cabinetry, designed by Poliform and sourced from Silvera Paris, offers both style and practicality. Thoughtfully curated accessories from Zara Home and Smeg complete the space with charm and elegance.

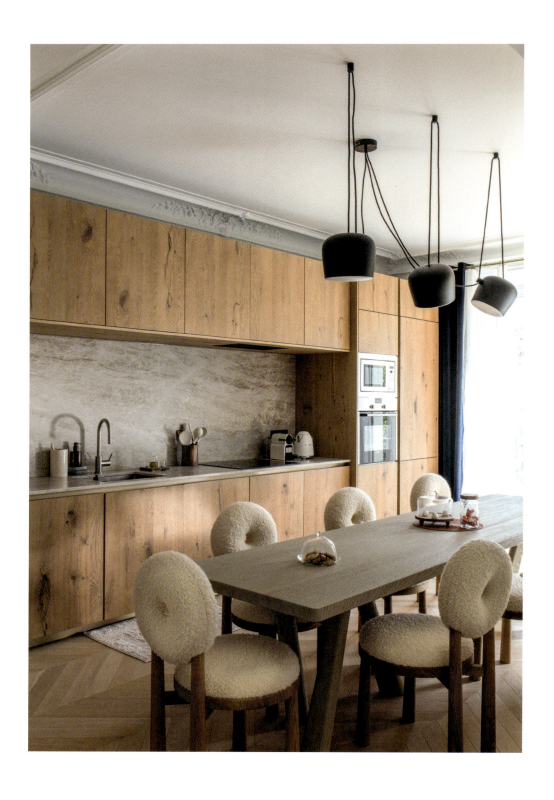

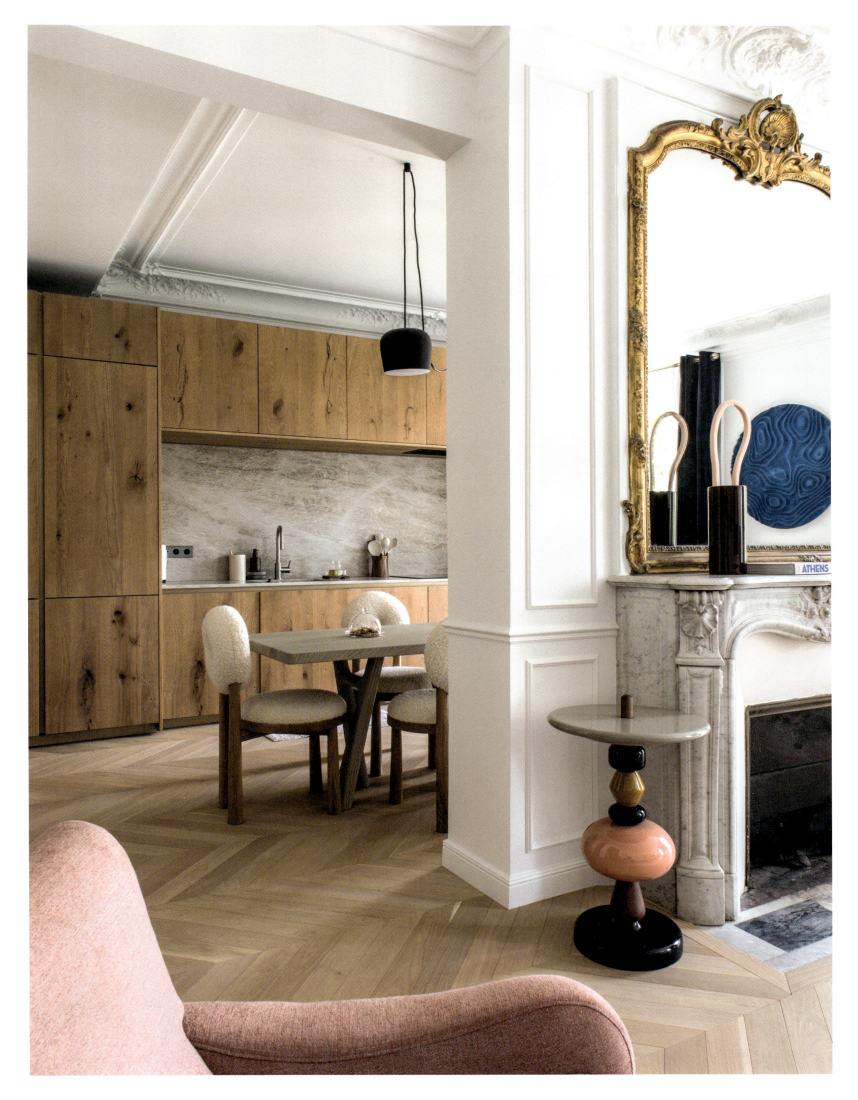

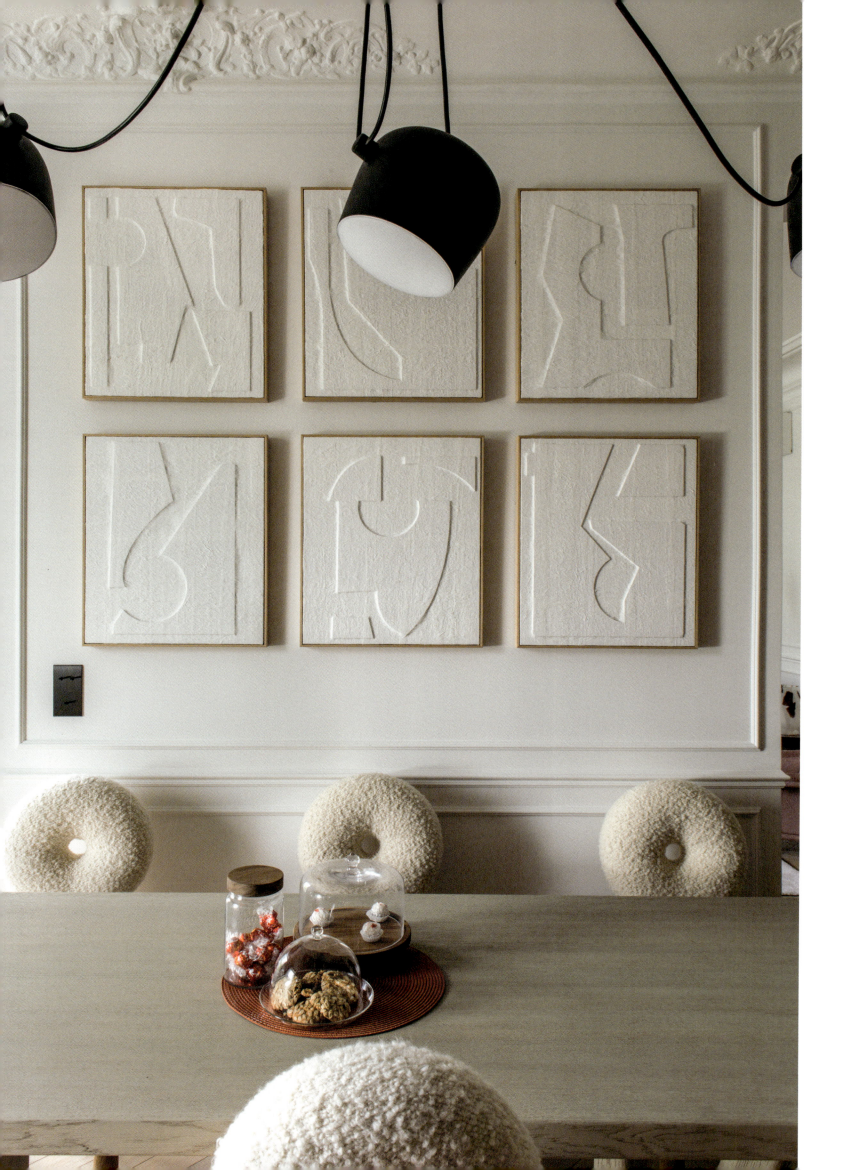

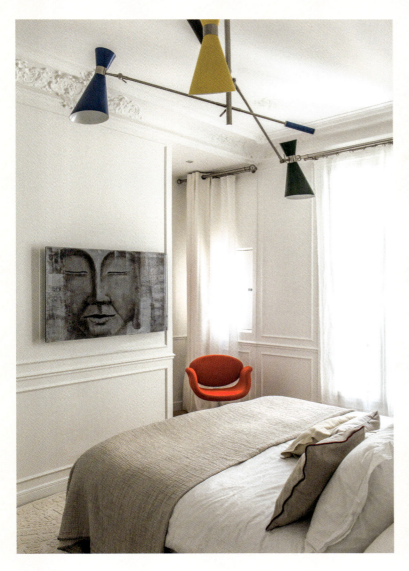 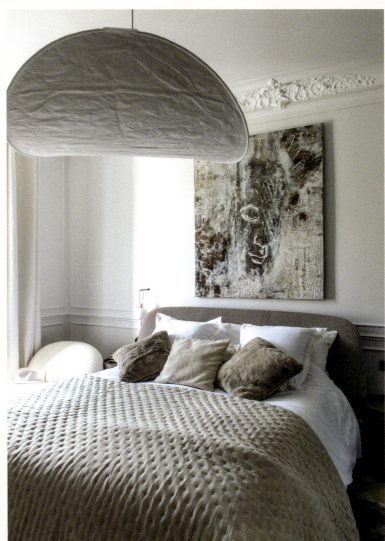

(Left) The dining table by Christophe Delcourt elegantly complements the plush chairs by Simon Emanuel. Overhead, a striking Flos chandelier casts a warm, elegant glow.

(Above left) A stylish bed from Pianca is accentuated by *Stanley* suspension lamps from Delightfull, adding retro-inspired charm. A bold red chair by Pierre Paulin introduces a vibrant, playful touch.

(Above right) This serene bedroom showcases understated luxury with a Poliform bed and matching nightstands, complemented by a chic Panter & Tourron pendant light. A Gubi Pasha armchair enhances the room with a touch of elegance.

As an expert in *creating environments* that *foster well-being,* Ghandour focuses on the psychological effects of *spatial design.*

# Fabric Fantasia

Within the serene precincts of Faubourg Saint-Germain, the Parisian home of Patrick and Lorraine Frey is more than a residence—it's a vivid tableau of the French art of living, masterfully curated by the couple at the helm of Maison Pierre Frey. This 150 square meter apartment, perched atop a quintessential Haussmannian building, is a sanctuary of light and creative fervor.

Daylight permeates the space through generous windows, each one framing views that weave the historic tapestry of Paris into the fabric of the home. At the heart of the apartment's architectural elegance is a hexagonal vestibule, serving as a central hub that seamlessly connects the rooms, each doorway leading to spaces that promise both comfort and aesthetic delight.

Stepping into this residence, one is enveloped by an ambiance that defies the monochromatic subtlety of modern decor trends. Here, colors and textures engage in lively conversation—bold, vibrant hues speak of the Freys' personal journey, with each shade and fiber selected with deliberate affection, echoing tales of distant lands and cherished encounters. The decor is not just to be seen but felt, a dynamic canvas reflecting their life's travels and artistic encounters.

A striking sculpture by Nathalie Decoster anchors this elegant setting, beautifully juxtaposed against a vibrant abstract painting and classic furnishings.

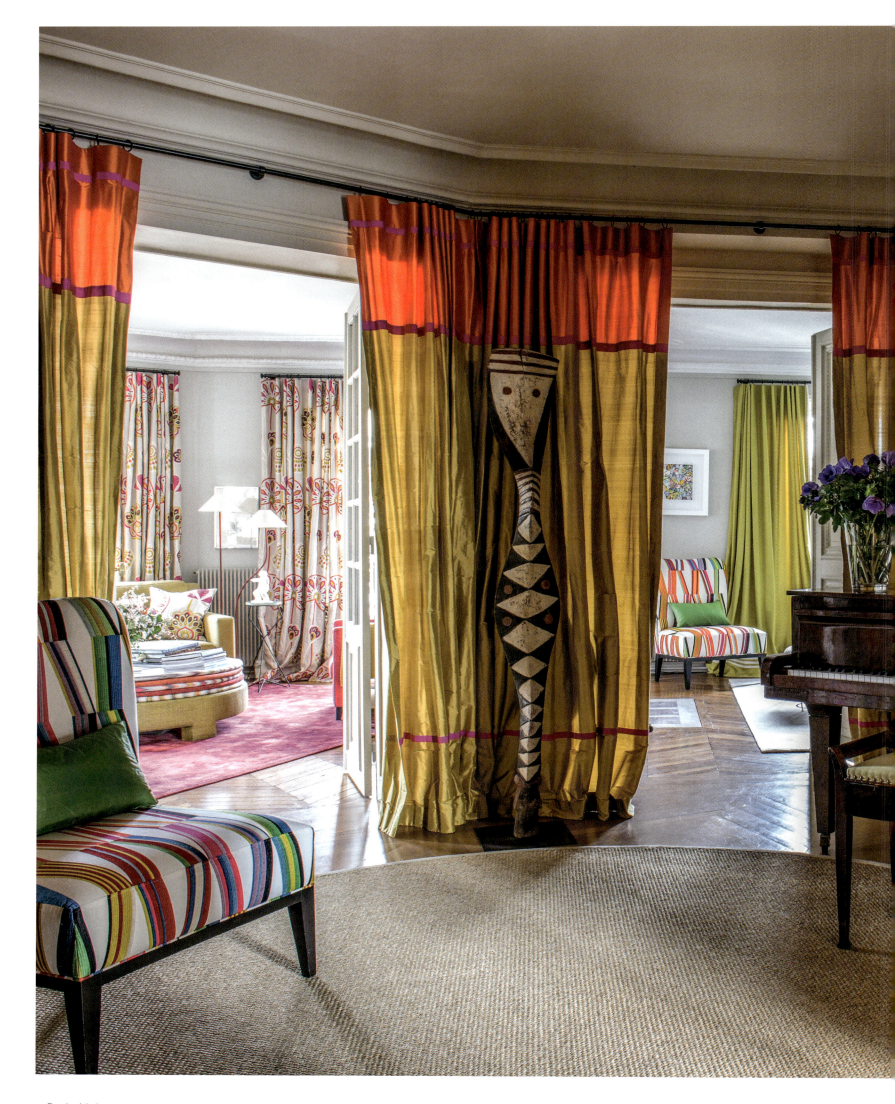

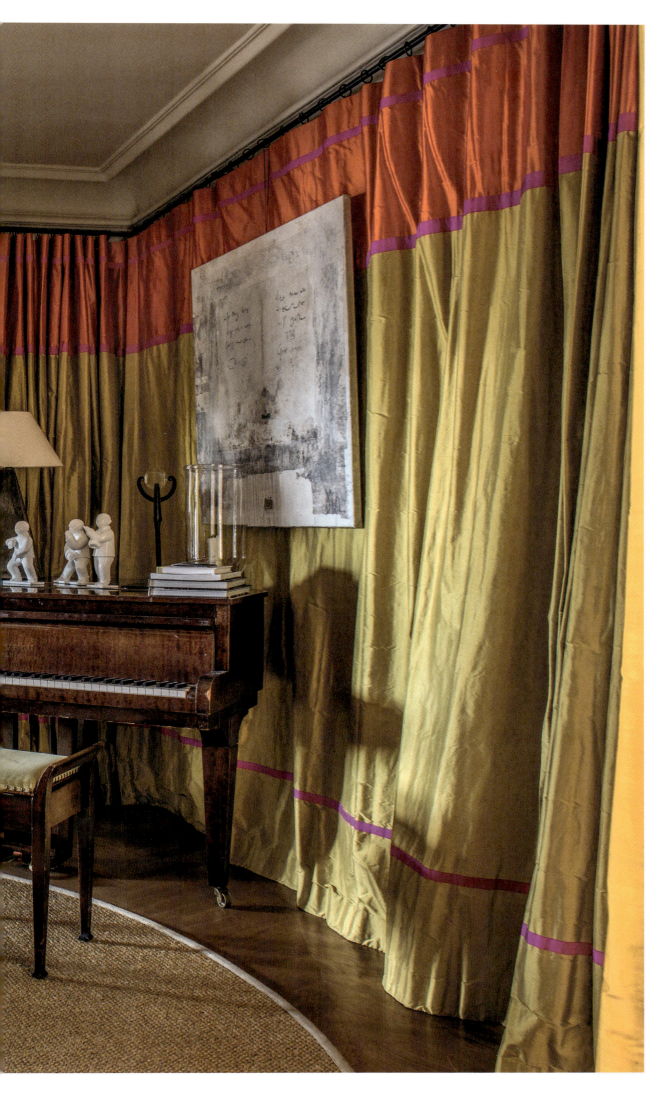

In the main room, vibrant *Sari* fabric curtains frame the space with color and texture. A multicolored Carriacou armchair and matching Sari cushion bring a playful touch, while the family piano and its vintage stool add warmth and nostalgia. A contemporary painting by Marie-Cécile Aptel complements the eclectic ensemble. At the back on the left, the *Shanghai* sofa, styled with a Sari cushion and framed by Grenadines fabric curtains, blends elegance with cultural decor. On the right, *Tipi* fabric curtains frame another Carriacou armchair, styled with a coordinating Sari cushion. A Jean-Jacques Ory painting serves as a bold artistic centerpiece.

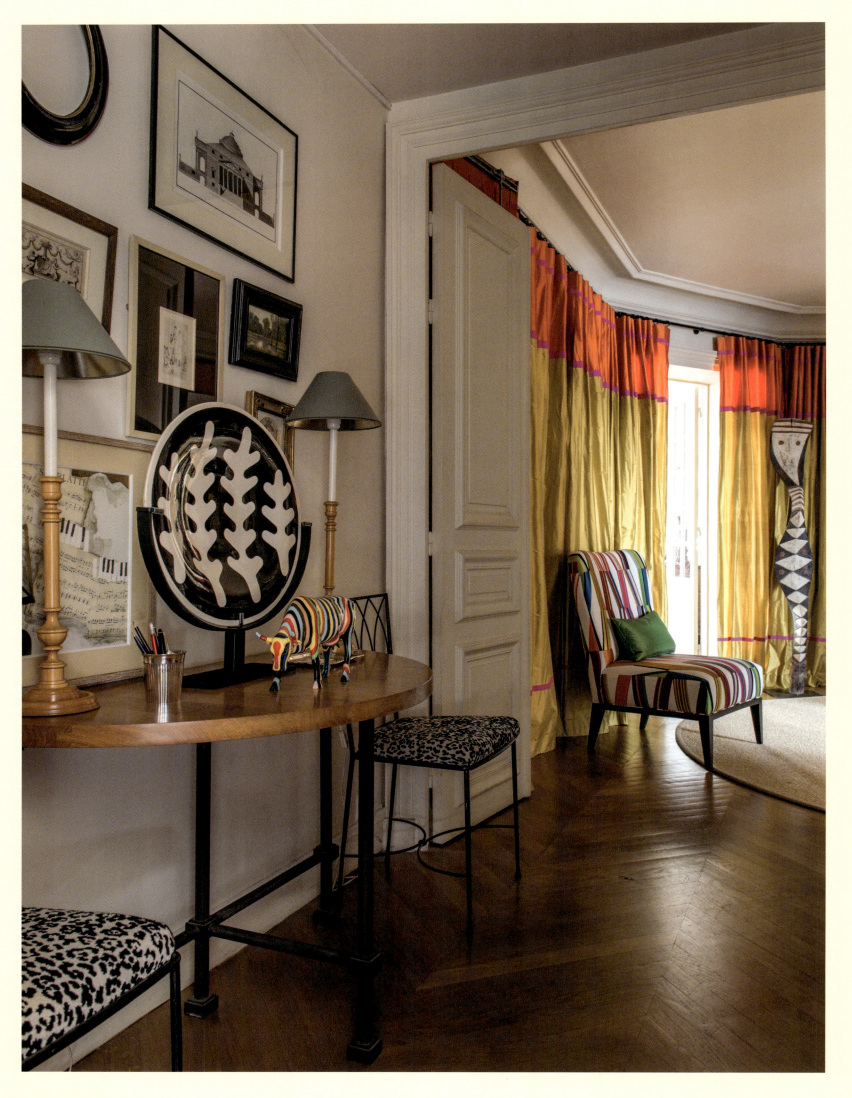

The Sari fabric curtains frame the scene, adding a splash of vibrant color that complements the multicolored Carricou armchair. On the Philippe Hurel console, an Atelier Buffile plate serves as a striking decorative piece. Nearby, the Tallien chairs, upholstered in bold black *Jungle* fabric, create a dramatic contrast. A Kazimir Malevitch statuette completes the ensemble, contributing an artistic touch that enriches the eclectic interplay of patterns and textures that define the space.

> In this *personal haven*, every thoughtfully curated artifact *reflects* the *creative spirit* that drives Maison Pierre Frey.

The textiles that adorn the Freys' residence are crafted in their northern French weaving workshop—a bastion of artisanal skill where tradition lives on in every thread. These fabrics are more than decorative elements; they are heirlooms, linking the present of Maison Pierre Frey to its storied past, with each weave steeped in history and craftsmanship.

This apartment is not merely a place for daily life but a wellspring of inspiration for Patrick. With Maison Pierre Frey just a short stroll away, through the lush Tuileries Gardens, the boundary between home and heritage blurs. In this personal haven, every chosen element, every curated artifact, whispers of the creative spirit that drives the Maison forward.

In their recent redecoration, the Freys have infused their space with renewed vigor, choosing elements that articulate their current aesthetic inclinations while remaining true to the ethos of Maison Pierre Frey. Each selection is a declaration of their philosophy: to dare is to create. Here, in the heart of Paris, their home is a living testament to this credo, where tradition and innovation are exquisitely intertwined.

In this way, the Freys' Parisian apartment transcends its role as a residence; it is an extension of Maison Pierre Frey itself, a manifestation of luxury and comfort that is both deeply personal and far-reaching, echoing a rich cultural legacy through every fiber and finish. —

The central Curacao sofa, adorned with bold stripes and vibrant cushions, inject energy into the space. Wool drapes in Tipi fabric frame the room with warmth, while the multicolored Carricou armchair adds a playful flair. A Gae Aulenti glass coffee table is a focal point, displaying an Atelier Buffile plate atop the black and white Louise rug, inspired by Louise Bourgoin's art. Two René Prou stools, upholstered in soft cream *Louison* boucle fabric, lend texture and refinement. To the left, a lamp from Maison Charles provides soft illumination, complemented by Philippe Hurel lamps framing the sofa. On the right, a Philippe Hurel console holds Kazimir Malevitch statuettes, infusing the room with artistic appeal, while a cherished family painting further enriches the setting with a sense of heritage and history.

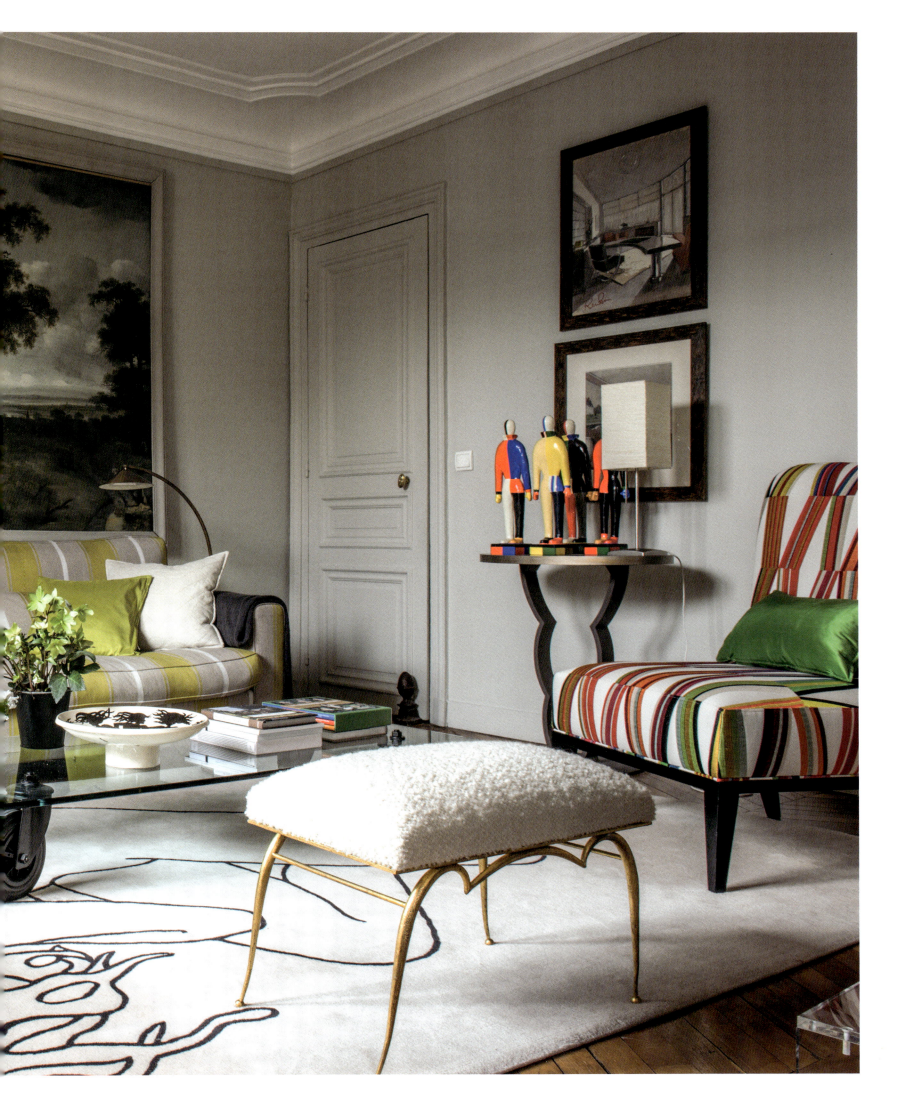

Fabric Fantasia

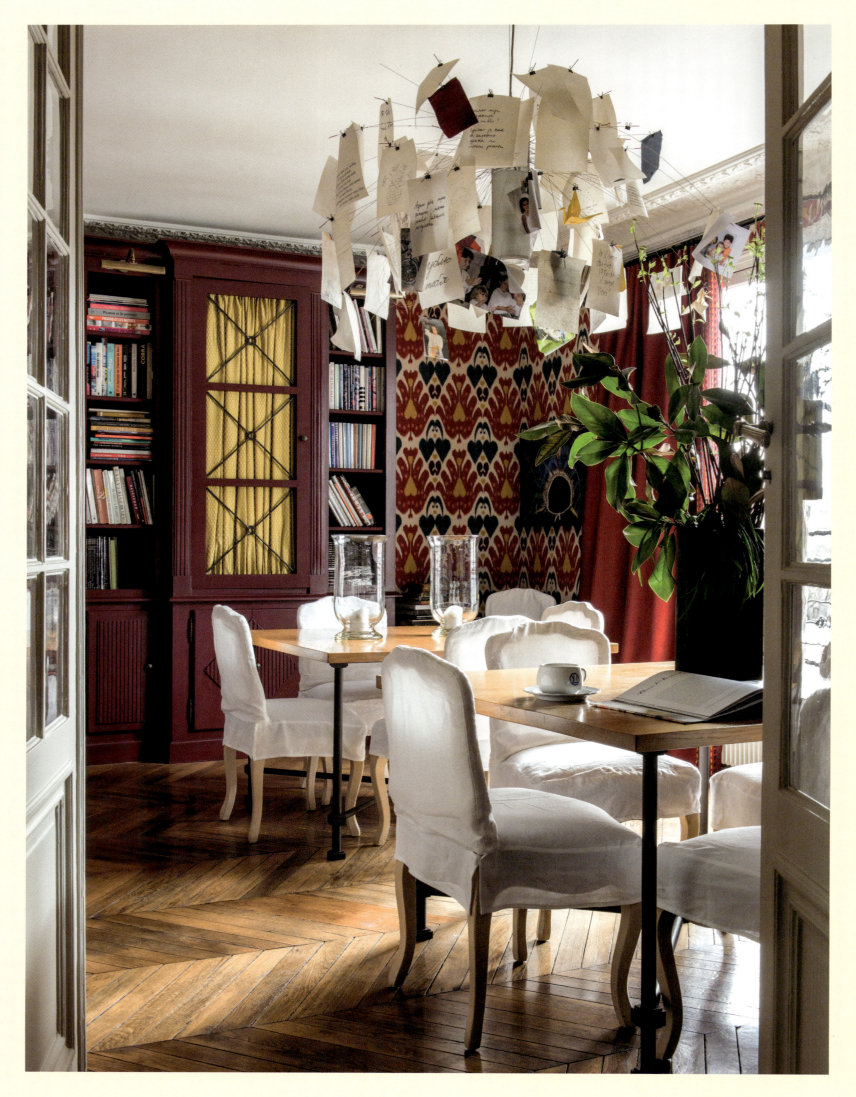

(Left) The wall is adorned with *Galigai* fabric. Philippe Hurel chairs and tables introduce an element of refined elegance, while Tipi fabric drapes add warmth and sophistication.

(Above right) A painting by Françoise Gilot, portraying her daughter Paloma Picasso, evokes a tender, intimate ambiance.

*Fabrics* transcend mere decoration, becoming *heirlooms* that bridge the present to Maison Pierre Frey's *rich past.*

Fabric Fantasia

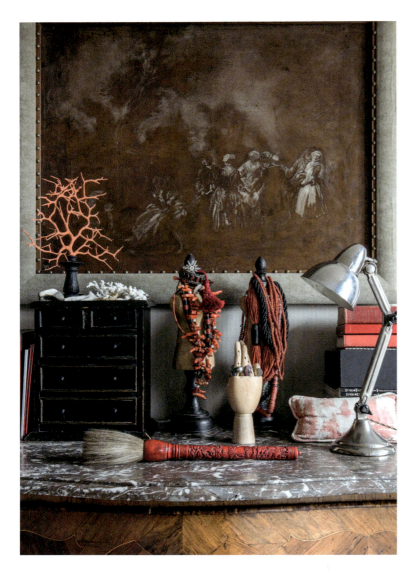 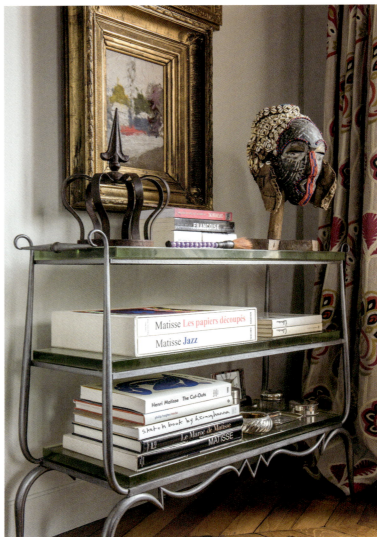

(Above right) The Prou console, with its artful display of books, adds intellectual depth to the room. Nearby, curtains in *Grenadines* fabric bring a burst of vibrant color and intricate pattern.

(Right) Multicolored *Bora-Bora* curtains enliven the space, complementing the high-resistance linen Craft wall covering, which exudes understated elegance. The bed, adorned with quilted *Craft* fabric, enhances the room with comfort and texture. On the Tallien console, Kazimir Malevitch statuettes add an artistic and sculptural element, perfectly balancing the room's refined decor.

The Freys' family home is a *testament* to their credo *"To dare is to create."*

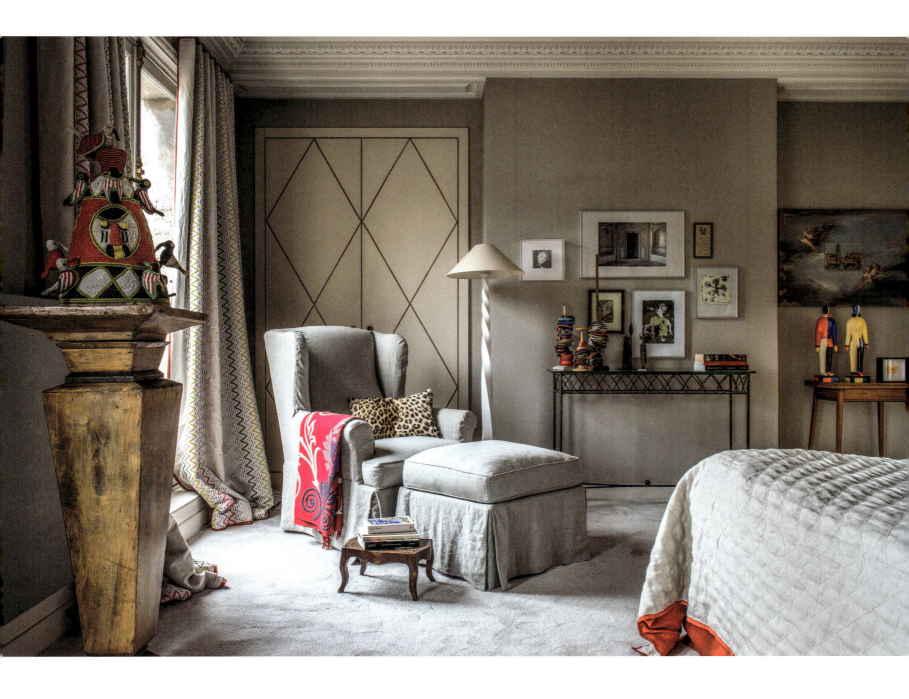

# Urban Haven

**The stunning mid-19th-century Hotel Particulier in Paris's 5th arrondissement has been transformed into a magnificent family haven. Acquired in 2018, major renovations commenced in early 2020, turning this historic structure into a retreat that combines old-world charm with modern comfort.**

The property's allure begins with its tranquil setting. Tucked between a courtyard and a garden, it offers lush greenery and privacy, a rare find in the heart of the bustling city. Its proximity to the lively, historic neighborhood of old Paris, including the nearby Jardin du Luxembourg, further enhances its appeal. Additionally, the residence presented an exciting opportunity for renovation, allowing the creation of a spacious and welcoming family home.

The residence comprises six main bedrooms and four independent apartments, making it a versatile space, ideal for both family living and entertaining. The ground floor, designed for socializing, features a bar, dining area, and formal guest lounge. The first and second floors are dedicated to the family's private quarters, with bedrooms, a library, TV room, and home office. The basement offers a leisure area, complete with a cinema, reception room, and gym.

(Next page) This lounge features a custom rug from Atelier Fevrier and a plush sectional sofa. A sculptural coffee table by Charles Zana and elegant stools by Delcourt add depth and dimension, complemented by Pierre Frey fabric curtains adorned with trims from Houles. A striking *Ozone* suspension light and a floor lamp by Dan Yeffet illuminate the space, tying together the ambiance with a modern touch.

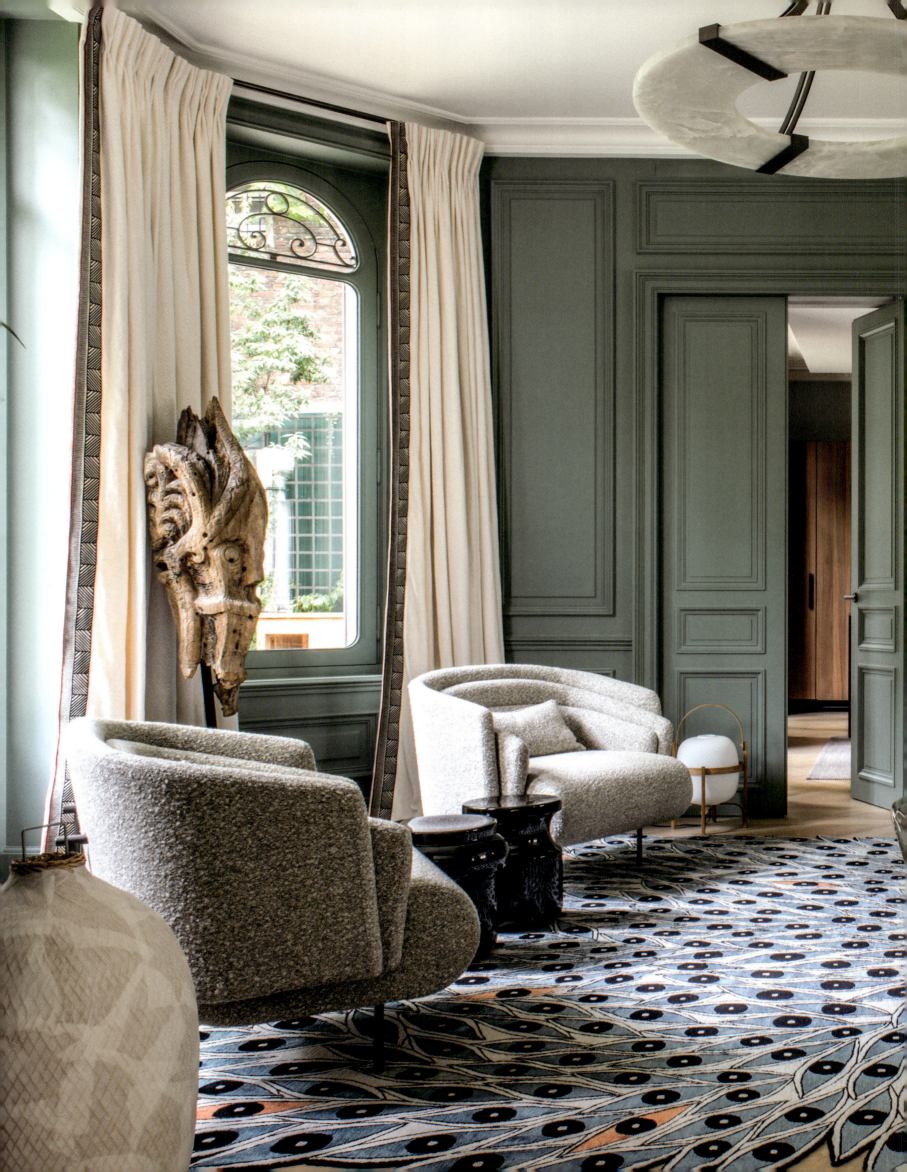

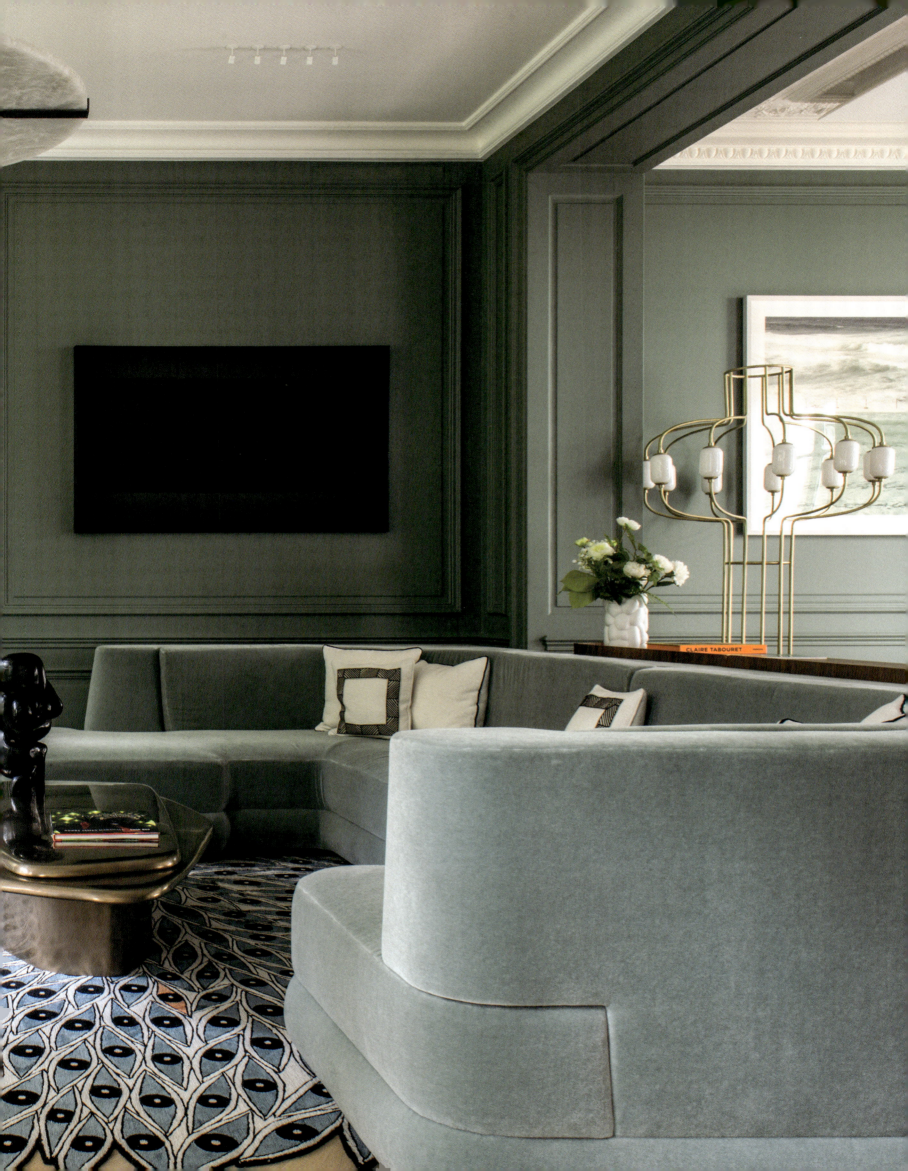

The design embodies the concept of a *"country house in Paris."*

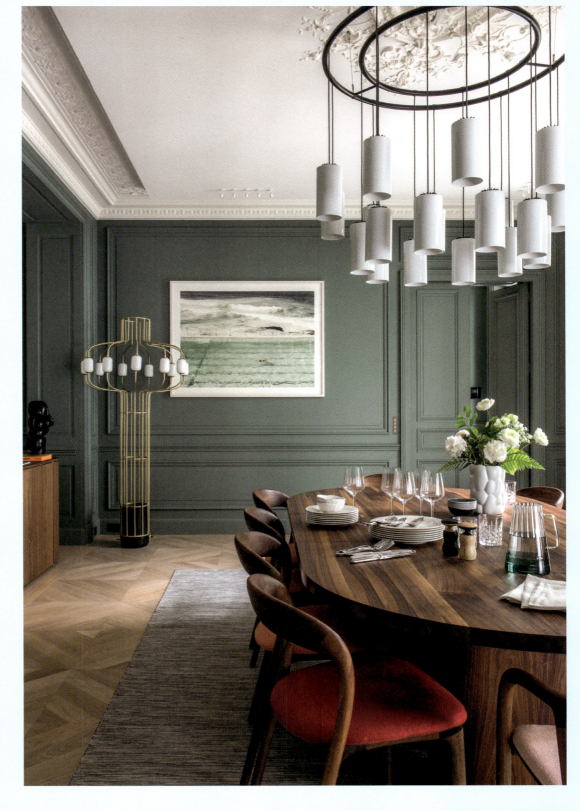

(Left) A captivating painting by Katrien de Blauwer commands attention.

(Right) The dining room showcases an elegant walnut table and sideboard designed by Camille Bazil and crafted by Alma Ébénisterie. Artisan chairs with rich wood tones are paired with luxurious Pierre Frey curtains, accented with trims by Houles (see image p. 129). The lighting, a Dan Yeffet floor lamp and a Santa & Cole chandelier, adds sophistication. A serene Bilboquet green wall color serves as a perfect backdrop, while a Josef Hoflehner painting enhances the room's refined aesthetic.

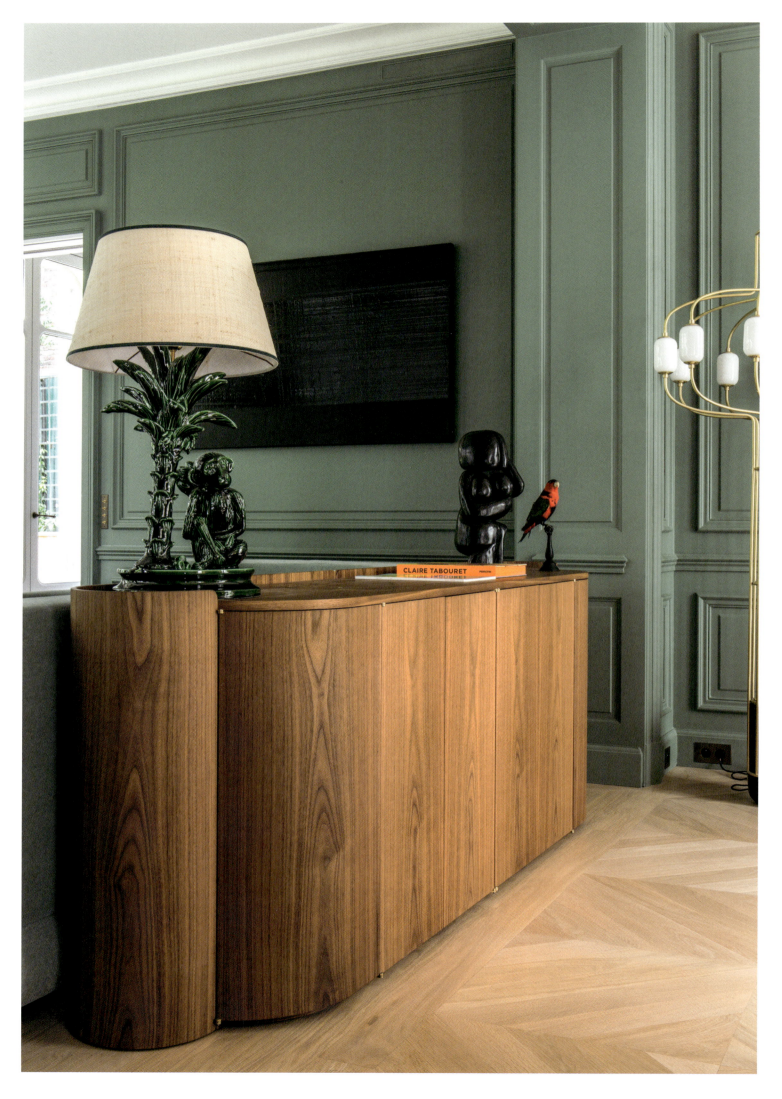

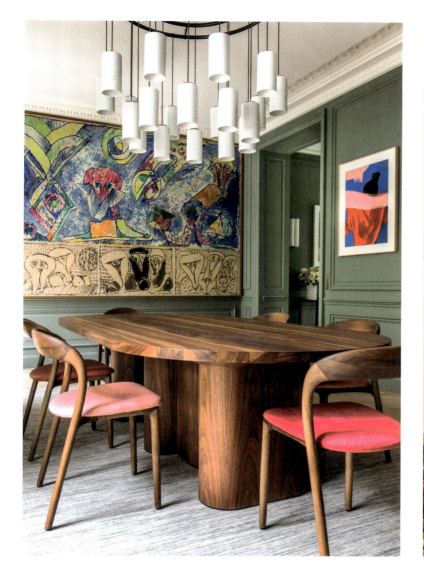
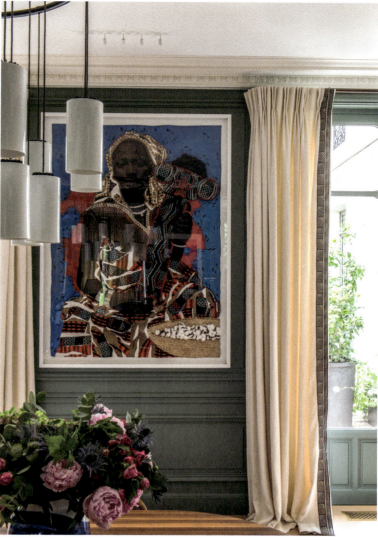

(Left) A walnut sideboard designed by Camille Bazil and crafted by Alma Ébénisterie serves as a striking focal point, adorned with a Jean Roger lamp and a Pierre Soulages painting.

(Above left) A walnut dining table designed by Camille Bazil and crafted by Alma Ébénisterie is surrounded by Artisan chairs upholstered in Pierre Frey fabric. Overhead, a Santa & Cole chandelier adds a modern accent, while an Alechinsky painting infuses the space with vibrant color and artistic flair.

(Above right) Pierre Frey curtains, accented with Houles trims, bring elegance to the room. A mixed-media painting by Marion Boehm enriches the space with cultural depth and intricate textures.

The family's favorite room is the library, bathed in southern light. It provides a peaceful retreat from the city's hustle, embodying the essence of tranquility. The home's design was guided by the concept of creating a "country house in Paris," brought to life by Perrot & Richard Architectes and landscape designer Louis Benech. The family quarters flow seamlessly with a spacious, warm design, while guest apartments and additional bedrooms are discreetly positioned for privacy. A beautifully crafted English garden by Benech enhances the rural ambiance of the property.

Interior designer Camille Bazil infused the interior with vibrant color and patterns while maintaining a sense of comfort. The grand scale of the house required a cohesive design that avoided repetition, creating a visually engaging yet harmonious environment.

Interior designer Camille Bazil *infused* the interior with *vibrant color* and *patterns* while maintaining a *sense of comfort*.

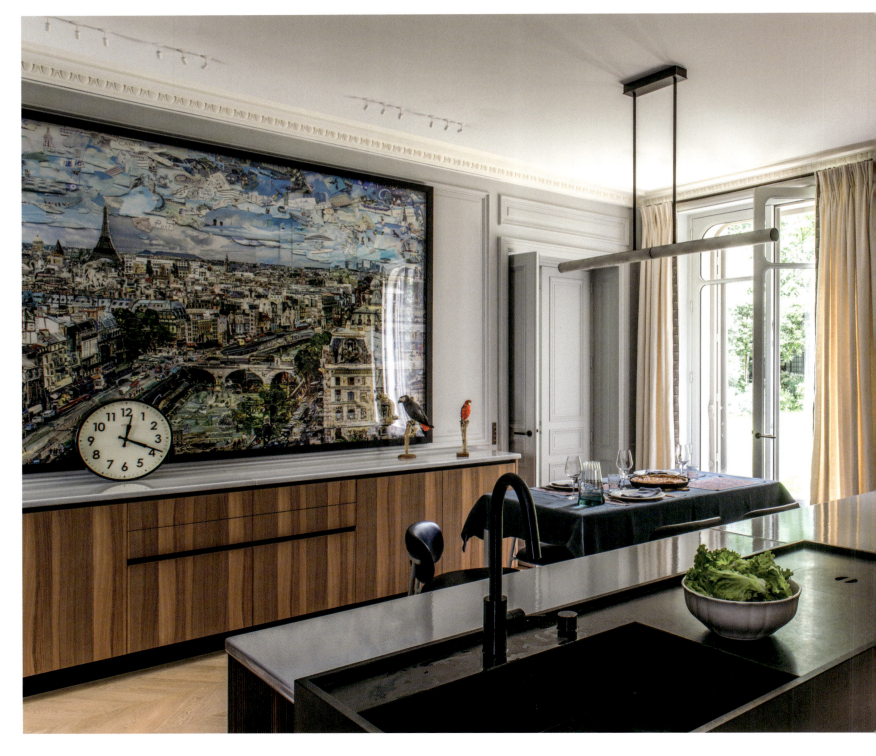

(Left) Sleek Boffi cabinetry is set against walls painted in *Ressource*, creating a harmonious and contemporary kitchen. A Garnier & Linker pendant light adds a contemporary edge, while Pierre Frey curtains adorned with trims by Houles complete the look with subtle elegance.

(Above) An intimate bar lounge is elevated by a mesmerizing wall tapestry by artist Eva Jospin, bringing depth and texture to the space. Artisan stools and a bar designed by Camille Bazil, crafted by C2A, merge craftsmanship with elegance.

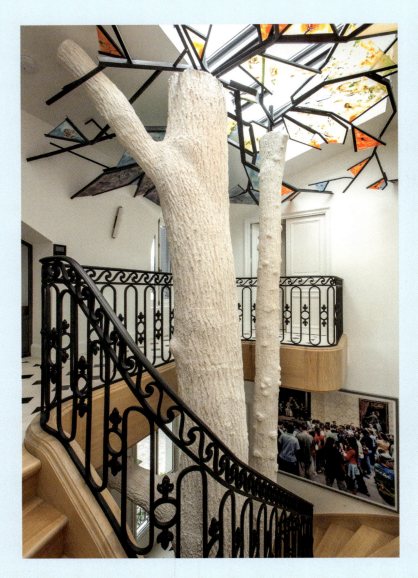 

(Above) A dramatic staircase features a tree sculpture attributed to Fabrice Hyber, seamlessly integrating nature into this historic townhouse. Designed by Perrot & Richard, the staircase leads to a vibrant stained-glass ceiling that bathes the space in colorful light.

(Right) Casamance fabric curtains frame a serene outdoor view, harmonizing with a Casamilano sofa, a Philippe Hurel coffee table, and a Stepevi rug. Walnut paneling and furniture by Camille Bazil complete the stylish and inviting setting.

Unique artistic touches, such as Fabrice Hyber's magnificent tree sculpture integrated into the staircase, and Eva Jospin's hand-embroidered silk panels in the bar area, add to the home's distinct character. Custom-made furniture, vaulted ceilings, and bespoke tapestries further enhance its individuality.

Ultimately, the house strikes a perfect balance between function and beauty. With children and pets in the household, practicality was a priority, yet Bazil succeeded in creating an atmosphere of warmth and elegance. Durable materials were chosen to withstand everyday family life, resulting in an eclectic yet harmonious home where modern art, classic furniture, and striking architectural details come together to tell a story of comfort, creativity, and refined taste. —

A beautifully crafted English garden by Louis Benech *enhances* the property's *rural ambiance.*

A practical yet stylish space features custom-designed shelves designed by Camille Bazil and crafted by Kermarec. A vibrant display of books and collectibles adds personality, while bold geometric Thorp of London curtains bring energy to the study area, creating a lively and organized environment.

Custom furniture, *vaulted ceilings*, and *bespoke tapestries* elevate the home's individuality.

A serene master suite is framed by luxurious Thorp of London drapes and elegant Holland & Sherry wall coverings. Custom shelving by Camille Bazil, executed by Kermarec, pairs seamlessly with bespoke elements, including an Alma-crafted bench and a double-sided seat designed by Camille Bazil. A Little Cabari rug by Camille Bazil ties together the calming palette with tailored elegance.

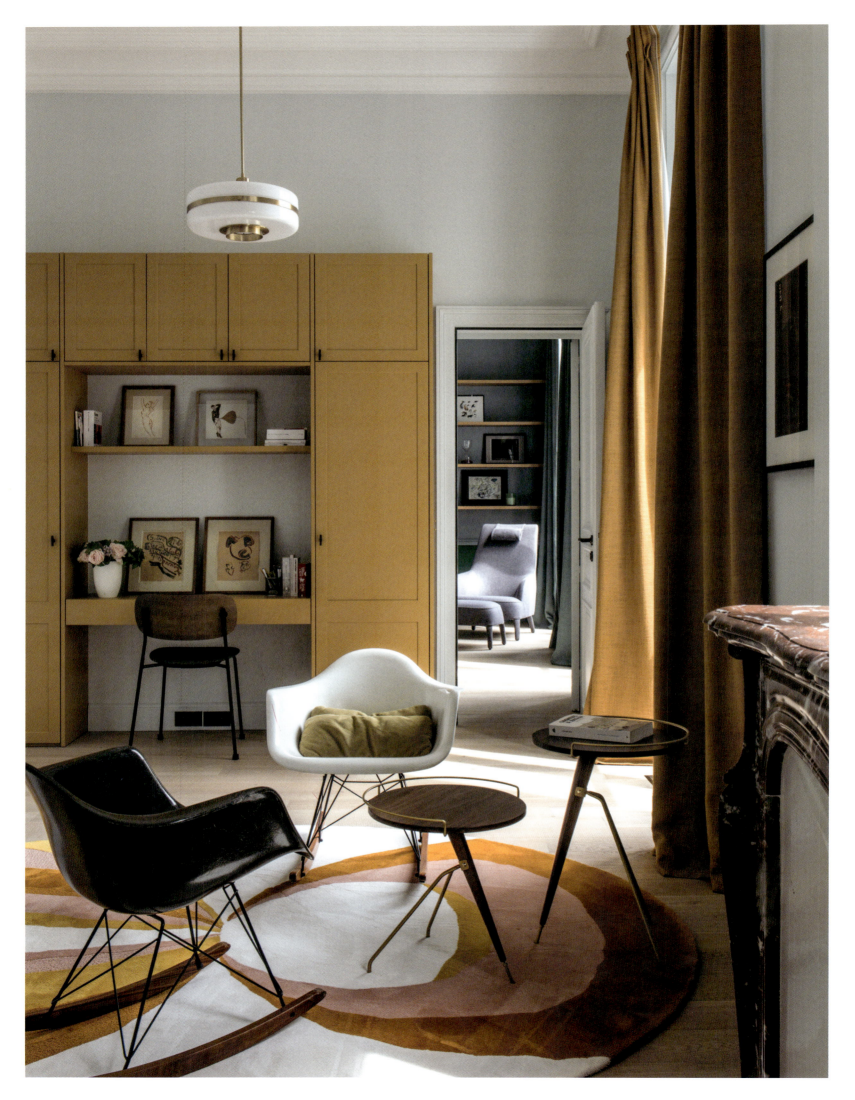

*Durable materials* were chosen to withstand family life, resulting in an eclectic yet harmonious home where *modern art*, *classic furniture*, and *striking architecture* converge.

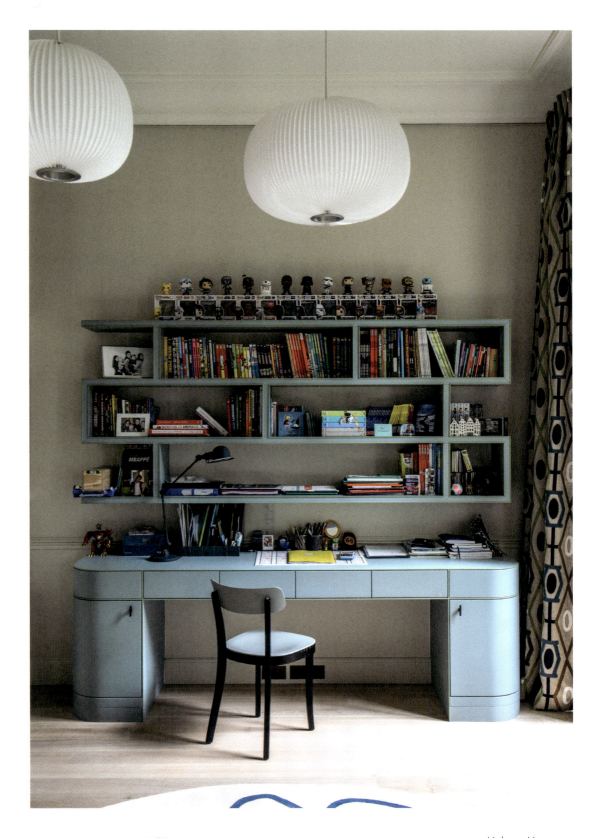

(Left) A warm, functional workspace includes custom cabinetry and a desk designed by Camille Bazil and crafted by Kermarec. Mustard tones in the cabinetry and Casamance curtains provide character, anchored by a stylish Tapichéri rug that defines the seating area.

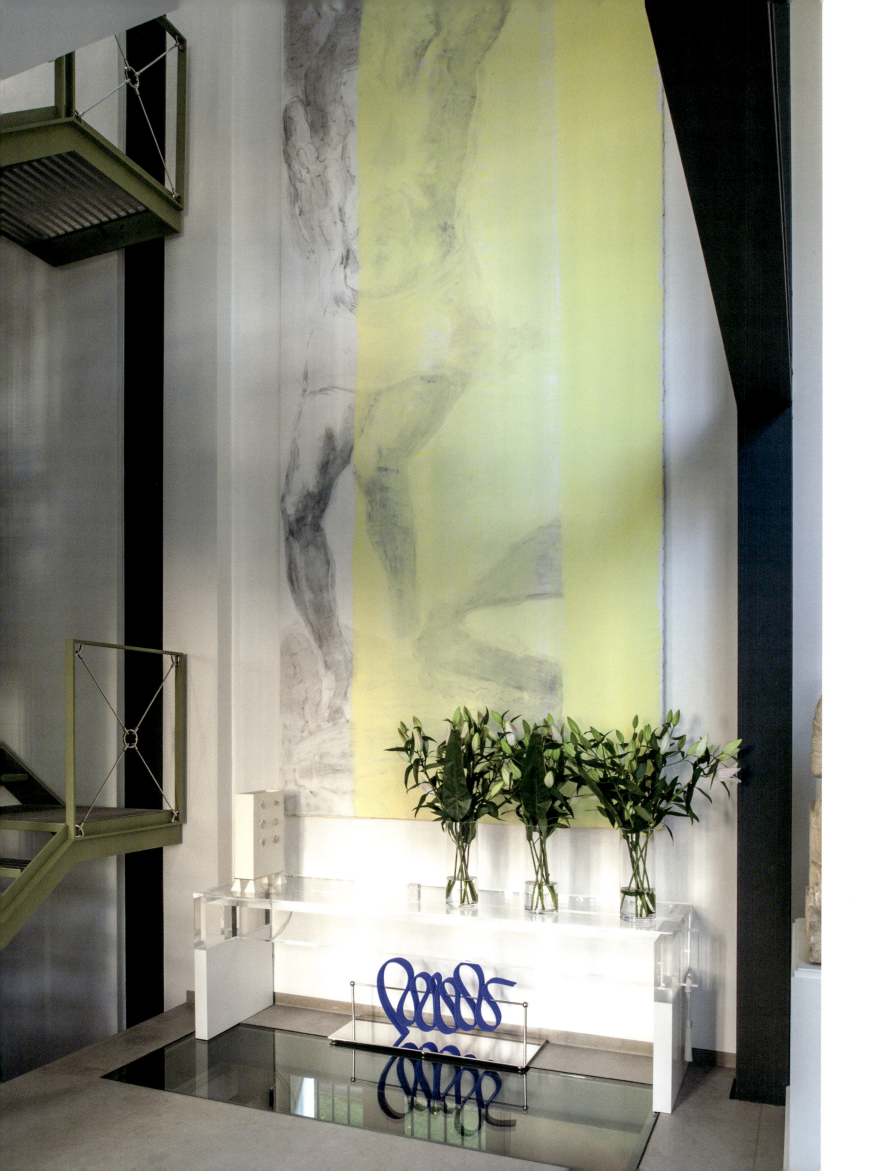

# Architectural Mastery

This captivating 6-meter-high artwork merges contemporary and expressionist styles, commanding attention with its emphasis on verticality and scale. The space balances industrial elements and modern aesthetics, anchored by a minimalist acrylic console adorned with fresh lilies, which introduce a soft, organic contrast to the structured environment.

**Located on the edge of the Bois de Boulogne, the Parisian home of Lebanese architect Joseph Karam stands as a modern cathedral of steel and glass amidst the traditional Haussmannian buildings. This architectural marvel, bathed in light and air, is a testament to Karam's perseverance and creative vision.**

Initially, two small houses occupied the site. Karam planned to demolish and rebuild them identically, but this time firmly anchored on solid foundations. His goal was to crown these structures with a cube of steel and glass, thereby expanding the livable space and maximizing natural light—a gamble that paid off spectacularly.

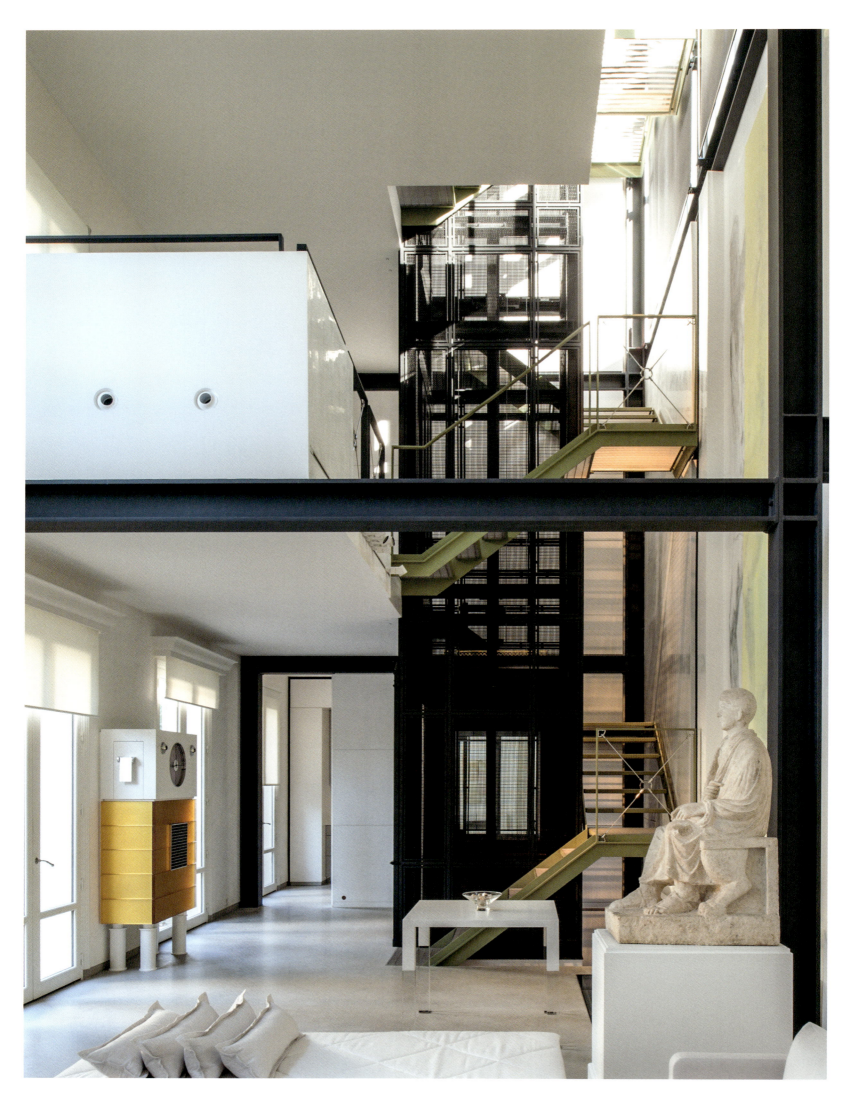

Paris Living

The floors, ceilings, door frames, and furniture *unify* in *pristine white.*

(Left) A striking juxtaposition of eras, where a Haussmann-style elevator meets Joseph Karam's contemporary design. Overseeing this blend of old and new is a Roman senator statue from the 2nd century, creating a dynamic dialogue between ancient and modern architectural influences.

(Below) A harmonious blend of classic and modern design defines this room. A concealed fireplace ingeniously transforms into a TV at the touch of a button, combining functionality with sleek design. The stately Roman statue pairs with minimalist decor, exuding elegance and refined simplicity.

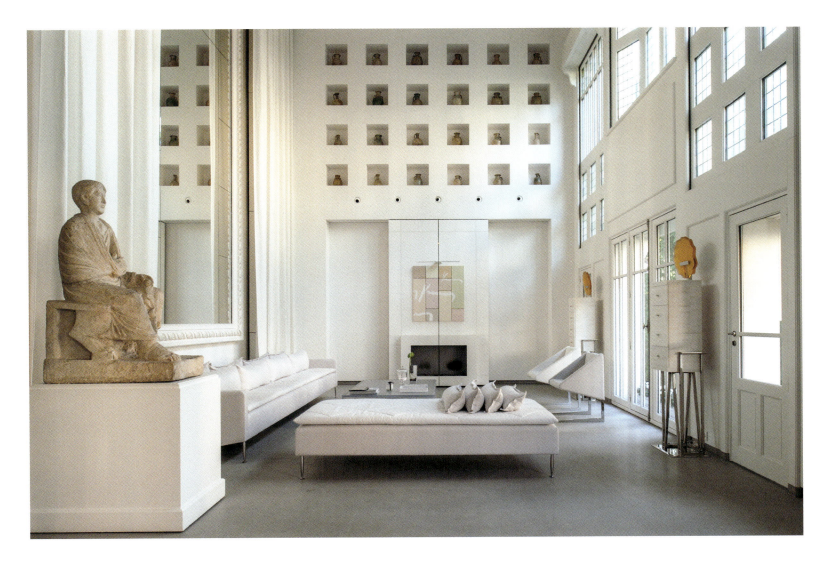

Architectural Mastery

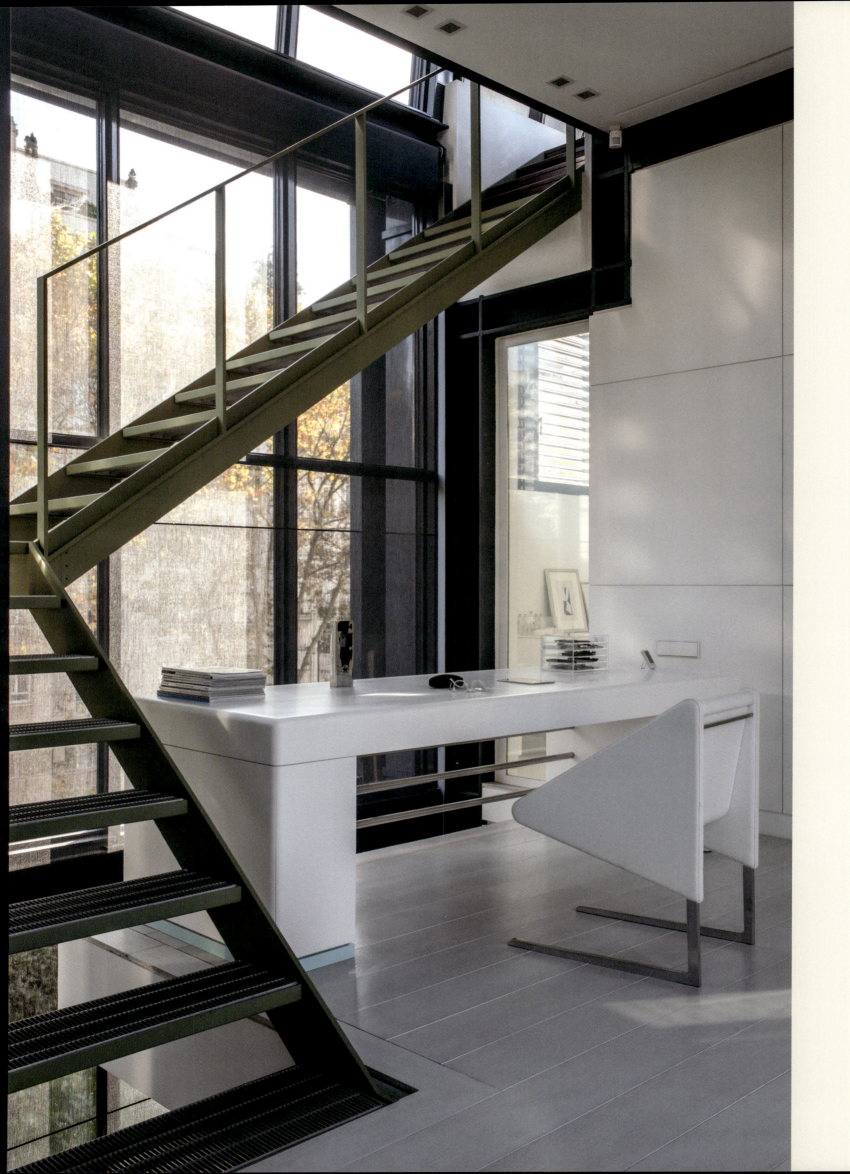

(Left) A dramatic light well spans the home's six floors, flooding the interiors with natural light. A minimalist desk doubles as a guardrail, seamlessly integrating functional design with architectural elegance.

(Above) Two custom storage units by Joseph Karam blend functionality with minimalist aesthetics. Positioned against expansive windows, they enhance the space's airy and light-filled ambiance.

From the moment one enters, the tone is set: airy, bright, and luxurious. The home unfolds across six levels, all connected by a monumental industrial elevator, encircled by a spiraling staircase. Karam chose to preserve the exposed steel structures, incorporating black beams into the design, which punctuate the monochrome atmosphere like pieces of art. The floors, ceilings, door frames, and furniture are all dressed in white. "This color acts as a conductor, allowing all kinds of boldness," Karam explains. Indeed, boldness abounds, from the 7-meter-high living room wall showcasing niches filled with Syrian, Lebanese, and Iraqi pottery, to the towering stained-glass windows that add a dramatic touch.

On the first floor, an intimate oriental salon is a nod to Karam's heritage, suspended as if floating above the space. The second floor is his wife's domain, featuring a bedroom, dressing room, and bathroom arranged around a charming boudoir. Here, a contemporary dresser, a divan, and two antique armchairs are perfectly blended, marrying modernity with tradition.

Architectural Mastery

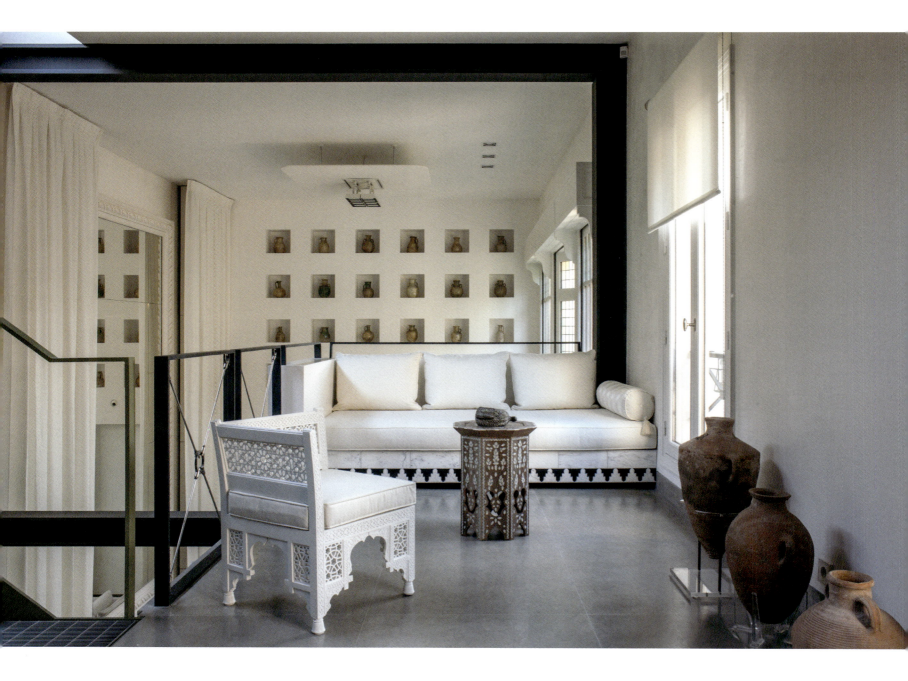

(Left) An oriental corner adorned with intricately carved furniture and traditional earthenware creates a serene, culturally rich retreat within the modern space.

(Right) A sophisticated interplay of 17th- and 18th-century boudoir styles with a contemporary edge is highlighted by a custom secretary designed by Joseph Karam.

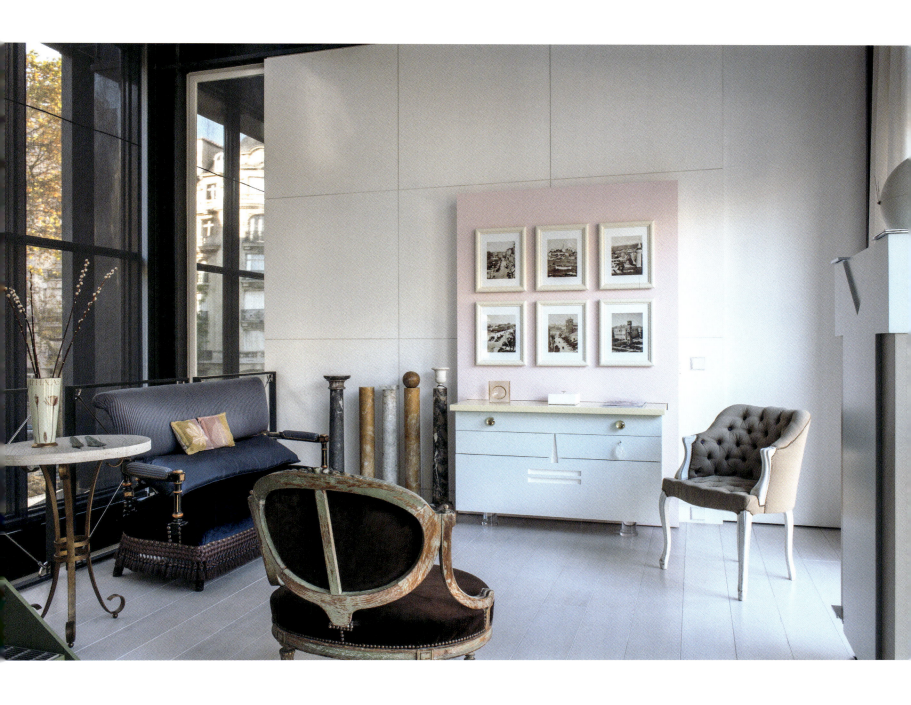

Karam, driven by his *passion for technology*, ensures his designs remain *aesthetically pristine* by concealing unsightly elements.

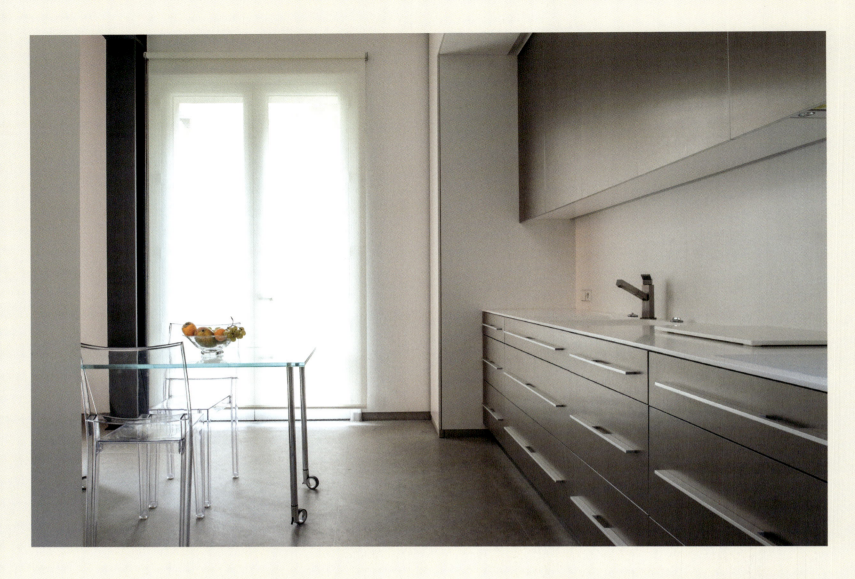

The third floor is Karam's personal retreat. Beneath the staircase leading to the rooftop terrace sits a long table beside a bookcase. The bedroom features a bed on wheels, positioned in front of a large, bare window, which, thanks to ingenious glass design, offers privacy without compromising the view. The bed leans against a marsh oak wall, and is crowned by a concealed TV screen, cleverly disguised as a white cloud. Karam, passionate about technology, strives to maintain the aesthetics of his spaces by hiding unsightly elements. The bathroom is equally minimalist, hidden behind a partition and featuring a white lacquered metal vanity topped by a Michele De Lucchi sconce. The walls double as towel warmers, ensuring functionality blends seamlessly with design.

The top floor of the house is a lush oasis—a hanging garden, offering a peaceful retreat under the stars. This masterpiece showcases not only Karam's architectural genius but also his talent for harmonizing innovation with minimalist elegance, creating a home where serenity and modernity coexist in perfect balance. —

(Previous page) A winter garden with a glass roof infuses the home with natural light and a lush, tropical vibe. Each floor offers a distinct ambiance and style, contributing to the house's layered aesthetic.

(Above) The minimalist kitchen design reflects the architect's signature style, with clean lines and a palette of subtle tones that evoke understated sophistication.

(Right) A natural wood headboard adds warmth to the bedroom, while an innovative, cloud-shaped fixture conceals a descending TV, preserving the serene view when not in use.

# A home where *serenity* and *modernity coexist* in perfect harmony.

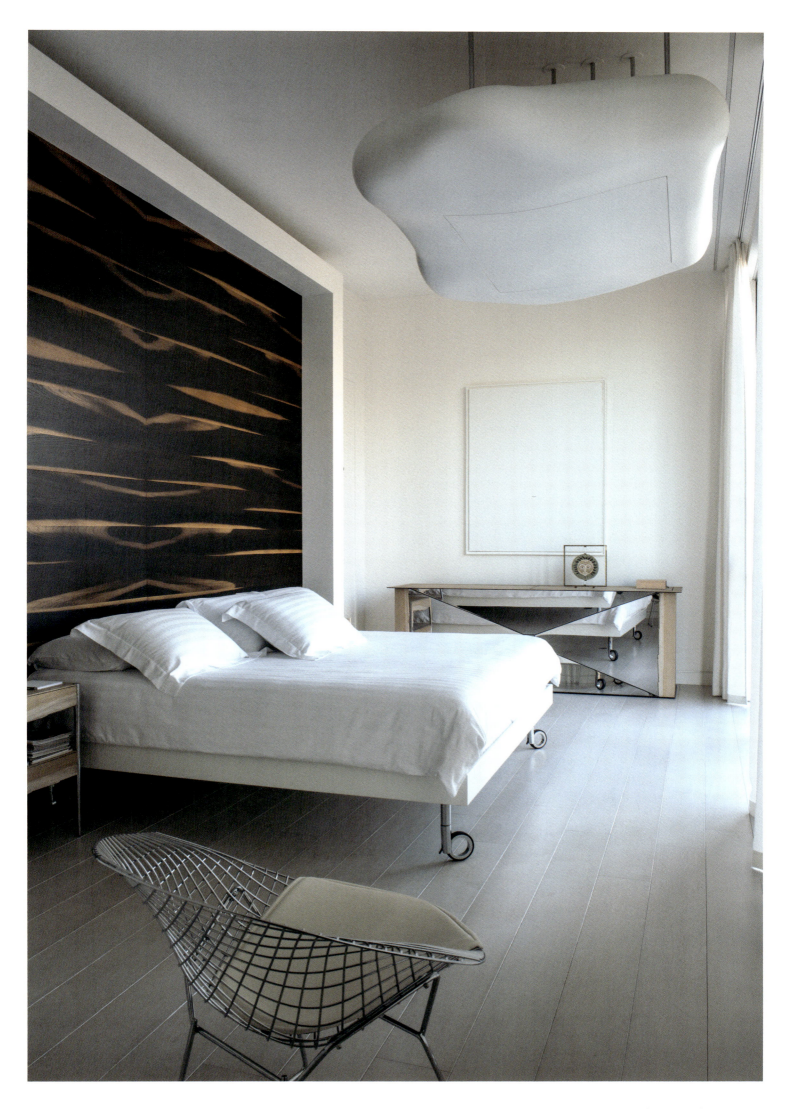

Architectural Mastery

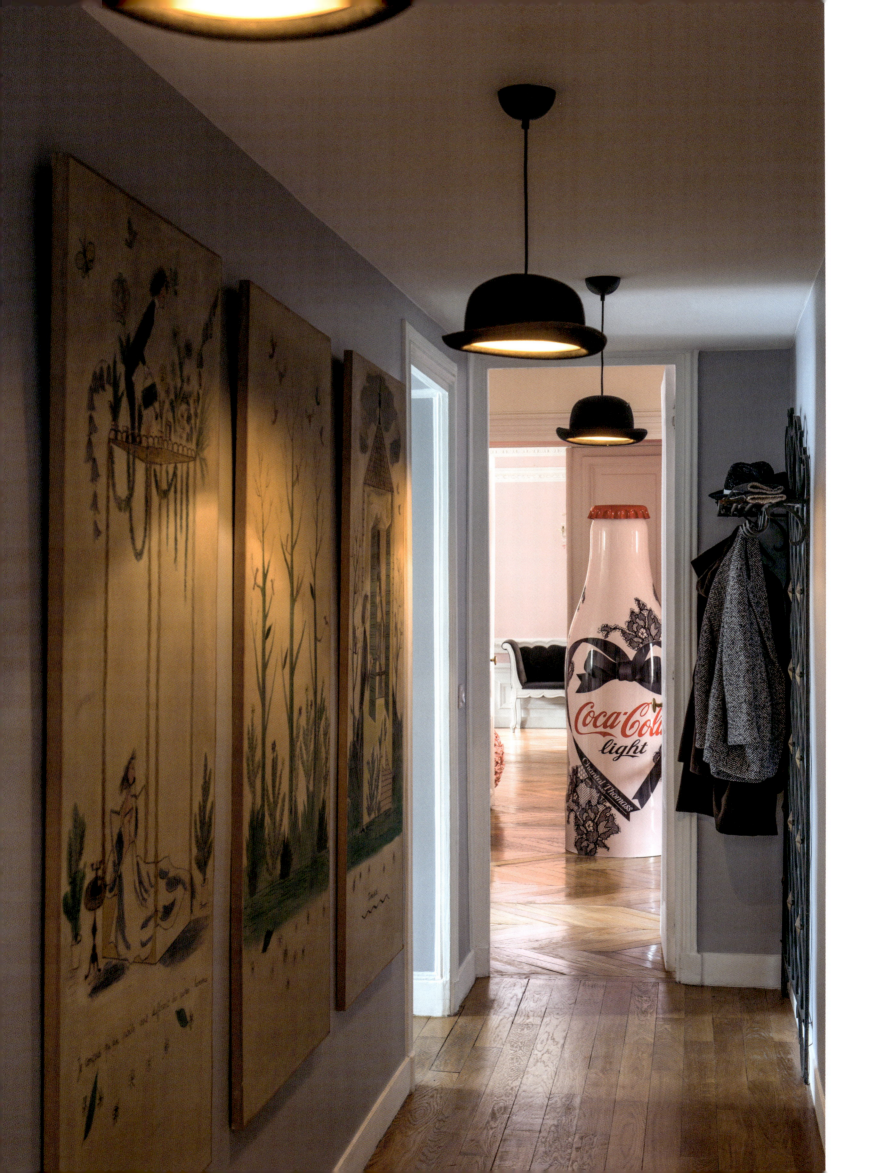

# Intimate & Feminine

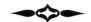

**In the 8th arrondissement of Paris, only a stone's throw away from the Élysée Palace, lies the captivating apartment of Madame Chantal Thomass, an icon in the world of feminine lingerie and fashion. Housed in a Hausmannian building, a former hotel that was transformed into luxurious apartments, her residence is a harmonious blend of historical charm and modern aesthetics, perfectly mirroring her distinctive style.**

Dubbed the "Queen of Corsets" after her revolutionary debut in 1975, Thomass has carefully curated her 300 square meter to reflect her pioneering spirit in fashion. The apartment is an eclectic mix of treasures from flea markets and auction houses, where 18th-century pieces coexist with 1940s finds. Romantic, retro, and contemporary elements converge, creating a rich tapestry of design eras.

Thomass's signature palette—black, white, and a playful pink—dominates the space. Pink hues wash over ceilings and select walls, evoking the blush of a nymph's thigh or the sweetness of a dragée melting under the tongue. This daring choice reimagines the classic Haussmannian architecture, infusing it with unapologetic glamour and seductive flair.

An elegant corridor leads to the kitchen, bedroom, and office, adorned with the *Les Amoureux* screen by Peynet, framed as artwork. Overhead, playful *Jeeves* pendant lights by Jake Phipps for Innermost add whimsical charm. A Coca-Cola Light resin bottle, dressed in pink and black lace, recalls the 2014 collaboration directed by Madame Chantal Thomass.

In the living room, the walls are adorned with photographs by Jean-Baptiste Mondino and illustrations by Hippolyte Romain and Jean-Charles de Castelbajac. Between two doors, a glimpse into the library reveals *L'atelier de couture* (1922) by Gardner Hale. Overhead, a stretched *Angels & Sky* ceiling piece by Madame Chantal Thomass for Barrisol pairs harmoniously with a vintage Murano chandelier. Two vintage 1940s armoires, updated in gray and pink by Madame Chantal Thomass, showcase plaster heads from the same era, and which she also curated. The display is further enriched by black and white ceramic *Venere* vases by Ambrogio Pozzi for Rometti. The room's centerpiece is a black velvet heart-shaped sofa with matching poufs, paired with a glass-topped side table on metal tripod legs, originally designed for a boutique. Pink silk bow-tie globes by Madame Chantal Thomass, designed for window displays, add a delicate, whimsical touch to the setting.

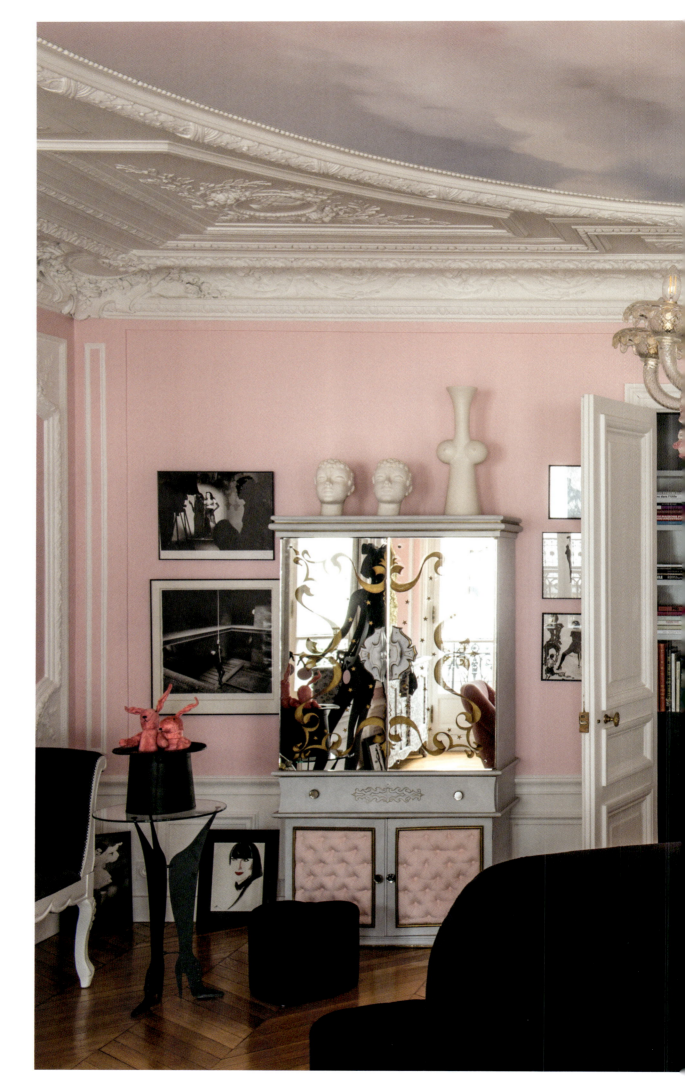

Paris Living

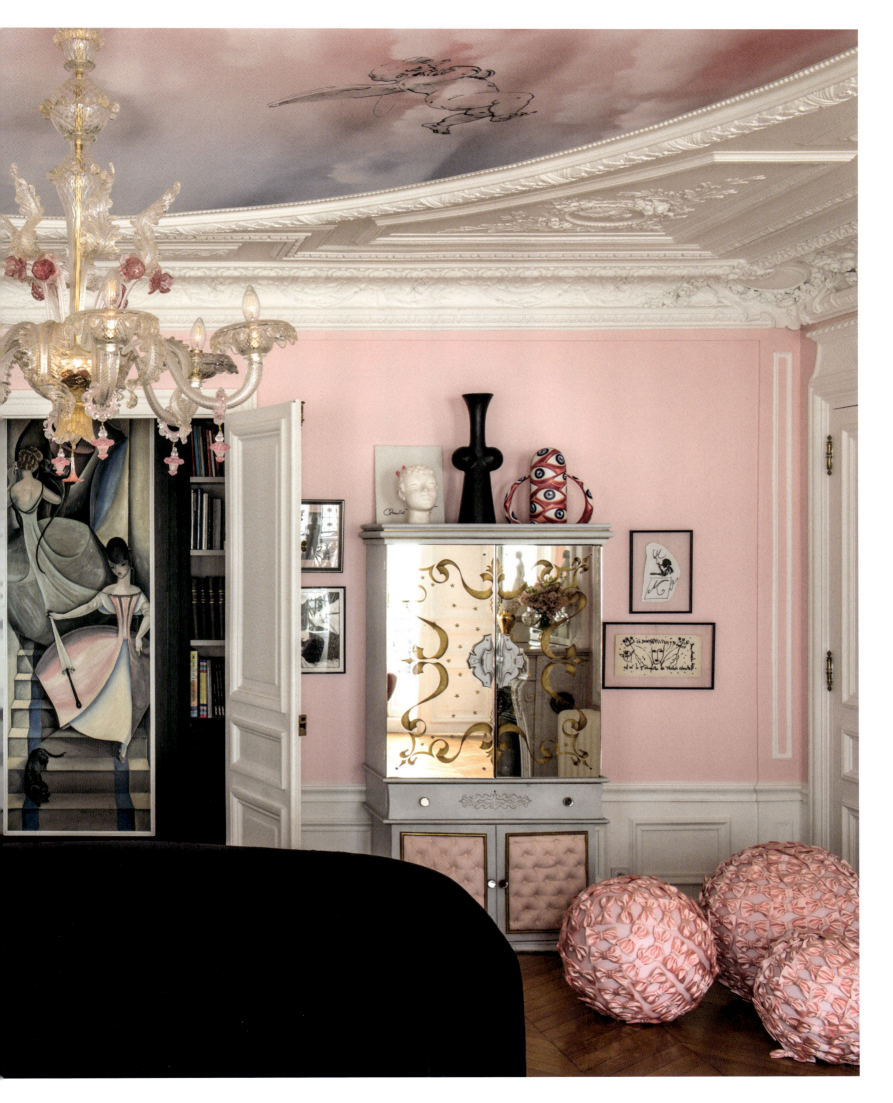

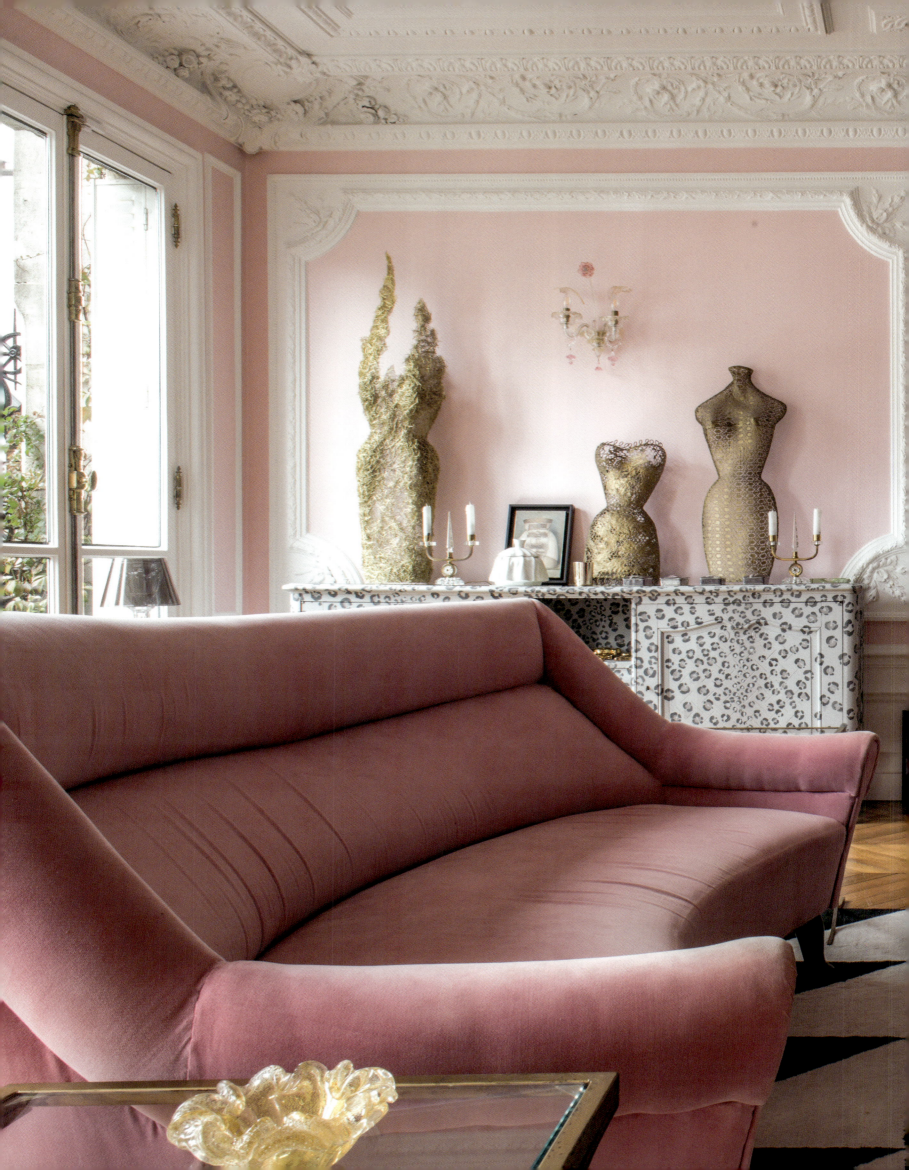

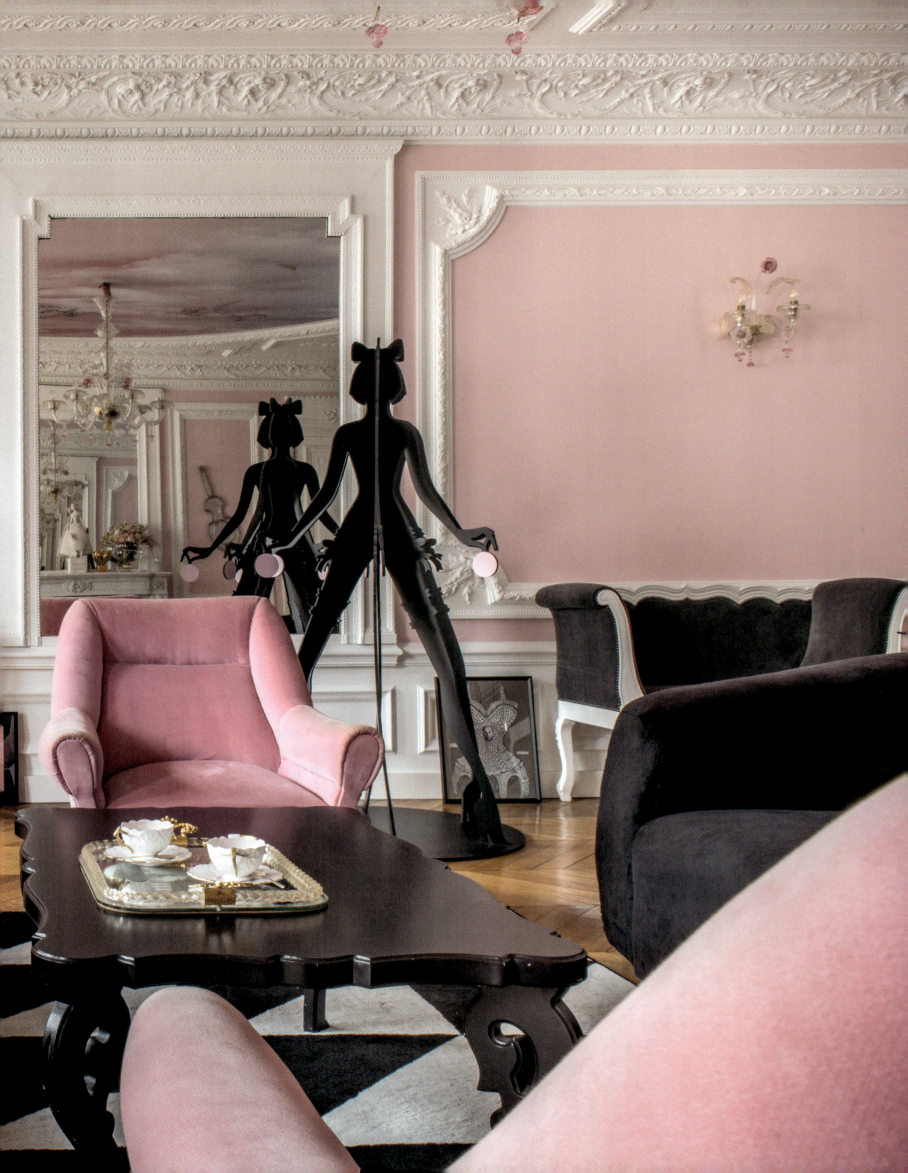

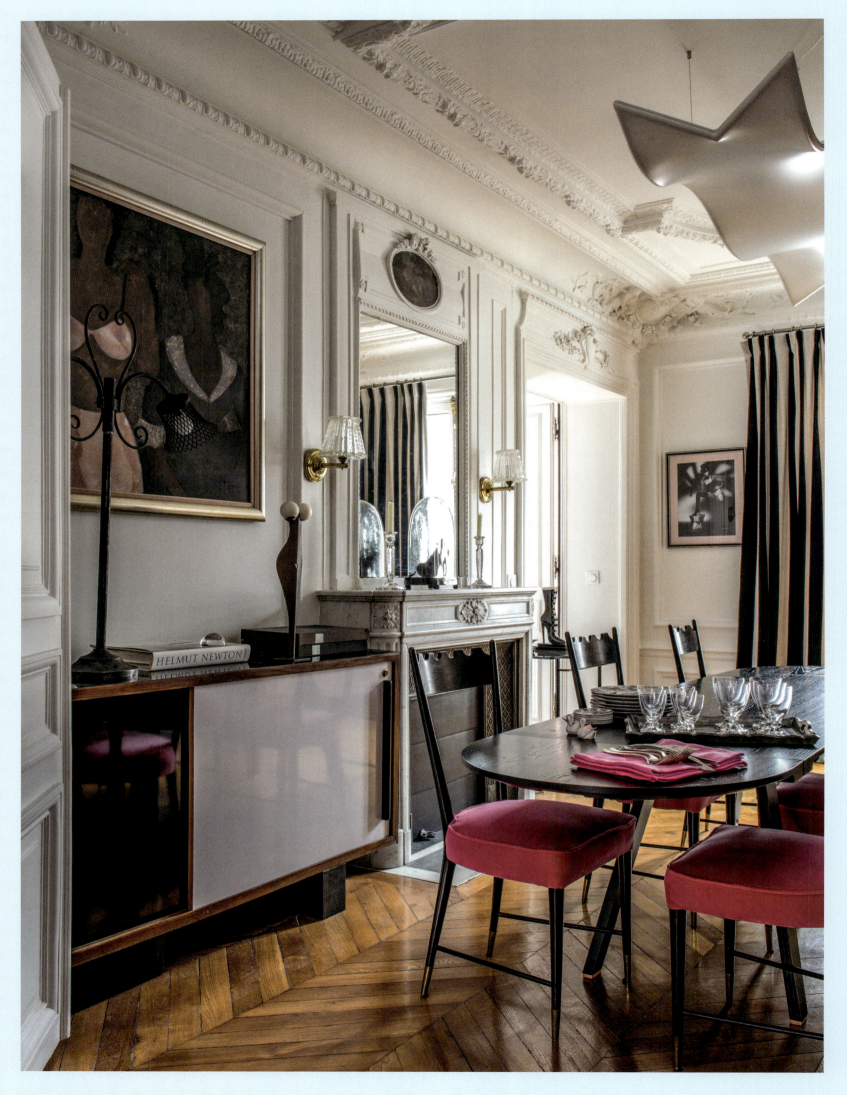

> Thomass's home is not just a living space but a *bold reflection* of her *identity*.

The apartment's plush decor invites warmth and luxury. Rose-tinted chairs envelop guests in soft comfort, set against a backdrop of a repurposed 19th-century bookcase, painted white and laden with *Fémina* magazines spanning from 1901 to 1950. These historical magazines serve as a source of inspiration for Thomass, feeding her creativity with their bold depictions of fashion through the ages.

As the sultry notes of Lou Reed's "Walk on the Wild Side" play softly in the background, the apartment's seductive allure is amplified. The space weaves together elements of Parisian luxury and fierce femininity. Thomass's home is not just a living space but a bold reflection of her identity, where every furnishing, every art piece, is an extension of her commitment to beauty and the empowerment of women.

Each room offers a distinct vignette of Thomass's appreciation for aesthetics and design. The living area, adorned with soft textures and a delicate color palette, radiates calm and tranquility, while strategic lighting accentuates the intricate details of the furniture and decor. Mirrors are artfully positioned to enhance the sense of space and light, creating an atmosphere that is both expansive and intimate. This thoughtful arrangement ensures that the apartment not only embodies Thomass's style but also serves as a serene urban retreat from the bustling streets of Paris.

In Thomass's apartment, fashion and living intertwine seamlessly, creating an environment that pays homage to historical elegance while embracing forward-looking design. It is a stylish sanctuary that champions the aesthetic power of femininity. —

This room unites a thoughtfully curated selection of vintage and contemporary pieces. A painting by Paul Colin and a Studio Harcourt photograph bring artistic depth to the walls, complemented by custom wall sconces by Madame Chantal Thomass for Veronese and her *Oriflamme* pendant light for Barrisol. A 1950s vintage sideboard pairs seamlessly with a black oak table and velvet-accented chairs from the 1940s. On the mantel, *Saturday Night Shoe* by Rébecca Fabulatrice—a sculpture fashioned from black bra straps—adds an intriguing, avant-garde allure.

Paris Living

In Thomass's apartment, *fashion* and *living* seamlessly *intertwine*.

(Left) The custom black and white oak library by Madame Chantal Thomass is accented with her signature *Bottine* vase and *Les Intrigantes* candleholder for Rometti. A Karl Lagerfeld x Toki Doki figurine adds a playful touch. The entrance showcases *Les Parisiennes* vases by Madame Chantal Thomass for Rometti, accompanied by a gold and pink *Clover* table, which she also designed. A vintage 1940s carved and gilded wooden mirror, a 1930s gold porcelain figurine by Porcelaine de Paris, and a sculpted wood pedestal from the 1940s further enhance the space's charm.

(Right) The office combines classic Studio Harcourt photographs with a vintage vanity featuring a Venetian mirror and a wooden ladder displaying Jean-Jacques Ory's *Eiffel Tower* sculpture. The space is anchored by a *La Mamma* chair by Gaetano Pesce for B&B Italia, adding a contemporary flair.

Intimate & Feminine

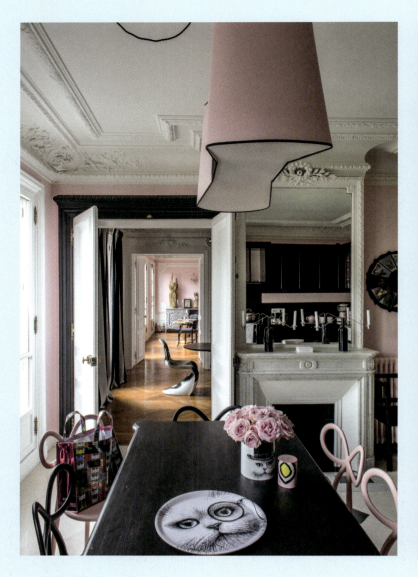 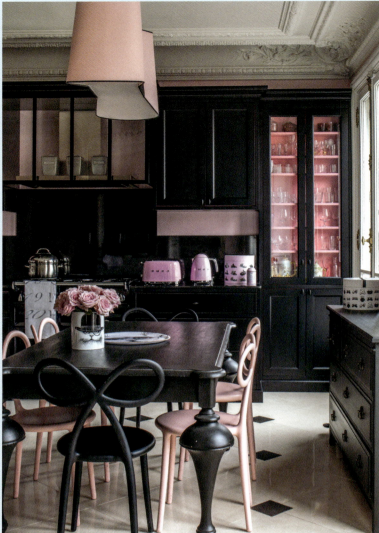

(Above) This custom-designed kitchen features black and pink oak cabinetry and a Falcon stove, illuminated by a bespoke pendant light by Madame Chantal Thomass for Barrisol. The table features charming porcelain pieces by Rory Dobner, while pink small appliances by Smeg add a vibrant pop of color. Hat boxes from Madame Chantal Thomass's 2014 collaboration with Tati complete the playful, stylish design.

(Right) An elegant retreat, the bedroom is adorned with a painting by Paul Colin and features a custom Lace & Boudoir stretched wall covering by Madame Chantal Thomass for Barrisol above the bed. The bed itself was designed by Madame Chantal Thomass for the Tréca brand. Vintage Venetian mirrors lend sophistication to the vanity and bedside tables, while a *Louis Ghost* chair by Philippe Starck for Kartell—customized by Madame Chantal Thomass—perfectly balances refinement and intimacy.

The space *weaves* together elements of *Parisian luxury* and *fierce femininity*.

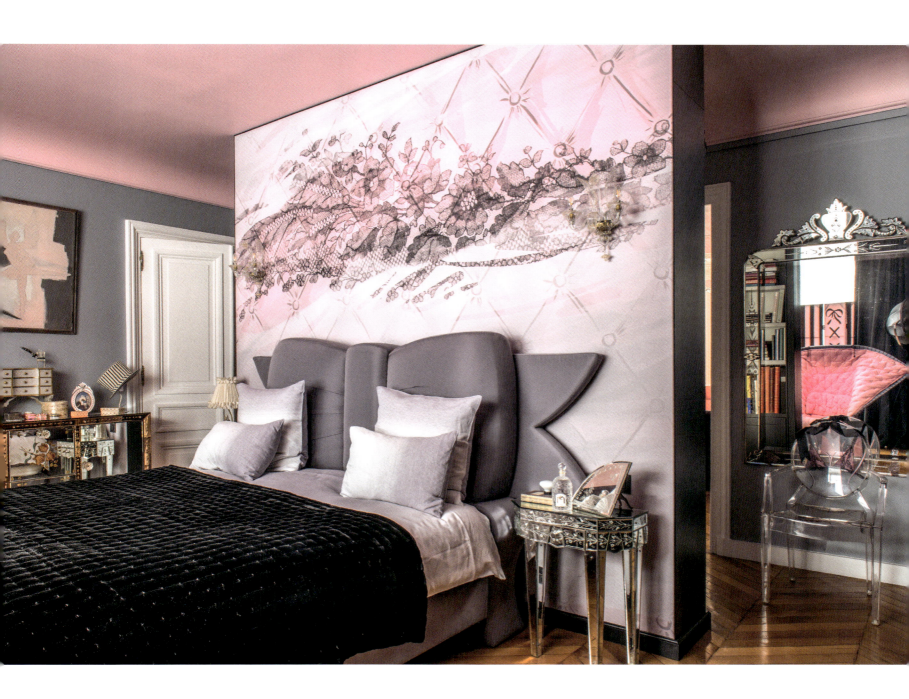

Intimate & Feminine

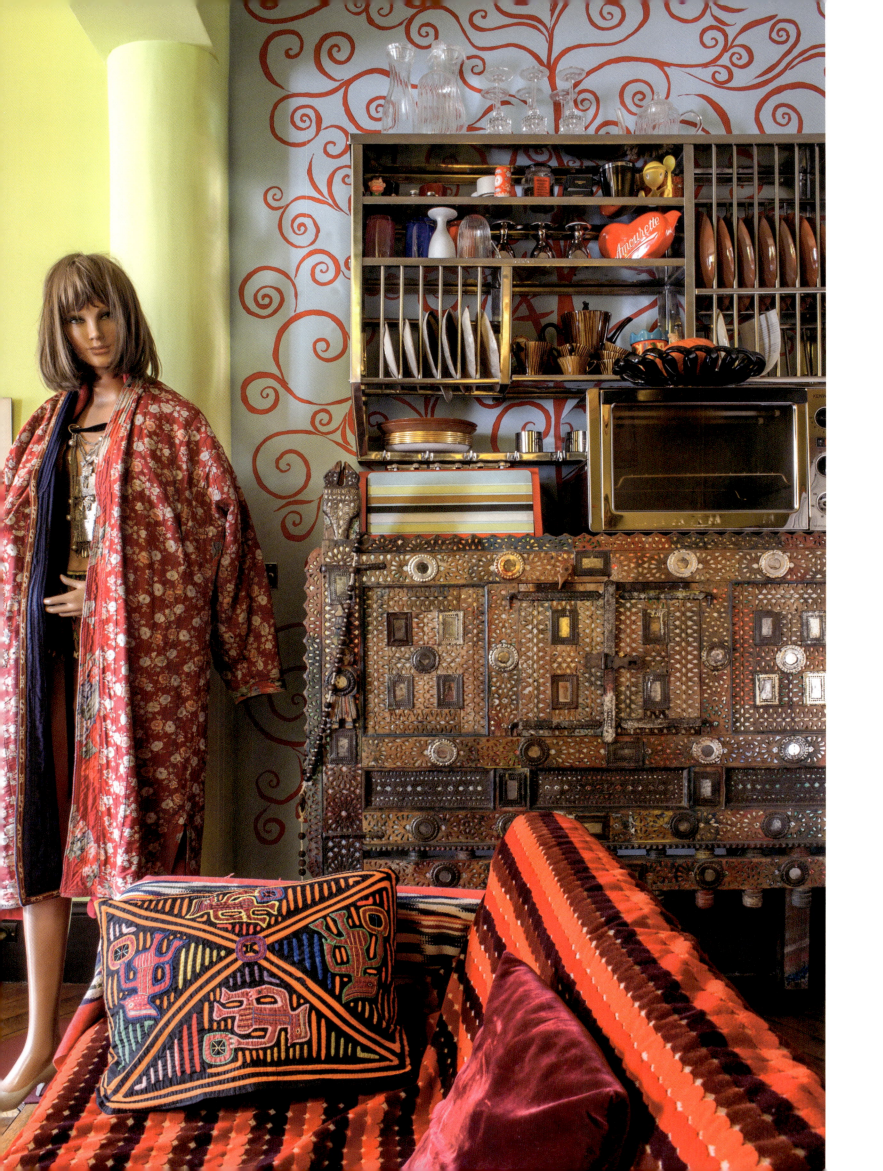

# Creative Sanctuary

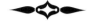

**Nathalie Valax, a stylist, journalist, artist, and gallerist at Galerie 291 Paris, has poured her creative soul into the transformation of a Haussmannian apartment in the lively Marais district. Her renovation approach embraced total freedom, allowing her to infuse the space with vibrant colors, playful designs, and a collection of repurposed objects that together create a dazzling, eclectic experience.**

The journey of revamping this five-room apartment began in 1995 when Valax purchased it to create a nurturing home for her two children, Térence and Lupita. Facing extensive renovations, including the complex task of dismantling a load-bearing wall, the project took a full year to complete. During this time, Valax's vision for blending functionality with artistic flair began to take shape, turning the apartment into an expressive, dynamic space.

A standout feature of the apartment is the kitchen, Valax's personal favorite. Strategically raised in the center of the apartment, it offers two striking views: one side overlooks a courtyard that resembles a lush patio, while the other side

In the kitchen, an antique Indian chest from Alexander d'Orient and a metal shelf from Tsé & Tsé bring global flair, while a cushion, showcasing the traditional Mola art of the Kuna Indians from Panama, adds cultural richness.

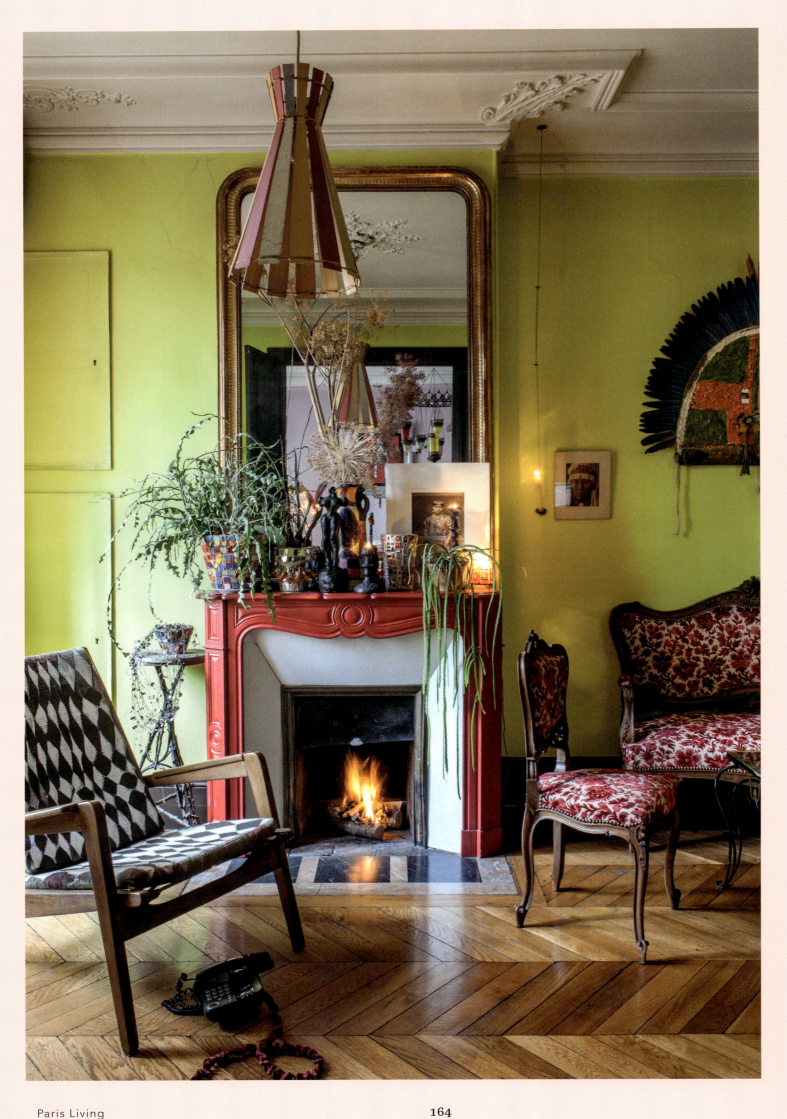

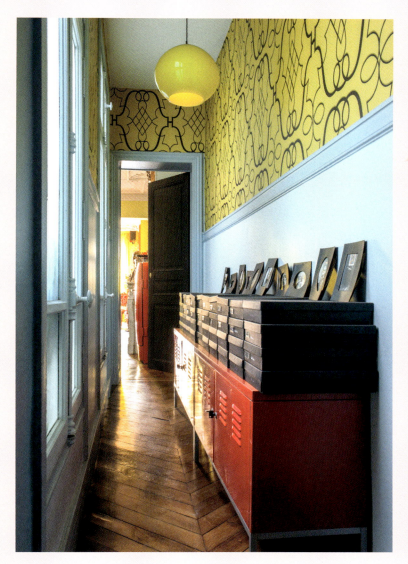
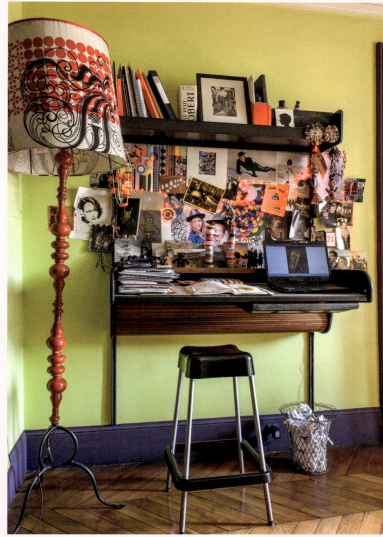

offers a scenic panorama of the Seine River and the historic Île Saint-Louis. The kitchen functions as both a culinary space and an artistic hub within the home. Valax crafted many of its decorative elements herself, including the golden, leaf-embossed entrance and the vibrant, round stained-glass window that casts colorful reflections across the dining room. The raised platform, a mural of the "tree of life," and intricate mosaics further enhance the kitchen's charm and functionality.

The apartment's eclectic design is reflected throughout, from bold, patterned wallpapers to a collection of vintage furniture and rare decorative items. Each room tells its own story, showcasing Valax's unique style and personal history through the objects she's collected over the years. Even the bathroom exudes character with its red Griffon flush system and a multicolored checkered floor, emphasizing the home's theme of creativity and individuality.

(Above left) In the hallway, vibrant yellow wallpaper from Au Fil des Couleurs infuses the narrow space with artistic energy, complemented by a curated collection of black-framed photographs and Paul Smith shirt boxes. Red metal storage units from IKEA's PS collection offer a bold, practical contrast, while a vintage glass globe pendant casts a warm glow over the herringbone wood floor, blending modern utility with vintage charm.

(Left) In this colorful living room, a vintage *FS105* chair by Pierre Guariche sits harmoniously alongside a late 19th-century Louis XV-style sofa upholstered in red velvet, exuding a nostalgic elegance. A striking red fireplace mantle, adorned with lush green plants, showcases a photograph of a Sri Lankan woman (1880) by W.L.H. Skeen. Another photograph, *Cheyenne Indian Red Bird* (1920s) by Edward Sheriff Curtis, hangs nearby. Above, a feathered mask from the Tapirapé Indians of Brazil adds an exotic flair to the eclectic decor.

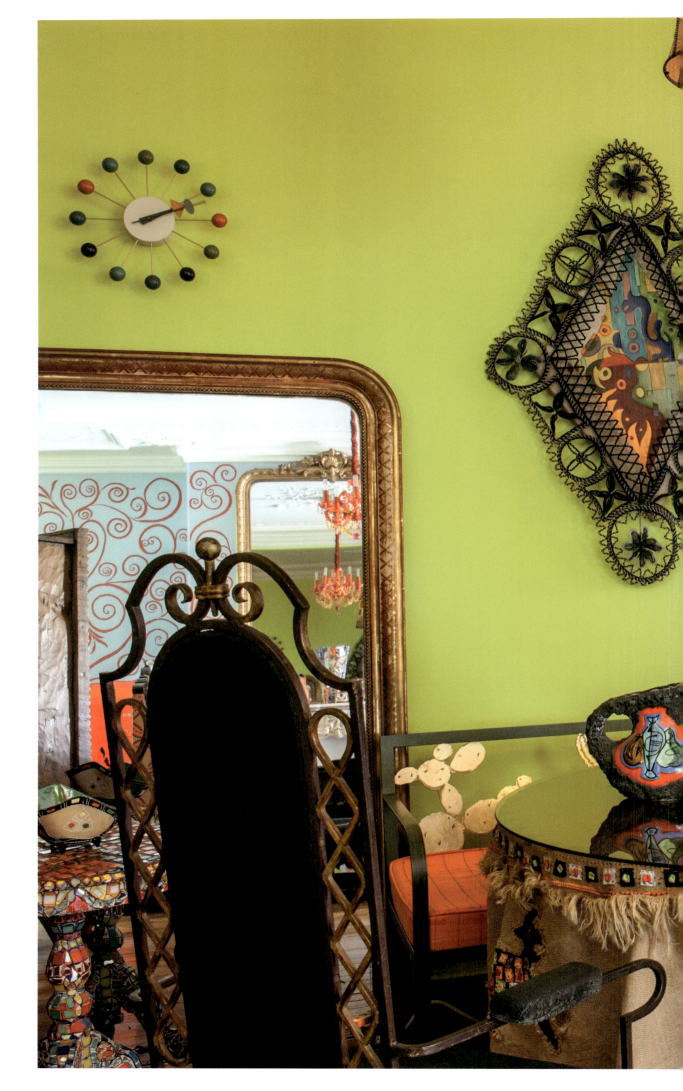

Vintage wrought iron chairs by René Prou surround a uniquely adorned table, dressed with colorful placemats and artistic centerpieces. A striking floor lamp and pendant lampshade by Marie-Claire Raoul—sourced from the En attendant les Barbares gallery—add whimsical charm, complemented by the iconic George Nelson clock from Vitra. The space is further enriched by a vibrant painting by Daniel Boursin, framed with an antique glass bead funeral crown, and a bold *Prince Impérial* chair by Garouste and Bonetti. A *Cactus* bench by Hilton McConnico completes the room with playful energy.

Paris Living

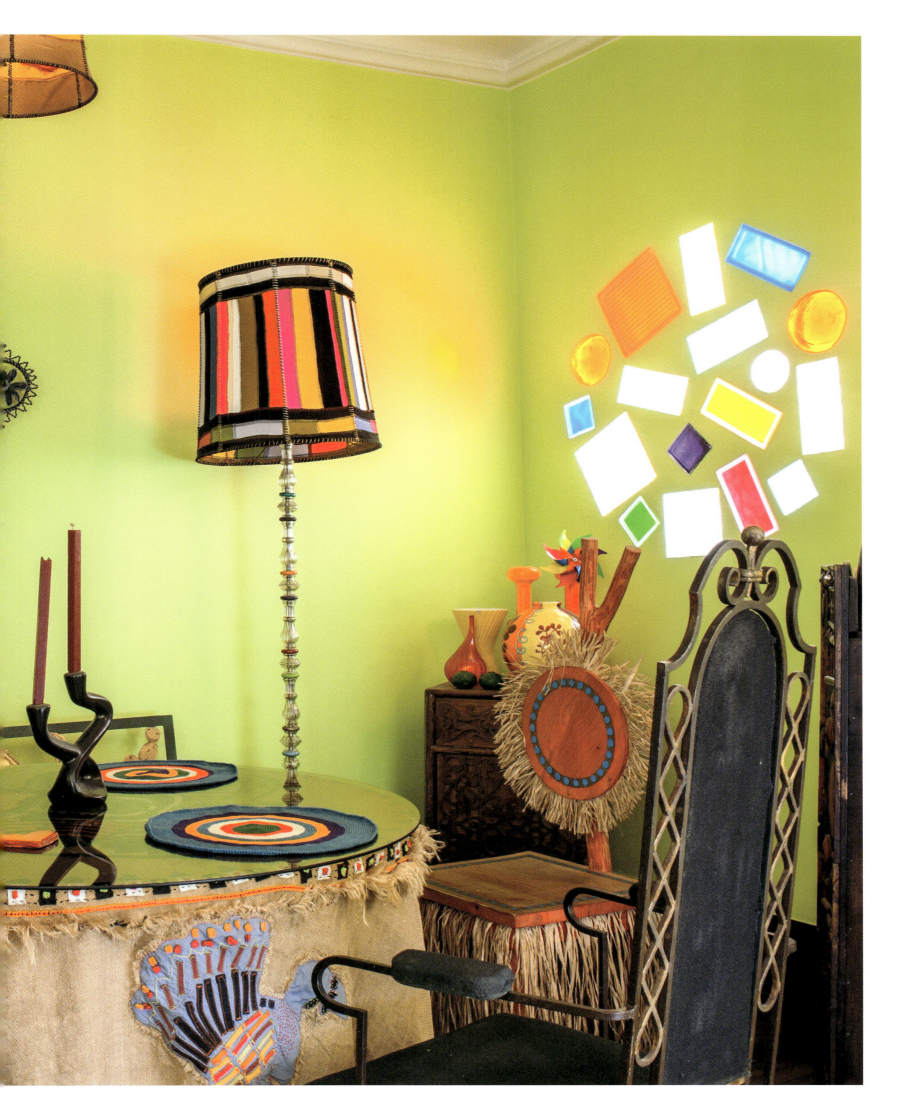

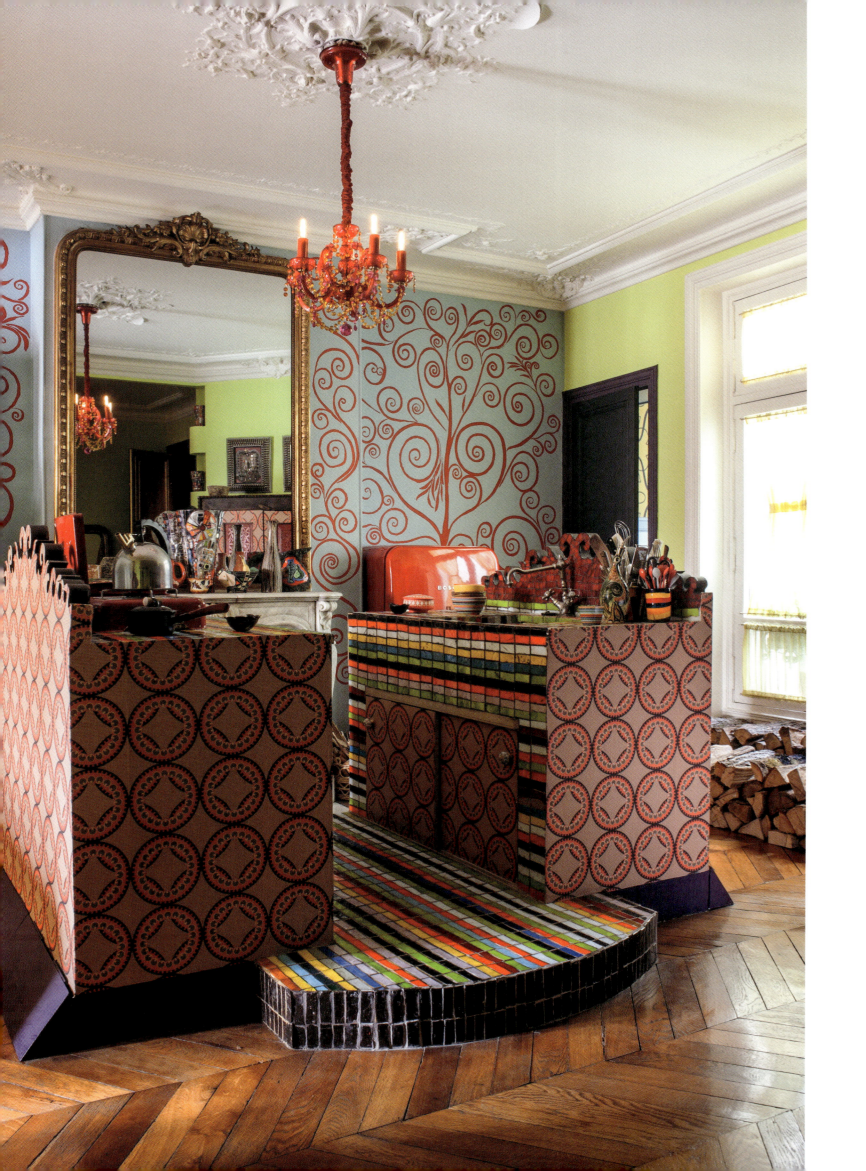

(Left) The kitchen cabinetry is wrapped in decorative wallpaper from Au Fil des Couleurs, lending an artistic and contemporary touch. Elevated counters are adorned with colorful glass mosaics by Albertini, serving as a lively focal point.

(Below right) The bedroom highlights an antique polychrome jackfruit wood bed from Kerala, imbuing the space with warmth and history. A vintage pendant from Istanbul casts a colorful glow, while a cherry blossom branch light garland infuses whimsical charm.

Adding to the personal touch, the walls are adorned with old photographs that Valax has collected from the gallery where she works. These images are not mere decorations but pieces of history, each contributing to the soulful ambiance of the space.

In transforming this apartment, Valax has created more than just a home—she has crafted a living work of art that exemplifies her talents as a stylist and her vision as an artist. Every corner of the apartment showcases her ability to blend different styles and epochs, making it a testament to her creative genius. Each element reflects Valax's journey, resulting in a vibrant and inspiring sanctuary that resonates with the personalities of those who call it home. —

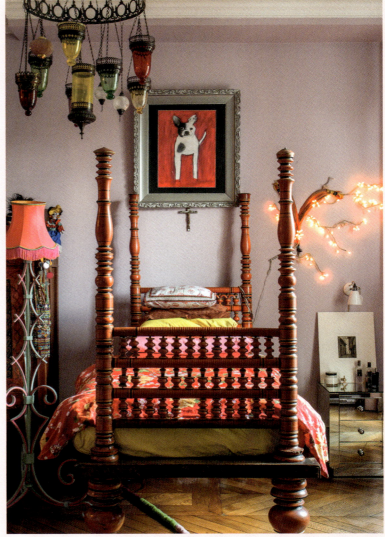

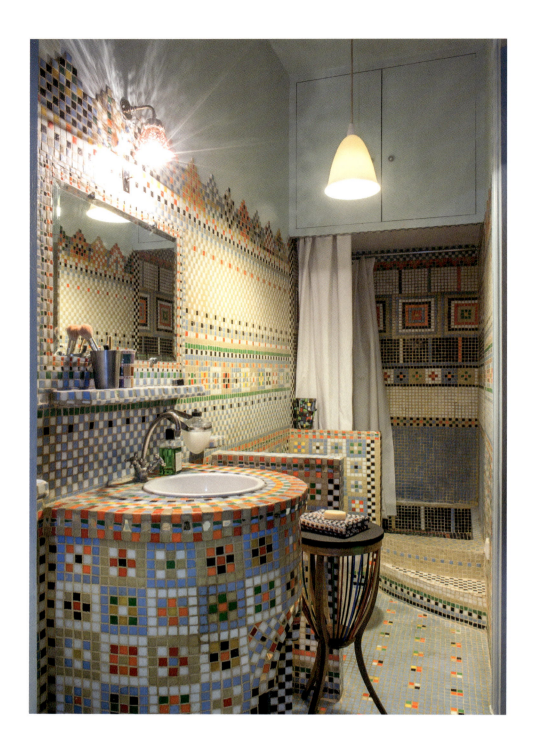

(Above) This charming bathroom features a custom masonry sink stand and shower base, both adorned with intricate mosaics, creating a vibrant and whimsical ambiance. A ceramic pendant light by Original BTC England adds a touch of refinement, beautifully harmonizing with the lively tilework. The result is a joyful blend of craftsmanship and creativity.

(Right) The bedroom showcases an intricately carved Indian bed from Le Monde Sauvage, set against a soothing pastel blue backdrop. The walls are adorned with whimsical wallpaper from Au Fil des Couleurs, and a classic porcelain pendant light from Original BTC England casts a warm glow, perfecting this serene retreat.

In *reimagining* this apartment, Valax has created more than just a home—it is a *living work of art.*

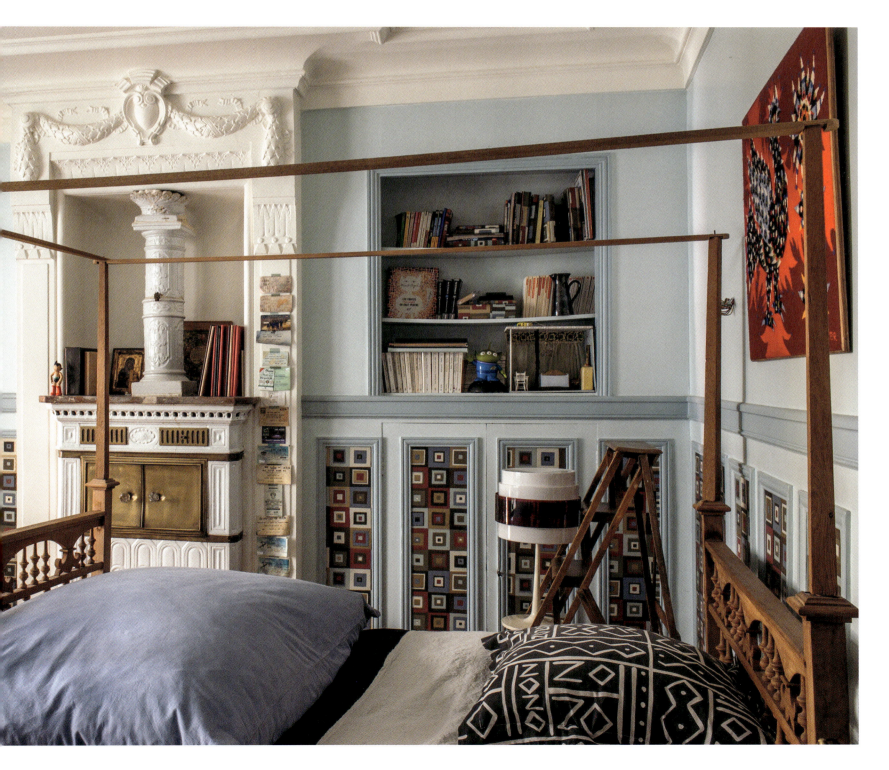

(Left) This alcove bathroom comes alive with Albertini glass mosaic tiles, infusing the space with a playful and dynamic energy. Vintage wallpaper *Right Hand Lady* by Allen Jones for Marburger adds a bold artistic statement, while the antique Cléo 1889 cast-iron bathtub with lion paw feet, crafted by Jacob Delafon, evokes timeless elegance. Historic photographs from Galerie 291 Paris lend a sense of heritage and depth.

(Right) The custom lampshade, crafted from vintage fabric, adds character, resting on a ceramic and wrought iron lamp base by Emery & Cie.

Each element reflects Valax's journey, culminating in a *vibrant* and *inspiring sanctuary*.

# Sculpting Time

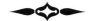

**Nathalie Decoster, renowned for her evocative sculptures that explore the human condition and the passage of time, currently showcases her works in Paris, housed within her distinctive studio home. Once an old airplane parts factory, this space has been transformed into a living gallery where Decoster both creates and lives among her art.**

Her sculptures are monumental, compelling viewers to look upward at towering iron circles and square steel frames. Within these geometric forms is a recurring motif—a slender, elongated man stepping forward as though transcending his metallic confines. These works express deep themes of freedom, fragility, and the inexorable march of time, which have been central to Nathalie's art for over two decades.

In 2007, Decoster acquired her space, drawn to its vastness and historical significance as a former factory. Its transformation into her studio and home marked a pivotal chapter in her life, with the space itself becoming part of her artistic expression. With its high ceilings and expansive glass walls, the environment embodies the transparency and perspectives that Decoster aims to convey in her work.

Facing desks, crafted from vintage laboratory tables, establish a distinctive tone for the space, complemented by industrial Jielde lamps sourced from a design flea market. *Renaissance*, an artwork made of feathers and bronze, adds a captivating sense of artistry and intrigue.

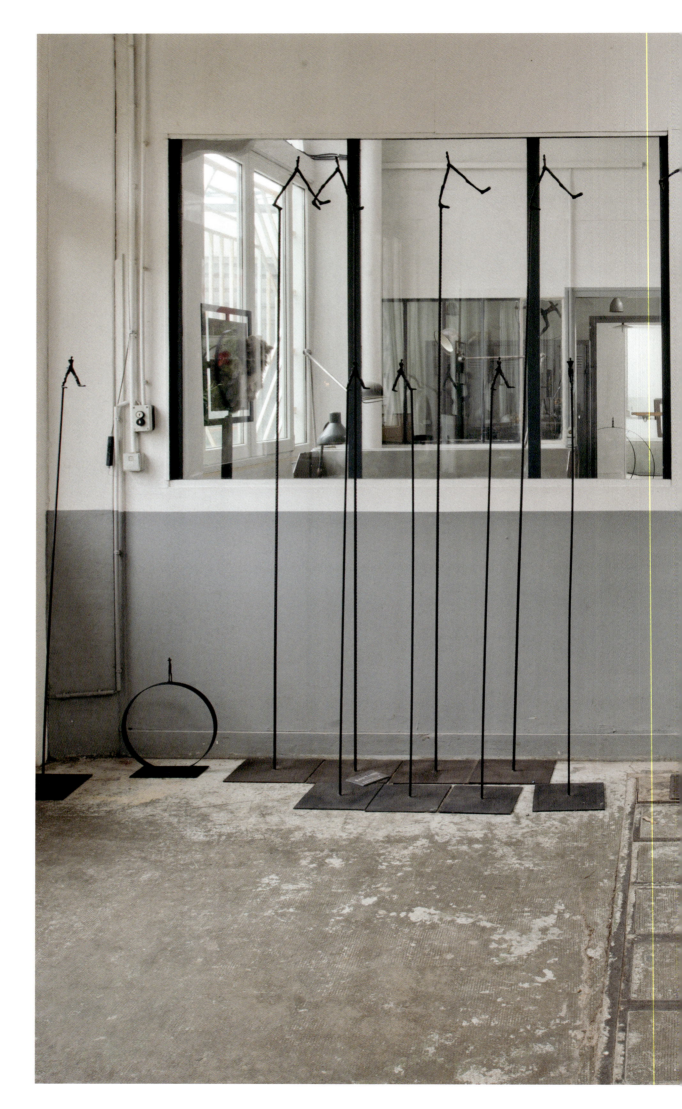

An industrial piece sourced from an antique dealer displays the sculpture *Le Droit au lâcher-prise*, framed by metal rods before a steel-framed glass piece inscribed with "La routine n'est pas une fatalité." To the right of the door, *Du temps et encore du temps* adds contemplative depth, while *Fragilité*, placed prominently in the foreground, weaves a layered narrative into the space.

Paris Living

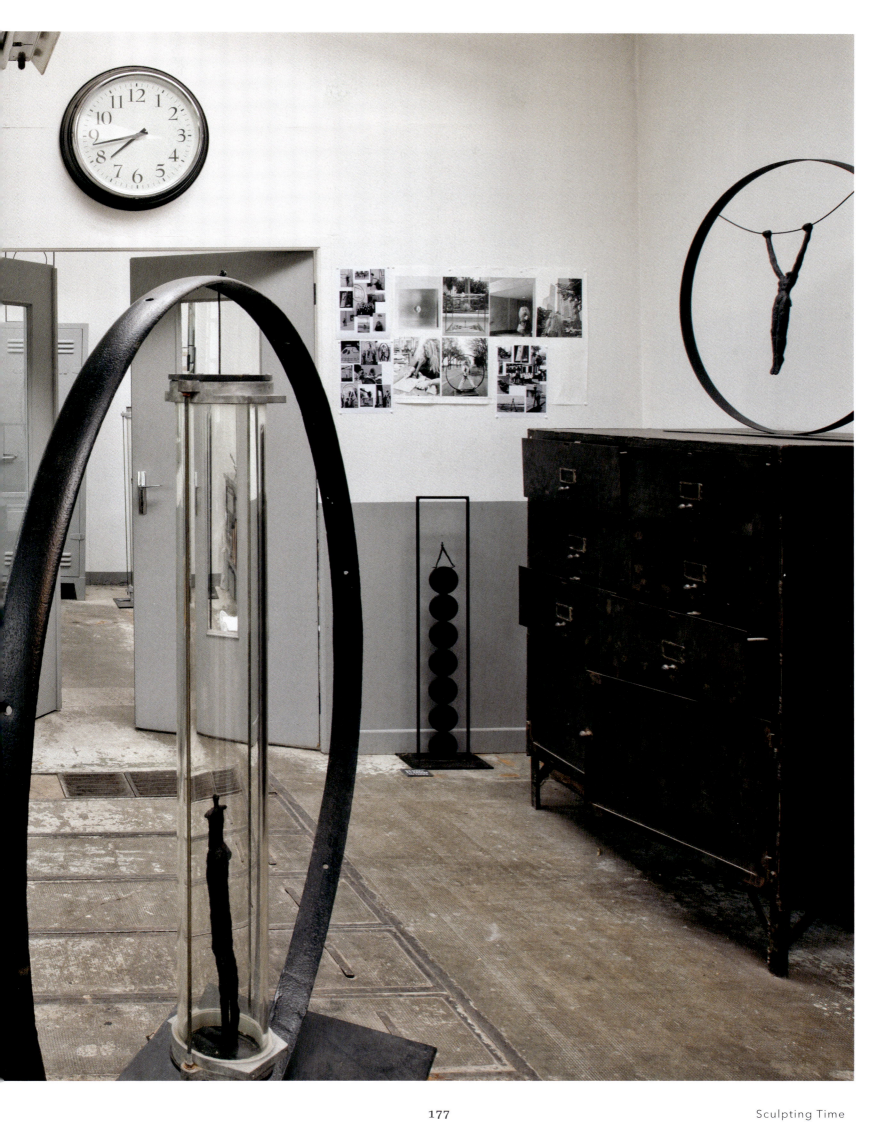

Sculpting Time

(Below) A repainted worker's cabinet from the factory era serves as the base for the whimsical sculpture *Prisonnier du temps*. Above, pendant lamps crafted from vintage ham molds offer an industrial yet humorous touch.

(Right) A Scandinavian wood stove radiates warmth, flanked by original Bertoia chairs. A striking pink chair by a Brazilian artist adds a vivid pop of color, effortlessly blending modern design with artistic expression.

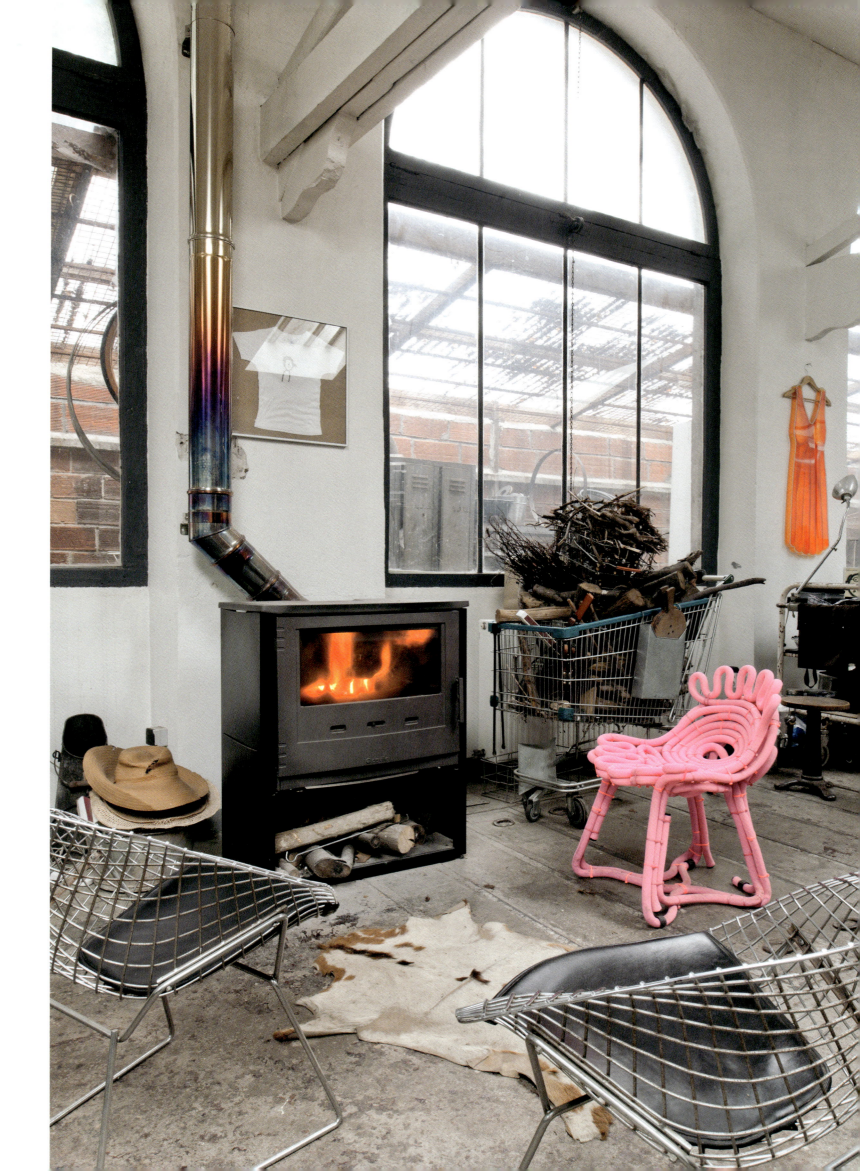

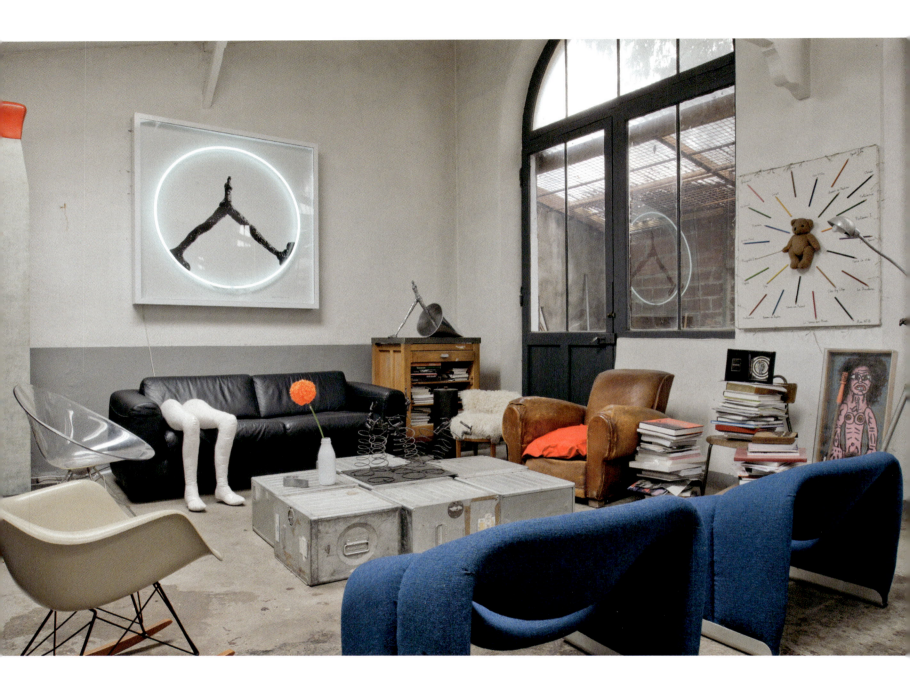

(Above) Above the leather sofa, *Time Light*, a neon artwork embodying the artist's signature symbol, serves as a luminous focal point. A transparent chair by Starck, two Pierre Paulin armchairs, and a Charles Eames rocking chair contribute to the eclectic seating arrangement. Vintage airplane crates repurposed as a coffee table introduce a touch of industrial charm.

(Right) The friends' canteen features a rustic wooden table with steel legs salvaged from a hotel kitchen, paired with an antique steel cabinet. Seating includes a mix of Bertoia and Fritz Hansen chairs. Atop the refrigerator, the artwork *Triple Protection* adds a creative touch, infusing the space with personality and character.

Paris Living

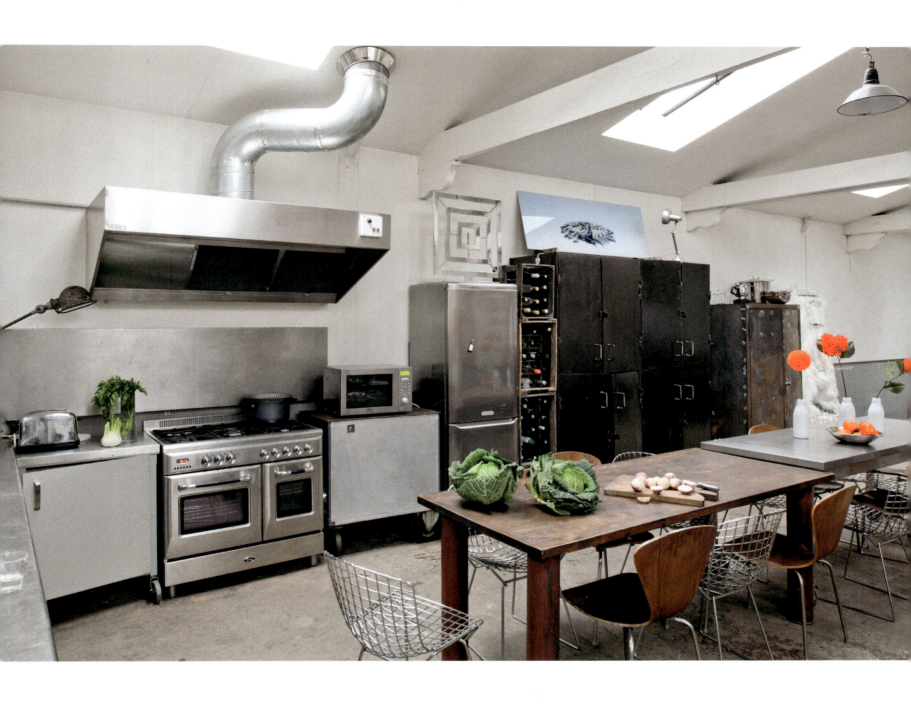

The workshop is a *dynamic space* where iconic design pieces mingle with *industrial materials* and *contemporary artworks*.

> The studio is a place of constant artistic exploration, where *traditional furnishings* exist *alongside* more *experimental installations*.

Upon entering her home, visitors are greeted by an array of industrial furniture interspersed with her striking bronze sculptures. Her workshop is a dynamic space where iconic design pieces mingle with industrial materials and works by contemporary artists in her collection, echoing her belief in the harmony of diverse elements. This fusion of form and function guides her interior design philosophy, where utility is balanced with historical depth.

Her favorite room, the heart of her creative process, is the studio where she draws, sculpts, and conceptualizes new works. Surrounded by iconic pieces by Charles Eames, Pierre Paulin, and Le Corbusier, this room is not just a workspace but a place of constant artistic exploration, where traditional furnishings exist alongside more experimental installations.

While design magazines such as *Wallpaper* and *IDEAT* inspire her, Nathalie's style remains distinctively her own, eschewing conventional decor in favor of a mix of signature design elements and reclaimed objects. This eclectic blend underscores her focus on clean lines and the stories each piece tells, be it a laboratory table or an aged leather chair.

Decoster is as much a host as she is an artist. Her studio home doubles as a gathering place where she prepares meals for friends and collectors, celebrating the communal aspect of her space. This openness extends to her design ethos, creating a living environment that merges functionality with aesthetic intuition—a home that is equally a workshop. —

(Left) The space features striking sculptures: *Triple Protection* in bronze, *Arbres de Vie* in steel and bronze, and *Intimité*, crafted from antique fur and bronze. Each piece enriches the environment with depth and character. Vintage armchairs from the 1950s and 1970s complete the scene, blending timeless design with artistic flair.

(Next page) Nathalie Decoster's atelier embodies a seamless blend of industrial and artistic elements. Pendant lights salvaged from an old factory add a warm glow, reflecting the creative energy of the space and embodying the essence of Decoster's artistic vision.

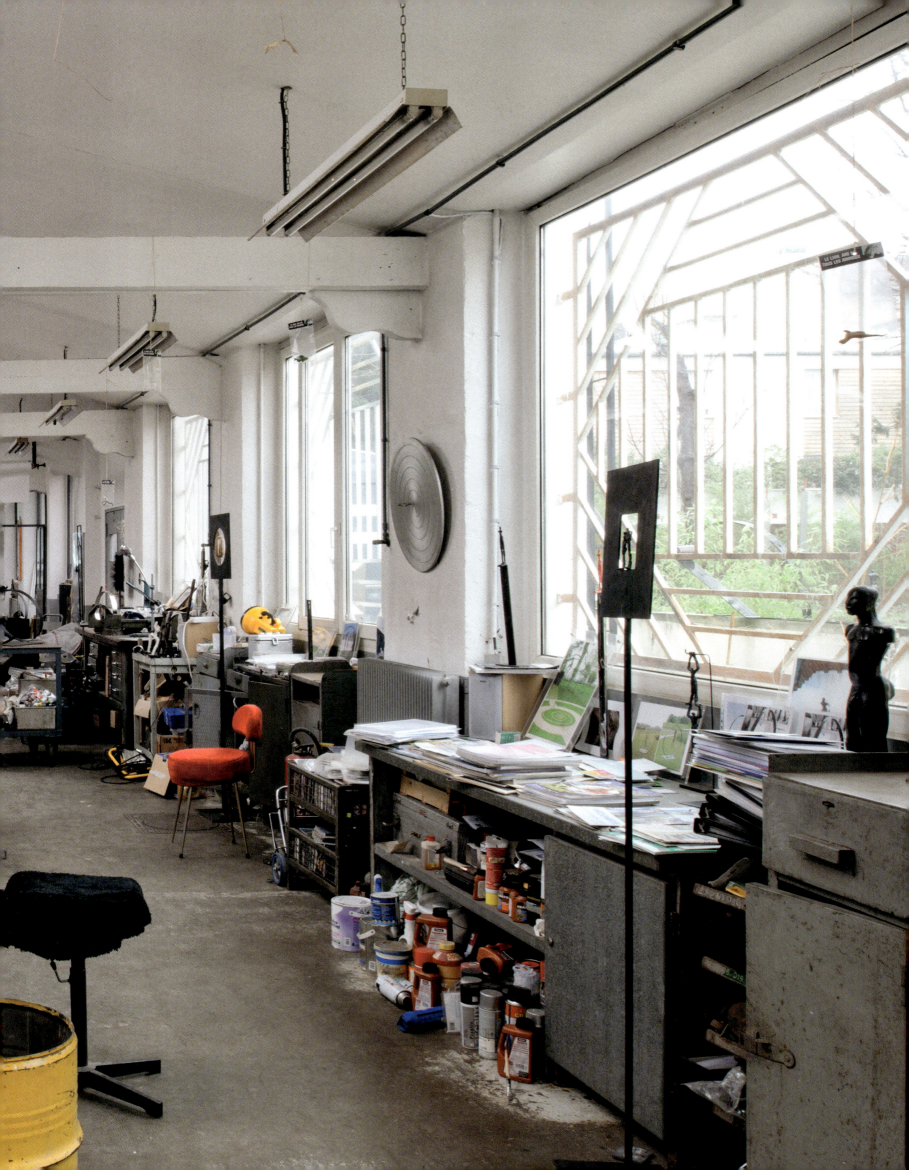

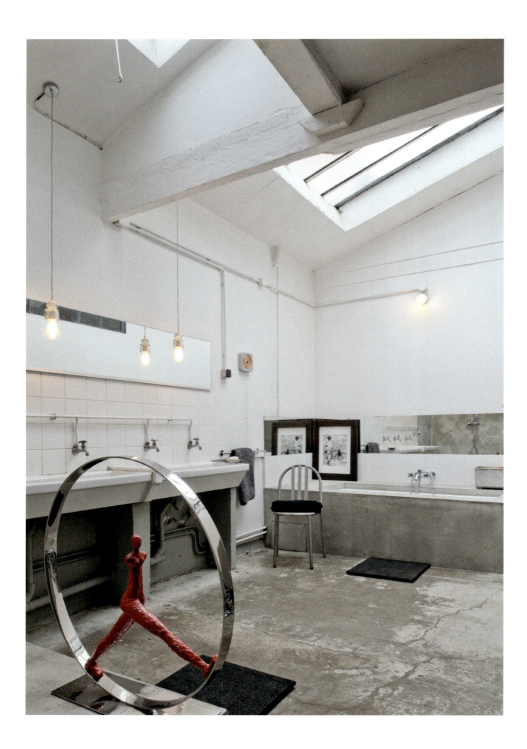

(Above) In the artist's concrete bathroom, the iconic sculpture *Le Temps qui Passe* commands attention. Filament bulb pendants hang above a vintage worker's sink from an old factory, offering a warm, industrial aesthetic and a timeless, contemplative atmosphere.

(Right) In the attic bedroom, a vintage airplane crate serves as a bedside table, paired with the polished aluminum sculpture *Culbuto*. Soft Muji linens introduce understated elegance, creating a cozy, minimalist retreat beneath the sloping eaves.

Paris Living

Decoster is both a *gracious host* and an *inspiring artist*, transforming her studio home into a vibrant gathering place.

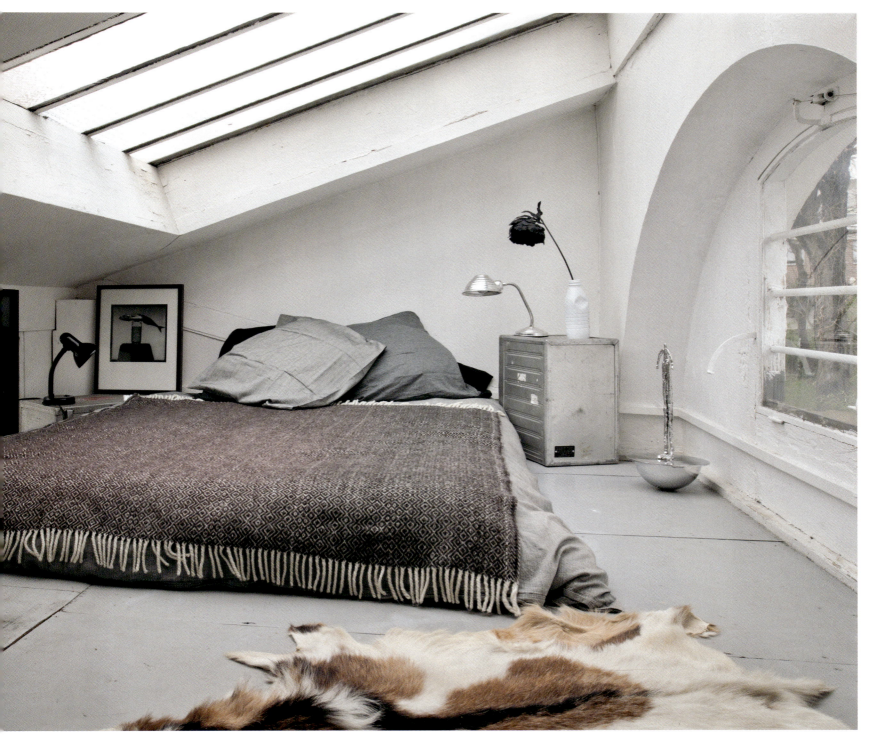

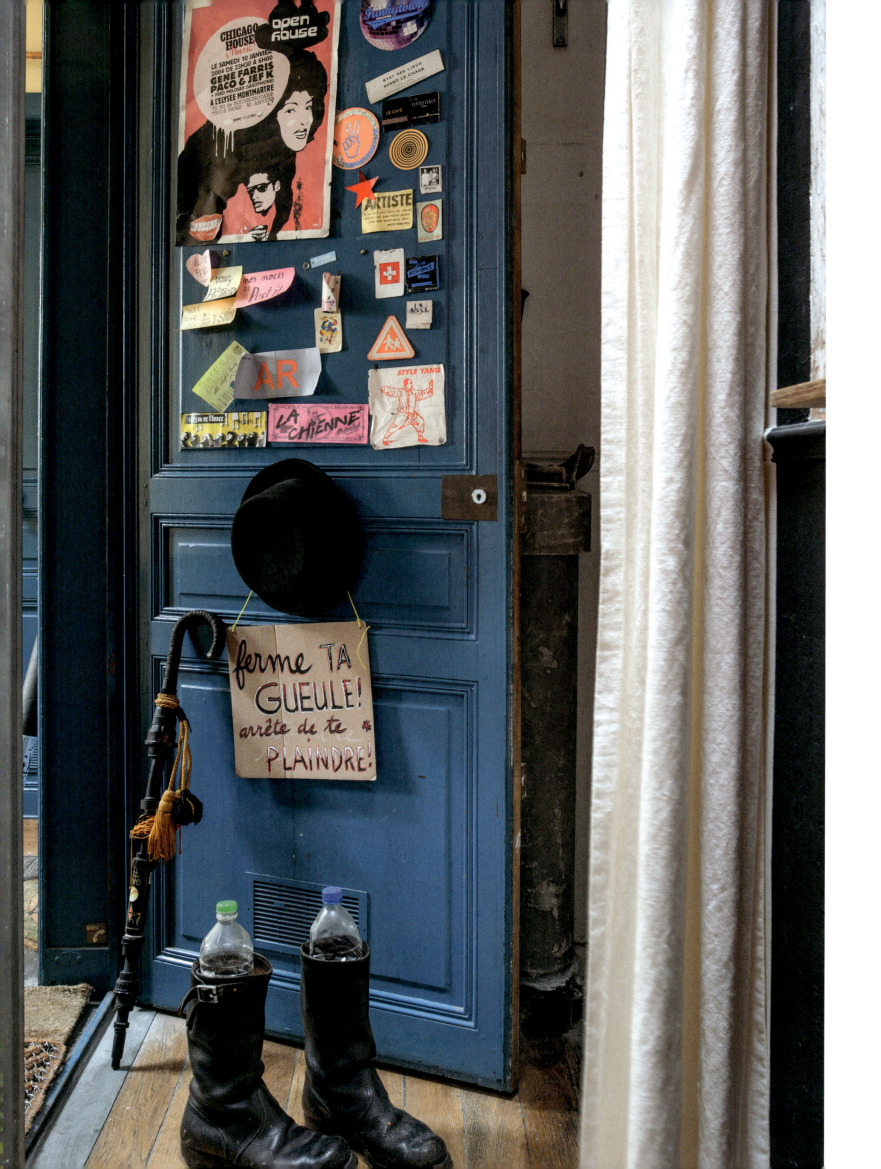

# Prince of Plastic

◆

**In the vibrant heart of Paris's 18th arrondissement, near the culturally rich area of "Little Africa" or the Goutte d'Or, sits the apartment of Regis-R, known as the "Prince of Plastic." This 40-square-meter home, which Regis-R purchased in 2003 as he approached his 30s, is a unique living space brimming with artistic flair. Situated on the sixth floor and accessible only by stairs, the apartment offers breathtaking views of Paris, embodying the artist's innovative spirit and his passion for turning recycled materials into art.**

Despite its modest size, the home is a marvel of efficient design. It houses a bedroom, living room, compact bathroom, a tiny kitchen, a DJ booth, and a distinctive "nest" sleeping space tucked under the roof. A stunning rooftop terrace adds to the magic, offering a 360-degree view of the city with not a single street in sight. The nest and terrace create a sense of spaciousness and freedom, echoing Regis-R's philosophy of "making cash with trash."

This entry door is a dynamic collage of memories and statements, adorned with patches, party flyers, and handwritten notes from friends and visitors. A vintage "anti-complaint" sign injects humor into the space, while a pair of well-worn German army boots, purchased from a Dublin thrift store in the 1990s, stand at the base, propped up with plastic bottles to maintain their shape. A casually leaning black cane adds a nostalgic and personal touch, completing this eclectic yet inviting entrance.

This vivid orange display wall showcases an eclectic collection of art and objects, each with its own story. Highlights include a necklace by an Australian artist alongside a *Being Bling* cardboard necklace by LittleK; a *Black and Red Galaxy* chandelier by Regis-R (2011); *FF88*, a picture of Regis-R's tattooed Ford Fiesta MK2 (1988); *Love in the Bush*, lettering crafted from an electric cable; *I Slept Alone Last Night* on a vinyl LP by Carlos Aires (2008); a drawing by Raphaël Vavasseur (1994–1995); Rose artwork by Ana Broder, London; a *Rocket* lamp by Regis-R; the *We Walked on Mars* coffee table, crafted from industrial plastic waste; *Boîte Noire*, a black cabinet with inscriptions; and the *Blitz Small* pink lightning bolt, created in 2008 by Secret des CP5, a legendary crew of graffiti artists from the Paris region.

Regis-R's home serves multiple purposes. It is his residence, occasional nightclub, art studio, museum for his recycled art, and even a hostel, as he rents out the main bedroom when needed. The "nest" under the roof is a particularly special feature, equipped with a bed, VHS player, and a nostalgic collection of VHS tapes. It opens onto the roof terrace, allowing Regis-R and his guests a private escape into the urban landscape.

The apartment's interior is a vibrant reflection of Regis-R's eclectic and creative spirit. Each element is unique, with art from various artists and Regis-R's own creations adorning the space. One of the most striking pieces is a large, colorful pendant light in the living room, crafted by Regis-R from recycled plastic objects, a symbol of his commitment to transforming waste into aesthetic treasures. Another standout is the ornate canopy bed, which adds a dramatic flair to the small space, enhancing its visual appeal.

Regis-R's design philosophy centers on ecological consciousness and the repurposing of discarded objects. He draws inspiration from trash, lost street objects, and gifts, all fueled by what he calls his "gigantic creativity." His approach balances aesthetic value with practicality, integrating numerous items into the limited space without compromising functionality or artistic expression.

The apartment's decor is alive with vibrant colors and textures. The walls are painted in bold hues that bring energy to each corner, while the eclectic collection of objects gives the space a layered, dynamic feel. For Regis-R, this living environment is a canvas for his belief in giving new life to the discarded, a space that challenges notions of waste and consumption while celebrating the potential for reinvention.

Ultimately, the "Regis-R alias Prince of Plastic" home is more than just a living space; it's a dynamic art installation, a museum of life's remnants, and a bold statement on the beauty and functionality of recycled materials. Through his home, Regis-R invites us to reconsider the value of what we too often throw away by turning the ordinary into something extraordinary. —

The vibrant dining and living space exemplifies Regis-R's passion for upcycling and artistic innovation. A *Zen Bubble* chandelier, made from recycled plastic, casts a colorful glow over the room, illuminating repaired furniture inspired by *Le Temps des Gitans*. The ceiling installation, *Enfance Foutue en l'Air*, features plush toys symbolizing lost innocence. To the left, a canisse, titled *Fils de Rien*, adds visual texture. A reinterpreted Brazilian flag painting commemorates the Rio Carnival of 2013, while a central pole adorned with a whistle from the same carnival adds an interactive element.

> Regis-R's *design philosophy* centers on *ecological awareness* and the creative *repurposing* of discarded materials.

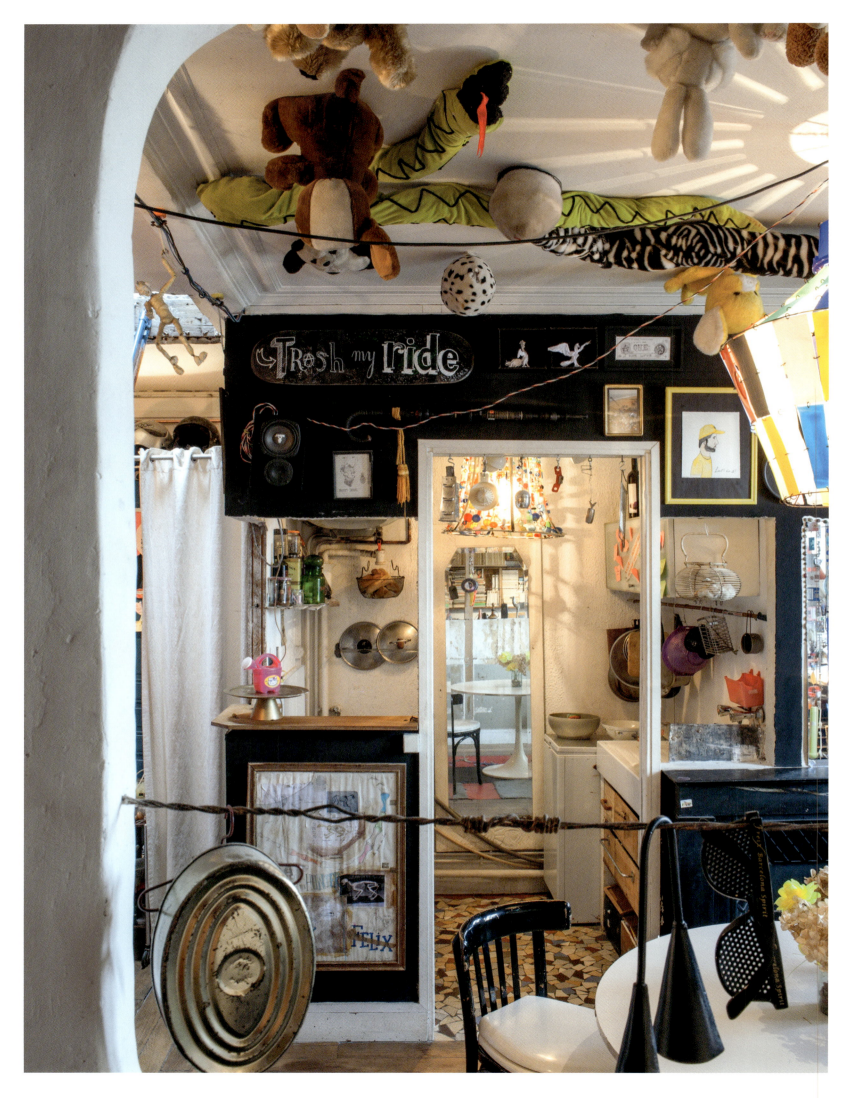

(Left) This eclectic view of the kitchenette captures Regis-R's signature fusion of artistic ingenuity and practical design. The *Radioactivity* chandelier adds an industrial edge, illuminating a space that blends functionality with creative expression. Preliminary sketches like *Fruity Devil* and *The Hunter* by Felix lend a playful yet macabre tone, while the *Trash My Ride* skate deck, creatively repurposed as wall art, hangs above. A portrait by an artist from the Creative Growth Center brings a sense of inclusion and personal warmth. The layout celebrates artful spontaneity, weaving together utility with imaginative flair.

(Below) A *Crucifix* (2009) and a *Skull*, also by Regis-R, add thought-provoking focal points near the workspace. The eclectic mix of personal artifacts, evocative pieces, and unconventional lighting creates an atmosphere that is unmistakably artistic.

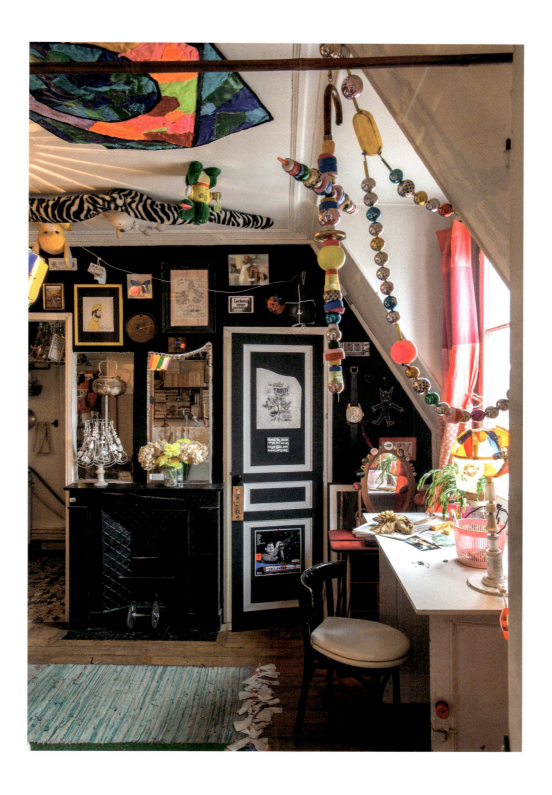

Prince of Plastic

(Below) A *View of The Room* reveals a luminous sign by Regis-R positioned above the doorway, casting a soft glow. Inside, David Brognon's artwork *Guns*, acquired in exchange for a chandelier called *The Plug*, makes a striking statement.

(Right, top left) Detail from the *Buts and Bugs* series include boxes created during a 2009 residency at the Creative Growth Center in Oakland, flanking a middle box featuring *Mosquito*, *Electrical Bug*, and *Scarab*, assembled at the Braderie de l'Est. (Top right) The *Black on White Mirror* adds a minimalist yet dramatic element. (Bottom left) A whimsical bathroom detail shows a hanger adorned with colorful clothespins. (Bottom right) A mosaic of broken mirrors reflects Regis-R's penchant for turning fragments into beauty.

Prince of Plastic

 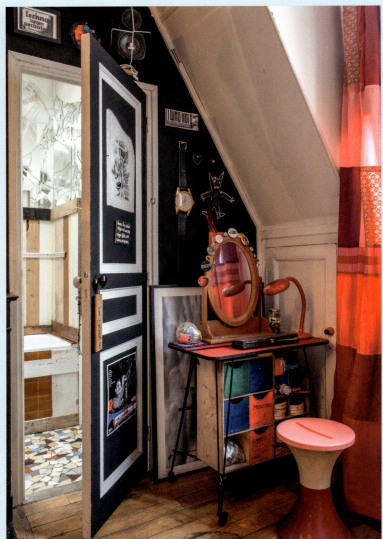

(Above right) A cozy corner of the living room showcases a vanity table constructed from an assemblage of unique elements, framed by a homemade patchwork curtain of vibrant red fabrics.

(Right) A tribute to Andy Warhol's *Marilyn* in pink and orange dominates this eclectic corner, setting a playful, bold tone. Prayer flag-inspired banners, originally used in African festivals and carnivals, drape gracefully over a canopy-topped daybed by Regis-R. The bed's patchwork of red fabrics and hand-lettered cushions harks back to a 100% recycled art exhibit at the Jean Monnet School of Art. Adding a final playful flourish, the inventive *Bassino* chair—a vintage basin reimagined with tapestry—anchors the space with quirky charm.

The apartment's decor comes alive with *vibrant colors*, *textures*, and *imaginative artistry*.

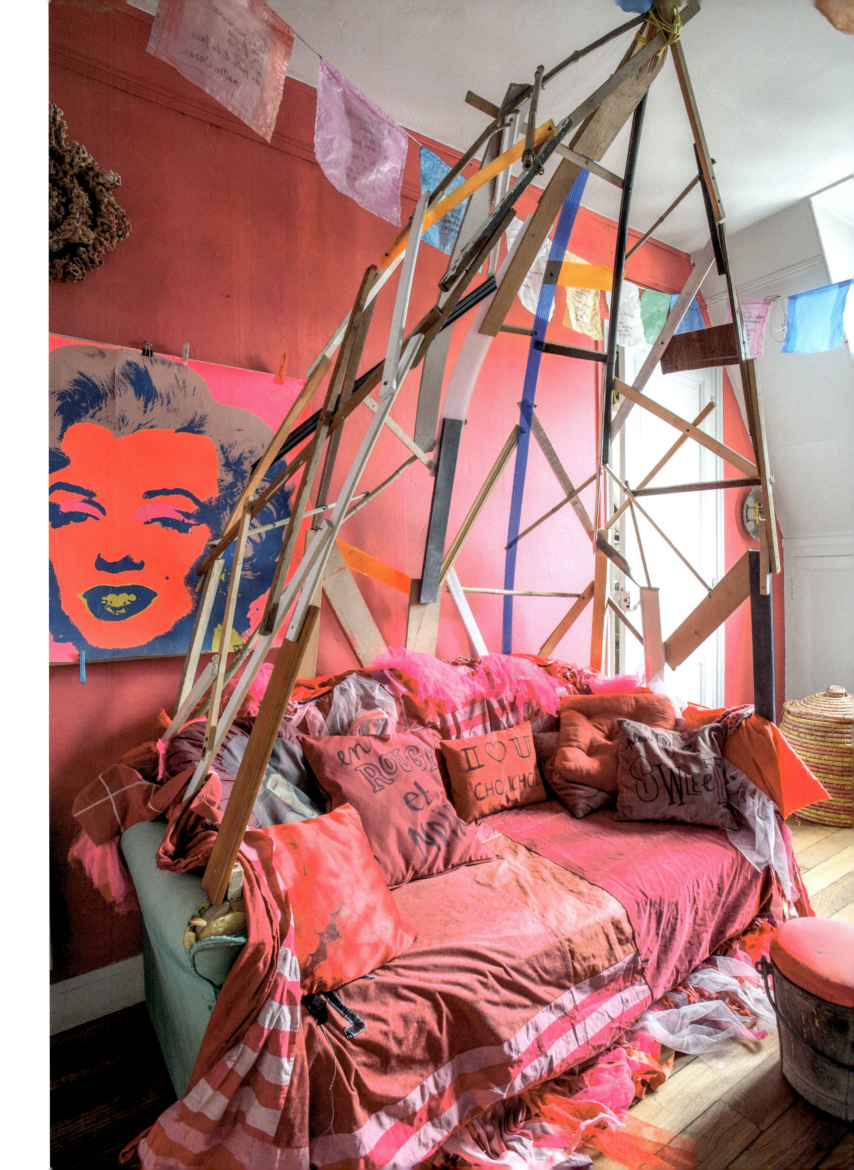

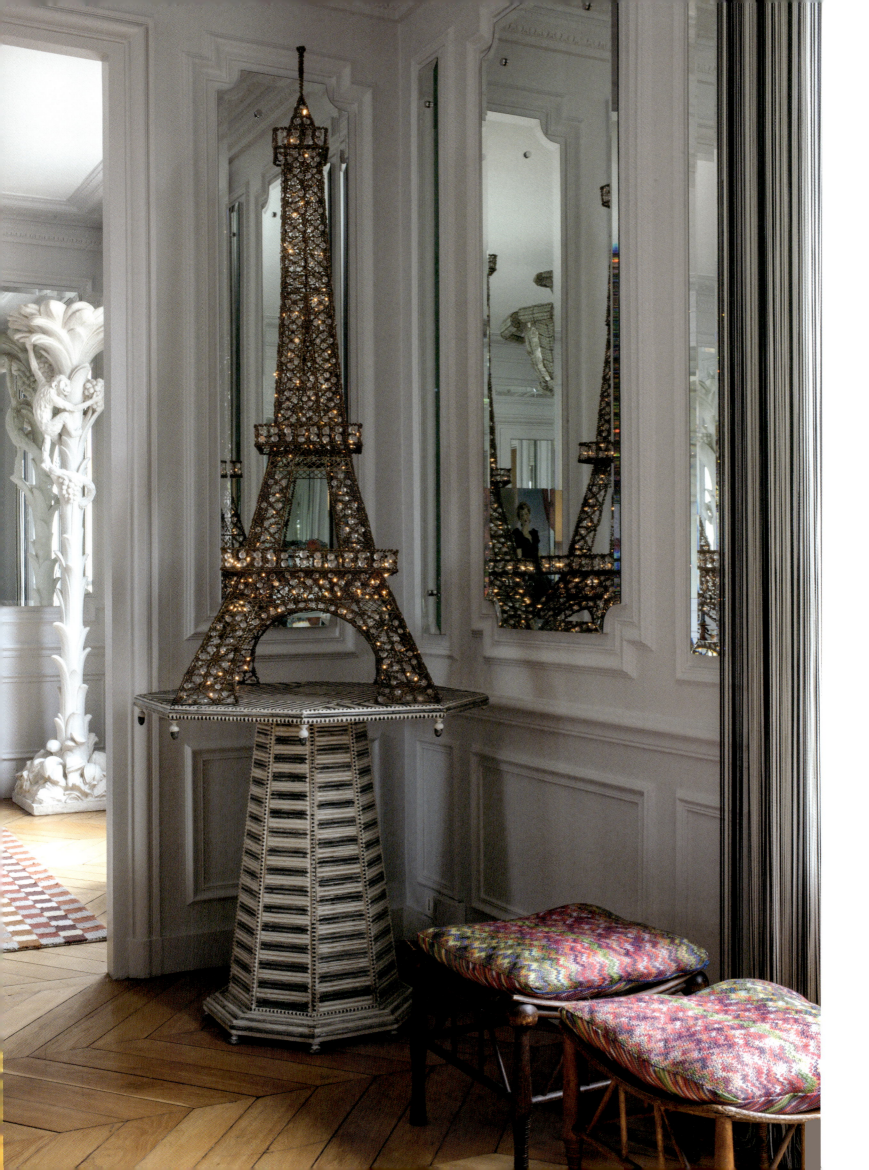

# Textile Tale

**Discover how Rosita Missoni (†), renowned for her vibrant and innovative textile designs, transformed her Parisian pied-à-terre into a living showcase of modern bohemian chic. This stylish enclave on the Left Bank serves as both a residence and a dynamic canvas, displaying her unique fusion of graphic elements and rich textures.**

The apartment is a masterclass in design, harmonizing bold patterns and luxurious materials that reflect Missoni's wide-ranging influences, from Chanel's pioneering use of fabrics to the Bauhaus's bold color schemes, and a variety of ethnic motifs.

Rosita Missoni's journey in the world of fashion and design began in 1953. Her life took a pivotal turn when she married Ottavio Missoni, an athlete who competed in the 1948 London Olympics. Together, they founded a couture studio in Gallarate, near her hometown in the Varese region, which later blossomed into a global fashion empire. Their joyful,

This beautifully curated corner displays a unique, mottled Eiffel Tower sculpture, sourced from the renowned Biron market. It blends Parisian charm and artistic flair, illuminated by Rosita, casting a warm and inviting glow that highlights the tower's intricate design and metallic texture. Adding a playful touch, two stools adorned with vibrant zigzag cushions from Missoni Home introduce a burst of color and a modern aesthetic.

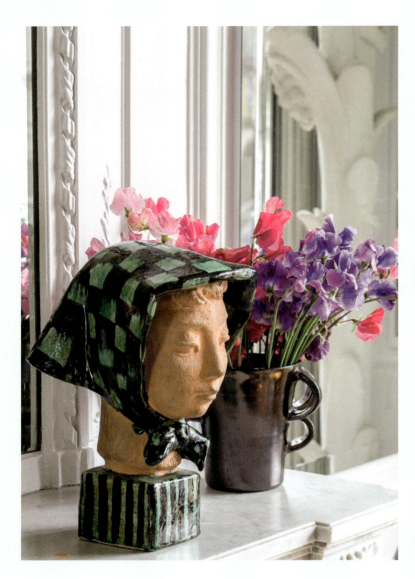
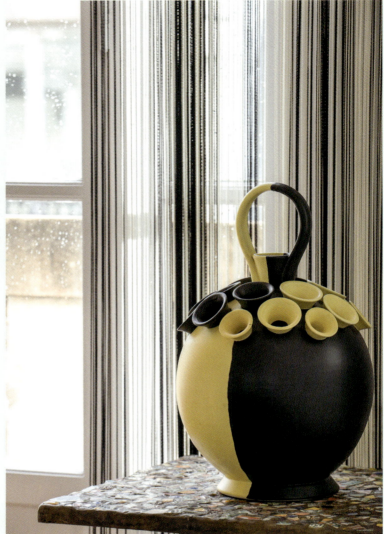

(Right) In this elegant hallway, a floral giltwood mirror by Jean-Paul Beaujard exudes timeless charm, paired with a matching bench below. Carved wicker armchairs from Fair Chatou add texture and warmth, while a bright hydrangea arrangement in a vintage vase from the Serpette market introduces a lively touch. Completing the sophisticated look, a painting sourced from the Vanves flea market adds a layer of artistic depth.

colorful designs captured the attention of fashion icons like Anna Piaggi and Diana Vreeland, as well as cultural figures such as Rauschenberg and Fellini.

The 1990s marked a turning point for Missoni. After planning to retire in 1997, handing over the reins to her children—Vittorio, Luca, and Angela—her passion for design soon called her back. She took charge of Missoni Home, breathing new life into the brand's signature motifs: zigzags, chevrons, polka dots, stripes, and florals, translating them into home decor. Rosita's profound love for interior design is evident not only in her professional work but also in her personal life, as she decorated numerous homes across Europe, from Sumirago to Venice, and from Sardinia to London.

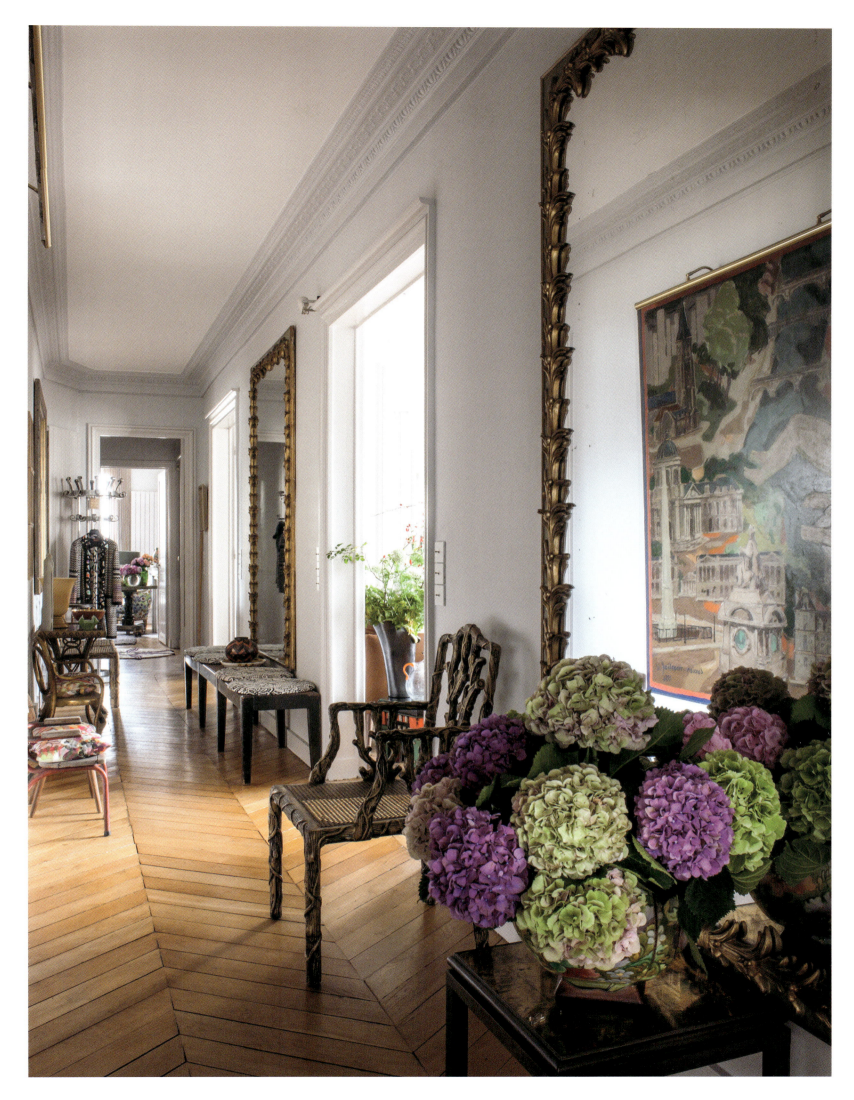

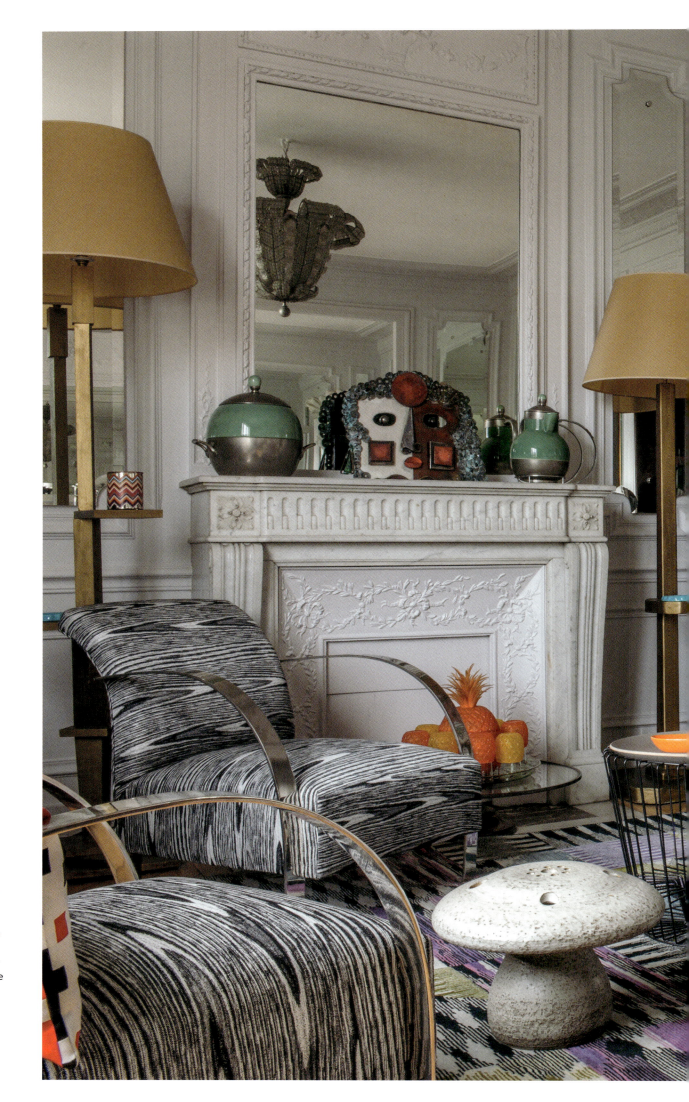

This elegant room effortlessly combines vintage charm with modern luxury. A 1940s folding screen serves as the focal point, adding artistic flair to the walls. The Pritzwalk patchwork rug from Missoni Home anchors the space with its intricate patterns, while a sofa upholstered in mottled Piaui fabric adds texture and comfort. Enhancing the space further, the *Sunset* vase by Richard Ginori for Missoni Home serves as a vibrant centerpiece, tying together the room's eclectic yet cohesive aesthetic.

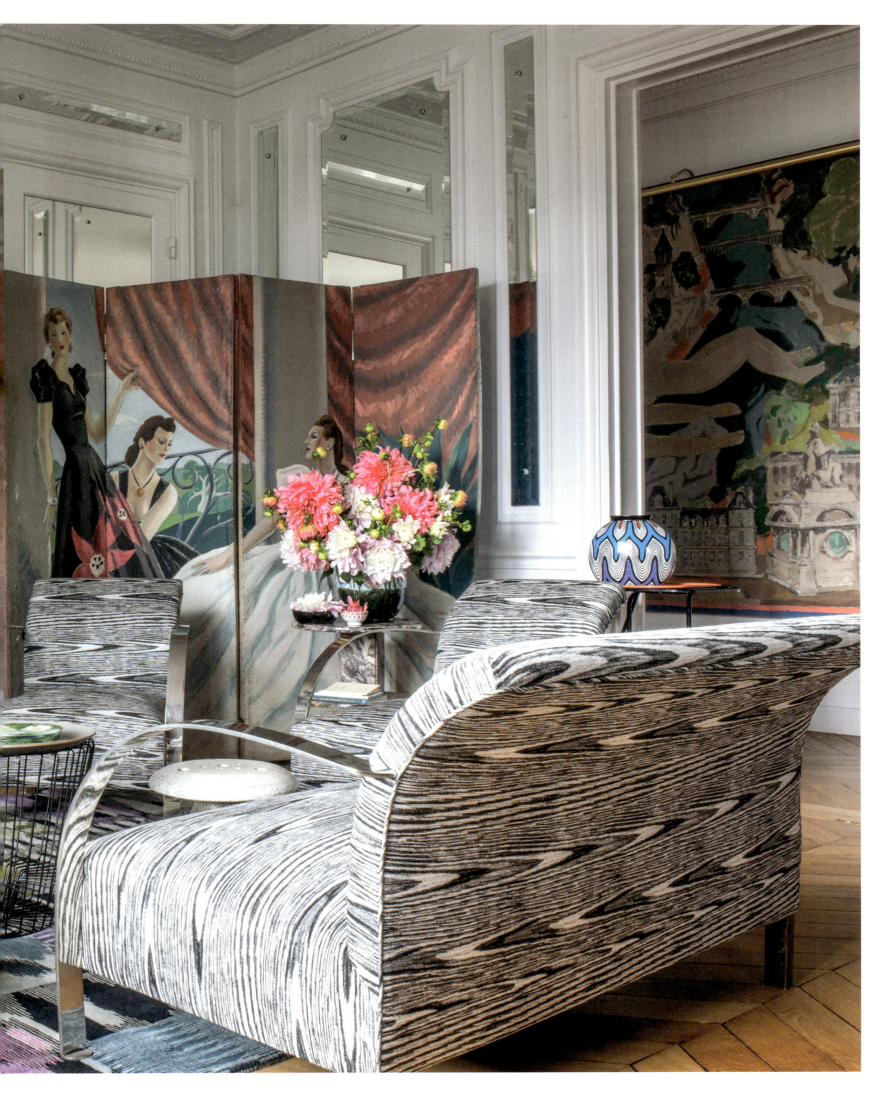

Rosita Missoni's Paris apartment, located on the top floor of a 19th-century building near Saint-Germain-des-Prés, spans 250 square meters. The layout includes five rooms, highlighted by a spacious living room adorned with white-painted paneling and beveled mirrors, which enhance the natural light. Each room exudes Missoni's distinct style, from a 1940s folding screen in the lounge that echoes the spirit of past decades to the boudoir and bedroom fully immersed in Missoni patterns, offering breathtaking views of the Saint-Thomas d'Aquin Church.

The dining room showcases Rosita's penchant for unique finds, featuring graceful plaster lampposts from a casino in Nice, alongside Hans Wegner's iconic "Y" chairs. Her passion for rummaging through flea markets is evident throughout her home, as is her love for cooking, as she would often share lavish spreads of delicacies from her homeland during gatherings with friends. —

(Below right) An artistic arrangement of vintage glassware and carafes, sourced from the Vanves flea market, adds a touch of nostalgia and elegance. The Italian leather sofa from The Conran Shop introduces warmth, accentuated by striped cushions from Claremont. The *Maset* pixel tile carpet by Missoni Home adds playful patterns to the space, while a whimsical mushroom table is a subtle nod to Missoni's fondness for fungi, creating a harmonious and character-filled corner.

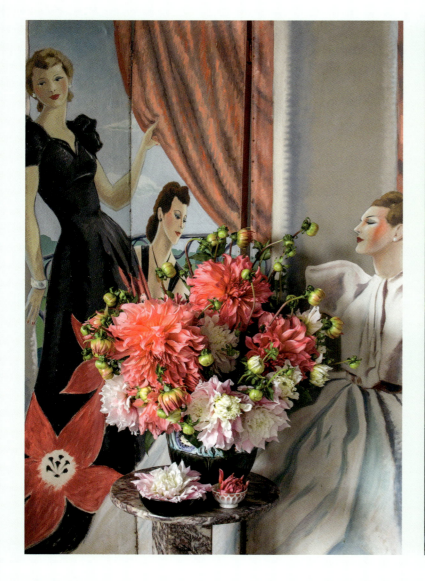

Paris Living

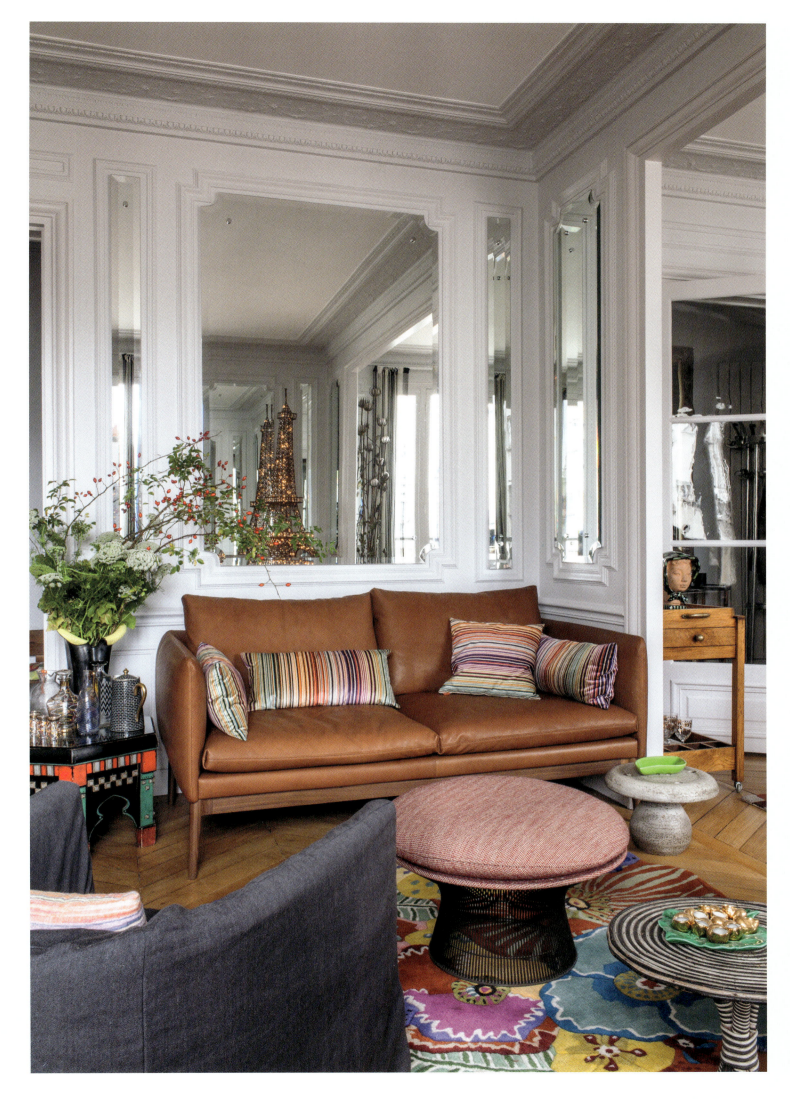

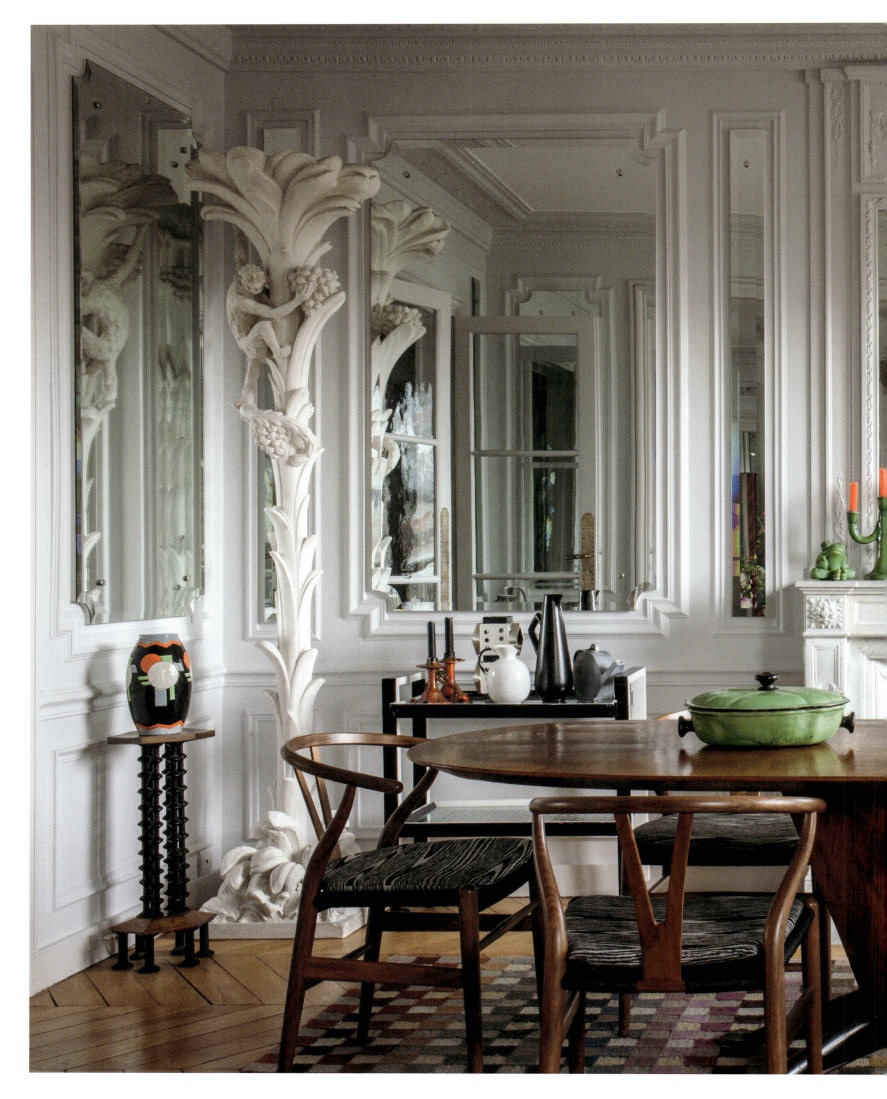

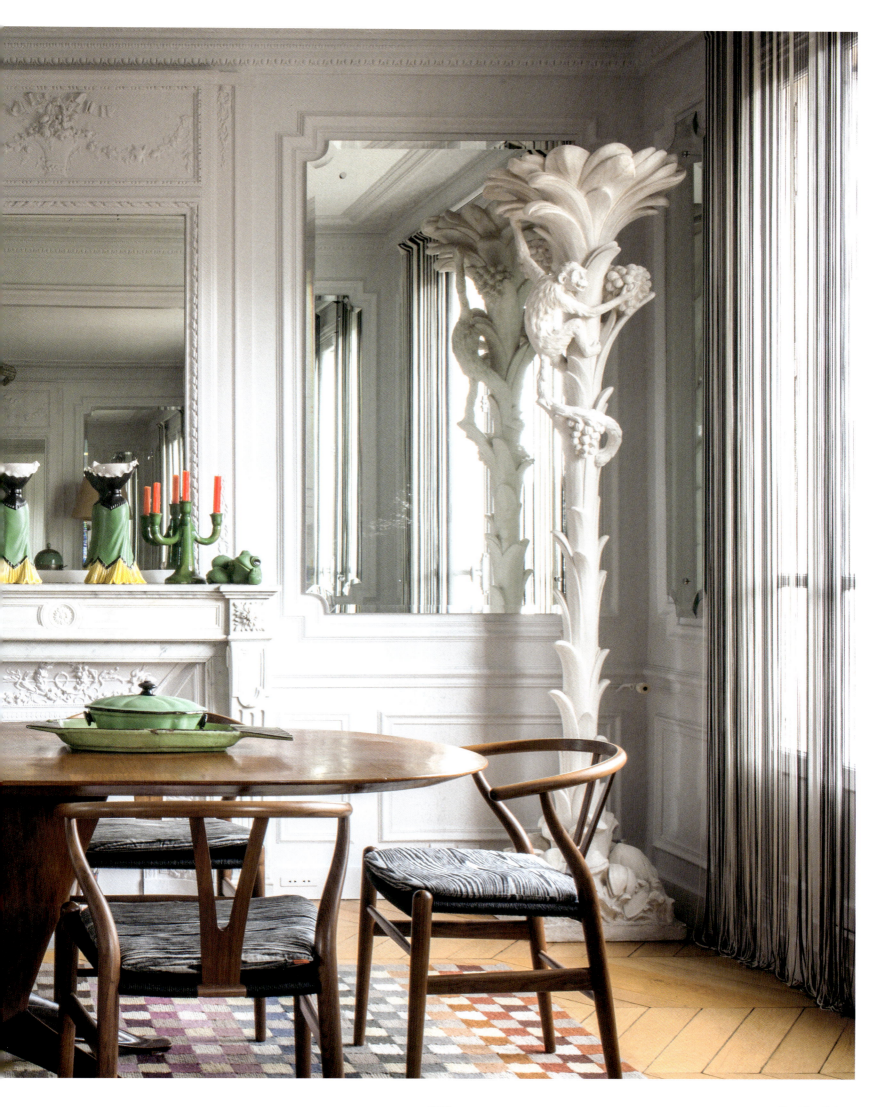

The apartment is a *masterclass* in design, seamlessly blending *bold patterns* and *luxurious materials* that embody Missoni's diverse influences.

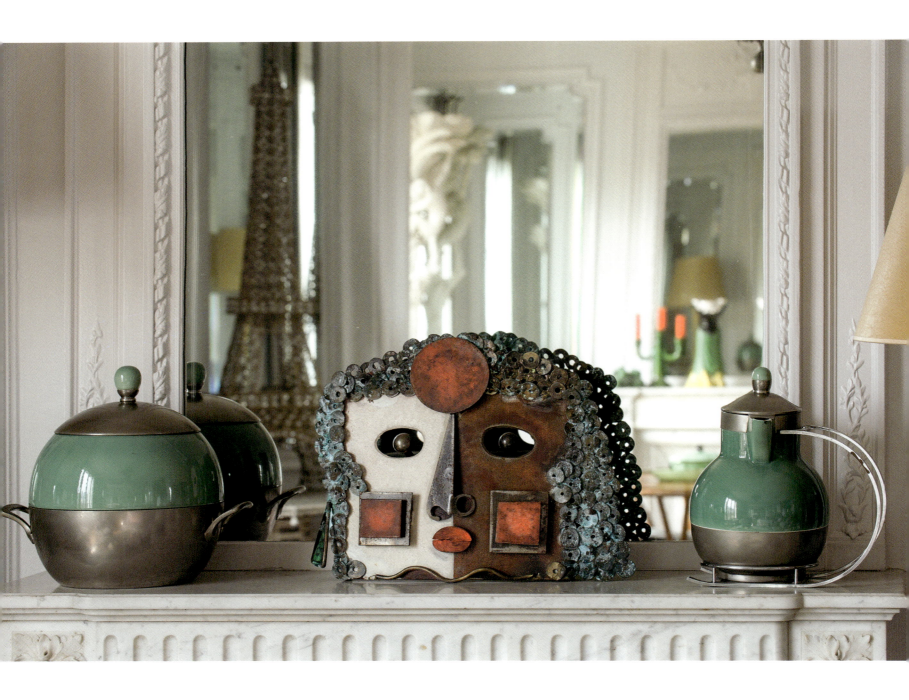

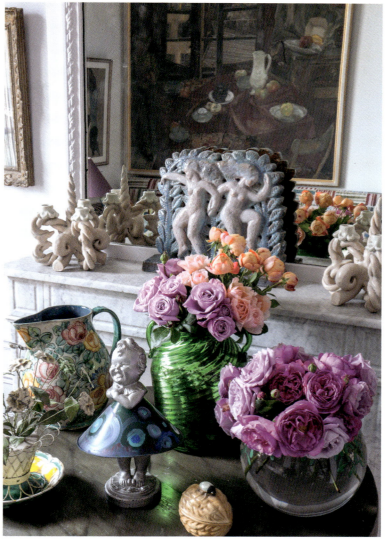

(Previous page) In the dining room, a timeless *Ico Parisi* table by Jean-Paul Beaujard pairs elegantly with Hans J. Wegner chairs from The Conran Shop, creating a harmonious balance of classic and contemporary styles. The space features candlesticks and distinctive decor sourced from the Vanves flea market, complemented by grand plaster lamps salvaged from a Nice casino. An assortment of ceramics bring natural beauty and texture, while Piaui cushions, bicolor-fringed curtains, and Missoni Home's Maset carpet tiles add layers of pattern and color. Overhead, a Baguès chandelier is elegantly reflected in the mirror, amplifying the room's refined atmosphere.

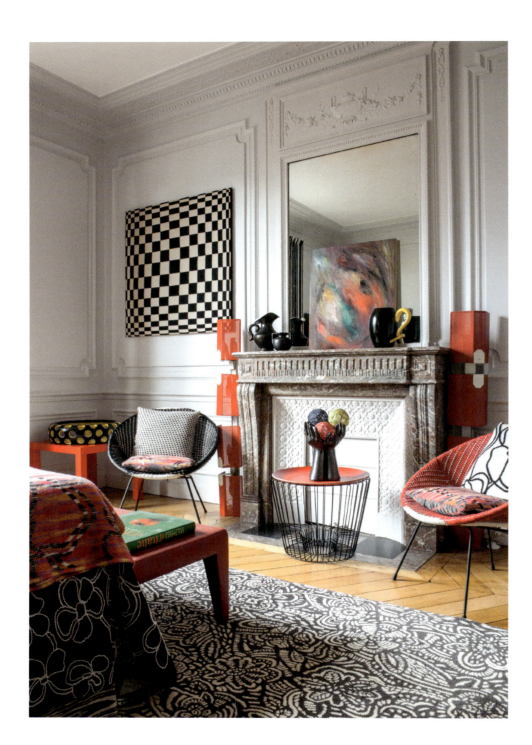

(Right) The bed is dressed with the patterned Missoni Home *Hedi* blanket and a collection of contrasting pillows, including the striking *Dalia* cushion. The *Henya* throw adds warmth and texture to the bedspread. A playful bistro coat rack sits nearby, while vintage decor pieces, patterned screens, and bright, striped vases contribute to the room's dynamic character. A stylish red and black wicker chair adds a bold statement, tying the elements together into a cohesive, inviting ambiance.

Rosita Missoni's passion for *exploring flea markets* shines through in *every corner* of her home.

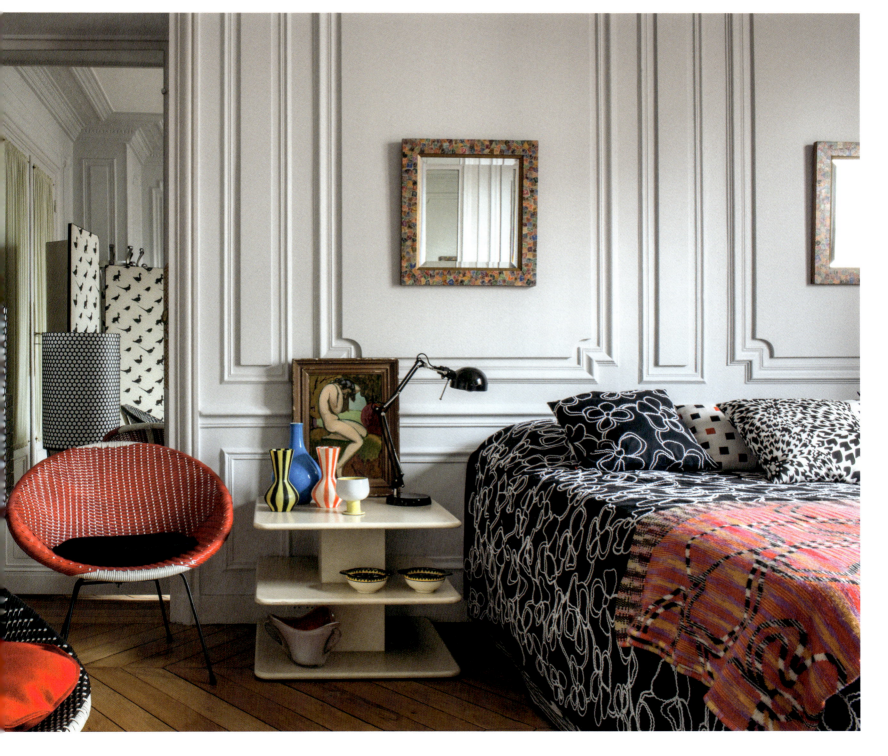

Textile Tale

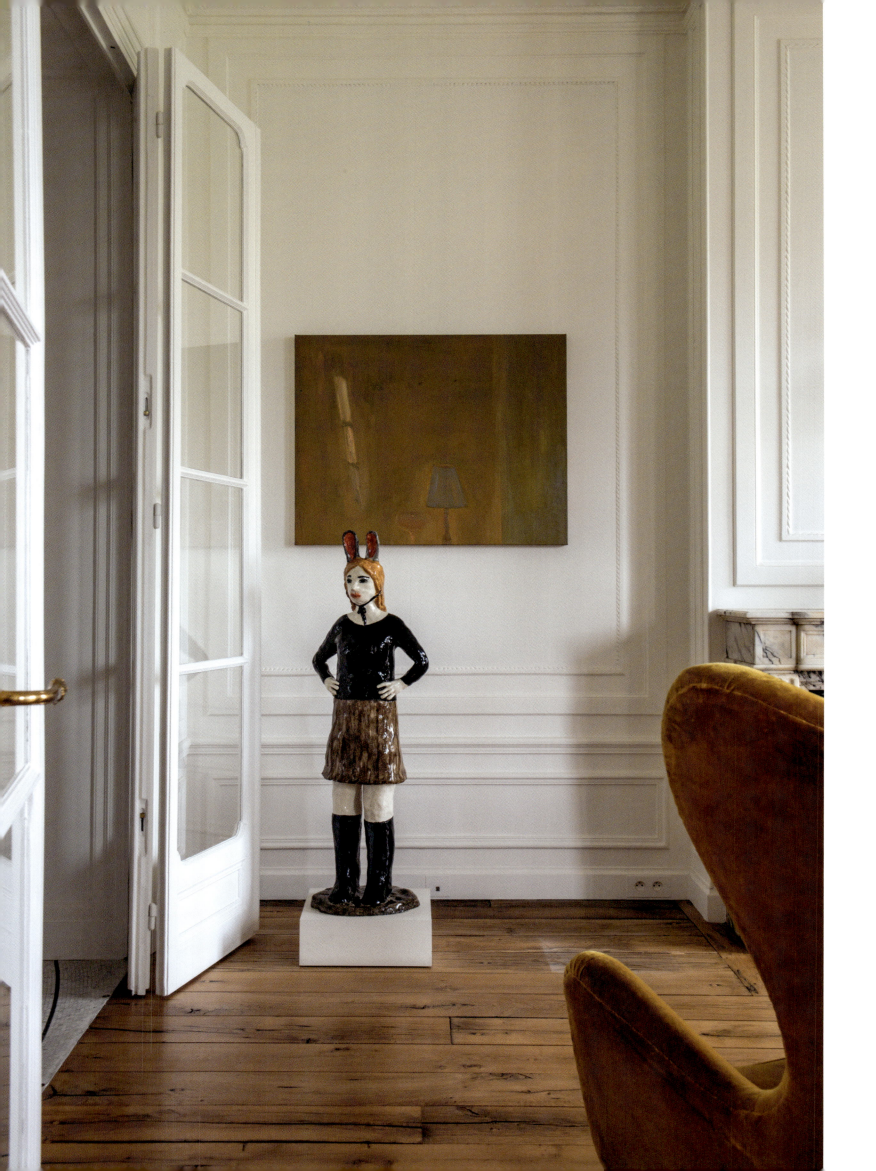

# Spatial Symphony

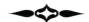

**Nestled in the prestigious Quartier du Trocadero, this apartment stands as a beacon of architectural beauty and sophisticated living, masterfully orchestrated by renowned architect and decorator, Laurent Maurice Minot. This home has been transformed into a masterpiece of interior design and functionality, reflecting the unique tastes and lifestyle of its owners.**

The apartment's south-west orientation immediately captivated the owners, flooding the space with natural light from morning till evening, and offering stunning views of the Eiffel Tower and the distant Bois de Boulogne. This luminous setting, coupled with their desire to remain within a familiar neighborhood, made the decision to purchase the property an easy one.

The apartment features eight to nine rooms, including a majestic hall that stands as a work of art in itself. Each room is thoughtfully designed, flowing seamlessly into the next, creating an open yet intriguing spatial experience. The spaces primarily serve as salons, with a grand bathroom that offers a sanctuary of relaxation and refined style.

On a rustic wagon floor, a striking sculpture by Klara Kristalova rests on a white pedestal, juxtaposed with a captivating painting by Xini Cheng. This unique arrangement seamlessly merges contemporary artistry with rustic elements, creating a dynamic interplay between form and space.

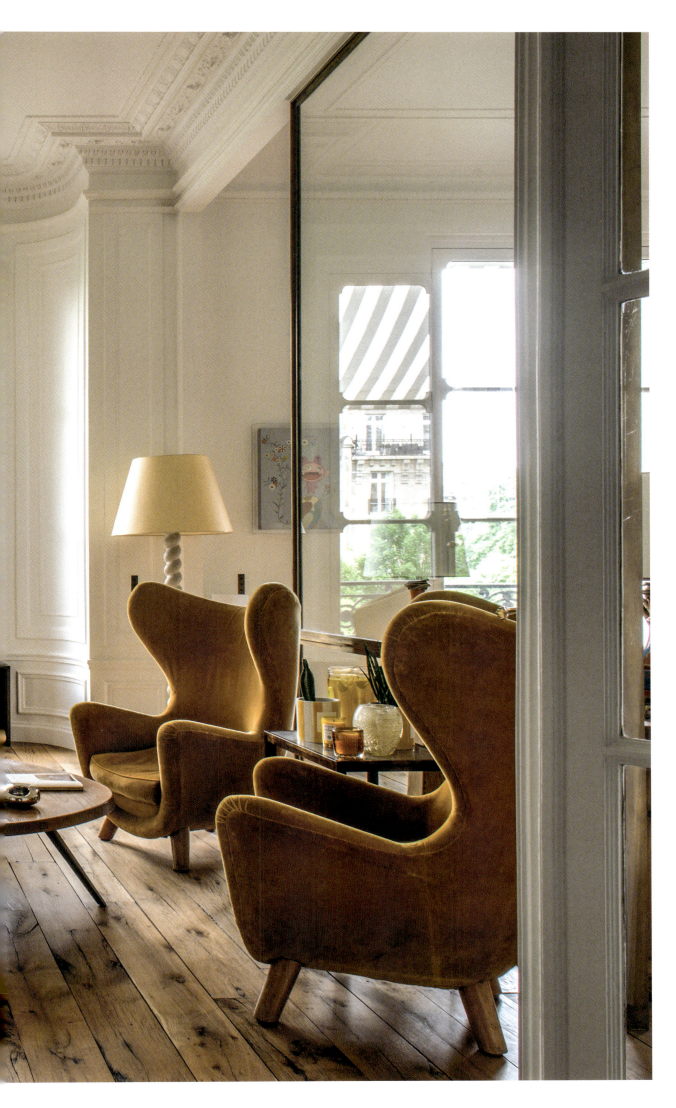

Above the fireplace, a sculpture by Sherrie Levine commands attention as a refined focal point. Armchairs and an ottoman by Jean Royère, along with a branching floor lamp from Galerie Jacques Lacoste, introduce a sense of elegance and warmth. Adding to the space's allure is a transparent partition with aged caramel brass detailing, alongside a sleek, darkly crafted radiator cover, which underscores the meticulous and sophisticated design.

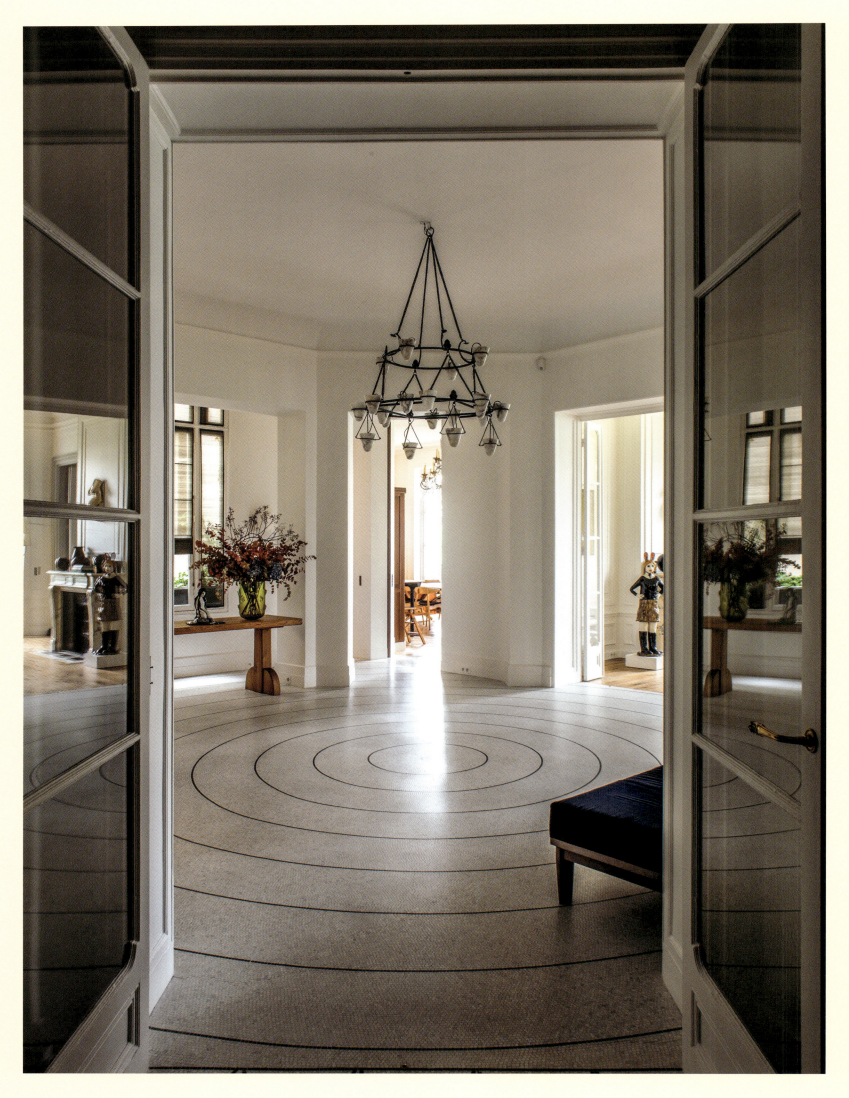

Facing away from the first two entrances, the third entryway reveals a rotunda lounge with multiple bay windows, flooded with natural light. A monumental bronze-and-alabaster suspension light, inspired by the Villa Kerylos and reminiscent of childhood memories, adds a touch of grandeur. This striking piece, sourced from Galerie Guilhem Touzellier, elevates the room's architectural drama.

> Laurent Maurice Minot's *vision* for this *apartment* is rooted in an *architectural journey* that unfolds within the interior space.

One of the most remarkable aspects of the apartment is its distinctive layout and architectural features. The entrance hall, defined by a non-rectangular parallelogram, is adorned with marble mosaics that evoke historical elegance. This leads into a pentagonal space, introducing striking geometric symmetry, which culminates in an octagonal main hall that serves as the heart of the home, where every passage and view converges.

Laurent Maurice Minot's design philosophy for this apartment centers on the idea of an architectural journey within an interior space. Every door, arch, and passageway has been meticulously crafted to enhance fluidity and grace, allowing natural light from the grand avenues outside to penetrate deep into the home's core. The custom-designed furniture, alongside carefully selected pieces, complements this fluidity, ensuring both visual harmony and functional ease throughout.

In curating their decor, the owners drew inspiration from diverse sources, including the film *Amore* and the unseen works of Gio Ponti, blending contemporary art with Scandinavian touches. This eclectic mix is skillfully integrated into the architectural style, giving the apartment a distinct yet harmonious ambiance, where history and modernity coexist in perfect balance.

Signature pieces within the home include a 1932 rug by Märta Måås-Fjetterström, which adds a layer of narrative to the design, and custom tables based on the golden ratio, providing the perfect platform for plaster works by Giacometti. These elements not only define the aesthetic of the home but also tell a story of cultural heritage and artistic achievement.

Perhaps the most satisfying project within the apartment was the complete demolition of existing partitions, creating a blank canvas for an innovative design. This allowed the reimagining of the space to respect the building's historical essence while introducing a modern layout designed for 21st-century living.

More than just a residence, this apartment is a cinematic space that captures a century of European culture, elegantly preserved and thoughtfully modernized for contemporary living. It stands as a monument to the idea that true style transcends time, seamlessly blending the past with the present in a symphony of design and function, all under the deft touch of Laurent Maurice Minot. —

(Below) A console by Axel Einar Hjorth brings an air of refined simplicity to the room, while a sculpture of a sleeping hare introduces a whimsical, gentle charm. This playful element invites curiosity and balances the space with a sense of lightheartedness.

(Right) Transparency between the lounges is beautifully achieved with a large, mirrorless frame that visually expands the space, reflecting the inviting warmth of mustard-yellow armchairs and natural wood accents.

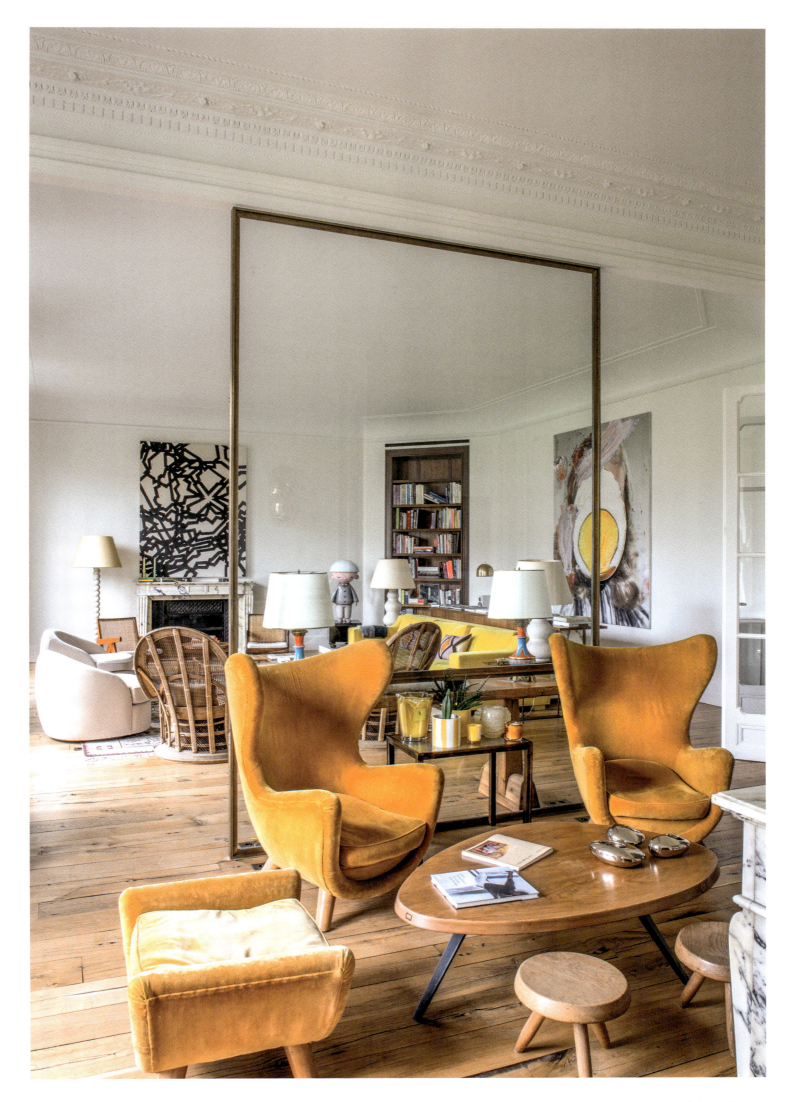

Spatial Symphony

The *Ratio* table by Rasmus Fenhann (Galerie Maria Wettergren) commands attention, resting atop an intricate 1932 antique rug designed by Märta Måås-Fjetterström. Nearby, Swedish *Bergboms* lamps by Eje Ahlgren (1960) grace an architectural sideboard, drawing the eye to a monumental painting, *Last Problem* by Urs Fischer. Its striking yellow egg motif provides a bold and surreal focal point, anchoring the room with artistic drama.

Paris Living

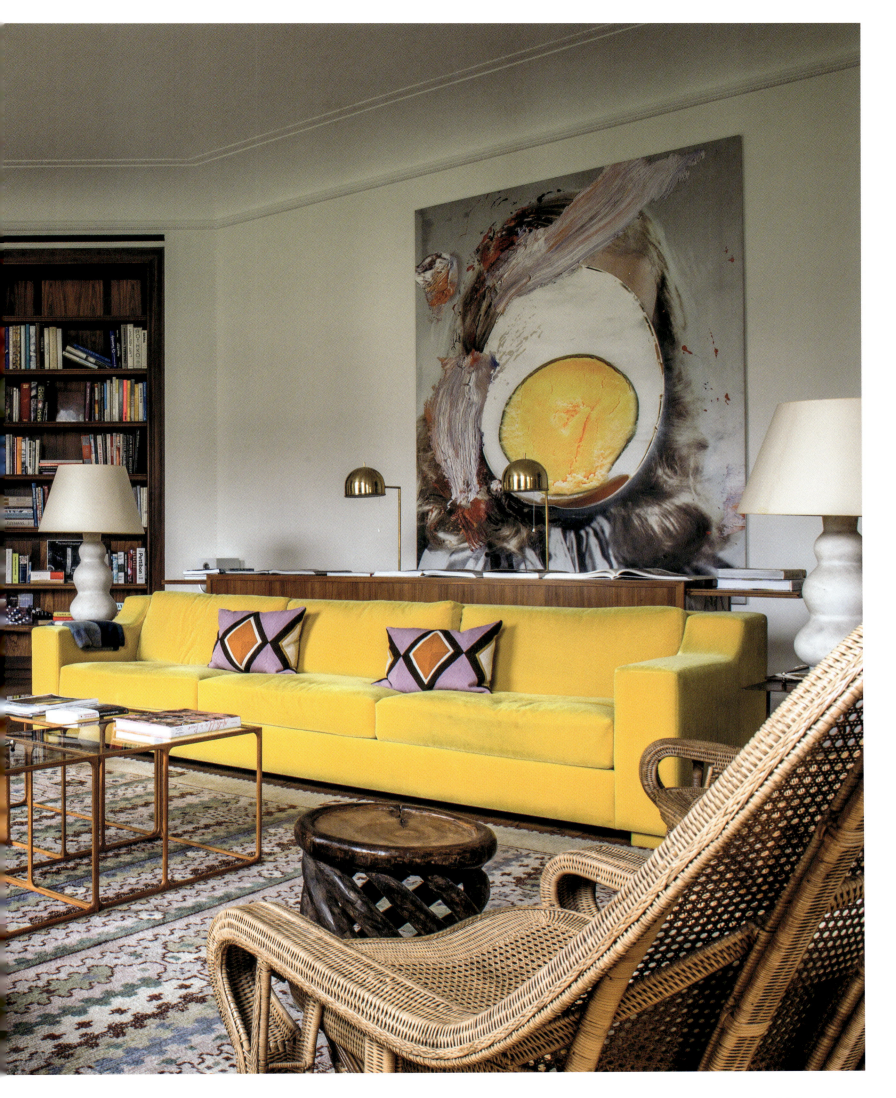

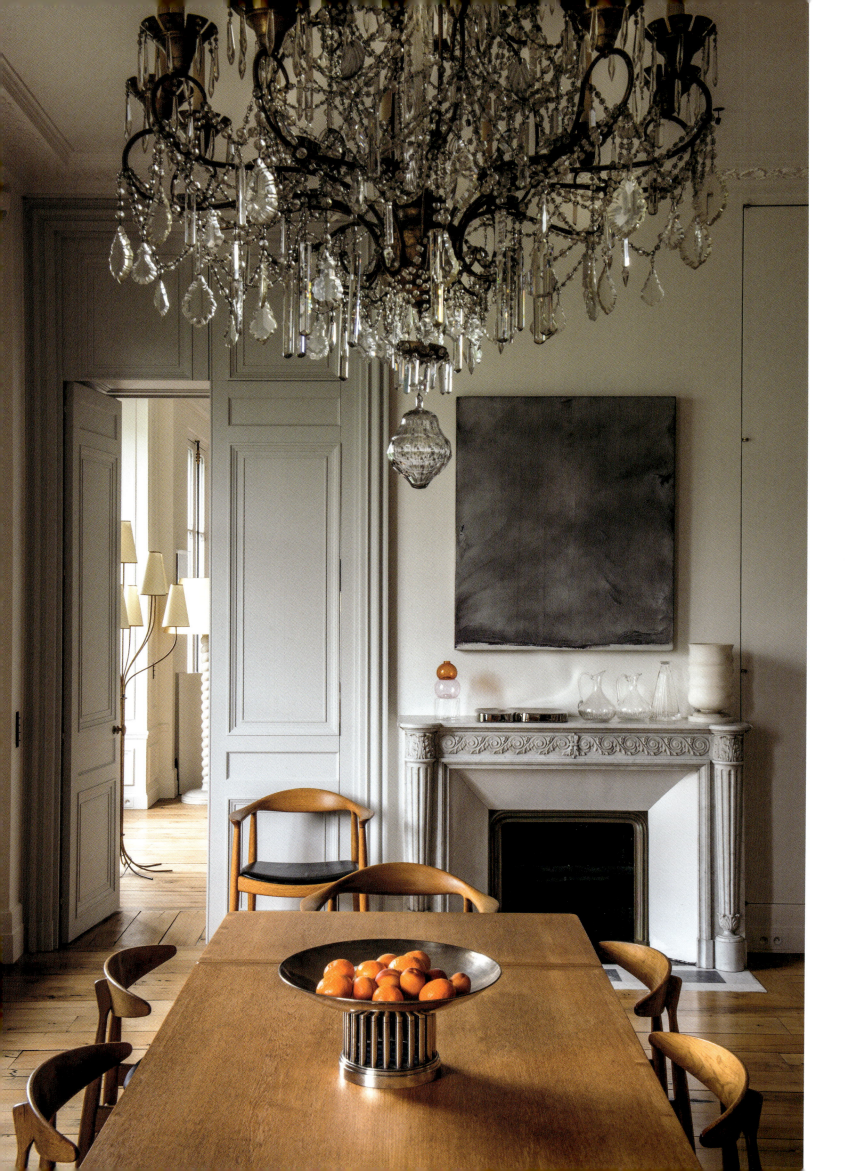

(Left) The dining room showcases monumental faux double doors inspired by the Directoire-style, seamlessly integrated into the architecture. Above the ornate fireplace, a minimalistic painting by Rudolf Stingel offers a contemporary counterpoint. A Hans Wegner dining table and chairs embody Danish craftsmanship, while a grand crystal chandelier casts a warm, timeless glow, balancing classic sophistication with modern aesthetics.

(Right) Refined simplicity defines this space, where two elegant buffets by Børge Mogensen flank the room with understated grace. Above the console, a minimalist artwork by Wade Guyton introduces a contemporary edge, thoughtfully contrasting the classic crystal chandelier overhead.

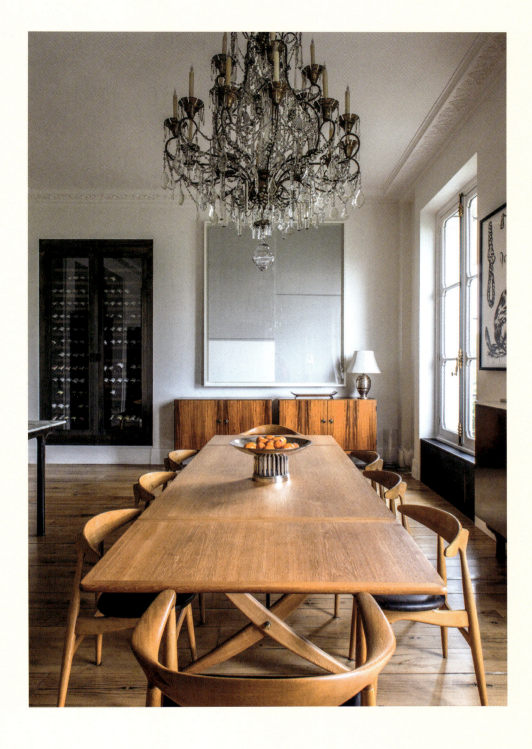

More than just a *residence*, this apartment is a *cinematic tableau* capturing a century of *European culture*.

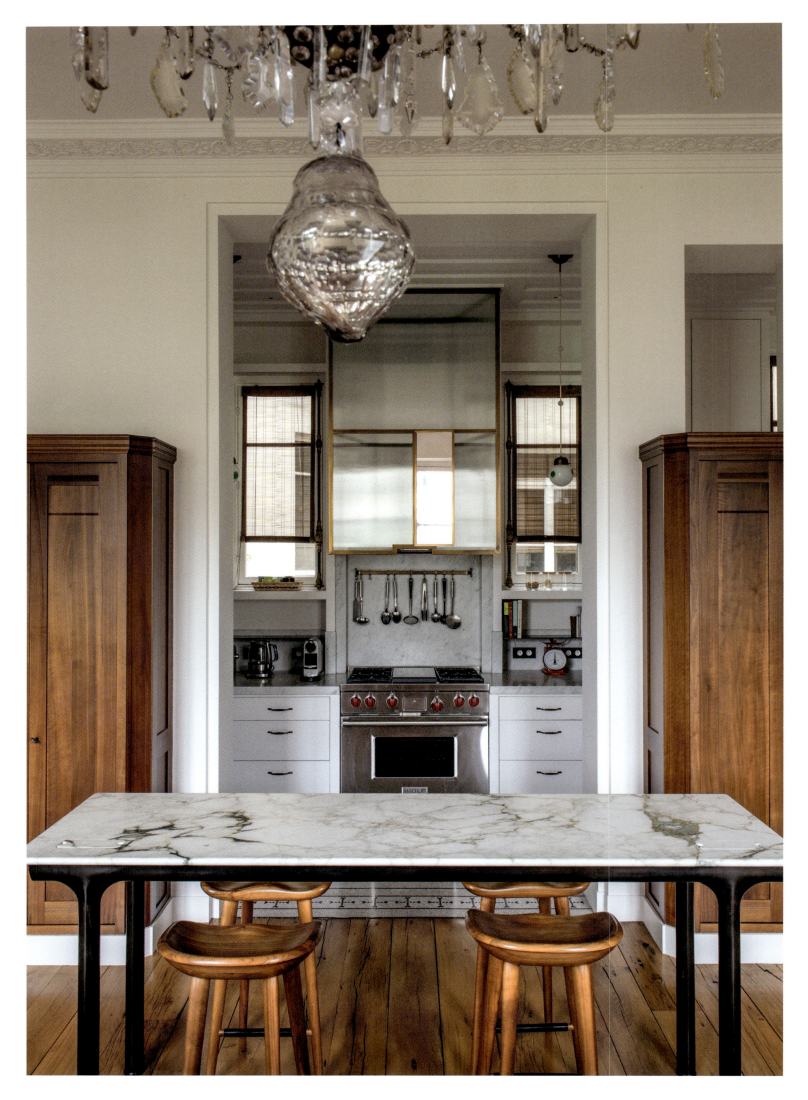

Paris Living

(Left) The kitchen achieves harmonious design through perfectly balanced faux symmetry: two walnut cabinets, a tribute to a German piece from the Château d'Aglie, frame a mirrored range hood. A marble-topped island and sleek stools add modern functionality, seamlessly complementing the warmth of the wood elements to create an inviting, contemporary kitchen.

(Below) A Roman-inspired Stabia floor anchors the kitchen, while the ceiling evokes the airy elegance of a Tehran *loggia*. Viennese pendant lights add nostalgic, classic charm, completing this cosmopolitan culinary setting.

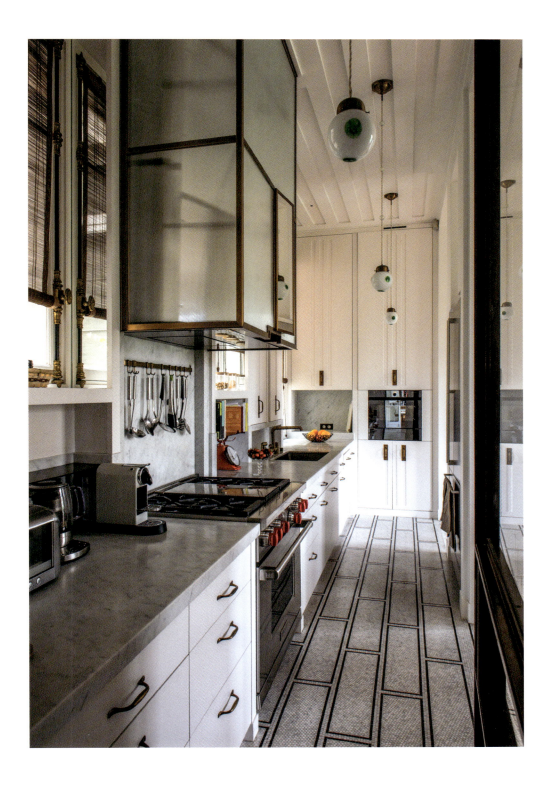

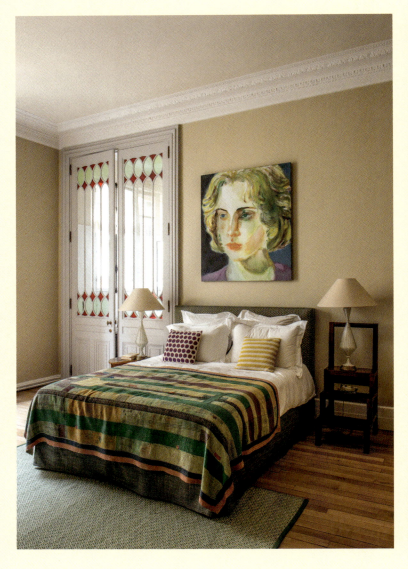 

(Above left) In the guest bedroom, a contemplative portrait by artist Jiang Cheng hangs above the bed, lending a personal and introspective atmosphere to the room.

(Above right) A striking double door by Laurent Maurice Minot, adorned with stylized fish motifs, elegantly echoes the charm of a private mansion in Avignon.

(Right) The primary bedroom achieves a harmonious interplay of art and texture, anchored by a striking Andy Warhol sketch of Mao, which takes pride of place above a marbled fireplace. Animal-patterned rugs by Gabrielle Soyer Lindell & Co. introduce an exotic playfulness to the hardwood floor, while artworks by Nathanaëlle Herbelin (left) and Michaël Borremans (right) enhance the space with sophisticated artistic depth.

The apartment stands as a *monument* to the idea that true style *transcends time.*

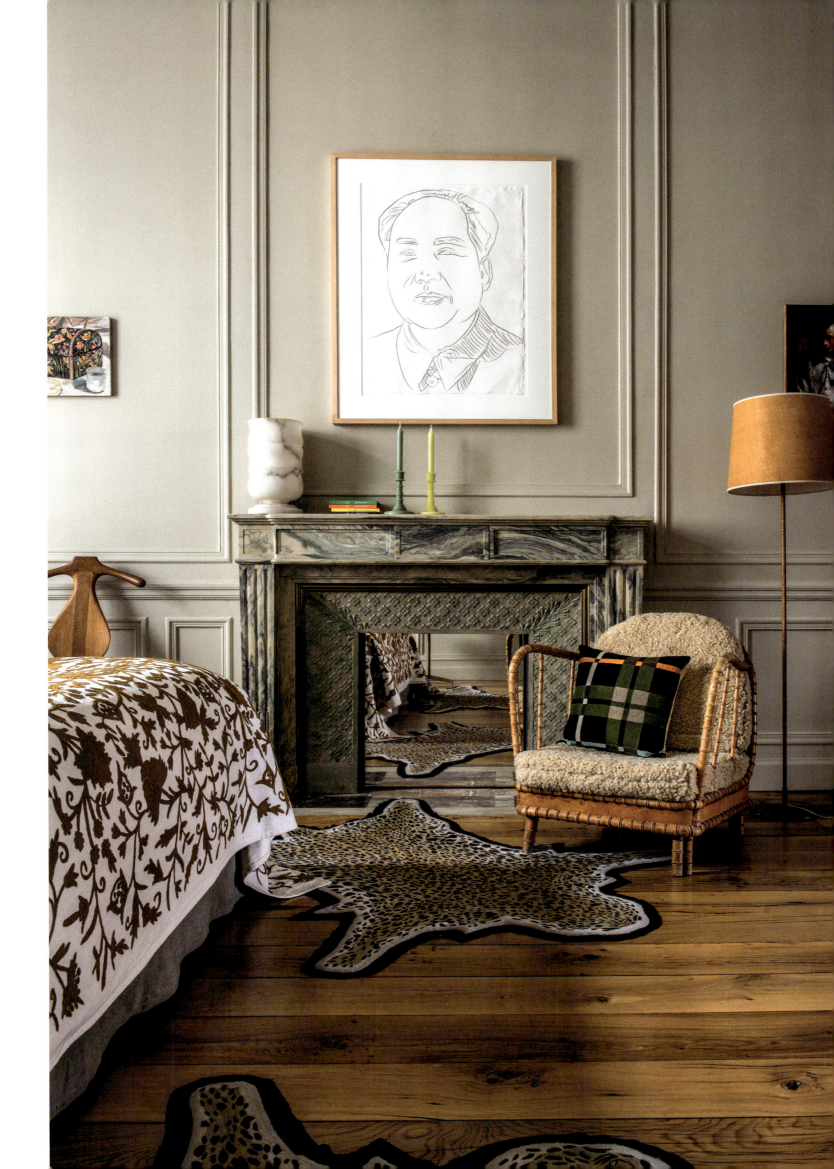

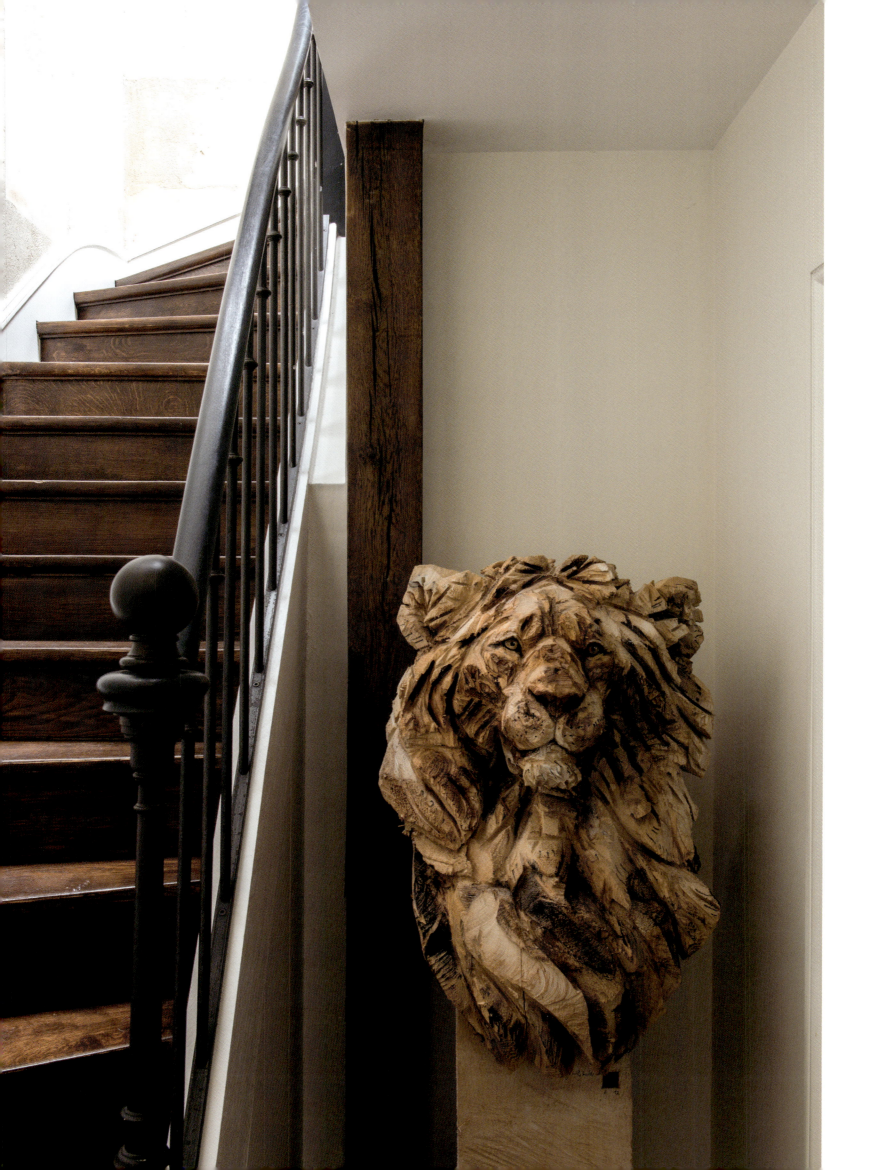

# Cosmopolitan

**In the heart of Paris, a former stable has been transformed into a serene pied-à-terre for a cosmopolitan New York couple. Just steps from Stéphane Olivier's renowned antique gallery on Rue de l'Université, this home is a peaceful escape amidst the bustling neighborhood of Saint-Germain-des-Prés.**

The couple purchased the property five years ago, captivated by the quiet ambiance of the cobblestone courtyard and the quintessential Parisian charm of the stone facade.
To bring their vision to life, they entrusted their close friend, Stéphane Olivier, a distinguished antiques dealer and decorator known for his Nordic-rustic style. With his talent for blending natural materials and charm, Olivier reimagined the space, transforming the stable into a spacious three-bedroom home, with a double living room, a large kitchen opening onto a terrace, and a cozy fireplace. Now, it's the perfect retreat for the American family, who often gather in Paris with their children and grandchildren, enjoying both the city's cultural scene and their close-knit circle of French friends.

A commanding lion's head sculpture by Jürgen Lingl-Rebetez, expertly crafted with a chainsaw, captures the fierce intensity of the lion's gaze and the majestic flow of its mane. This masterful piece exemplifies Lingl-Rebetez's unique ability to transform raw wood into lifelike, emotive works of art.

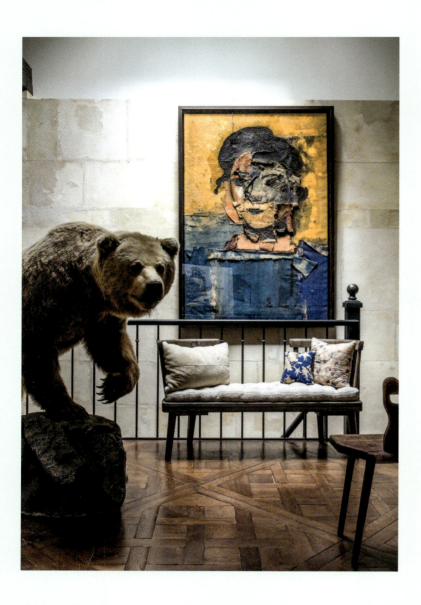

A grizzly bear mount, posed atop a rugged rock, brings the untamed spirit of the wild into the home. Nearby, a vibrant collage painting by Manolo Valdés adds a burst of modern artistry. A rare *Uto* bench in pine wood by Axel Einar Hjorth for Nordiska Kompaniet (c. 1932) offers timeless Scandinavian craftsmanship, complemented by a Swedish folk art low chair in pine.

Olivier's design philosophy focused on creating warm, calming spaces. He preserved the home's lofty ceilings, allowing natural light to pour in throughout the day. A soft, neutral color palette enhances the light, resulting in an airy, serene atmosphere. Though equipped with modern conveniences, the home retains a sense of comfort and coziness—a welcoming refuge in the lively Saint-Germain neighborhood.

Nature was the guiding inspiration for the decor. Olivier chose noble materials like wood, wool, linen, silk, leather, and beautiful organic-toned stones to create an inviting, luxurious environment. The furnishings are an eclectic blend of styles and eras, seamlessly transitioning from 18th-century antiques to contemporary art. This thoughtful curation creates an elegant harmony where each piece contributes to the overall character of the home.

*Nature* was the *guiding inspiration* for the decor. Olivier chose noble materials like *wood, wool, linen, silk, leather,* and beautiful organic-toned *stones* to create an inviting, luxurious environment.

A 19th-century Swedish clock cabinet stands gracefully beside an 18th-century pair of French low-back chairs in bleached oak. Adding mid-century elegance, tall Swedish armchairs upholstered in off-white lambskin (c. 1950) are paired with two earthy Paul Kingma coffee tables from the 1980s, their embedded white stones adding texture. A rustic olive trunk table with a blue slate top completes this curated ensemble.

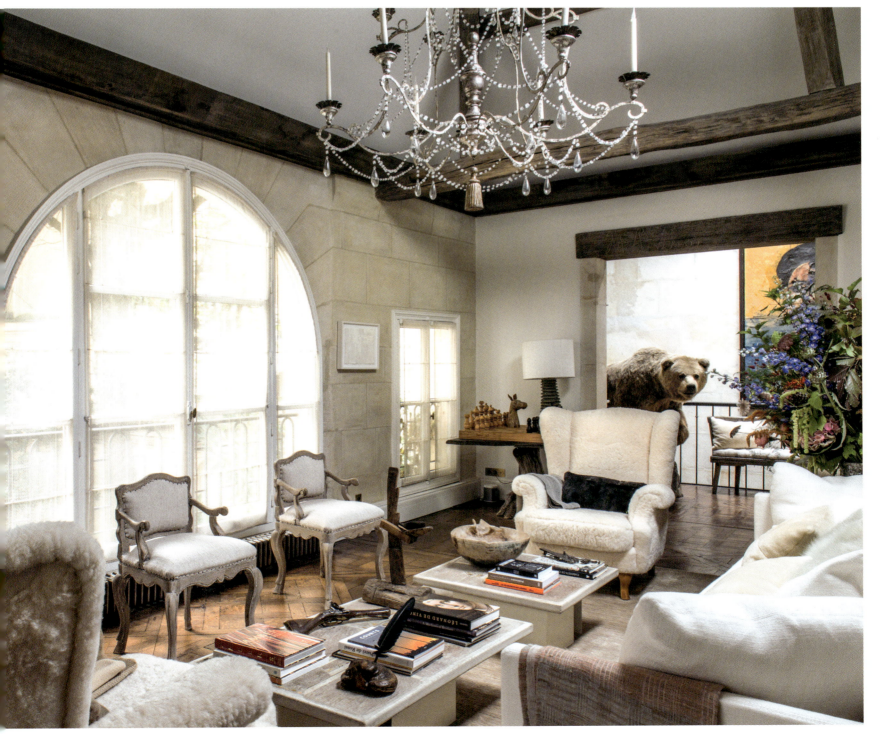

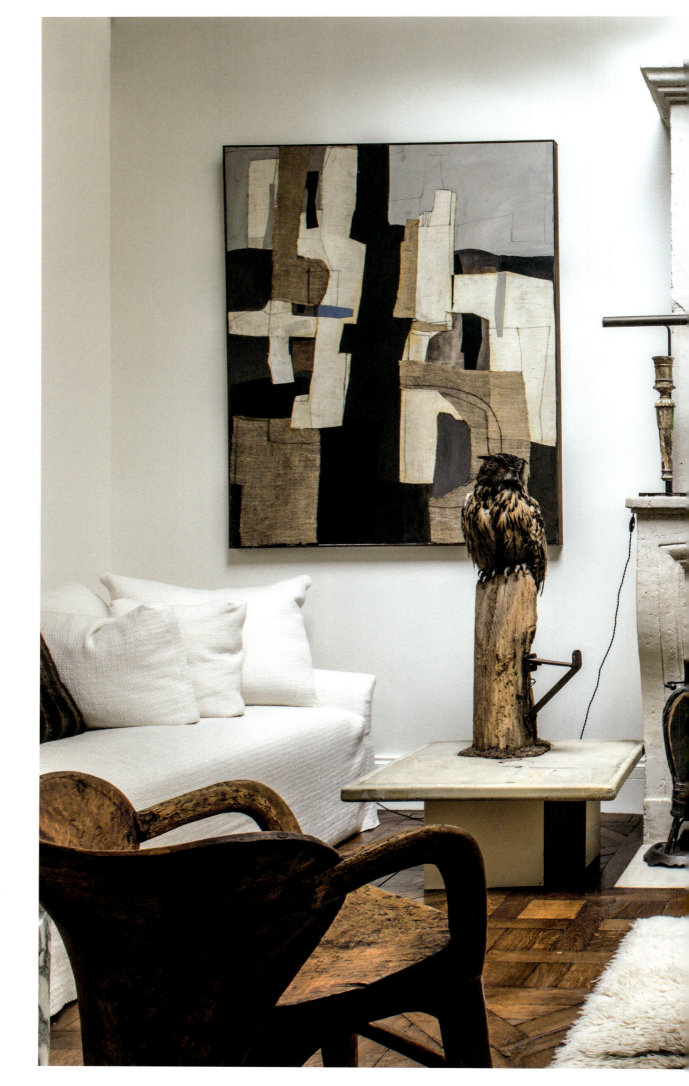

A 2016 collage by Edoardo Menini (Galerie Stéphane Olivier) juxtaposes an 18th-century French carved and gilt wood mirror with matching gilt wood lamps, creating a dialog between eras. A 1950 brown ceramic vase by Carl Harry Stålhane adds mid-century elegance, while rustic Swedish elements, such as the primitive blue trunk, evoke timeless charm. Other standout pieces include a high-back bronze and leather chair by François Thevenin, a painted child's low chair, and leather-and-wood fishermen's boots, all unified by Ann Jonasson's 1979 *Migrating Birds* rya rug from Finland.

Paris Living

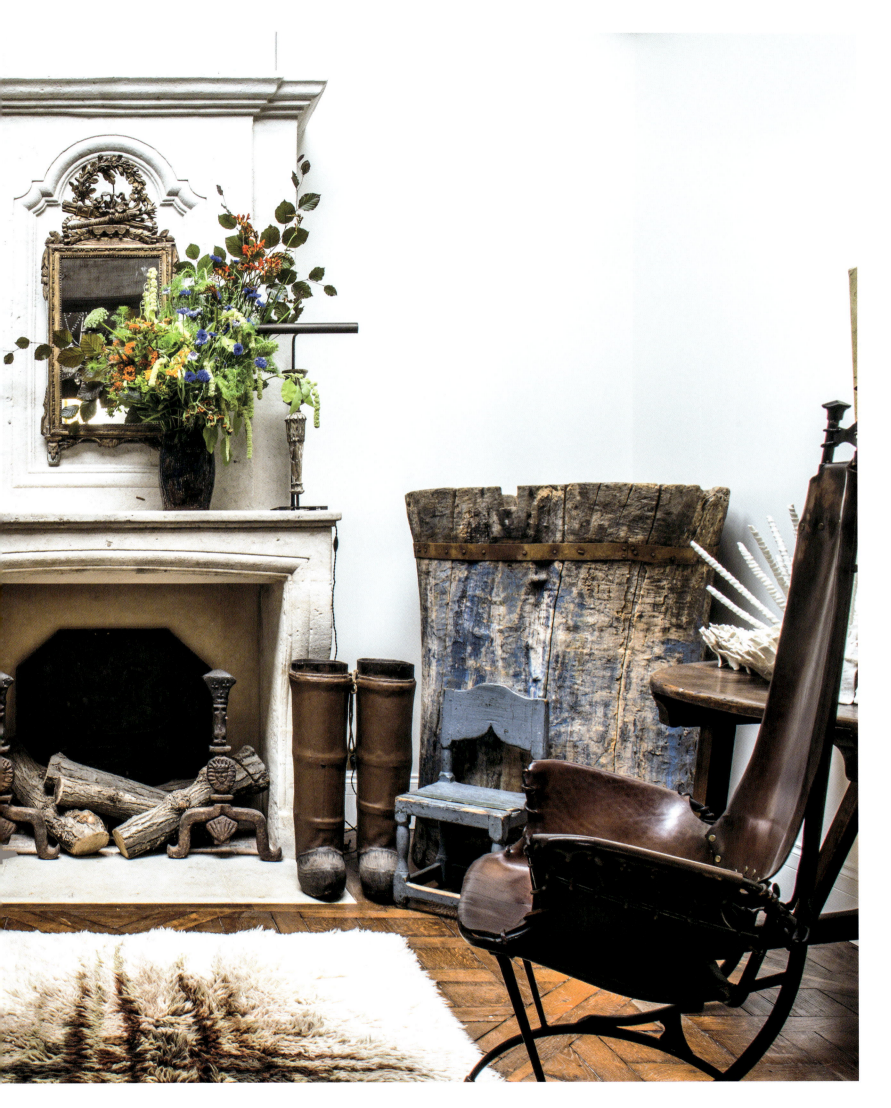

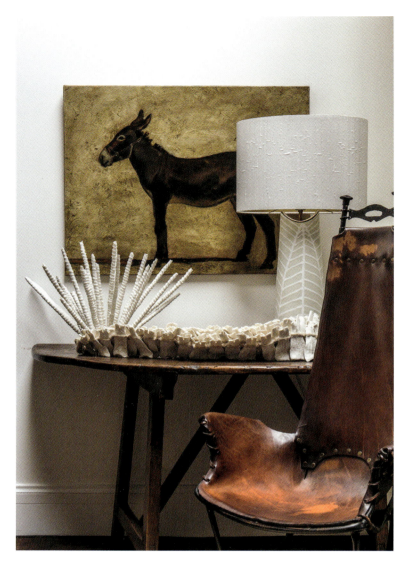

(Above left) Modern artistry meets vintage refinement with Grégoire Hespel's 2020 oil painting of a donkey and Bénédicte Vallet's 2018 biscuit porcelain sculptures (Galerie Stéphane Olivier). These are elegantly paired with a 19th-century Italian walnut console and a 1970 ceramic table lamp by Mari Simmulson (*Fossil* for Upsala-Ekeby), adding vintage appeal and character. Completing the ensemble is a sculptural high-back bronze and leather chair by François Thevenin, elevating the space with its bold, artisanal presence.

(Above right) A 1962 black aluminum wall sconce, *Mod CP1* by Charlotte Perriand, adds a sleek, sculptural element, while three Argus pheasant feathers from New Guinea lend an organic, exotic accent.

(Right) A rare 1948 adjustable pendant lamp by Paavo Tynell for Taito Oy, crafted in perforated brass and frosted glass, infuses the space with vintage elegance. A collection of shoe horses and farrier signs introduces industrial charm, while an iron cow's head and a 19th-century Italian farm table underscore a rugged, pastoral aesthetic. Seating includes *Hunter* chairs by Børge Mogensen (1968) in leather and natural oak, complemented by *Tree Men* candelabras by Edouard Chevalier (2022) from Galerie Stéphane Olivier.

The furnishings are an *eclectic blend* of *styles* and *eras,* seamlessly transitioning from *18th-century* antiques to *contemporary* art.

Paris Living

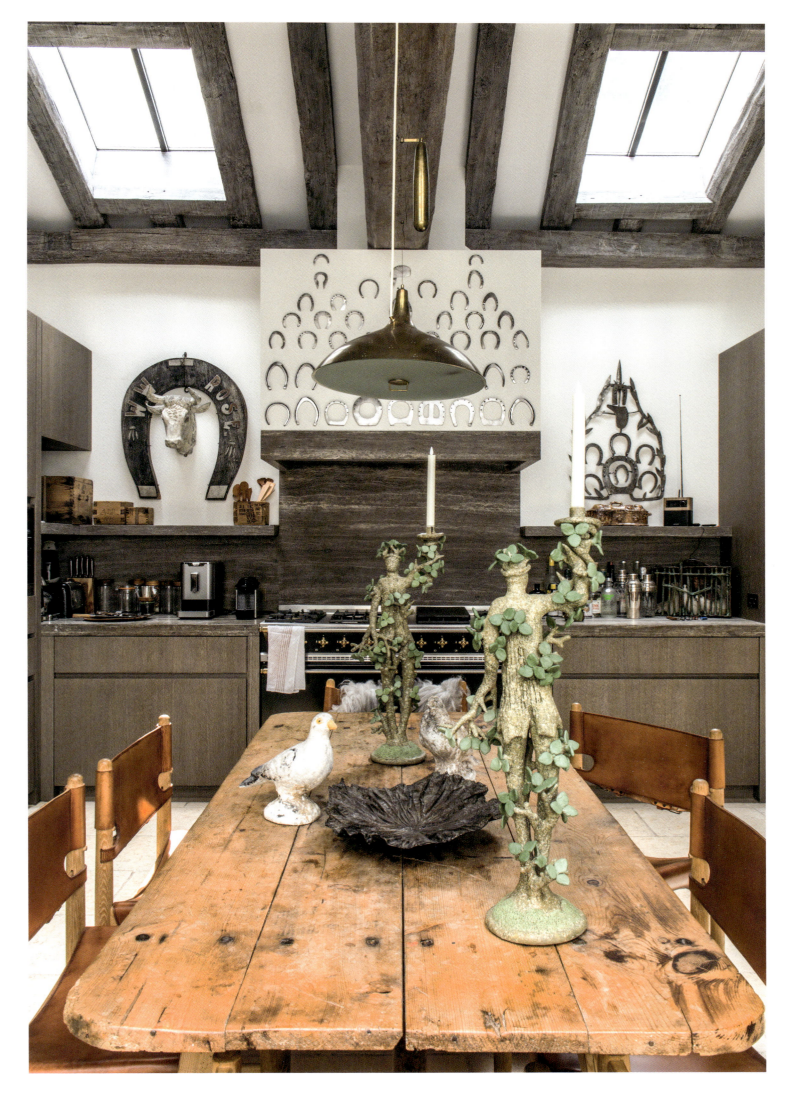

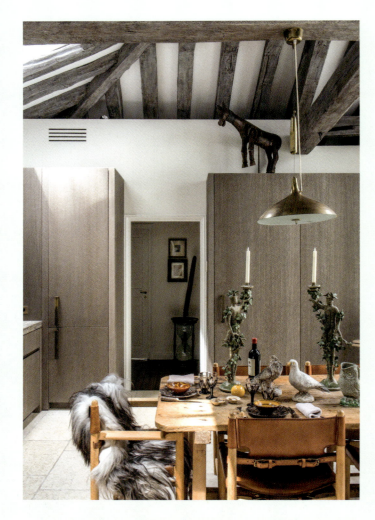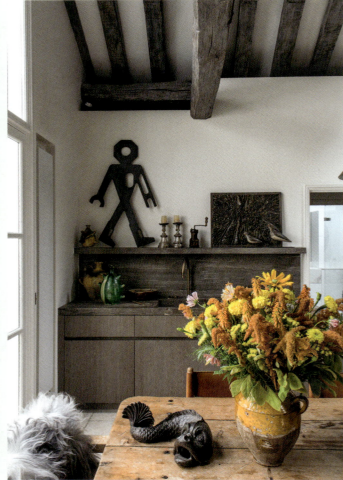

Paris Living

One of the owners, an avid collector with a keen eye for meaningful objects, has a particular affinity for the Arte Povera movement. His personal collection, combined with Olivier's curated selections, imbues the home with timeless and rich narratives.

In addition to the design elements, personal touches abound, making the space a true reflection of the owners' personalities. From vintage pieces to art collected from around the world, each object tells a story. The couple's passion for travel is evident in the diverse decor, where every corner offers a glimpse into different cultures and styles. Yet despite its cosmopolitan influences, the home remains quintessentially Parisian at heart, with its classic architecture and effortlessly chic atmosphere. It's a place where past and present, tradition and modernity, converge in perfect balance, creating a timeless haven for the family's cherished moments in Paris.

More than just a place to stay, this pied-à-terre is a beautifully designed sanctuary where history, art, and nature come together in perfect harmony, offering its owners a peaceful retreat from the world outside. —

> In addition to the design elements, *personal touches* abound, making the space a *true reflection* of the owners' personalities.

From *vintage pieces* to *art* collected from around the world, each object *tells a story*.

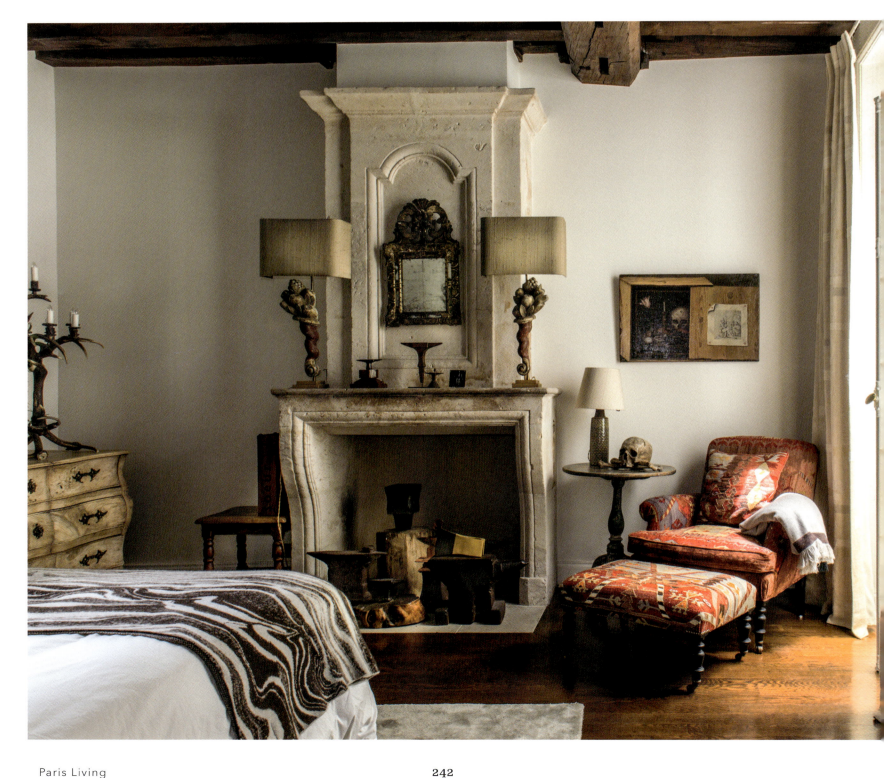

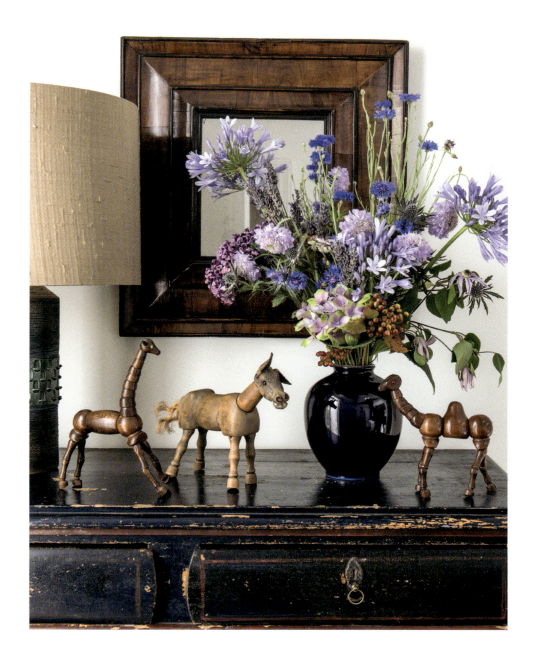

(Left) An 18th-century French chest of drawers in natural walnut exudes timeless charm, paired with a Regency-period gilt wood mirror. A pair of table lamps with carved gilt wood cornucopias add a touch of opulence, while a collection of anvils introduces an industrial edge. A small 1950s table lamp by Søholm Denmark infuses mid-century flair, and an oil painting in trompe l'œil technique creates a captivating, artistic illusion.

(Above) A whimsical collection of toys adds playful charm, balanced by the sophistication of a 17th-century Italian walnut mirror. Together, they embody both the innocence of childhood and the refinement of historical craftsmanship.

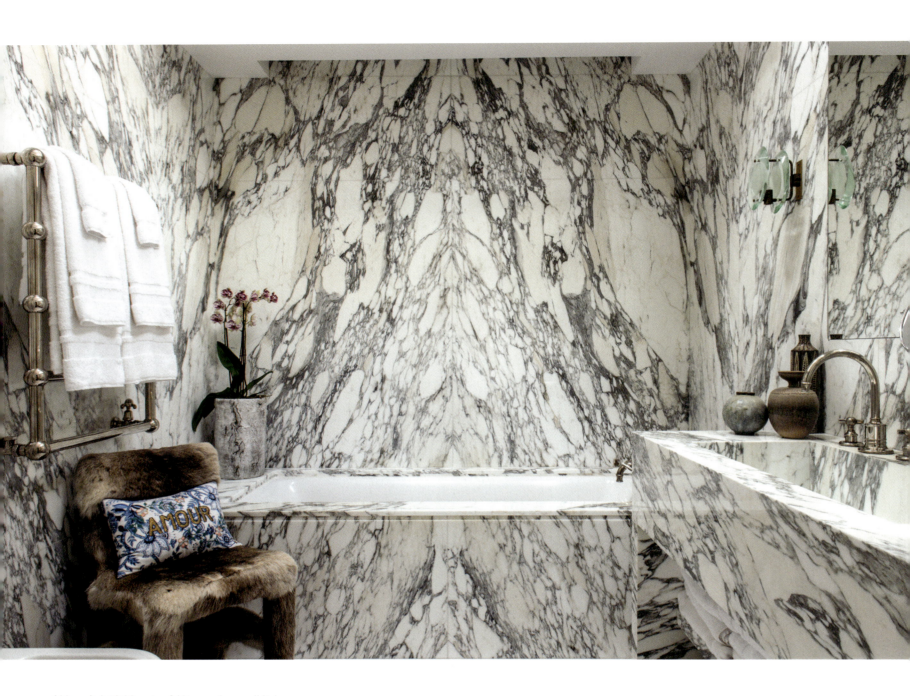

(Above) A 1960 pair of *Micron* glass wall lights by Fontana Arte, Italy, provides a soft sophisticated glow, while a collection of ceramic vases by Arne Bang adds sculptural texture and handcrafted beauty.

(Right) Repurposed 19th-century Swedish painted doors bring history to life as cupboards, complemented by a framed *Verdure* tapestry from the same era, evoking lush, botanical imagery. A Gustavian painted wood bedside cabinet completes the setting with classic Scandinavian refinement.

More than just a place to stay, this *pied-à-terre* is a beautifully designed *sanctuary* where *history, art,* and *nature* come together in perfect harmony.

# Cultural Heritage

**Marie Victoire Poliakoff, a dedicated gallerist in the heart of Saint-Germain-des-Prés, passionately upholds the artistic legacy of her grandfather, the renowned abstract artist Serge Poliakoff. Her charmingly arranged apartment serves not only as her home but also as a tribute to her family's artistic heritage, filled with cherished childhood memories and some of her grandfather's most exquisite paintings.**

Centered on a 1968 abstract composition by her grandfather, Serge Poliakoff, are an eclectic array of contemporary works: red silhouettes by Floc'h, a wooden form by Franz Absalon, a feathered egg by Brigitte Cardinal, and *Forêts Bleues* by Maria de Morais. The dollhouse cabinet, crafted by her daughter's father, illustrator Floc'h, is adorned with miniature sculptures by Bernard Cousinier and Laurent Baude, alongside a portrait by Michael Lindsay-Hogg. Plaster pieces and a table from Maison Lorenzi complete this artful display.

Within her home, Poliakoff has created more than just a living space; she has crafted an environment that reflects the nostalgic atmospheres of her youth, capturing the spirit of Rue de Seine, a street that epitomizes artistic vibrancy in 1960s Paris. It was here that Paris's art elite—friends, artists, collectors, and dealers—gathered, and where Poliakoff recalls formative moments of her childhood. Equally significant is the family estate in the countryside, which Serge Poliakoff purchased for his beloved wife, Marcelle. This estate and its surroundings became a creative haven for the family, filled with warmth and a lively atmosphere that deeply influenced Marie Victoire's early years.

Within her home, Poliakoff has crafted an environment that *reflects* the *nostalgic atmospheres* of her *youth*.

In the library, daughter Sacha's first painting is displayed alongside the renowned *Musée Miniature de Marie Victoire*, created in 1991 by talented artists. Meticulously detailed sculptures and paintings at 1/10th scale add whimsical charm to the space.

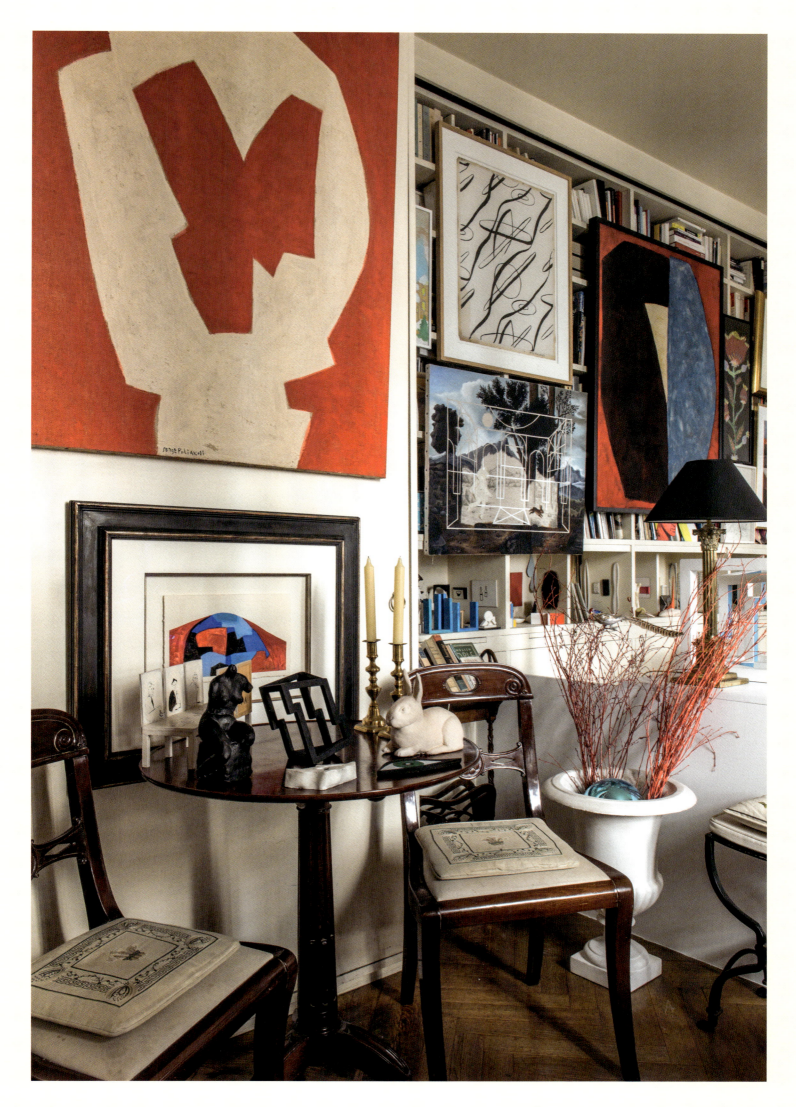

This space celebrates the legacy of Serge Poliakoff, with his works complemented by a portrait of Guillaume Apollinaire by Alexis Poliakoff, a Casa Lopez rug inspired by Poliakoff's designs, and sculptures by Rupert Mair, Sébastien Kito, and Irina Volkonskii-Rasquinet. In the background, a portrait of Jane by American artist Duncan Hannah adds a layer of narrative depth. The game table features delicate porcelain flowers from Cabinet de Porcelaine and Malicorne earthenware, adding an air of sophistication. Seating includes Marcel Breuer's *Wassily* chair by Knoll, an *AA* butterfly chair by Airborne, and a sofa by Belgian brand Du Long et Du Lé.

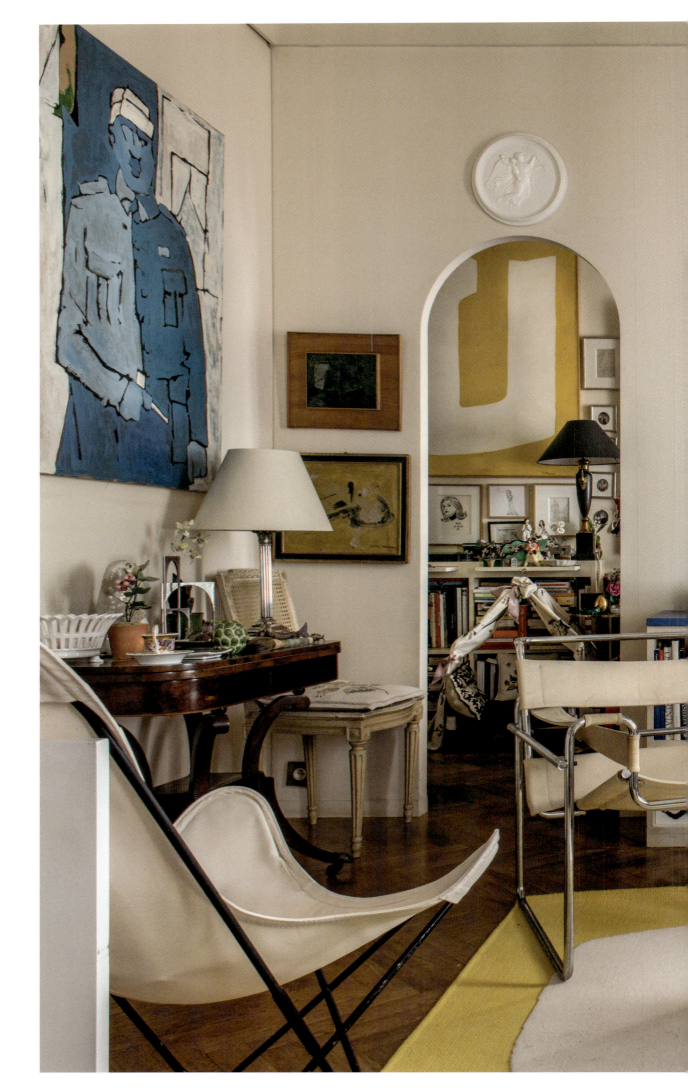

Paris Living

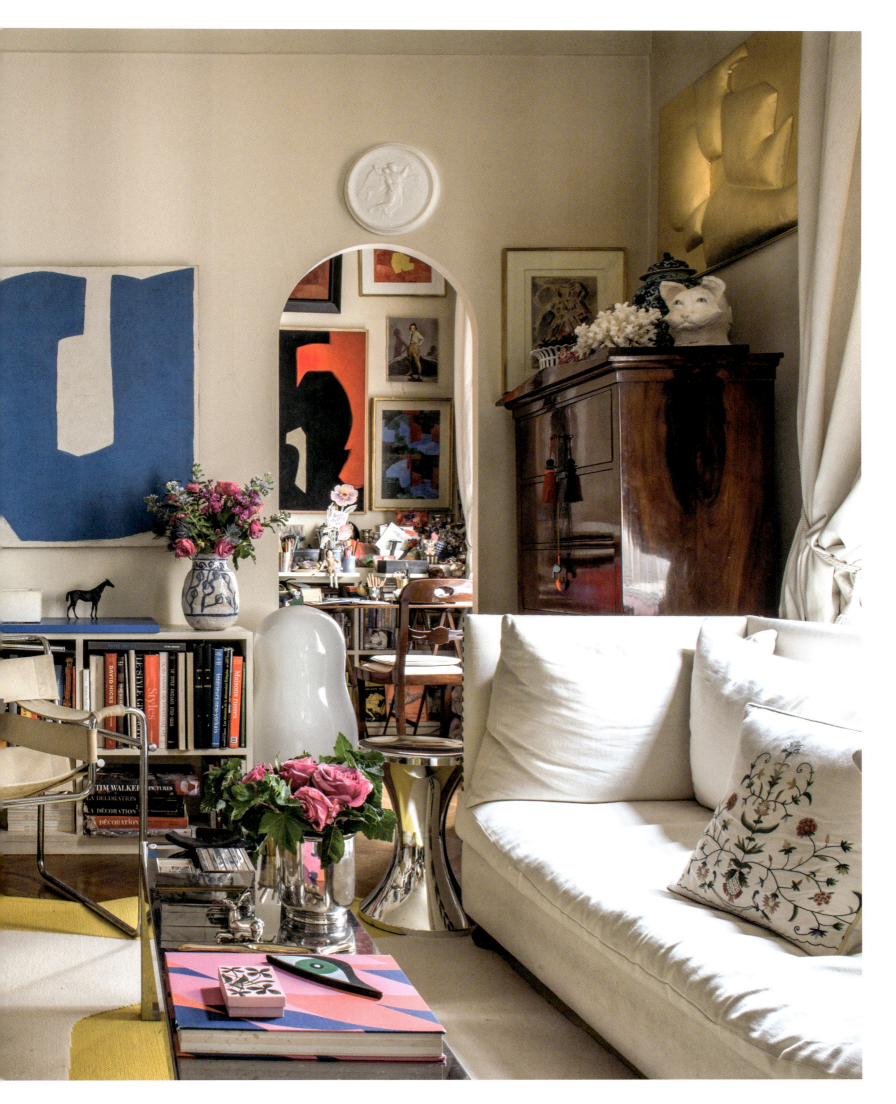

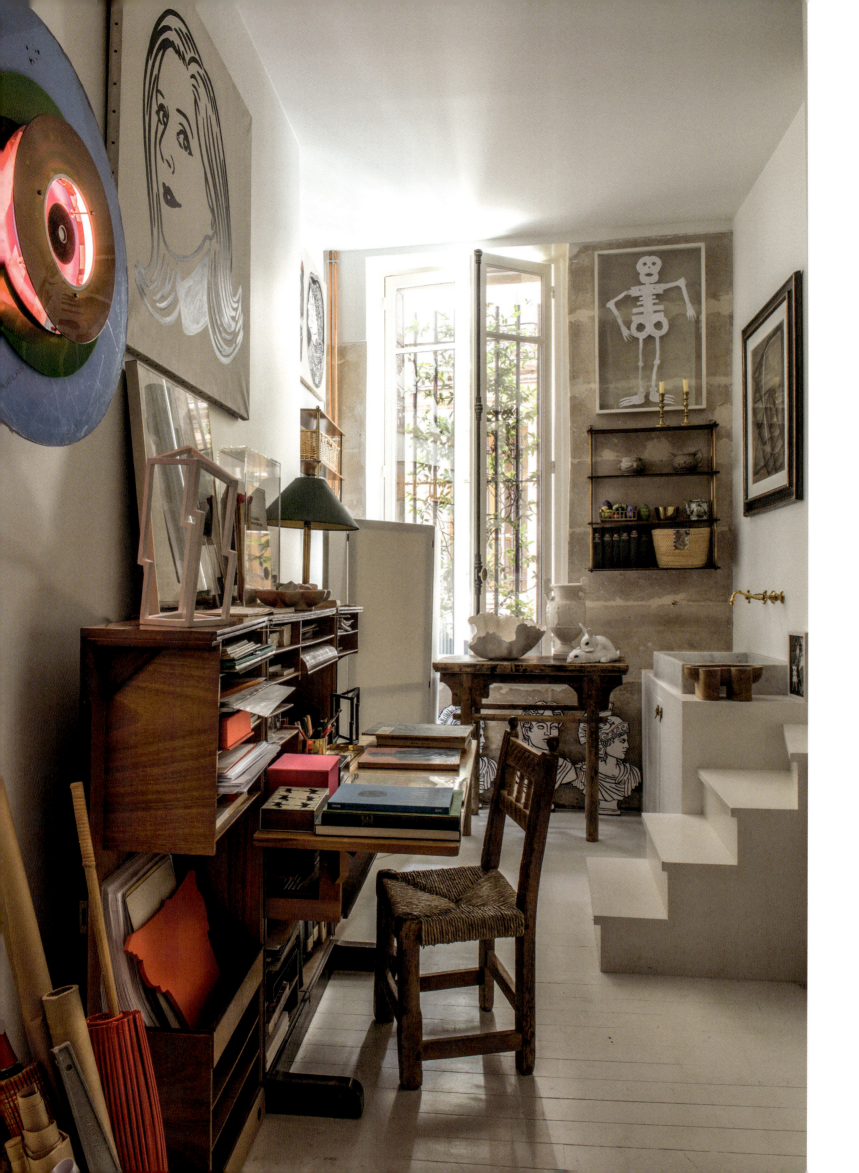

Above the *Bureau Magic Box* by Mummenthaler & Meier (Switzerland, 1960s), a curated display features a portrait of Marie Victoire by Floc'h, a target by Laurent Baude, a tribute to Raymond Hains by Stéphane Calais, and *Passevolume* sculptures by Bernard Cousinier. The eclectic mix is enriched with a form by Romain Taïeb, *Kanaria's rabbits*, a wooden sculpture by Julian Schwarz, and a paper-cut skeleton made by Sacha as a child.

Her home today is a narrative space where every object and artwork holds a story of familial bonds and artistic devotion. The decor is a meticulously curated palette of deep reds, brilliant blues, and nuanced greens, reflecting her Slavic roots and evoking memories of a vibrant past. Alongside her grandfather's artwork from the late 1960s are eclectic furnishings, including a robust marble table with griffon feet and a quaint wooden dollhouse in the living room.

Beyond her personal connection to art, Poliakoff is also a staunch advocate for contemporary artists. Her gallery, just a short walk from her home, has been a cultural landmark for three decades, born from the inspiration of a trip to New York. Through her gallery, she nurtures new talent and continues the artistic dialogue that her grandfather championed.

In her home, daily life is interwoven with a rich artistic legacy, where preservation meets celebration. The objects, whether famous or anonymous, share the same space, reflecting her heart and vision. Her apartment is a living museum, a cultural salon, and a tribute to Serge Poliakoff's enduring influence, all while embracing the evolving world of contemporary art. —

> In her home, *daily life* is interwoven with a rich *artistic legacy*, where *preservation* meets *celebration*.

(Below) Every item tells a story of travel, weaving a deeply personal tapestry of memories: Wedgwood, Staffordshire dogs, mercury glass candleholders, paperweights, traditional baskets from around the world, Iranian glassware, Russian folk art, Chinese porcelain, German Christmas baubles, Nuremberg tin figurines, Astier de Villatte plates, and a delightful *Peter Rabbit* collection.

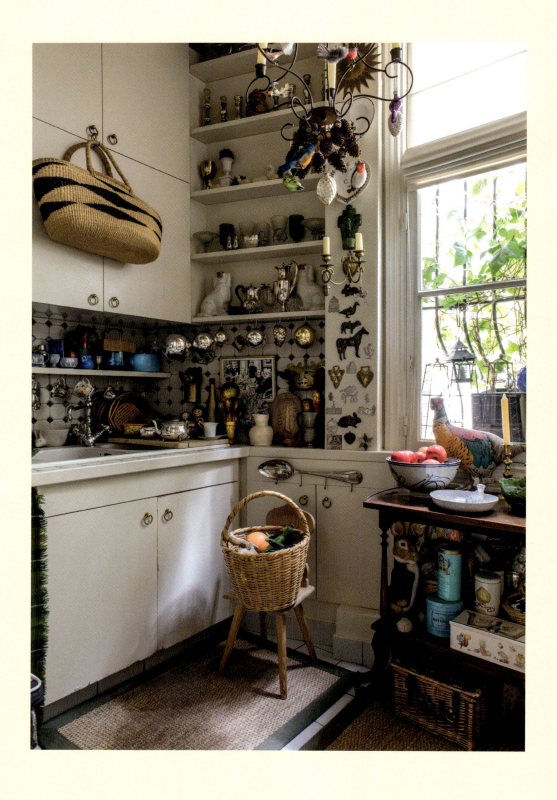

"Show me your home, and I will tell you who you are." A home reveals a lot about its owner. Each of these Parisian interiors, from diverse neighborhoods across the city, offers a glimpse into the secret and intimate lives of those who live there, whether artists, designers, gallery owners, architects, or stylists.

Amidst this rich variety of styles, decorative worlds, and personalities, I extend my heartfelt gratitude to all those who graciously opened their doors and supported this project. Some of these stories came to life thanks to the friendly collaboration of journalists, including Anne Rogier from *Point de Vue*, Philippe Seulliet, Muriel Gauthier, and Pascale de la Cochetière.

Special thanks go to Juliette de Laubier for introducing me to the creative talents of her friends, Desiree Sadek for her tireless efforts in discovering and promoting Lebanese decorators both locally and globally, and Maria Aziz, who managed the editorial work from Beirut under increasingly challenging circumstances due to political upheaval. — **Guillaume de Laubier**

TEXT & PHOTOGRAPHY
**Guillaume de Laubier**

BOOK DESIGN
**Han van de Ven**

EDITING
**Melanie Shapiro**

Sign up for our newsletter with news about new and forthcoming publications on art, interior design, food & travel, photography and fashion as well as exclusive offers and events. If you have any questions or comments about the material in this book, please do not hesitate to contact our editorial team: art@lannoo.com

© Lannoo Publishers, Belgium, 2025
ISBN: 9789020930580
NUR 454/450
D/2025/45/254
www.lannoo.com

All rights reserved. No part of this publication may be reproduced or transmitted in any form or by any means, electronic or mechanical, including photography, recording or any other information storage and retrieval system, without prior permission in writing from the publisher. Every effort has been made to trace copyright holders. If, however, you feel that you have inadvertently been overlooked, please contact the publishers.